not
quite
straight

not
quite
straight

not
quite
straight

Jeffrey Smart

a memoir

VINTAGE BOOKS
Australia

A Vintage Book
Published by Random House Australia Pty Ltd
Level 3, 100 Pacific Highway, North Sydney, NSW 2060
www.randomhouse.com.au

First published by William Heinemann Australia in 1996
This Vintage edition published in 2008

National Library of Australia
Cataloguing-in-publication data:

Smart, Jeffrey, 1921– .
Not quite straight: a memoir.
Rev. ed.

ISBN: 978 1 74166 627 4 (pbk.)

Smart, Jeffrey, 1921–
Painters – Australia – Biography

759.994

Cover photograph by David Mariuz/Fairfaxphotos.com
Cover design by Greendot Design
Printed and bound by Griffin Press, South Australia

Random House Australia uses papers that are natural, renewable and
recyclable products and made from wood grown in sustainable forests.
The logging and manufacturing processes are expected to conform to
the environmental regulations of the country of origin.

This book is dedicated to the memory of
Justin O'Brien and A.W. (Mic) Sandford.

'Precious friends hid in death's dateless night.'

ACKNOWLEDGMENTS

THE AUTHOR wishes to thank Stephen Rogers, because without his aid the book could not have happened. Thanks to patient typists in Italy, Kimiko Dornberg and Francesca Zaccheo, who deciphered my bad writing. Mark Roberts at the British Institute in Florence was always helpful. Friends in Italy who have also assisted me are Desmond O'Grady, Russell Foreman, Iolanda Leveroni, Osvaldo Righi Thannasi Moulakis and Helen Richmond.

My cousin in Adelaide, Elizabeth Beare, helped with information on our family. Adelaide friends Kym Bonython and Denis Winterbottom cleared my memory. I have to thank Frank Rickwood at Barbados who was really the instigator of the book.

I thank the staff of the Australian Gallery of South Australia, and finally, because they stepped in at the end when last-minute band aids had to be applied, Barbara Wiley, Joan Hoare and David Cook.

Thanks to C.A. La Farge who taught me about brushes.

Australian friends who helped are Stella Downer, Stuart Purves and Philip Bacon. Barry Pearce encouraged me with

praise (but was he just being kind?). Geoffrey Dutton encouraged me to publish my memoirs. Thanks also go to Ermes De Zan, Bruce Beresford and Michael Bryce.

John and Audrey Rogers in London freshened me up on some points, also Luisa and Peter Quartermaine.

I would also like to thank Faber and Faber Limited for permission to reproduce excerpts from T. S. Eliot's *Collected Poems 1909–1962*.

BOOK ONE

ADELAIDE

ONE

AT MY birth, in 1921, I refused to breathe. Dr Gault had to work doggedly on my tiny lungs until at long last I reluctantly consented to enter this world—and have had breathing problems ever since.

To mark the occasion of my birth my father named a street after me in some land he had just had subdivided. It is near Hawthorn, in Lower Mitcham, Adelaide. Jeffrey Street is not quite straight; it has an odd little bend to it. The zealous pilgrim will today find a street crowded with 70-year-old trees, and lined with solid bungalows of the same vintage, all set in more or less shrubby gardens. The kink, of course, is still there, softened by age.

My father was born in 1881, the same year as Picasso. Just before this year, everyone said that the world was coming to an end because the number 1881 is a palindrome—reversible in every way. Francis Isaac Smart was born at Bowmans near Balaclava, which is near Port Wakefield, farming country north of Adelaide. The Smarts arrived in the colony about 1841 and in 1848 were the first settlers in the Inkerman, as the area was called.

He was named after St Francis of Assisi and Isaac Newton. My grandparents, unaware that acquired characteristics are not hereditary, piously hoped he would have the good

3

heart of St Francis and the great intelligence of Newton.

F. I. Smart was an uncle the day he was born, as there were already married children in the family. My grandmother, Caroline Jeans, had a total of twelve sons and daughters. The farm must have been large because, after my grandfather died and the farm was divided up, my father and his brother Thomas retired, rather over-optimistically (as it turned out), to live in Adelaide.

That must have been about 1910. My father had married Annie Atkinson, who'd died after ten years of marriage. My half-sister Dawn was the only fruit of what she remembered as an unhappy union. Indeed, my sister claimed my father poisoned his wife. She had died with atrocious stomach pains. My sister must have been about eight when she lost her mother—quite an early age for a diagnostician.

When my father and Uncle Tom retired to Adelaide they both bought houses designed by Percy Culley. Later, when Dad set himself up as a licensed land broker, he started a firm called Culley Smart, with Percy Culley as his partner. The premises in King William Street seemed very grand. (Sadly both my father and Uncle Tom were obliged to sell their Percy Culley houses in the Depression.)

My parents were married in 1920, and on the marriage certificate Dad gave his occupation as 'company secretary'.

Emmeline Mildred Edson was 25 when she married my father. Her mother, my grandmother, was born Millington, and the family lived near Gawler. I have met her brother, my great-uncle Mortimer Millington. We were told that my great-grandfather Millington had made an unsuitable marriage, and as his wife was unpresentable, he was sent to Australia, a remittance man. This meant that when he died, the money stopped. They were Anglicans in the country and became Methodists in the city.

My mother was the second of five children. The eldest, my uncle Charlie, was killed in the First World War. He was one of a few Australian airmen, an unusual and glamorous thing to be in those days. My grandparents cherished all his letters, which were beautifully written. He was, like my grandmother, a poet, and liked drawing and painting water-colours. He was also a good pianist. My grandmother said he did not fool around with girls, he was the serious type.

I was said to resemble him in appearance and in my ways. Once, when I dropped in on my grandparents and found my grandmother by the fire, she screamed, 'It's Charlie! Heavens above! I thought you were Charlie.' We visited his grave in Flanders.

My mother said they were all very suspicious of my father, the Flash-Harry Mr Smart, with his telephone and new car. (Anyway, I suppose few people had *old* cars in those days.) She was good-looking in the Spanish senorita way and, faithful to Dr Freud, I have often fallen for the Mediter-ranean type.

TWO

MY MEMORIES really begin with our trip to Europe in 1925. This was decided on the spur of the moment. My father saw an advertisement by P&O for a return journey on one-class ships; my mother complained that she had only two and a half weeks to prepare for the journey. Dawn was sent to boarding school and this embittered her for the rest of her life. She always maintained she symbolised Unhappiness—and Murder—for my father.

The journey took four to five weeks in those days. We went via Suez on the *Barrabool* and returned going round the Cape of Good Hope on the *Chitral*. My maternal grandparents went with us. The whole enterprise was always referred to as 'The Trip Home'.

It is difficult to judge what I really remember about a lot of the trip home. The photograph album and my parents' reminiscences have confused my memories. And anything of Adelaide I could have remembered before the trip was obliterated by the vivid events of shipboard life, and of hotels in London, France, Italy and Switzerland.

But some memories are obviously my own, like seeing the paintings and models within the Waterloo cyclorama; I didn't know what they meant, but the images are clear. Another is of paintings in the gables of a wooden bridge on

a lake. Was it Lucerne? There are tantalising shreds of memory: Venice was some women in the hotel putting down floor covers; me sitting on the steps of a dining room with a jolly guide, and the carousel on a dining table—futile, teasing things. The photographs taken in St Mark's square in Venice show that in the twenties there were very few tourists; the place is deserted. In Florence, my father took us to see the Protestant cemetery, among other things, which was a slightly odd thing to do—there are so many more important things to see in Florence. I found out why we made this visit many years later.

Bridge playing was always very important for my parents, and two of their bridge-playing friends, the Gardens, happened to be in Holland when we were there. I was very struck by the houseboats—what a wonderful idea, a house on the water. Mr John Garden was also fascinated, and I asked him if he would build a houseboat when we were all back in Adelaide. He said he certainly would. For the rest of our time in Holland I would pick up nuts and bolts, nails, pieces of wire, and hand them to Mr Garden 'for building the boat'. He would dutifully accept all these things.

One of the clearer memories is Switzerland, crossing a lake to see a monument to William Tell, and being caught in a storm, the dark water chopping around the little landing at the shrine. On the way back we could see people frantically waving towels at us to indicate the direction to take.

When I was tucked up in bed, somewhere in Switzerland, I could hear terrifying chthonic rumblings from the mountains. I was told it was glaciers moving.

Nothing of Italy remains, and we went to Rome and Florence and Naples. I used to look at the old labels of hotels on our suitcases, and try to picture these places

—'Hotel Roma, Venezia' or 'Hotel Sistina, Roma'. How *tantalising!*

The clearest memory of all is when we stayed with the Neaversons in Peterborough in England. We stayed with Uncle John Neaverson and Aunt Polly at their house The Chestnuts in the village of Peakirk, near Peterborough. (Sid Neaverson, their son, returned to Australia with us. There were some absurd photographs of us in Natal, sitting grandly in a bar on the street, and another of us in a rickshaw. This, in those days, was pulled by another human being.)

In the same village was Olive Lang, a niece of Aunt Polly's. She played the organ in a small local church and was choirmistress. One of her singers was Malcolm Sargent, to whom she was engaged. Alas, he left her, just as he was becoming famous.

Uncle Herbert, John's brother, was known as 'Toffee Neaverson'. This was because in his youth he had a friend called MacIntosh, who made sweets in a house in the town of Peterborough. He needed a promoter and Uncle Herbert agreed to take on the selling of the sweets for a percentage. MacIntosh eventually became Lord MacIntosh. They remained close friends, and I believe the agreement held. Uncle Herbert had a large house called Airedale at Dogsthorpe and this was also near Peterborough.

Uncle Herbert, who had a false ear and a hearing aid, took us to see his wood. It was called Monk's Wood, and in the centre was a log cabin, built for the gamekeeper. The cottage was furnished but not occupied, as Uncle Herbert couldn't afford a gamekeeper any more. The gamekeeper's wife loved the place and was distressed to leave. I was lifted up to be shown some writing on the wall just over the mantel

shelf. It was behind a photograph of a woman, and they read it to me: 'PLEASE DON'T TAKE ME AWAY.'

I would enjoy Uncle Herbert's hospitality again, years later.

My grandfather and my father hired a large touring car, a Durrant—another fact gleaned from the photograph album. They drove all over England, from Land's End up to John O'Groats. They travelled by train in Europe, and were away just under a year.

THREE

CHILDREN SEEM to adjust easily, and when we returned to Adelaide, I went to the local kindergarten. Surely it must have seemed dull.

Perhaps this is why I was drawn to Sex and Crime at the age of 5. There was a girl called Joy Frane, and she had such delectable little folds in her armpits that I was compelled to stick my fingers in, and had to be held back and dealt with. That was Sex.

The Crime was larceny. Because I was best at drawing, the very young teacher had made me the monitor and I was entrusted with the distribution and collection of the pencils. She had already confused Art with Ethics.

These pencils were glossy cadmium yellow and hexagonal in section. They were so beautiful I always held on to mine and didn't collect it. After a few weeks of steady petty theft I had accumulated a lot, and transferred them to my bag. In this way I could lasciviously run my fingers through them during the lessons.

But the teacher became concerned at the loss of so many pencils and asked me, the thief, to inspect every desk. I found nothing, so then she asked us to empty our bags on to our desks. By this time I was in the spirit of the thing and thought this was how we could find the culprit. The bright

yellow cascade of pencils amazed the teacher, and me as well, because I had forgotten all about it.

After kindergarten at the Vardon Memorial Church, I was put into the Westbourne Park Public School.

———————

My father and mother's closest friends were Herbert and Doris Holland. They were such close friends that I knew them as Uncle Bertie and Aunt Doris. Uncle Bertie had a well-known jeweller's shop in King William Street.

Uncle Bertie's father, a lawyer in Christchurch, New Zealand, gave him a sum of money when he turned 21 and said, 'Now go around the world and come back when you've spent it.' Uncle Bertie bought a racehorse in Sydney and by the time he reached Adelaide, on his world tour, he was broke. He met a beautiful woman, who was also a great cook, and married her. His brother, Sydney, who stayed in New Zealand, became prime minister and was knighted.

Of course the Hollands and the Smarts were keen bridge players. At home we had an illuminated scroll called 'If'. But instead of Rudyard Kipling's famous lines it began with 'If you can trump your ace when all about you' etc., and in the last line, instead of 'You'll be a man, my son', our parody said, 'You'll be a Culbertson'—an American authority on bridge.

Aged 5, their daughter Royce Holland and I were relent-lessly and shamelessly sexy and we used to have furtive 'feelies'. She was my first lover and she had a lovely sense of sin. (If you lose that, as T. S. Eliot deplored, it is a tragedy.) After evenings at the Hollands I dimly remember being rolled up in a rug and put on the back seat of the car.

There were very few pictures on the walls at home. Most

remarkable were large, well-framed sepia photographs of Rome. I think today they might have some value. They were taken in the twenties, when we were in Europe.

But the picture I looked at most was a genre painting, a coloured print, by Marie Bashkirtseff. It was a vertical composition and the main element was an unpainted wooden fence. Some children were grouped, in a conversation, in front of the fence and just above it was a glimpse of tenements. I spent a lot of time looking at it, but I wonder if I thought how it was painted. I don't think I did. I suppose my parents bought it in Paris.

When I was drawing some trees as a background, I found the best way to suggest the leaves was by doing a lot of dense scribbling. My mother, Mildred, trying to be helpful, showed me a print by Constable in a book. (I only found out later it was Constable.) She pointed out that if I wanted to paint a tree, I had to paint every leaf, as this artist had done. This was daunting, so for a long while I left trees out.

We used to go to Port Elliot for our holidays, either there or Victor Harbor. On one visit to Port Elliot, my father had walked down to the little jetty and we found a rowing boat tied up with a rope. My father put me in it and pushed me out and then pulled me back and forth, and I was crowing with joy at this game.

A few weeks later my father received a summons from the local police at Port Elliot to appear before a court there. Mr Page, the owner of the boat, alleged that Dad had damaged it.

There is a whiff of fascism in this story. My father rang up his lawyer, who was his great friend Sir Shirley Jeffries, after whom I am named, and who was also the attorney-general. He said, 'Come on, Jeff, let's have a day in the country, and a bit of fun.' So they went down for the

hearing. Mr Page offered the evidence, three tiny splinters of wood in a small envelope. The case was dismissed by the overawed magistrate.

———————

My half-sister Dawn married, disastrously, aged 18. I remember parties and hearing the word 'flapper' for the first time. She was to inherit a little money from her mother's estate when she turned 21, but she sold her inheritance at a discount and married John Holland.

I liked her young husband very much because Jack showed me how to put brilliantine on my hair and make it all hard and shiny. He also knew how to lace your shoes so there was no knot showing. He had flared trousers and coloured shirts.

They bought a bungalow in a new suburb, and I enjoyed visiting them. The little house already had an overgrown hedge and sat in a sea of weeds. They had photographs of film stars pasted on the walls. Dawn showed me how she painted her eyelashes and put on eyeshadow. They would take me to the pictures, *in the afternoon* (this was sinful, my parents declared). What a treat, and we always sat in good seats.

My father had procured a job at a bank for Jack, but he was so consistently late that he was sacked. After about a year of marriage Jack said he had to go to Melbourne 'on business' and my sister awaited his return, but he didn't come back. She pursued him, but couldn't find him. He later became a celebrated gambler in Sydney, and a friend of Jack Davies and appeared on his radio and stage show. My sister recounted that Jack Holland was asked to name the cardinal at the time of Louis XIV. He furrowed his low brow, put a finger to his conman lips and thoughtfully said, 'Was it

Mazarin?' It was. He got the jackpot! Dawn said it must have been done to settle his gambling debts. No wonder she became cynical.

When Dawn left to be married, I suppose I should have been lonely, but I don't think I was, because as soon as I was by myself, there was drawing. It was an obsession.

This obsession meant that there was the ever-present need for something to draw on. If I was let to my own devices I would draw in the blank pages at the beginning and the end of books, and had to be controlled; blank endpapers were not spared.

FOUR

ART LESSONS at school didn't interest me much because it was usually pastels in small brown pastel books, copying other pictures, often silly ones I thought. What I liked was drawing in pencil, and my parents would give me large sheets of paper, often the backs of posters or calendars, publicity sheets for land sales, anything. I would busily cover them with drawings of faces, often film stars. At first it was always profiles, but I became tired of that and invented different angles and some overambitious attempts at foreshortening, faces tilted up, or looking down. A face at a three-quarter angle was an adventure.

The Regent Theatre was the most beautiful place in the world and as homage I did a huge drawing of the interior. I used coloured pencils in a pathetic attempt to show the mysterious hidden lights, which made the false architecture glow exotically. Our local church was not as splendid as the Regent, and it was years before I had learnt perspective and tried drawing St Peter's Cathedral.

My mother got me a drawing book, a largish album which I would fill up with drawings. I tried to make it interesting and varied. I would draw a tennis player, a head study, a house, a dancer. They were hardly ever copied from anything, almost all made up. When the album was full I was

given another and so it went on until there was a group of them in a corner of the bookcase.

When I looked through them I noticed I had not drawn any men's fashions. I'd copied a drawing of a cricketer, but I drew lots of women in evening dress, or ballet dancers. I suppose I was unconsciously critical of men's fashions then, which were pretty dull compared to women's.

I don't believe anyone has a gift for drawing; all you have is the desire to draw. Facility comes with constant fooling around, strength comes with understanding the forms. You can teach yourself, but, like skiing, you learn more quickly with a good teacher.

When I was living in Sydney in the fifties I often visited my parents, and on one visit I glanced through the albums. They were really so feeble, they filled me with shame, and I burnt the lot of them, despite Mildred's protests.

If I wasn't at school, or drawing at home, I would see my playmate Brian Pile who lived opposite. Mr Pile worked in an office in town, and Mrs Pile spoke in a very plummy way and breathed noisily through her nose. She was said to be an heiress.

Brian and I were Indians, Red Indians, and we were at war with the white settlers. We collected a lot of feathers—everyone had 'chooks'—and we made huge headdresses: long strips of brown paper with the feathers stuck on with flour and water. Our faces were darkened with Nigger Shoe Polish.

We decided that the most effective way to attack the Pale-faces was to have a Night Raid, when the settlers were all sleeping. Three-thirty in the morning was agreed upon as a suitable time, and we were to meet at Brian's sleepout, which adjoined Mr and Mrs Pile's bedroom.

I couldn't go to sleep, I was too excited. At 3.30 a.m. I crept over to Brian's place, trailing my long headdress and clutching my bow and arrow, my knife in my belt and my face darkened.

I stealthily entered the sleepout and gently pressed a finger on the centre of Brian's forehead—the correct Indian way to wake a warrior. But Brian did not stir. 'Brian, Brian,' I whispered, 'The Night Raid! The Night Raid! Wake up!' I pressed harder but Brian, who to my dismay was still in his pyjamas and not even dressed as a warrior, slept on. 'Brian, come on,' I was whispering urgently, when suddenly the light went on in Mrs Pile's bedroom. She was screaming, 'Who's there? Who is it?' Then she appeared in her dressing gown and saw me in my full regalia, ready for the warpath. She was furious; 'Jeffrey Smart! Return home at once.' I was crestfallen and very disillusioned.

She called on us next day to complain, but Mum seemed amused, and not cross like Mrs Pile. Well, she hadn't been disturbed and frightened.

Shortly after this, Mrs Pile became very rich, and they moved from suburban Hawthorn to the next suburb, Unley Park. Their Victoria Avenue was only 500 yards away, but miles above us on the social scale. I never saw Brian again. We had to drive past the Piles' house on the way to town, and it always had an admonishing look. In one of the few known cases of justice being done, I shall later describe how it was dealt out to Mrs Pile and me less than twenty years later.

FIVE

OUR STREET, Denning Street, was not a long one. It ran from the Hawthorn railway station down to Cross Road and the Hyde Park tram terminus. The houses were Federation at best, or bungalows. The house next to the railway station belonged to the Gunns, and as he was state premier, this gave our street a little touch of class.

Opposite the Gunns, on our side of the street, and on the corner, was the Farquars' house, large Federation. Mr Farquar was head of the Harbours Board, and you could see him every morning walking to the tram in his striped trousers and black jacket. Mrs Farquar hardly ever appeared; she suffered constantly from remorseless headaches. Their only child was Mabel, who had a long neck, and it was Mabel Farquar who was my first piano teacher. I always think of Mabel Farquar as a tragic figure, crucified by suburban family life.

Next to the Farquars was a maisonette owned, but not lived in, by my grandparents. One side of this was tenanted by my great friend Mrs Jardine. She was unbelievably old, and her face was so heavily wrinkled that there wasn't a clear patch anywhere. Unlike Mrs Pile, she was very poor, but spoke like her without Mrs Pile's noisy nasal breathing. She

lived with her son George Jardine who was said to 'fancy negresses'. I don't think I knew what that meant.

The Rogers were next to Mrs Jardine, and they were rumoured to be vegetarians. There was something strange about them because when they walked down to the tram they went Indian file, with Mrs Rogers in front and Mr Rogers directly behind, which looked very odd, particularly because he was carrying her bag. Whatever the battle had been about, she had clearly won it.

Then came the Whites' house, our next-door neighbours. There was old Mrs White with her two unmarried sons, Athol and Wesley ('West'). Athol worked in the theatre and was a natty dresser in a rather sissy way. West White was my admired friend and he was building a boat in a shed in their back yard. The boat shed was right up against my father's garage, so I knew when West was working on it, and I would nick through a hole in the fence. It was a wonderful thing for a boy to see all those ribs, a great skeleton making the shape of the boat. It seemed huge.

On the other side of us were the Mittons. Mr Mitton was on the Milk Board, no children of my age. Then came the Rosses with an old maid daughter, then the Clunes, and at the end the Lamsheds in a fine Federation house. Engineering they said. Their house had been owned by my grandparents, who moved across the street to a large modern bungalow.

My grandfather, George Antony Edson, had been a wool tally clerk for Elder Smith in Port Adelaide. He was also a magistrate. He moved to the western suburbs and must have made some money buying and selling houses. I was very fond of him. From his deathbed he advised me, 'Never take out a second mortgage.'

A perceptive reader will have observed that there were no European or Jewish or Asiatic names in this leafy street. One of my father's nieces married the Adelaide millionaire Mr Gordon Sim Choon. She was always referred to as 'poor Ivy'. Roman Catholics were also suspect, and a rarity in Hawthorn. There were no Roman Catholic churches in these suburbs. Nor were any built, I was told, until the 1860s, when the Irish were brought out as domestics.

Behind Denning Street, away from the railway, was a large vacant area known simply as 'The Brown Hill Creek', through which flowed this creek. I suppose it was about three or four acres. There were also low parts where rubbish had been dumped as fill. It was an ideal playground for boys and I was one of a gang from the Westbourne Park school. We had a meeting place and special jump areas where the creek could be spanned in one long run-and-jump. We established a ritual for this. My main friends were Keith Jackson, Rodney Kerr and Len Porter.

I was sometimes head of the gang. It depended on what we were doing. My opinion was often sought during arguments on the grounds that I had been in Europe—I must have done a lot of bragging.

My wanderings on my bike took me near to the Roman Catholic monastery at Glen Osmond. I saw a gap in the thick hedge, and hid my bike and wriggled through to find myself in quite a heavily planted shrubbery. After some more furtive crawling, I came to a space, a large area of lawn, and I saw the monastery building.

Seated on the verandah was a monk, and he was at a small table and by his hand was a *glass of wine* and he was smoking a *cigarette* with a *cigarette holder*, which only cads and women do. He was reading a book—no doubt a dirty

book—and in spite of all this, this satanic monster of depravity looked quite content in his mire of sin.

It was impossible for me to even hope to get into the monastery, to find the hidden door that led to the underground passage under Cross Road which ended in the convent–orphanage on the other side of that road. It had been whispered to me that it was here that the nuns looked after their children, all sired by the unspeakable monks, one of whom I had now seen!

SIX

BY 1930 there were big changes. My parents were worried, and I could hear them talking long into the night, and I heard this word 'mortgage' used a lot. I had no idea what it meant when Mildred would say, 'Well, Frank, can we shift the mortgage on such and such to so and so?' This was the depression, which had begun in the United States in 1929. Now it had come to Adelaide.

Dad's firm, Culley Smart & Co., had bought two farms from a Mrs Christie. They were developing the farms into beach resorts, Moana, and Christie's Beach. I remember how proud I was when I saw a full-page advertisement in the *Advertiser* announcing the sale of their building blocks. Unfortunately, it was a bad time to try to sell allotments.

The Moana sale was organised on the site, and several hundred cars were parked on the beach. A road and two buildings had been built, one a pavilion, the other a guest house. These were supposed to start it all off. My father even arranged for the South Australian Railway to have a stop there. It was only half a mile from the beach.

Imagine my father's frustration to find that the railway authorities had put up the 'Moana Station' sign quite a long way from the road and from the beach. Rather than go through all the tedious red tape, I helped my father dig up

the sign and we moved it nearer the road. The railway station is still where we put it.

Despite all the publicity and fanfare, the sales were not enough to pay for Culley Smart's investment. The firm went into liquidation. We had no money at all, we had only the house we lived in, and that was mortgaged.

In the depths of the depression my parents were forced to let their comparatively large family house in a garden suburb and take a small flat in the city. They decided to let it furnished, and a visiting Sydney detective and his family moved in.

Perhaps I should explain that Adelaide is a square city— it is one mile by one mile. This square mile of city is surrounded by parklands, an encircling belt of vast parks. So the bordering terraces of the city, called East Terrace, West Terrace, and so on, all look over the parklands.

Our flat was on the South Terrace. It was upstairs, in a handsome 19th century building. The two bedrooms had French doors on to a balcony. From our bedrooms we looked across the parklands, then across the suburbs to the blue hills of Adelaide. In these suburbs lived all those people whose idea of going abroad was going 'home'—that is, to England. London of course, but a lot of them would decide, in cold blood, to go to places like Bournemouth—very popular with Adelaide people. Switzerland too, because it is so clean.

The rest of the small city flat was a living room and a kitchen with a porch. This porch was trellised and had a wonderful view over the roofs of the inner-city slum houses, then small office blocks, and then the few skyscrapers Adelaide had in those days. This view of the city was even more enchanting to me than the views from the bedrooms' balcony.

It is curious to think back on it and reflect how my mother and father counted the days until they could return to suburbia, while I was hoping we could stay for ever. I even liked the furniture—it was a furnished flat, with loose-covers on chairs, unlike our upholstered ones.

Although I had an extraordinarily protected life, I always seem to have had an unwavering attraction to squalor. The walks into the slums behind the flat were full of interest. There was even a mosque nearby. It had high walls so I couldn't see in, but I supposed that the rituals that went on inside would be even more exotic than the ones I had seen in Roman Catholic churches. There was much more life in the streets here than in a garden suburb, and if I walked a little further there was a budding Chinatown.

I was still at Westbourne Park school, so every morning I walked across the park to the tram, to Thomas's corner. This was to save a section, and saved money. Sometimes the magpies would attack me; frightening the first time, after that it was a game.

There was a little girl in the flat below, Joyce Pulleine, and through her I met Max Roach. Max lived in a large old-fashioned house in Gilles Street. On Saturday afternoons we could smuggle into the nearby Tivoli Theatre at interval. They had vaudeville shows. This was much better than life at leafy Denning Street. It was here that one afternoon I saw and heard the most moving little item which has remained with me all my life.

The stage was dark; the curtains parted and a soft light came on to reveal two rows of bottles suspended from horizontal poles—that was all. Then a very old sad clown shuffled in and bowed to us. He held two drumsticks and with these he sounded some little tunes, gently tapping the bottles,

making extraordinarily sweet notes. When he finished his music, the clown bowed low again. We were all so moved that the applause was very slow in coming, and then gradually mounted to a crescendo. He did not return for another bow, the moment was too solemn. No encore was possible.

Many years later I came across a prose poem by W. B. Yeats, and I recognised my clown. I quote from 'The Golden Age'.

> The sounds filled me with the strangest emotions. I seemed to hear a voice of lamentation out of the Golden Age. It told me that we are imperfect, incomplete, and no more like a beautiful woven web, but like a bundle of cords knotted together and flung into a corner. It said that the world was once all perfect and kindly, and that still the kindly and the perfect world existed, but buried like a mass of roses under many spadefuls of earth. It said that with us the beautiful are not clever, and the clever are not beautiful, and that the best of our moments are marred by a little vulgarity, or by a needle-prick out of sad recollection, and that we [this music] must ever lament about it all. It said that if only they who live in the Golden Age could die, we might be happy, for the sad voices would be still; but they must sing and we must weep until the eternal gates swing open.

Because it was too far for me to go to piano lessons from Miss Farquar, Max introduced me to his piano teacher, Professor Parker. I was sure he was a better teacher than Miss Farquar. He got me going on 'Viennese Nights', much more interesting than her boring old Czerny.

Max was a chorister at St Peter's Cathedral, and he suggested I go with him to their choir practice. It was good fun

he said, and they paid you. I liked singing Stainer, Villiers Stanford, Handel, Mendelssohn and sometimes Bach.

I enjoyed singing in the cathedral and chanting the psalms and I became very fond of our stout choirmaster, Mr John Dunn. He also taught piano in his studio in Allens in Rundle Street, and was very alarmed when I played him my Rodgers and Hammerstein.

'Who taught you this, Jeffrey?'

'Professor Parker, Mr Dunn.'

'Professah Parkah! *Who is he?*'

I was put back to Czerny.

At this time of the depression—it was 1931—John and Norma Garden did actually decide to build a houseboat, and live on it. Was it the power of suggestion? It was built in shipyards at Murray Bridge and then towed up the Murray River to Cobdogla near Barmera and Lake Bonney. 'The Riverholm' was large and luxuriously furnished because the Gardens sold their home on Park Terrace and moved everything up to the houseboat.

It was a good arrangement for us because we could exchange homes. We were on the boat in 1932, with the Gardens in our house, when there were tremendous floods. It was extraordinary, with a lot of ghost gums reflected in the water, making fantastic shapes. There was an abundance of tiger snakes and sometimes you could see a dozen marooned in a tree. Occasionally they would dash to another tree.

I had a small canoe and was very careful about the snakes because they are deadly. You had to have a piece of fencing wire always with you. If you counted the red spots on the

white belly of the snake it always came to 150, I was told. But my researches indicated that the number varied.

This was the time of apple-pie beds. I had a brilliant idea. I would prepare an apple-pie bed for my mother, not with just spoons and forks and a plate, but a real tiger snake! I could imagine her surprised squeals, until she found it was not alive.

So I cleaned and polished up a dead tiger snake, and sneaked it onto the houseboat, and got it to their bedroom. I carefully laid the double-bed open and worked out the place where Mildred's feet would go. Then I wound it into a very natural-looking circle, as if it was curled up asleep.

I could hardly wait for bedtime and hovered about, not wanting to miss the fun. As expected, the moment my mother's toes touched the tiger snake she screamed, and I was crowing and jumping with joy, yelling 'It's dead! It's dead! Hasn't it fooled you!' But my joke fell flat.

Unfortunately, my mother did not stop screaming, she went on and on. She had to be taken onto the rowing boat and put, screaming, into the car, and Dad drove her to the Barmera Hospital, where she stayed the night.

So much for my tiger snake apple-pie bed. There was no need to punish me, I was ashamed and penitent.

SEVEN

A YEAR after I joined the choir, I was informed that I had been given a scholarship to Pulteney Grammar School, just along South Terrace. Things were looking up. The school was nearby, the building was more interesting than Westbourne Park, and the classes were smaller. I liked the school uniforms of black and white and grey. But the art lessons were no better. We had a local artist visiting us, Miss Priest. It is such a cliché I hesitate to write it, but she asked us to copy a picture of a lighthouse, and showed us, lovingly, how to round the column.

Being a choirboy, and being paid, became a big problem for me later on. We were paid one shilling and sixpence a month, and I had sixpence a week from my parents. When I had been in the choir two years, I was promoted to leader of the cantoris, and for this I was paid not one shilling and sixpence but a capitalistic seven shillings and sixpence. It was a big jump. Bob Calvesbert, the former leader whose voice had broken, advised me, 'Don't tell your parents you get seven and sixpence. Tell them they've only doubled your fee; if you tell them you get seven and sixpence they'll make you save it.'

So I was committed to duplicity. How was I to hide this vast sum and how to spend it? I couldn't buy too many new fittings for my bike, it would arouse suspicions. I was allowed

to see only one film a week, usually Saturday night at the Unley Star, but now I could afford Saturday afternoons too.

By this time we were, alas, back in suburban Denning Street. After lunch on Saturdays I would pretend I wanted to go out on my bike, and it was a rush to get away, leave my bike at a petrol station, get the tram, and be at the movie-house by 2 p.m., all the time knowing that going to films in the daytime was bad.

Then the first item of an elaborate program would start. There was the Fox Movietone News, trailers for coming attractions, Jack Ripley's 'Believe It Or Not' and the dynamic 'Time Marches On', then the support film. The main film came after the interval, after more trailers. There was much to and fro-ing of the curtains and raising and dimming of the lights, all of which was sheer enchantment.

In this way I saw all the Gaumont British films, usually at The Majestic, and of course I saw the first Alfred Hitchcock films, Korda's London films, and Charles Laughton as Rembrandt, never to be forgotten.

My only confidante about my secret life was Mrs Jardine. I told her how I had to fib about my Saturday afternoons. I could tell her all about the films and she was condoning and approving. Later, when de Basil's Monte Carlo Ballet came to Adelaide, she arranged tickets for us, in the Gods. I hope I paid. She then gave me my first commission. She wanted a watercolour of Helene Kirsova as 'The Firebird'.

Most of the films I saw were American, but I preferred the British, and seeing this wonderful place, Europe, stirred memories. Then came an Elizabeth Bergner film, *Escape Me Never*, with lovely shots of Venice so taunting to me. I could just remember it; was it truly so beautiful, was it even real?

My obsession with drawing gradually started to include watercolours, but you really need some instruction to manage them. Students are so lucky today: schools have poster colours, which I knew, slightly, as gouache, and they have all the acrylic colours—so much easier to handle. You can teach yourself watercolours, but you learn more rapidly with a teacher. I couldn't even imagine what it would be like to paint in oils.

At the Adelaide art gallery, the framed pictures were totally divorced from my own scribbling—there wasn't any link. I was like the peasants inhabiting Rome in the Middle Ages, who thought all those great ruins had been built by a race of giants. To me, a framed painting in a gallery must be by this holy, mysterious and admirable man, The Artist. I think even the films were more real.

One of the paintings which was fascinating for a young art lover was Henry James Johnstone's 19th century *Evening shadows, backwater of the Murray, South Australia*. This enchanted me. My love for the painting went out the window when I learnt it had been painted in London from photographs.

My other favourite was *Still Life* painted at the turn of the century in Lucca, Italy, by Giorgio Lucchesi. Trompe l'oeil is certainly surrealistic and wasn't it Oscar Wilde who said that to be deceived by art was a pleasure? *Still Life* was a never ending source of wonder. How was it possible to paint anything so realistically? I am sure it remains, deservedly, one of the most popular pictures in the gallery.

By the time I was adolescent I had moved on and was captivated by Streeton's *Australia Felix*. When we drove in the country I often became car-sick in those days, and I remember standing and becoming so totally absorbed by the magical atmosphere Streeton conjured up that I felt

twinges of car-sickness. My other later favourite was Frank Brangwyn's *Bridge at Avignon*. Such lovely slabs of paint, and such a romantic gigantic bridge; how evocative it was with those bathing figures. How disenchanted I was when I saw the actual bridge ruins—so small, and no place to bathe.

My parents must have sensed my struggles with drawing and painting because, when I was about 12, they enrolled me for the Saturday morning children's class at the South Australian School of Arts. This was run by Miss Gladys K. Good. The reader will think I am stretching it, but one of the first things she asked us to draw and paint was a candle in a candlestick. But I did learn something about watercolours.

The depression dragged on in Australia. After the fall of Culley Smart, my father had set up as a licensed land broker and real estate agent, in more modest offices, still in King William Street. At one point, he had to collect the rents himself—for his few remaining clients. He had no houses of his own any more. Then the terrible day came when he had to tell tiny Miss Pittman, his secretary for many years, that he could no longer pay her. She begged to stay and said he could pay her later. But it wouldn't do and she had to go. My mother had already started going to business school, and had learnt typing and shorthand, and she took Miss Pittman's place at the front desk.

I asked my father, 'What's it like, Dad, when there's no depression?' and I've never forgotten his answer: 'Life is heaven.'

There was a whole shanty town of huts along the river, between the Morphett Street bridge and the weir. Hessian was stretched over wooden frames and white-washed. Lots

of petrol tins, opened out, made walls. In the winter time, Lady Bonython launched a 'Blankets for the Needy' appeal. When she talked on the wireless, she was so moved she broke down and wept. The money poured in for a while after that.

At Pulteney Grammar School, immediately after lunch, we boys would run across South Terrace to the parklands. One day we found a woman standing there, at the entrance to the park. At her feet was a cheap suitcase with the lid open and a sign 'CHIP POTATOES, one penny a bag'. The suitcase was full of neat brown chip-filled paper bags, and we asked to look at them. 'Wrong sort,' we cried, and passed on. Boys like potatoes in the shape of chips as with fish, and she, instead, had made thin oval flakes. She waited for our return, poor thing, but the bell had rung and we couldn't stop. We all ran past her, and I saw that her suitcase was still full.

Back in class, I began to think of her, and how she must have gambled a precious sum in the hope of gain. It was a disaster caused by the capricious taste of boys. I calculated that thirty bags at one penny each would only be two shillings and sixpence, yet she had to pay for the potatoes and the oil. Two shillings and sixpence was about what I had for weekly pocket money, with the choir and the money I was paid for mowing the two lawns we had. I felt my pennies in my pocket and asked to be excused.

I ran out across the road, but she was gone. I became very upset. I could see how careless I was, and I was overcome with remorse. The more I thought about it the worse it became. I had been callous. It was my first intimation that there was absolutely no justice in this world—it made me physically ill and I got the squitters. Of course I recovered,

but I had yet to learn to curb my pity. Only a few years later, reading Stefan Zweig's *Beware of Pity*, it struck home.

My second year at Pulteney Grammar School was hilarious. I seemed to have lots of friends. Mr Gregory, our form master, had no discipline at all, and we were getting up to pranks all the time. I was the class clown; you could always rely on Smart for a laugh. We looked forward to each day's fun. I had a friend in John Calvesbert who was the leader of the decani section of the choir, and young brother of Bob who had been my financial adviser.

When John and I left school to go to choir practice, we spurned the tram and walked. John knew all the little by-ways of the city. He showed me how from Angus Street we could go right across the city without walking along a street—just crossing streets. He knew every office block, and how to nick through by lavatories and light wells, past caretakers' rooms—very exciting.

EIGHT

ONE NIGHT, after choir practice, walking back to the city through the park, I paused by the bronze statue of the young Hercules. It was so beautiful, I took off all my clothes and climbed up and embraced it. It was surprisingly small, the same height as myself. I don't think I knew why I did this. When I read Proust ten years later, I was tremendously moved to read he had done the same thing in the Tuileries.

It was about this time, dawning adolescence, that I had an extraordinary experience. I was walking through the park to the cathedral. Quite suddenly, I was overwhelmed by the most ecstatic music flooding down all around me. It was as if the whole sky was bursting with heavenly sound. I felt the clouds had opened and released this vast majestic music. (The nearest I've ever come to it, years later, is some-times in the music of Mahler.) I heard a huge symphony orchestra with an immense choir. I was so moved and amazed I ran to tell Canon Finniss at the cathedral. He did not laugh or try to explain, but gravely said, 'Jeffrey, you have just heard the Music of the Spheres.'

I was having difficulties with the Anglican faith. I was due to be confirmed. In a bookshop I had browsed through H. G. Wells's *Outline of History* and I was struck, firstly by the illustrations of prehistoric man, and then by the text

explaining the theory of the evolution of the species. I was very excited by this, and I was completely convinced of the truths of Darwin's theory. It rang true, immediately. It was an important discovery for me. I had been wondering about Adam and Eve; and where and when was that Garden of Eden anyway? This revelation had to be shared with someone immediately. I didn't think my parents would be interested to know we were descended from monkeys, so I ran down to my grandparents' house and burst in on them and gave my grandfather the amazing news.

My grandmother screamed, 'Lord above! Monkeys! What is this boy coming to!' And my grandfather, instead of sitting down and discussing it, took a book from his shelves saying, 'Tut, tut, you take this book home with you and it will cure you of those ideas.' I was so disappointed that I crept out, lonelier than ever, and put the book away, so fed up I didn't look at it. It was years before I discovered that the book Grandpa gave me did not deny evolution, and he didn't share Grandma's views, he was simply too sensible to argue with her. The book was *Human Origins*, which had belonged to my great-grandfather; it is now in Tuscany.

But if I ceased to believe in Original Sin, then there had been no sense in baptism. And, if this was so, then I couldn't accept the idea of confirmation. The catechism was puzzling, boring and even disagreeable. I went back to Canon Finniss and told him how I felt.

He arranged special tuition for me from a remarkable woman called Rita Cussens, headmistress of a girls' school. She explained the theory of emergent evolution and the symbolism of the Old Testament. My heretical thoughts were temporarily quelled, and I reluctantly submitted to confirmation, but I still felt uncertain about it.

When I took my first communion I was expecting and

hoping that something would happen, some revelation, as with the music in the park. But the strongest sensation I had was the smell of starch in the priest's surplice. I can see why some religions have incense—you need to capture all the senses.

I felt such a fake, kneeling there and shutting my eyes and trying to pray. I lacked piety and humility. Above all, I lacked faith. I thought it was a contradiction to pray for faith, and never did. I found it later, in other ways.

———

After school I would collect my bike at home and then go off with my friends for a spin. My favourite place to go was up the valley at Mitcham and above Mitcham, where the Brown Hill Creek sprang; I tried to find its source. It was a lush valley where you could often find yabbies in the pools of the creek. Sometimes we would go with glass jars, and you could bring tadpoles back, and watch them grow and make their metamorphosis.

Often, I would bike alone around Mitcham, where the old houses interested me, and I was beginning to look at the gardens. One house I sometimes went to see was up on the Cross Road at Fullarton. This was entirely Spanish Mission but had an interesting block structure and a Mediterranean garden which seemed right. I preferred it when the garden hid the house.

The most glamorous of all suburbs was Springfield, where there were mansions set in large gardens. The most impressive building at Springfield was an immense house under construction. At first I thought it must be for a huge school. But I chatted up the builders and they said it was for a man and his wife. It was large even by Springfield

standards, with three, not two floors. The garden was going to be vast, acres and acres of it. I kept going back: it was fascinating seeing it taking shape.

One of my school friends was Les Martin. He lived at Belair, a small hilltop suburb on a ridge overlooking Adelaide on one side, and on the other the national park. I liked those weekends with the Martins. It was a large family. Their house was at the top of the old Belair road, one of my favourite rides. It was known as the Old Coach Road. I used to think how exciting it was, probably the way they went to Melbourne in the old days. You could walk your bike up the Old Coach Road and then glide, freewheeling at great speeds, down the new bitumen highway, dodging alarmed motorists.

Les took me on some wonderful expeditions. We bicycled down into the national park and went through a large flat area I'd not seen before, past a lot of tennis courts and then into a thicket. When we came through the thicket a high earthen viaduct was revealed. We were at the base of it, and right up at the top Les said was where the Melbourne Express went by. We looked into a tunnel at the base, with a stream running through. It was almost that most exciting thing, an underground river. Les led me, splashing into the tunnel. At the other end we came into a valley, absolutely primordial and untouched, with no paths. We walked up the valley, over rocks and around trees and after about three or four hundred yards we came to the end to find a cliff and a waterfall.

This place became a secret retreat for me, and when my prim suburban family life got me down I would bike up there and it would lift my spirits. Here I could sing, and dance, throw off my clothes, and yell in the ecstasy of being young.

NINE

AT THE end of the school year the school had Swimming Sports Day at the Adelaide Baths. We weren't allowed to swim until all the visiting parents had left, and as soon as they were gone there was pandemonium and splashes and yells as we flung off our clothes and threw ourselves into the water.

Over the pool, and running the length of it, was a series of rings suspended from the roof. You could swing, Tarzan-like, the entire length of the pool. I looked up and saw the naked, shining figure of a handsome young god. 'Who's that?' I asked, expecting to be told it was some famous visiting athlete, but they said nonchalantly, 'Oh, that's Kellett.' That scruffy, untidy, lumpish lout, Kellett, how could it possibly be Kellett? I felt strangely disturbed at the transformation. It was another intimation of physical beauty.

Every summer the *Advertiser* ran sandcastle competitions on the local beaches. An area was cordoned off and thirty or so children would build sandcastles, always watched by a large crowd. We were given an hour, and then the judge, usually a local architect, would award the prize. I won these prizes for several years. As soon as the judging was done, a line of boys who had been waiting at one end, would run all over the area, kicking at and destroying all the sandcastles with whoops of joy. It was upsetting and puzzling to see their

savagery, all my battlements and towers and bulwarks, all gone with one kick.

My voice broke in 1936. For a while I tried to sing off the roof of my mouth, but it wouldn't do, so I left the choir. Business must have picked up at the office, as Dad had a secretary again, and a salesman who would also do canvassing and rent collecting.

There was a terrible murder in Adelaide in a western suburb. A man ran amok and killed his wife and children and then suicided. There were photographs of 'The Murder House' and on Sunday people would go to see it. My father bought the house and had it repainted inside and out, and put in an 'instant garden' with fresh gravel everywhere. After a little while, when the whole tragedy was forgotten, he sold it. I think that was when our finances started to improve.

My parents said that when I gained my Intermediate Certificate they had me down at St Peter's College for the final years of learning and Leaving honours. But my fooling around the year before, in Mr Gregory's class, had ill prepared me. I failed to gain my Intermediate Certificate. I would have to do it all over again, and this would mean I would be 17 by the time I gained my Leaving Certificate.

It was very depressing and I felt ashamed of myself. But I had to get my Intermediate before I could go on, and it was decided to send me to nearby Unley High School. I felt this was really a come-down. It turned out to be an excellent school but without the glamour and snob value of St Peter's.

———————

About this time an owl flew into our back garden and seemed to settle there. He was very handsome and friendly. His favourite food was chicken livers, and mice, when he or

we could find them. After he had been given a mouse, he would sometimes sit there with it in his mouth, with the tail hanging down on one side.

It was all too good to be true, having a pet owl, and after his arrival we saw an advertisement in the *Advertiser*:

> LOST, a fine grey barn owl
> Answers to the name Hector
> Please telephone U2286.

We rang, and a man dressed as a cowboy came with an attractive little girl with a fringe, and that was the last of Hector, I thought. I was wrong.

I was still going on my roamings, looking, hoping for magic in the suburban architecture and gardens. I went more often to Springfield, and I would look at the big house of Sir Josiah Symonds, whom my father knew. I decided it had been deliberately designed to have an asymmetrical, lopsided appearance.

The enormous house being built at the top of Springfield was now almost completed. There was a lot of oak panelling which the men said had come from England. Then I saw them putting in huge old fireplaces and beautiful wood-carvings they would not let me touch. The grand staircase was also old—it looked Tudor to me.

One day, when I went to see how it was going, the foreman said I was not allowed to enter any more. I was asked, kindly, not to come back, and it was just at this point that the whole place was becoming really splendid. Huge trees and shrubs and drives were being laid.

I left feeling sad. Of course I didn't know that it would become an important house in my life, and its owners become my friends.

TEN

UNLEY HIGH School had no charm, but at least it had an art teacher. Art was the Cinderella of the Muses in the Education Department of South Australia. Literature and music had long been considered as being sufficiently serious to be accepted as matriculation subjects—but not art. Art was a newcomer. Perhaps it was thought frivolous.

The art room was in a pre-fabricated shed in the school yard. The art mistress had come a few steps up from light-houses in pastel, but not a long way up that staircase. She was a devotee of the William Morris school of design and that is what she taught. True, it was the thirties, and the Bauhaus had made its great impact in the twenties, but not a ripple reached the backwaters in Adelaide. Only girls, apparently, studied art, and I noticed that the art mistress had a couple of favourites.

Sometimes I was the only student, and the art mistress often left the room, coming back smelling of exotic Turkish cigarettes. She was just one jump ahead of me in some of my subjects, I felt. Subjects like perspective, geometrical drawing, and dimensional sketching.

My English master was Brian Elliott, memorable because in 1943 he was one of the first to detect fakery in the Ern

41

Malley edition of Max Harris's *Angry Penguins*. He stated in an acrostic that it was a 'MAX HARRIS HOAX'.

I gained my Intermediate Certificate, and was elevated to the Leaving class. The art teacher now had a swanky new room, and more students. The colours she recommended had a cold red, no warm one, something I found very frustrating in design. A sign of her times, and not mine. My English teacher was Clement Semmler, jazz critic and author, and he was inspiring. Poetry and Shakespeare came alive in the classroom; he made it thrilling. He was passionate about literature, but also could be humorous, and droll. He was very complimentary when he marked my essays, and I felt encouraged.

In the sitting room at home there was a bookcase filled with books. My sister derisively said it was bought holus-bolus, books and all, by my father as interior decoration. But there was a book entitled *The Collected Poems of Arthur Hugh Clough* purchased from a Sydney bookseller with the name F. I. Smart in it. I did not know that my father thought he might be the reincarnation of A. H. Clough, and one of the reasons we went to Florence was so that he could sit on his own grave in the Protestant cemetery there.

There was also a collected edition of Charles Dickens. My father declared that when I had read them all, in chronological order, he would give me a wrist watch. This was a great incentive, and I had read them all by the time I was 16. I was then switched over to Alexandre Dumas—in English of course. All the Dickens are still with me in Tuscany; the watch has been superseded.

At home, it was becoming obvious that I wanted to be an artist. The objection to this was that painting, as a career, was financially hazardous. Of course they were right, in many cases. I could be a commercial artist, which I despised,

because even then I knew it rested on clichés. Or I could be an architect, which I would have liked, but my parents baulked at the expense of the university for five years. Even today, I still consider myself a frustrated architect. Several architects I know have declared they are frustrated painters. Teaching was another possibility, and the years at the teachers college would allow me time to study painting.

So I did all the required subjects, rather specious divisions of art. These required subjects were dimensional sketching and design. I found them fairly easy, so I added plant drawing and object drawing and perspective as subjects.

By my second year at Unley High School, I was rather dismayed to notice that I was not falling in love with girls, unlike all my friends. I hoped that I would 'develop', vainly as it turned out.

The boys with whom I would have some furtive gropings and wankings were very lighthearted about it, and said we were 'going through a phase'. But in my case I already knew it was more serious, and I couldn't be casual about it, so I remained physically pure much against my will, and very corrupt in mind. Much later I read André Gide who wrote, 'Here I am, a virgin, and totally depraved.' How well I understood that.

In 1938, in the Leaving class, my great friend was Peter Crosby. I felt passionately about him, but my scruples prevented me from showing any physical affection.

We went to Mount Buffalo with a group from the school. The snow was sparse on what they ambitiously called 'The Cresta' but there was enough snow for ski lessons from some Austrian teachers. It was September, and while we were there the Munich crisis occurred.

The skiing instructors were all called back to Austria. There was lots of patriotic singing, and Europe seemed

much nearer. We were all preoccupied by Hitler's mad actions, we hated the British policy of appeasement, and there were lots of arguments among us. But I was so happy having ten days of sharing every moment with Peter that the threat of war took second place.

Anyway, we thought, it was inconceivable that nations could be so stupid as to go to war. In faraway Adelaide, Hitler and Mussolini seemed rather comic figures.

ELEVEN

I MANAGED to gain my Leaving Certificate and, more importantly, matriculated. If you wished to be an art master, you had a one-year probation as a junior teacher, assistant to a senior master. After this year, you could be recommended to the Adelaide Teachers' College. I wasn't at all keen to go to this institution, but I had to, at least nominally. All I wanted to do was to attend the art school. I was appointed a junior teacher at the Adelaide High School, under senior master T. H. Bone, who was a well-known watercolourist. The art room, again pre-fabricated, was in a shed in the yard, and next to a biscuit factory. There was a curiously insistent smell of stale cooking, it permeated everything.

Tom Bone had a cubby hole, just off the art room, where we kept pots and pans, cubes and cones—all props for still life. He sometimes used a bowl to relieve himself, and I knew this, and would catch a cheeky look from him as he pissed, half-hidden from the girls.

Although Tom Bone was a rather rough chap, his water-colours had a personal distinction. It was a privilege to know him and work for him, a real artist who held exhibitions. His masters were Constable, Cotman, Girtin and De Wint. His 20th century masters were Hans Heysen, Blamire Young and Frank Brangwyn.

My broad plan was to obtain passes in all the tiresome required art subjects, so that by the time I went to the art school and the teachers college, I could devote all my time to painting and drawing. Tom Bone helped push me through some of the really fatuous things, like second-year plant drawing or second-year object drawing—which was quite another thing from still life. They even had a weird subject called freehand drawing—you had to copy stilted 19th century decorative lines in scallops and arcs. Some subjects were good, like projections of shadows and even lettering, where I learnt the incredibly subtle Roman lettering on the Trajan column, and the fascinating way it developed into script.

I was at the South Australian School of Arts and Crafts every night and Saturday mornings. It was difficult keeping in touch with Peter Crosby, we were both working so hard. He was at the National Bank in King William Street.

In September, war was declared. I had just turned 18.

About this time I was reading Christopher Isherwood's *Goodbye to Berlin*. He wrote about homosexual life in Berlin, and as I knew I was the only one in Australia, I was determined to get to Berlin, where there were others like myself. But the war put paid to that idea.

Dr Freud told me what I thought were erroneous things about myself, and had put me on to Magnus Hirschfield. But when I went to the public library and asked for some of his books the fishy-looking librarian at the desk looked at me in a very suspicious way and asked, 'What do you want to read him for?' and so I slunk away.

Penguin Books published a work on male sexuality by Kenneth Walker which was a great help. I learnt there were plenty of others in the same plight. Some of the famous

painters, writers and musicians had these 'unfortunate ten-
dencies' which dismayed me so much, but I still thought
I was unique in my queerness. The subject was never dis-
cussed or mentioned in the paper, except in the most veiled
fashion.

But then I realised there *was* another one, and felt very
uneasy. He was right here, in Adelaide, a well-known
member of the South Australian parliament. Bert Edwards
was convicted of 'grossly indecent behaviour' with a male,
and was sent to jail. It was a famous case, and his name
enriched the Adelaide vocabulary. 'He's a bit of a Bert'
meant he was a pervert, or it could be used as a verb: 'He
wanted to Bert him.'

In this sort of Adelaide sexual conservatism, I had to go
very quietly. My mother was often saying 'birds of a feather
flock together' and I hoped I wasn't of that same flock.

Bert Edwards owned some property at Victor Harbor—
he had several hotels and boarding houses. My mother was
searching for a holiday place for our help, Lina (Nanny)
Nicholls, and saw an advertisement for a room to let at
Victor Harbor. Mildred rang the number and asked for
details. The man was evasive about the nearness of bath-
room and lavatory and said, 'All you have to do, madam, is
put on your kimono and go down a short passage.' Mildred
said, 'Do you know, I think I'm talking to Bert Edwards.
Don't say kimono, it dates you,' and hung up. She was not
going to deal with an infamous homosexual.

TWELVE

THE WAR didn't seem to affect life in Adelaide for the first few months. We went to Victor Harbor or Port Elliot every Christmas for summer holidays. We always drove the 60 miles and it took half a day to get there. (In the twenties, we took spare petrol cans on the running boards. One year, going to Victor Harbor, we saw only one other car, a sports car. It flashed past us. My father said, 'That was Frank Penfold Hyland.')

In the summer of 1938 we were staying at Cliff House in Port Elliot. I was wandering around the rocks hoping to see some spectacular spray, when a man and woman came towards me. The lady cried out when she saw me, 'It's A Master!' She introduced herself and her husband who was a pharmacist. Mrs May was French, and she was very excited to see me. She didn't seem mad, and I felt rather flattered when she explained that I had a great white light over my head, and that she had never met A Master before.

She wanted my name and address and said she would be in touch. Shortly afterwards, back in Adelaide, I received a letter from the Theosophical Society saying I was a member and had access to their library for two years. I went to their rooms in King William Street. They greeted me so warmly and treated me with such respect that I was beguiled into

reading Annie Besant and Bishop Leadbeater. Madame Blavatsky's *Isis Unveiled* was really heavy going, even for A Master.

Trying to keep an even keel, I was reading Sir James Jeans and Sir Arthur Eddington. I read Pearson on astronomy. The Theosophists insisted that the moon was older than the earth and we argued about that. (Since then I've heard they may have been right.) But through them, and thanks to them, I read books on Buddhism and yoga and discovered Rhadakrishna's writing.

Later, I read a book which impressed me a great deal. It was *An Experiment with Time* by J.W. Dunne, who helped design Spitfires. Dunne's theory is that dreams are neither in the time in which we live, nor completely out of time–space. He wrote that some dreams are just fantasies and results of bio-chemical functions in the body. But other dreams are reliving past events, and, he maintained, some dreams are 'memories' of the future.

He recommended a simple experiment. Write down some of your dreams when you wake and then re-read them from time to time. When he did this, he was astonished to find that some of his dreams had been of future events, unimportant, but they happened.

For a few weeks I wrote down some of my dreams, and I found he was right, on a few occasions. They were trivial things, which could be explained as a habit pattern, who knows?

J.W. Dunne also had the best explanation that I have read for déjà vu, namely, that it is the moment when for a split second you are 'in and out' of time.

I was 18 when I started going to the art school full time. I had to put in obligatory appearances at the teachers college. A good friend, Reg Kelley, signed on for me if I didn't

turn up, and I was hardly ever there. I bribed him with a watercolour.

The lectures were all roneoed out, so my friend would pass them on. Curious subjects like literature, studying *Romeo and Juliet*; speech therapy; and psychology which was mainly John Locke! Music consisted of singing Gilbert and Sullivan songs and learning the hand music symbols. The good one was a course in life-saving and artificial respiration. I graciously attended that. There was a subject called method. The slogan was 'Aim, Aids, Method, Achievement'.

There was absolutely no training for art teachers. The whole conception of what we call 'Child Art' was completely ignored. Montessori and Cisek did not exist.

It was presumed that if you learnt to draw and paint you could be an art teacher. But very few people want to be artists, and there is no point in teaching the 'craft of art', or 'the science of appearances' until a child is well into adolescence, and then only if he wishes to be a painter. We had to find these things out for ourselves.

I made some lifelong friends at art school. Jacqueline Hick was one of them. Shirley Adams, Doug Roberts, Nan Hambidge and Pauline Stevens were others. When I first met Jacqueline she made a solemn face and said, 'The owl, Hector.' She had been the attractive little girl with the fringe. We burst out laughing and went on laughing, and sometimes crying, for the rest of our lives.

All of them, except Nan and Pauline, were supposed to be over at the teachers college, and we all agreed how absurd it was that art was so neglected. We were all of us indignant about this, but fatalistic, with a 'what would you expect' attitude. As we were reading Clive Bell, we were quick to adopt the word 'Philistines'—they were the enemy, not Hitler.

THIRTEEN

THAT CHRISTMAS holiday I went to stay with my grandparents. They had moved from Denning Street in Hawthorn to a very nice house on the Esplanade at Largs Bay. From the front rooms you looked directly across the verandah and garden to the beach and the sea. I had a room to work in. I did a lot of the tiresome stuff needed for the year ahead. I had studied the requirements for design and lettering and history of art and by the end of the holidays I had done the required sheets of design and lettering and would be free for painting in oils.

Next door to my grandparents lived a very friendly family, the Trembaths, and they often invited me to their house. They had a son and daughter about my age and were good company. They served iced hock and lemon; it seemed so good on hot days.

But my grandmother was a strong supporter of the Women's Christian Temperance Union. She assured me that the first time I touched alcohol I would be overcome with an irrepressible, irresistible desire for more. I took the hock and lemon with nervous misgivings: Grandma was right. I immediately wanted more and more. Only manners kept me from demanding more, and more.

They had a guest, Lewis Burgess, who was my age,

cherubic, and our conversation really sparkled. We talked about Plato, Socrates and the *Symposium*—heady stuff.

He said he had been at the Westbourne Park school when I had been there. He was working at the Australian Broadcasting Commission's studios in Hindmarsh Square, and suggested I look him up at his rooms on North Terrace, just opposite the art school.

I had worked so hard at gaining all the odd little Victorian art subjects that I had passed in about twenty-five of them by the time I had entered the teachers' college. All those subjects were enough for the art teacher's certificate, so I was free to attend life classes, landscape classes, still life painting, anatomy—the serious things I wanted to learn. I needed a basic training.

When I stayed at Cliff House one summer, my parents became friendly with Mr and Mrs John Giles and I became a friend of their son Jack. Mr and Mrs Giles seemed, at first glance, like any average Adelaide couple on holidays, but they were both painters. They had studied at the Julian Ashton School in Sydney. Mr Giles had two large paintings in the Art Gallery of South Australia, and was known mainly for his pictures of fishing trawlers by the wharves in Port Adelaide. I admired the way he handled the reflections in the water, thick huge swirls of colour.

Mr Giles invited me to go out on painting expeditions with him on Saturday afternoons. He was a tailor, and we should leave from his shop in Port Adelaide, he said. So, every Saturday in 1939, I would go to the Adelaide Art School in the morning, then down to the station by 12.30, and by 1 p.m. I would arrive in Port Adelaide. I had my painting gear and sandwiches. The moment you arrive at Port Adelaide the magic is there—you can see the masts of boats at the ends of the streets.

The first time I went to Mr Giles's shop, he surprised me. He was sitting up on the table cross-legged, just as I'd seen in images of traditional tailors in paintings and photographs.

To my disappointment, he didn't want to go painting around the wharves. I imagine he had exhausted the motif, and preferred pure landscape, so we got into his car and headed east, inland, to undulating hills near Modbury, north of Adelaide, south of Gawler. I imagine it is now built over, but it was still open country then.

I learnt a lot, just sitting alongside him and working. I noticed he always had his canvas prepared with a tone, a wash, of oil colour. He would talk about his student days with Elioth Gruner, about George Lambert, Streeton; it was wonderful.

It was very cold sitting still, outdoors in the winter wind. At the end of the day's work Mr Giles took me to a local hotel where we had a drink 'to warm us up'. We had rum and cloves, which was delicious and warming. It was my first visit to a public bar and I felt very grown up, and slightly bohemian.

My first teacher for oil painting was Marie Tuck, very old and very gentle. She had lived in France for many years. She taught me how to lay out my palette, and because she did it with such reverence I realised how important it was. She said it was the same as that used by Degas and Manet, and pointed out what you had to add to have an impressionist palette.

The still life was to be drawn in with charcoal, then gently dusted off. Then the objects and background and foreground lightly put in with diluted colour. The whole thing was to be built up. I had three onions and two pots in my first still life, and the first onion was really difficult. I had never handled oils before and it was hard going. The second

seemed a little easier. By the time I came to the third onion I had the extraordinary feeling of remembering how it was done. Miss Tuck came around and looked and said, 'Yes, you've painted before.' I did not really believe in reincarnation and I don't think she did, but there was something happening. As Turner said, 'Painting is a rum business.'

I was in Miss Tuck's class the day the fall of France was declared. Miss Tuck was very distressed. I was even so stupid as to say how sad it must be for her. She had to sit down, and we could see she was ill. We helped her down to the staff room, and they called an ambulance. She had had a slight stroke.

As you entered the art school, on your left, looking through the windows, you could see the Armstrong Memorial Library. It was hardly ever open, but a large Cézanne print could be seen clearly, and it was a majestic and arresting painting. It must have been a facsimile and I now know it was *View of the Valley of the Arc with Mont Sainte-Victoire and Aqueduct* of 1886.

This was just a tempting glimpse of another sort of painting. In conservative Adelaide it seemed out of our tradition, slightly puzzling, and challenging. Why did it seem so majestic, I wondered.

FOURTEEN

THE ADELAIDE art School was in the old tradition of art schools: two years of drawing from the antique casts was required before you could go to the life class. I had done this in evening classes and on Saturday mornings. There were superb casts of Michelangelo and Donatello, of Roman and Greek sculptures. Drawing these really puts you in touch with the masters.

By the end of the second year at art school I was getting near The Life Room, the holy of holies. The antique rooms were next to this mysterious, grand, life painting studio. I could see these very superior people banging their paint boxes and easels along the passage and disappearing behind the closed door of the life room. The door was always closed and had a snip-lock on it. Models posed in the nude and had to feel fully protected.

Finally, the great day came when I, too, could be permitted to enter the life room. As I mounted the stairs, I was exhilarated.

I found Ivor Hele a dynamic teacher, and he had had first-rate training in Europe. He was not teaching composition or how to make a picture—he simply taught us to draw and then to paint. It was not really the sort of painting I liked, but it was good training. He made us aware of

anatomy, taught us how to comprehend the forms, the hundreds of different forms of the human body. Ivor's heroes would have been Sargent, Delacroix, Degas and Manet, the German Slevoght, Max Beckmann at a pinch. He liked Derain but detested Cézanne and Picasso. He was a dyed-in-the-wool academic painter and a gifted, inspiring teacher.

He taught the Rubens method of cool and warm shadows, and with his help you began to see the blues, greens and mauves made by the light, as the form turned in it. The life room at the old art school had a great window to the south. It cast a pearly light on the whole studio.

We were taught in painting the nude that you should draw in charcoal on a canvas which has the white taken down a tone by a wash of burnt sienna. The real perfectionist will paint in only burnt sienna, black and white. We were shown nude studies done with this limited palette, and you would not be aware of the limited colour. A lot of the old masters worked in burnt sienna, black and white, then glazed with transparent gold ochre, glazes of terra verte for recession and glaze with rose madder for lips, noses and knees and hands.

I have since seen students struggling with a full palette trying to paint the nude. It is very difficult, and a lot of them must despair. It was Marie Tuck who told me about transparent gold ochre and I learnt about the other glazes like terra verte in London.

Our close-knit group was dissatisfied with the anatomy course at the art school. It consisted of drawing anatomical plaster casts and copying anatomical diagrams.

Someone knew Dr Posener at the medical school of Adelaide University. Was it me? I am not sure; he lived near us. He came from Vienna, and one of his uncles was a painter. We asked him if he would give us some lectures, and he did,

at the medical school. It was a revelation, but more was to come. He managed to find us a preserved body, pickled, and he could lift up muscles and show us how a limb moved.

For another lecture, Dr Posener produced half a head. It had been cut through vertically, so that it lay flat and you could see all the muscles of the cheek and neck. Nan Hambidge fainted.

The last lecture he gave us was a joke one. He had assembled slides of a lot of famous nudes and, with a perfectly straight face, he gave us a diagnosis of the ailments which affected the models in the paintings—from goitre to birth defects. A lot of Rubens' and Pontormo's figures were ill, goitre was frequent. Michelangelo's nudes in the Sistine Chapel would not be able to walk.

While I was at art school, a group of us were invited to Dorrit Black's studio. We had met the artist, and we all liked her immediately. It was wonderful to see her studio, built mainly as that, but also as a dwelling. She sat us down and then generously gave us all her notes, details of dynamic symmetry which she had learnt from Lhote and Gleizes in Paris.

Cubism became immediately acceptable to us, and it was marvellous to go to an artist's studio built for that purpose. Dorrit taught us above all to make pictures, to examine the bare bones of composition. The design, the composition was all-important. The word that impressed was 'when you *make* a picture'.

One evening, between classes I thought I'd drop in on Lewis Burgess—he had become Louis Burgess now. He seemed pleased to see me and asked me to stay and have a meal. I was looking foward to resuming our discussion. After

we had finished our supper, we were chatting and he came over and kissed me. I was so amazed, I was a stunned mullet. I was paralysed, and wanted to burst into tears. Here was someone else, another one! I was so emotionally overcome that I embarrassed him. I stumbled out, sobbing. He must have felt very exasperated with me. Louis was much more sexually sophisticated than anyone I had met. He knew a whole group of people at the ABC and the university. I went to the ABC studios a few days later and asked to see him. He came to the vestibule. He was busy, he said, and I gave him a small framed oil sketch. It was homage. I heard he gave it away to a friend.

FIFTEEN

TOWARDS THE end of my last year at art school, Jacqueline painted something which had a tremendous influence on me, an abiding one, too. She must have had an ecstatic vision, and it was clearly stated.

She painted the tram stop on North Terrace by the entrance to the Botanic Gardens. It was a large cement cone painted white, and she painted it in the late afternoon light with the most luminous greys of the road and warm black stripes. It was a most arresting image and remains very vivid even today.

As she was looking south-east, in the late afternoon, the background of the dark Adelaide hills and dark-toned sky was plausible and reasonable. Alas, she claimed it would not work itself into a composition and, despite my pleadings, she painted over it. It is remarkable that just one painting could have such a strong influence for so long. It was finally and thoroughly exorcised thirty-four years later, in 1975, with the painting of *The Traffic Stand*, now in the Thyssen-Bornemitza collection.

By now, aged 19, I had a proper artist's paint box and easel, but I usually painted with the canvas in the lid, so most canvases were limited to being 11 inches by 15 inches (28cm

x 38cm). If I wanted to do a larger canvas it meant carting the collapsible easel plus paint box in the tram. That sounds easy enough, but it was really difficult with a wet canvas when the tram or train was crowded.

There is a very early, surprisingly different painting by Hans Heysen, *The Adelaide Shunting Yards*, that was painted from the Morphett Street Bridge. I found a subject from that same bridge and spent a very hot and trying afternoon working there. When the people see the Heysen painting in the Adelaide art gallery it does not occur to them that the artist ended up covered in soot and grime, because every five minutes you are enveloped in a black, heavy, sooty cloud from a passing train beneath you.

At the end of my period at the teachers college I had a final interview with our chief there, Dr Penny. He was a fine man and a dedicated educationalist. He upset me a lot by telling me I had some bad 'personality defects'. I think he may have had some suspicions about my sexuality, and I was not letting on about any of that. Dr Penny said the trouble for me would be working under my first headmaster. He shook his head with gloomy predictions, he could see serious trouble ahead. He would be very interested to see my headmaster's report.

He probably felt a bit miffed with me. I had had to attend a significant number of his lectures as it was obligatory. They were usually very interesting, but he must have sensed or heard about my rare appearances at the college for all other lectures. I avoided his probing questions, and so finally he said that I was a good fencer. He asked me, ironically, what I thought of the teachers college.

It seemed to burst out of me. I complained that there was no training for art teachers, nothing. I then spoilt the solid

reasons for my criticism by saying priggishly that in music they shouldn't be singing Gilbert and Sullivan at the college, why not a Mozart opera? If the Adelaide Teachers College was full of Philistines, what hope was there for education?

SIXTEEN

AS SOON as I had finished at the art school and could leave the teachers college, I took a ship, the *Sarpedon*, to Sydney. There were few passengers and I was told the ship was carrying Spitfires, the British fighter planes, for the Australian air force. It was impossible to go to Sydney by train as a travel permit was needed, but none was needed for the sea journey. Who would be so silly as to travel by sea in wartime?

The *Sarpedon* was a Blue Funnel liner, and very elegant, with impeccable service. The interior had elaborate wood-carving and really splendid fittings in the day rooms and dining room. The captain, a very interesting and impressive man, moved from one table to another during the journey.

One of the passengers, Mr Simpkins, was a geography teacher from St Peter's College in Adelaide. An educated conman, he sold us sheets of coloured paper at sixpence each, and showed us how to fold the little pieces into tiny gyrating zeppelins. At a given word, we threw our zeppelin-kites out into the air. The one whose paper touched the water last scooped the pool. He always won because he knew how to shape his paper better.

Simpkins took bets on the berthing time in Melbourne. We all bet on the listed time, or earlier or later, but he went

to the wireless operator, got the very latest information, lodged his bet and won again.

It was an unusual journey. The galley crew mutinied in Melbourne and there was fighting and arrests and a lot of broken crockery. I was at a symphony concert in the Melbourne Town Hall when it happened. I had gone around to the orchestra's entrance behind the hall in order to see my friend Harold Beck, the cellist. There was a police station just next to the stage entrance and I heard a terrific rumpus, with announcements over the loudspeaker. There was a mutiny on a ship in Port Melbourne—I heard the name, the *Sarpedon*!

After we left Port Phillip Bay we must have been attacked by submarines because the ship kept dropping depth charges. It makes a curiously flat, horrifying sound, like an enormous door slamming. The depth charges went on for hours. We were told we were not to undress for the night, but to sleep in our bunks fully clothed. We had three minutes to get to the lifeboats if the alarum sounded and the ship was torpedoed.

I asked the barman what chance we had of getting to Port Jackson and he said, 'about three in ten'. The captain invited me up to the bridge and I saw the pattern made by our wake, a series of zigzags, then a curve, then a line. The captain explained it would be dangerous to steer a straight course, and when he met the other captains in port the talk was often about what manoeuvres were best, and they had to have the latest information on Japanese torpedoes, which had become more efficient. He said we had joined a convoy, but all I could see were very distant ships on the horizon all around us.

Our arrival at Sydney Heads was dramatic. The captain said that Japanese submarines usually tried to enter Sydney

Harbour under the cover of a ship. There were nets at the Heads to block submarines, but as a ship entered the boom had to be lowered, and that is when a submarine could enter. So we came into Sydney from a choppy sea, dropping depth charges, and then calm waters and peace, and the beauty of Sydney Harbour.

When the worst of it was on, after we had left Port Melbourne, I was surprised to note that I felt no fear. I wasn't in the least frightened. When I talked about this with another passenger, he agreed, but he said he was suffering from 'loose bowels', and I had to agree that I was, too. I suppose the body keeps itself ready for flight.

This was the nearest I came to the war.

SEVENTEEN

ONE OF the reasons for going to Sydney was to see my sister Dawn. After she had been deserted by John Holland, she lived in Melbourne and she obtained a divorce. She met a young lecturer in physics, Roy Hedrick, who worked at the University of Queensland. They married and the union was to be blessed, shortly, by my niece Margaret.

When I arrived in Sydney, Roy had been seconded to the Australian air force. He said he was helping design an aeroplane to be made in Australia. They had a very pleasant flat in Coogee with a view of the sea, and I stayed with them. He knew of J.W. Dunne, his writing and his aeroplane designing. Roy was a good chess player.

I went out working almost every day, some of the time in the Rocks area, where I found a lot of subjects. I also worked in Woolloomooloo and Paddington.

One really hot day I was working away in the Rocks. I heard, quite near, the sound of splashing and shouts. I tracked it down and found about twenty men and boys bathing from a wharf. They were all naked and it was a wonderful sight. Cézanne said there was nothing like nudes in a landscape, and this is so true. It was magnificent, like a George Bellows, whose work I knew from reproductions. I

threw off my clothes and dived in, and because the water seemed oily, I swam well out. Soon, I heard them all yelling at me, 'Sharks', and I quickly came back to the crowd.

In the evenings there were several sketch clubs and at one of them I met Rah Fizelle, the Egyptian cubist, and he invited me to his studio in George Street.

The Art Gallery of New South Wales had a much larger collection than the Adelaide gallery and there were several private galleries in George Street, all very conservative. The Macquarie Galleries in Bligh Street was an eye-opener, the first private gallery in Australia with modern painting I had ever seen. I was awestruck by Martin Place, a real city centre, with canyon-like walls of almost uniform height. This 'grand place' was going to be marred one day when they built the MLC Centre. It now looks like a mouth with a missing tooth.

While I was in Sydney, my parents telephoned to say my appointment as art master had arrived. I was to report to the headmaster at the Goodwood Boys Technical School. This was a very convenient place to work, and I felt grateful to the powers above, but very depressed at the thought that I would only be able to paint at weekends. I was on a bond to teach for four years.

Because I was in the Department of Technical Education, I was spared from compulsory military service. I had had the well-known, humiliating military examination at the Keswick Barracks and had spent a cold day totally naked with a hundred or so other chaps. I had been declared A1, so I was liable for duty. I lacked the conviction to be a con-scientious objector. But being in 'The Department' surely saved my life.

Both my friends, John Calvesbert, aged 22, and Peter Crosby, aged 21, were killed. They had joined the air force

and been transferred to England. They did not know each other until they were sent to the same base in England. They became great friends for the brief time left for them. I mourn them still, but the strongest feeling is rage. They were robbed of their lives.

EIGHTEEN

BY THE time I had finished at the Adelaide Teachers College, Jacqueline and I had become close friends. She had the most beautiful eyes I had ever seen and a keen sense of humour. Her laugh was golden. She was very attractive and popular. She was also born wise.

We started being asked to parties, as a pair, and we had already been on short painting expeditions. One evening we were having a drink and I thought I should tell her about myself. I had started, in a very clumsy way, and she instantly divined what I was trying to say and started laughing. I persisted with just a few more words, but her laughter was so natural and warm and understanding I gave up my miserable would-be confessions and started laughing too, and that was the end of it. There was no need to say anything.

Her background was very different from mine. Her father, the cowboy, went through a period when all he would say was, 'Ooff, yegman! What's your name. Sit down.' I asked why, and Jac just said, 'Oh, he likes saying it, you know.'

Her mother, Julie, was French. She was amusingly eccentric and drove around in a tiny sporty Morgan, which Jac sometimes borrowed. Julie was in the city one day and she saw an elaborately decorated bicycle in a shop window. It had streamers threaded through the spokes of the wheels,

the handle bars decorated with paper flowers. She bought it and when the salesman removed it from the window display and asked where the bicycle should be delivered, Julie then rode it home, decorated.

Their house seemed to be chaotic. In the garden they had two pets, a kangaroo and an emu, large ones. They would chase each other around the house and when the emu got to a corner she would slip and fall over with a mighty thump. The owl had gone.

There was a large dead tree in the street just outside their house. I said what a pity, but Julie said that trees always died outside their house. When they had lived in Millswood, and also at Glenelg, the trees outside had died. I wondered why and Julie said, rather impatiently, 'Because trees always die outside our house, that seems obvious.'

Adelaide seems to foster eccentrics. One of my friends, Edith Cutlack, bought a red roadster, rigged up a sort of uniform, and would delight in following the fire brigade when they were called.

———————

As my technique grew, I found I could paint those things I liked looking at, those slum streets behind the city apartment where we had once lived briefly but so gloriously.

At the same time I was reading the poetry of T. S. Eliot. 'Preludes' was enough for me initially. It seemed that all poetry I had read before was about roses in the spring, sparkling dew, billabongs and gum trees and daffodils. But here were phrases like 'newspapers from vacant lots', which was authentic poetry with images I could accept immediately, and 'His soul stretched tight across the skies/That fade behind a city block'. 'Vacant lots' are mentioned twice

in 'Preludes' and it was not long before I had painted several vacant lots.

If 'Preludes' fed me images, you can imagine what Eliot's 'Rhapsody on a Windy Night' meant to me: 'A broken spring in a factory yard,/Rust that clings to the form that the strength has left'.

On my first acquaintance with Eliot's poems they provided me with images of urban life which were valid. I had painted my last flower piece, the gum trees and the billabongs and blue hills had been thrown out with the daffodils.

NINETEEN

WHEN I went to the unlovely building of 'Goodie Tech',
I reported to my headmaster. He was Paul Hilbig and I liked
him immediately, and more importantly it turned out that
he liked me. It was his first appointment as a headmaster. He
was a totally dedicated educationalist with very advanced
ideas; I was moved by his sincerity. He gave me absolute sup-
port when I outlined my idea of what I should do. There was
no syllabus for art, none at all. It was an open go and up to
me to infuse my students with a love of painting and respect
for art. Three years later, I was asked to sit on a board to sug-
gest a syllabus, and it was implemented.

His eloquent first report on me was very complimentary
and encouraging. I wonder what Dr Penny at the teachers
college thought; he would have been pleasantly surprised.

Even though I had read that a 'gift' for drawing was
common, usually 10 per cent—about the same figure as for
colour-blindness—I was still amazed at the talent my stu-
dents showed. They fired me with enthusiasm, enough to
make me think that perhaps Adelaide could be an Aus-
tralian Florence. It seemed so remarkable.

Young people have no hang-ups about art. I had them
enjoying Paul Klee, Miro and Matisse. I could put up a row
of Ben Nicholsons and Mondrians and ask them which they

preferred, and they could give reasons why they preferred this to that.

The boys were drawn from a very large area as it was the only technical high school for all the south-western suburbs. We had a mixed bag. Boys from so-called 'good homes' and quite a lot from very rough backgrounds, and it usually showed. The staff were all a bit lefty, as I was, and there was a sprinkling of atheists and Roman Catholics—a good lot of agreeable men.

Discipline was my first problem, due to my so-called 'enlightened ideas'. There should be no need for discipline if the students are interested, and after a few months it worked. Students were allowed to chat while they were painting, but as they became absorbed I was often pleased to notice a busy silence. They were expected to sit and listen when I gave short talks on the history of painting, but these were always illustrated of course.

My only cross was a boy called Don Day. Don was irrepressible, intractable, cheeky and subversive, and deliberately wanton. When I realised he would not respond to any warnings (he wanted to be sent out of the room, he hated art) I found the only way to curb him was with violence. I couldn't box his ears because I believed it was bad for the eardrums. I resorted to violent knuckle-bone blows on his thick head—it was very distasteful. I hated inflicting pain, but it was the only way I could control Don.

So, twice a week I would have quite a lot of violence. Don had to be hit about three or four times a lesson because after twenty minutes he would seem to forget. I had a bad conscience about it; it was contrary to my ideals.

On one sunny day, I had all the doors of the art room open on to the verandah. My class was happily painting, and

even Don, who had just been knocked on the head again, was painting away. I stood on the verandah contentedly surveying my happy class and then I saw, walking slowly across the yard, and coming straight for the art room, a big burly figure of a man.

He was in his shirt sleeves, no jacket, and no collar, with a pair of vehement braces. The unshaven, brawny brute came on to the verandah and said, 'Are you Mr Smart, the art teacher?' When I admitted I was, he said, 'Well, I'm Don Day's dad, and I understand you've been hitting my Don.'

I realised immediately that I was about to be beaten up, right here, in front of the whole class. The boys had become quite silent and there was a dreadful hush as I drew on a tiny faint spark of courage and said, 'Yes, I'm afraid I have, Mr Day. It's the only way I can control him.'

Mr Day's great arm reached out and he extended his hand saying, 'Put it there, Mr Smart, you're the only one who can manage him.' After shaking hands he turned and beefed his way out across the yard.

In about my third year at the school, some wildly indecent drawings and poems were discovered in the lavatories. Mr Hilbig asked me and the English master, Reg McLean, to go there with him to give an opinion. We all kept very straight faces. 'Now, gentlemen, what do you think?' They were all by the same hand. Reg thought they were by a gifted literature student and I considered them stylistically very capable. We also solemnly decided that the drawing of the vagina indicated there was more than theoretical knowledge. It had nothing to do with the old visual cliché, known so well to all of us. This indicated carnal experience. So the boy had to be one who possibly was sexually

active, and gifted in literature and drawing. We used logical deduction.

I listed the boys I thought could do it, as Reg did, and we arrived at the same boy—Kennedy. When interrogated by us, Kennedy broke down and confessed. *Victory!*

During the four years I was at Goodwood Tech Mr Hilbig saw my enthusiasm wane, but he sympathised and respected me. He even bought a painting. When I left we remained friends, and he and his wife visited me in Rome years later.

———————

By the time I was teaching, my parents had moved to 43 Marlborough Road in Westbourne Park. It was a house I had passed as a boy many times on my way to school and I had always liked it. A well-built unpretentious bungalow, and we constructed a studio between the rear of the house and the side of the garage. The studio was made of weatherboard and was just large enough for me to work in. It had a good south light and I did a lot of paintings there. I insisted that my parents put in a high fence and plant a lot of shrubs.

My reasons for remaining with my parents were purely venal. I had started to save money to get back to Europe and if I had to pay rent for a place I would not be able to save so much. The family car was very useful for me to go on painting trips. I usually bicycled to the school, but if I was going into Adelaide afterwards I would take the tram. I dreamt of independence and money, not because I wanted to be rich I just wanted all my time for painting.

Teaching went on until 3.45. Sometimes after class I would ask a boy to sit in a chair near my table and I would do a head study. In this way, I must have done over a hundred.

I still have two or three of the better ones. Brian Seidel was one of my best students and he often stayed behind to draw. Another was Laurence Mullen.

At about 5 p.m. I would go into town and meet Jacqueline at some hotel lounge. We would have a drink and then go and eat, and by 7 we could be at the art school to do some life drawing. So in these ways, in spite of teaching, I managed four hours' drawing a day.

The teacher of the life class was Frederick Millward Grey. He was very anti-Ivor Hele and tonal painting, and had studied under Meninski in London, 'in the flesh', he would say.

We found life drawing difficult at first because the art school was in a new modernised building behind John Martin's emporium. There were six overhead lights all around the life room, so the light was diffused and there were no shadows. When we complained and suggested switching off a few, he refused.

Freddie Grey was right, I'm afraid. We had been drawing shadows, 'shading'. He taught us to conceive the form, with no shading, just lines to indicate the changes of form. We had been using shadows as crutches. Freddie's painting was stylised, commercial, but he was a good teacher.

The principal of the art school was John C. Goodchild, like Tom Bone a distinguished watercolourist, but more cultivated than Tom. He became a friend and we had some good times with him. One night we had a riotous drinking session with him. Bets had been made, I can't remember what about, but I know that he lost a bet and had to crawl on his hands and knees across King William Street against the lights, and our principal did it, gamely.

His wife, Doreen Goodchild, was a gifted oil painter, but her talent disappeared with children and the dynamic

personality of her husband. John Goodchild permitted us to use any of the life classes, so we had free models.

If I had been drawing at the art school I could be home about 9.30, and in those days I could work until midnight and still be up early for school.

Jac and I were walking down Rundle Street one evening after class, and we were talking about how people don't really notice things, how you could get away with anything if you don't raise suspicions. We saw that one of Myer's store windows had no glass, but was lit, and empty. We jumped up and took up mannequin poses. We kept very still and people walked straight past us, chatting, no one noticing us.

Ever since her marriage, my mother had a char, a woman to come and do the washing and the heavy work. She was important because we loved her. Her name was Lina Nicholls, but I couldn't say Lina as a child. The nearest I got to it was Nanny, and Nanny she stayed—it sounds pretentious of course. Nanny, although she was not married, had a daughter, Daphne. Daff was a bit tarty, and with reason. She often came to our house for Nanny's pay, and when she came she knocked on the front door, which we thought was a bit of a cheek, and she was often very familiar with my father, I noticed. Also with reason, I was to find.

TWENTY

I HAD sold a painting at the Society of Arts exhibition and had the cheque from the secretary. As with my choirboy money, I decided to squirrel it away, and not put it in my savings bank account, where my parents might be able to control it.

Rather grandly, I surveyed the architecture of the various head office banks in King William Street (the reader must think there is only one street in Adelaide). I frivolously decided on the Victorian Gothic of the English, Scottish and Australian bank, ignorant of the fact that at a bank like that, one should have an introduction.

I was just entering when I met Lady Bonython going in. 'Ah Jeffrey, so you bank here too!' she said. No, I said, but I was thinking of starting an account here.

'Let me introduce you to the manager,' said the wife of the richest man in the town. I thanked her and said I could talk to the teller. She insisted, and introduced me to Mr Laurie, the bank manager, as one of Adelaide's up and coming artists, and would he look after me?

He certainly did. For many years to come he was my support in times of need, and they were going to be frequent. One day he gave me good advice about money. He held up a pound note and told me it was worth nothing—it was not

gold. But it had stamped on it the promise to pay one pound of gold, on demand, years ago. Money was an act of faith from someone. He told me that he had just backed a client who wanted to start a milk bar. He said that if I wanted that much money he would not let me have it. But if the bank believed I was a good painter, or could be, they would back me.

———————

Jacqueline and I were beginning to make friends. Almost the first parties we went to were given by Joan and Dave Dallwitz. They lived at Seacliff. Dave was a good young art teacher, and a gifted painter and musician. Both he and Joan were rigorously and enthusiastically 'modern'. Dave was then painting abstractions.

When you first entered their sitting room, it was exhilarating. Dave had a *white* piano. Above it was a large facsimile gouache of Picasso's *Three Musicians*. It looked very handsome. Dave had copied it, and he had done it skilfully. He was a good pianist and could play anything, but he was best at jazz and he had a great collection of records. It was here we first heard Ellington's 'Mood Indigo' and 'The Symphony of Psalms' of Stravinsky.

The regulars were John Dowie and Vi Johns, Annie Ayliffe, Shirley Adams, Doug Roberts, the poet and writer Max Harris, Yvonne Hutton and David Barnes—a lively lot. Dave would extemporise while Max Harris stood by the piano and sang 'The Cunt Song'. It just consisted of saying the word over and over again with different expressions, very funny and sometimes tragic, occasionally desperate. Max would recite his poetry and we would all sing dirty songs. The Dallwitzes sometimes arranged absurd party

games. If the Dallwitzes were very avant-garde; an oasis in a conservative desert, the art and musical establishments were anything but.

The Elder Conservatorium of Music often gave concerts on Sunday afternoons; usually the musicians were members of the staff. At one of the Sunday concerts, it was announced that the string quartet would play the F Major Quartet of Ravel. The musicians had just seated themselves, and were about to play when venerable Professor E. Davies, the principal of the conservatorium, rose from the front row and turned to address us. Slowly taking off his pince-nez for emphasis, he said we were about to hear a quartet in which the composer had achieved some clever effects of chattering animals in the jungle. We would hear the whines and screeches of jackals, the screams of wild cats, the chattering of monkeys, and so he went on, and then sat down to a resentful silence from us all. The piece was written in 1902 and could hardly be called modern.

Haydn Beck, the principal violin teacher, rose, announced the characteristics of each movement, and calmly sat down, to warm applause.

Can you imagine the in-fighting, the intrigues at the conservatorium?

———————

Jac and I decided we would have a two-man show, and we booked the South Australian Society of Arts gallery for two weeks in 1943. Our ambition was to make our names and be able to sell paintings and not have to teach.

The first painting I ever sold was to Max Ragless, a South Australian painter whose work I used to like. (When Clement Greenberg, the famous art critic, shortly to become

infamous, came to Australia he stated that the best Australian painter was Max Ragless. Oh, how wrong he was, and how wanton and perverse.) I was very pleased and proud to be selling to Max Ragless. Years after, I rang his widow to locate the work. She said she couldn't remember, what was my name again, in any case he gave away all his pictures.

The two-man show was not a great success. I can't find any review of it. I sold an etching to Canon Finniss, an oil to my uncle Alec Rolland, and the one to Max Ragless. Lady Bonython bought a painting and that was it. Jac sold some prints—she was a dab at that—and one painting.

———————

The Torrens River becomes a lake between the railway station and the Adelaide Cricket Ground. I was painting a Cézanne-inspired 'View of Lake with Trees' and I was settled in among a lot of reeds, through which I could see my 'motif'.

Sometimes, being a landscape painter can be like fishing. You sit still for so long that the natural life around you, which your arrival quelled, once again resumes all its many activities.

There was a swan nesting quite near me, and after about an hour I realised I had a great piece of luck. I was going to witness the first Swimming Day for her cygnets. She rose off them to reveal five tiny chicks. She stood by them and then, very slowly, with her long neck and beak gracefully and gently rolled each squealing, protesting cygnet to the water. At the first touch of the water they would squeak and protest and scramble back to the warm nest.

With great patience she insisted, rolling each one down

until gradually, one by one, she had them happily floating around her. All but one. This one scrambled back every time, but she gently, patiently guided him back to the water. But he didn't want to go in, and persisted with returning to the nest.

At this, her patience spent, she changed her whole attitude and became transformed into a monstrous murderous mother, hissing and darting her beak down to savagely crush the unwilling one.

I put down my palette and brushes and found a stick and fought her off. She was furious with me, but scared by my stick. In the end, she gave up and joined her brood on the lake, and she and her four cygnets went off on their first family outing. I ruefully reflected that I was interfering with evolution.

The little recalcitrant one was left squeaking in the nest, and now, missing his family, came to the water's edge and was desperately calling them. I went back to work, there was nothing I could do for him.

After about ten or fifteen minutes, another swan passed near us and saw the plight of the little deserted cygnet. She came up on to the bank and very gently rolled little squeaky into the water, and he would clamber out. But she had much more patience and, finally, I had the satisfaction of seeing her swim off with her happy adopted cygnet.

———

Some of my paintings were large, for that time, and I didn't think they were too bad. I decided it was a typical case of pearls before swine, that I was wasted on the desert air of Adelaide and that I should seek elsewhere. So, in early 1944, I decided to spread my pearls further.

TWENTY-ONE

LAFCADIO HEARN, the English writer on the Orient, impressed me enormously. In something I had just read of his, he said that a great city was paved with gold for a young man if he did things in style. I took his advice. I sent fourteen of my paintings by train to the great city of Melbourne, and I somehow managed to get an air ticket to the Essendon aerodrome.

The plane, a DC2, took off in the late afternoon. About half-way, we were told to make sure our seat belts were fastened. The plane flew over vast bushfires and the hot air currents buffeted it about like the kite it was. The fires were a dramatic but horrible sight from the air. When we got out of the plane we could hardly walk. We all felt a bit unsteady after the rough trip, and as it was my first flight I had no idea how really rough it had been. We were met by a bus, and I got a taxi from the depot in Bourke Street.

I went to the beautiful Oriental Hotel because I had been recommended to Miss Sherrin, the receptionist there. She gave artists good rooms at a discount.

As I unpacked and prepared for bed, I realised I was so groggy I wouldn't be able to sleep, so I went for a walk. I went down to the Flinders Street bridge and smoked a cigarette and looked at the river. Along the railing I noticed a

policeman looking at me. It was wartime of course, and you had to have an identity card wherever you went. I decided to view the river from the other side so I crossed the road and gazed downstream. The policeman followed me and I felt a bit put out. I walked along to the station and dodged in among all the kiosks which at that late hour were now closed; I wanted to throw him off. I thought I had, so I walked down to the traffic lights to go back to the hotel. I suppose I thought of myself as some sort of international spy, in this exciting and great city.

Then I saw that he was alongside me. 'May I see your identity card please, sir?' I handed it to him. 'Where do you live?' I told him I had just come from Adelaide and was at a hotel. He looked at the identity card carefully. 'Very well. You may go.' I felt a bit miffed. I could go! So I asked him why he had followed me. He didn't seem to want to say, but I insisted, I was curious. Finally, he said, 'You look like someone we've got in the books.' Well, that wasn't very reassuring. I went back to the hotel feeling slightly uneasy. I looked like someone in their books, did I? I was so totally innocent that I didn't understand the implications of the incident.

Next day I searched for a gallery. The Athenaeum was too large, the Victorian Society of Arts too far out I thought. I found a small gallery in Little Collins Street—Kozminsky's. I talked to the part-owner, Joshua McLelland, and showed him some photographs of my work. He liked them. I said the paintings could be there tomorrow. The gallery had a cancelled booking, so we could open in three days' time. It all seemed so easy.

Melbourne had a big-city feel about it. Besides the impressive National Gallery with a real Rembrandt and a real Cézanne, it had larger and higher skyscrapers than Adelaide. It had a real river flowing through it, the Shrine of

Remembrance on an impressive axis with Swanston Street, and there were at least two fabulous cinema palaces—the State and Burley Griffin's Capitol.

There was no art book shop in Adelaide. I had to send for art books, like René Huyghe's *Les Contemporains* and T. Craven's *Treasury of Art Masterpieces*. So Gino Nibbi's art bookshop was a revelation, a treasury. Here you found books you never knew had been published.

Nibbi didn't seem to mind you thumbing his precious stock, he seemed to like you being so interested. Besides buying some art books, I went through his portfolio of prints and bought two hand-done stencils of a Léger and a beautiful Albert Gleizes—the latter had taught Dorrit Black.

Lafcadio Hearn said you had to meet people and woo the critics. The three important critics in Melbourne were Clive Turnbull (Melbourne *Herald*), George Bell (the *Argus*) and Harold Herbert (the *Age*). I telephoned each one and invited them separately for lunch, a dinner and a lunch, all at the Oriental. Each one came, and we seemed to get on well. Of course I had to go carefully with Harold Herbert, and we talked about a mutual friend M. J. MacNally, an old watercolourist and art critic in Adelaide. Mr Herbert was very conservative.

Mr Bell was wonderful and passionate about contemporary art. We had been corresponding about his defection from the Contemporary Art Society and he had written to me about the 'parlous state of painting in Melbourne'. It was either the messy Heide lot or the academics, with Jock Frater and Lina Bryans in between. He told me how the very young Sidney Nolan came to him with some drawings, asking if he could be a student. Mr Bell said the child-like drawing indicated no training at all and explained that his was a postgraduate school. Once you had had some basic

training you went to his school and he tried to lead the student to a personal style, as he had succeeded with so many well-known painters. But it was Clive Turnbull who became a friend, maybe because he was by far the youngest of the three, and so a little nearer my age.

I had a few friends in Melbourne and asked them to the opening, and all the critics came. I bought some dry sherry and some flowers and we had a party. In the middle of it all, Robert Menzies happened to walk past, looked in, saw faces he knew, and came in. Harold Herbert said, 'Bob, just what we wanted, an opener.' In a moment Mr Menzies was standing on a chair, drink in hand, and doing a very funny imitation of a dowager opening an exhibition. He played with his pearls, primped his hair, and in a falsetto voice said, 'It is with unfeigned pleasure I declare this blasted exhibition open.'

It was hard to believe what I heard when Harold Herbert and Clive were talking together.

Harold Herbert: 'Ah, there you are Clive. Are you still Keith Murdoch's bum-boy?'

Clive Turnbull: 'Don't tell me it's poor old Harold Herbert! Are you still doing those pissy watercolours?'

I managed to butt in and stop it.

Clive took me up and introduced me about. He was a large Edwardian-looking man with a big moustache. When we started drinking at the Oriental bar I was astonished to see Clive empty out his pockets and put all his money on the counter. He said the barmaid knew him well, and would just take from his heap as his turn came around.

The exhibition was reviewed in every paper of course. Clive said I was the most promising young painter to appear for years. The show sold extremely well and I took the Douglas DC2 back to Parafield thinking how right Lafcadio Hearn was.

TWENTY-TWO

WHEN I was at the Adelaide Teachers College it was required that we spend one week of every term with a demonstration teacher in an actual school. This was a real drag because it meant no painting for a week. One teacher to whom I was allotted was Miss Jean Bond. I always took 'a sickie' when I had this week of teaching; at least I could get in a day's landscape painting. I didn't want my parents to know of my evasion. Armed with paint box and easel I asked the ticket-box mistress at the Unley Park railway station if I could use her telephone. I rang the school and spoke to the headmistress and left a message for Miss Jean Bond that I had bad earache, and I was sorry I couldn't turn up that day. I'm sure the demonstration teacher would be relieved.

Next morning I arrived with ostentatious pieces of cotton-wool in my ears. Miss Jean Bond seemed very amused. She had a good friend, she said, who worked at the ticket box at the Unley Park railway station. She had supper with her yesterday evening. I immediately took the cotton-wool out and we laughed a lot and became friends.

She was older than I, of course, but had been interested in theosophy and discarded it. She had read Ouspensky and decided he was wrong and that Gurdjieff, like Blavatsky, was bogus. She had been interested in Indian religions. By the

time I met her she had become an old-fashioned thirties agnostic, like myself I suppose.

We kept up a friendship and I would sometimes drop in on her after evening classes. She always had something stimulating to read, some pieces of Jung or the Bhagavad Gita. I had, sometimes, excerpts of T. S. Eliot.

Jean told me she had heard there was a remarkable medium in the city who was supposed to be very good. We could go, but not for laughs, and it might be interesting. I spoke to my friend Jack Giles from the physics department, by now a militant atheist, and we booked with Mrs Katie Duggan, the medium, for the next meeting, or séance.

Mrs Duggan lived with her husband in one of those really small slum houses which I had seen from the back porch of the flat on South Terrace. I could have been looking down on her roof. The door, on the street, gave straight into the sitting room. Mrs Duggan was in her late fifties. She had a sweet and lively nature, and had had little education. I thought of the sibyls at Delphi. The priests usually collected their sibylline candidates from Itea down on the coast, and insisted they must be past the menopause and without education.

We didn't start a séance immediately; there was a little chatting. There were three other people there—a woman called Beulah, who it seemed attended a lot of séances, and a married couple, who, I think, had lost a child and must have wanted news of him.

Mrs Duggan said, looking at Jack and Jean, 'Perhaps you've come here to mock.' She turned to me and said, 'I think you have a letter in your pocket.' I had written to my sister Dawn and had not yet posted the letter. It was in my breast pocket.

I gave her the letter and, without glancing at the address,

she held it between her hands. We fell silent. After a while she smiled and looked at me and said, 'You're very wicked, Mr Smart. There's a lot of blasphemy in this letter.' There was, too.

Mrs Duggan said, 'I can see a tall blonde lady. She's standing in a beautiful room with a green carpet. There's a view of the sea out the window,' and suddenly she stopped.

She looked distressed and said quietly, 'Oh, the poor soul, the poor soul.' She handed the letter back. As she was so right about Dawn being tall and blonde, and even the carpet and the view, I didn't send the letter. Instead, I wrote telling Dawn what had happened. She replied saying that Roy had become a dipsomaniac. He had been arrested twice for drunkenness, had lost his job, and was suspended from his club. They had no money at all and she was working as a receptionist.

After a while Mrs Duggan said to Jean, 'You are a healer; didn't you know it?' Jean replied that it was news to her. She was trying to look as though she believed it, not to hurt Mrs Duggan's feelings.

Mrs Duggan invited us to sit down, the light was lowered, and we all had to hold hands to make a circle. We were to be quiet and wait. I learnt that a medium had to have a door-keeper. It is supposed that when a medium is open, waiting, she is liable to be entered, possessed, by some unfavourable spirit. Mrs Duggan's doorkeeper was her sister Ivy, who had died in New Zealand some years before.

Mrs Duggan asked us for questions. The beginning was not good. Beulah asked for news of her dead husband. 'He's here, I can see him,' said Mrs Duggan. 'He has a lovely smile with lovely teeth. Are they his own?' 'No,' replied Beulah, 'but he had a good set.'

It was not promising. Mrs Duggan went into a deeper trance, and another voice came from her mouth, I presume

her sister's voice, and said she was introducing a Maori who had died some years before. He would recite the Lord's Prayer in Maori. A man's voice then came, chanting what seemed a lot of gibberish.

While this was going on, I felt a strong pressure on the back of my neck. There was no one there behind me. I knew it was a presence wanting to possess me; I had read about it. It was quite easy to thrust it aside. I felt 'no you are not—go away' and 'it' did.

Ivy came back and spoke, and thanked the Maori, and then blessed us all, and said she was going, and good evening. We waited, and Mrs Duggan gave a great sigh. Mr Duggan put on the overhead light. Mrs Duggan looked very tired; she said it took a great deal from her. They both went to the kitchen and a little later wheeled in a 'traymobile' in with an enormous supper of tea and sandwiches and cakes. A collection was made just before we left. It was for Mrs Duggan's church which was nearby. It had a curious name like 'The Spiritist Centre'.

Afterwards we talked it over. Could someone as simple as Mrs Duggan be such an accomplished actress? How did she do the man's voice? You could have training and learn all that abracadabra of Maori. And yet we weren't sure. She was such a sweet nice woman. Jean and Jack and I decided that there was something odd going on, that we would go again. I told them about the pressure at the back of the neck, and neither of them had felt it, but Jean said she had read about it ages ago and thought it was a joke.

The next time we went things were much better. When Ivy came, we bade her good evening, and I, or Jean, asked could we have someone more interesting, please? Could we have a philosopher, a teacher, perhaps? Ivy said she would try. She added that serious people were more difficult to

find, could we wait? We waited quite some time, in silence. We were shocked when a man's harsh baritone voice suddenly barked out into the darkened room. 'Good evening. I am Jinnarajahdasa, and I have come to teach you.' He had a slight accent, and the voice was educated. It could not have been a 'plant', there wasn't enough room for someone to crouch behind Katie Duggan.

He had died five or six years before, and was a philosopher, and published in India and in England. Someone told us he had lectured at Oxford as well as at London University. He talked to us about meditation, the ways it could be done, and spoke of how to learn to control your breathing. It was all very good stuff and I think I remember most of what he said. We were to start meditating in the way he suggested. When he had finished he said good evening.

Ivy asked us if we had been diverted, and Katie Duggan came to. She asked us what had happened, and she seemed genuine. She did not know what had happened. The evening finished the same way, with the enormous supper and our contributions.

TWENTY-THREE

I HAD arranged to meet Jack Giles one evening when we were both free. We had decided to have a quick meal and go to a film we wanted to see. As we were walking down North Terrace I asked him where he thought we might go to grab our snack. He said he couldn't stop, he had to go home to Port Adelaide. I reminded him we had arranged to see a film. He said he had been looking forward to it, but we should eat something first.

I pointed out he had just declared he wanted to go home, and he didn't seem to know what he was doing. He nearly burst into tears; he said he would be thinking one thing and then his mind would suddenly change. It was as though he had someone else in his brain. He was feeling terrible, going mad.

It was obvious that we had to go to Katie Duggan immediately and we got a cab. When she opened the door she clasped her hands and declared, 'Oh, Mr Giles, you are possessed, and such a good soul you've got there.' Jack said it might be a good soul but he didn't want it.

Mrs Duggan put a chair in the middle of the room and asked Jack to sit down on it. Then with clasped hands she walked slowly around him quietly saying the Lord's Prayer. This went on for quite a time. I thought of Red Indian rites.

Mrs Duggan must have gone around Jack very slowly for five minutes, intoning, when suddenly she stopped and gave Jack a strong blow on his back with the flat of her hand and cried, 'Begone! You are earthbound!'

Jack seemed to slump forward, and then smiled, sat up straight and relaxed, and said, 'Katie, you darling!' It was all over and done with, but Jack didn't want to go to Mrs Duggan's again.

The next week was even better. The control, Jinnarajahdasa, came through splendidly. He lectured us on the spiritual energy centres of the body. At one stage his voice broke. He apologised and said the medium was now receiving more energy during the week, and that she and her husband were indulging in too much sex. He said this made it more difficult for him to control her vocal chords. He commented, in passing, that the medium was so exceptionally good that if we took her to a higher altitude she could do materialisations for us.

Jinnarajahdasa went on to speak of the Kundalini. He was really teaching us classic Indian techniques of meditation. Quite suddenly, while he was talking, I saw his face superimposed over Katie's. He resembled a benign Lenin. 'Ah!' he interrupted himself, 'You see me! That's good.' He had looked straight at me. It was like a flash and he disappeared, instantly, but he went on talking. Jean was very impressed. Had I really seen him, and I said yes, yes, I really had seen him for a split second, but how did *he* know?

A week later, when we turned up, there was a very different atmosphere. The Duggans were not quite as welcoming as before, and Mr Duggan said the séances were very tiring for his wife, and that she would only go into a light trance this evening. He must have told Katie about Jinnara-

jahdasa's criticism of her vocal chords and they felt it was an intrusion into their private life.

We realised then that this would have to be our last sitting, and that we should try to have Jinnarajahdasa back again. The last time, he had promised to introduce us to another Master.

Katie went into a trance, and we already knew that we could make her go deeper than she wanted. Ivy spoke to us, and then came Jinnarajahdasa, and he was as clear and strong as before. He cautioned us against too much meat, if we really were wanting to achieve an exalted state, and spoke of how you can train yourself to meditate anywhere.

After a most affectionate talk he then told us the name of the Master who was about to speak to us. Jinnarajahdasa said we were never to reveal the name of the Master. He was a man we had read about, a well-known saint in late medieval history; it was a great privilege.

His presence and his talking were unforgettable. As he talked, we ceased to hear the physical sound of his voice; his words were in our heads, very quiet and very strong. He went on to say that we were now in the highest state of communion with Reality that was possible in our world. He told us we were not to go to a séance again, we did not need proof, we knew. We were never to tell anyone who he was. Then he blessed us, and promised that he would help us always, and that we could always call upon him.

Katie came back and we had our supper, and she was very quiet. I think that for the last fifteen minutes the room had been in complete silence. Probably Mr Duggan had not heard anything and had thought we were meditating.

It was a gentle end to an extraordinary experience I have remembered all my life. I know it cannot be believed and I know we were not hypnotised or deceived. I wrote down and

made diagrams of a lot of what Jinnarajahdasa taught us, and on occasions I have passed it on when I sensed a friend was really interested.

Jack Giles started to paint more and made some astonishing copies of Cézanne's still lives. We lost touch when I left Adelaide, but I heard he married the sculptress Rosemary Madigan.

Jean Bond was moved to try healing people and found that she was indeed very gifted. She resigned from the Education Department and took rooms in Lister House on North Terrace. Her healing became well known. She never charged, but accepted gifts. About a year after setting up as a healer she went to India where I believe she still practises and teaches. She must be nearly 90 now.

I think I saw her with a group of very distinguished-looking Indians in a quiet restaurant in Delhi. She had not aged very much and she looked splendid, but I could not speak to her for some reason I do not understand. It was about ten years ago.

Katie Duggan was committed to a mental hospital. It seemed that she could not stop herself from evangelising, and she would harangue groups of people in the street. It was very sad; she must have become possessed. I often wonder how modern psychiatry can give a materialistic explanation of the 'split personality' illness. (G. K. Chesterton wrote that a loose tile lets in a little more light.)

TWENTY-FOUR

I F I had been in the city in the afternoon, and was going home, I would often drop in to my father's office in King William Street and go with him. We were just leaving the city one afternoon when my father asked me if I would meet a boy, the son of a client, who seemed to have a gift for drawing. His mother wondered if he should have some training.

He took me to a drab little house in Parkside, and we were met at the door by a Mrs Johnson, who asked us in. She had her son there; his name was William. I looked at his drawings, which were not very impressive, but being evangelical about art, I pronounced him promising enough for some tuition.

On the way home, my father said that it would be better if I did not mention Mrs Johnson to my mother, as she didn't like her much. I couldn't imagine how Mum would know Mrs Johnson. She didn't seem at all like any of my mother's bridge-playing friends—quite another type of woman. She seemed a little seedy, and was even a bit 'arty', in a dingy way. I was to hear a great deal about her later on.

———

Early in 1944, Jac and I had got to know Louis McCubbin, who was the director of the Adelaide art gallery. He was the son of Fred McCubbin. Louis had his studio in what is now the Archives in Adelaide, a gabled building just behind the gallery. Here he showed us a lot of his father's paintings, but there was no interest in them he said. Some of them were very highly glazed, and Louis explained that his father had earned his living in Melbourne painting coats of arms on the sides of coaches. In these years, Fred McCubbin's auction prices were low.

Louis McCubbin was very popular in Adelaide. A single gregarious widower, he was much in demand for dinner parties. He was a very entertaining man and he could remember wondrous things about his father and his father's friends. He told us about how *How We Lost Poor Flossie* by Conder arrived in Adelaide. It was posted over to the gallery by Streeton wrapped up in newspaper and tied with string. He also related how he found their Renaissance Flemish *St Martin of Tours*. He was asked to go down to Port Adelaide to examine a false bottom in a crate and in it was the *St Martin of Tours*. I have seen an identical painting in Bruges.

We were in Louis's office in the gallery when he showed us the Ern Malley edition of *Angry Penguins*; he must have got it that day. He was laughing at the poems and thought they were nonsense. When we read them later I must confess I found some of the lines memorable. 'I shall be raised on the vertical banners of praise' and 'the black swan of trespass' were good enough to persuade us to take it seriously. And yet there were those bogus paintings of Sid Nolan's reproduced there in that publication, and so I felt uneasy about the poems. Birds of a feather? The poems turned out to be as bogus as the paintings.

Max Harris had asked me to do some art-editing for *Angry Penguins*. It was for an article he wrote on American Realists. He didn't have much feeling for painting, and I could edit how I pleased, he wouldn't know.

Jacqueline came to me and said we must have a serious talk. The war was going very badly. She felt she should throw in teaching and painting and join the VADs (Voluntary Aid Detachment), and she wanted to know what I thought about it.

My attitude was very clear. We, painters, musicians, writers, Art, are the things we are fighting for. Although Jac and I, immature and unknown, were hardly emblems of Australian culture, I told her we could perhaps be, one day. Our duty was to waste no time, and work as hard as we possibly could, and try to justify those people who were ruining their lives. I reminded her of my two dear dead friends, Crosby and Calvesbert. I had heard of a violinist friend who had had his fingers shot off. These things enraged me.

We decided to go and see Louis McCubbin. Louis sat on the Commonwealth Art Advisory Board in Canberra which recommended war artists. We begged him to push our cause. If Nora Heysen could paint flowers in New Guinea, surely we could be of some use? The whole thing would be too good to be true. We wouldn't have to teach, we'd be paid to paint, with all our materials provided. Louis assured us he would try to do something for us.

TWENTY-FIVE

ONE NIGHT I was awakened by a truly dreadful dream, a nightmare. I had just killed a man, he was on a bike, I was driving the car, it was night. It had just happened. I could remember seeing his tweed jacket through the windscreen, and the dull reflector on his thin mudguard. I was still shaking in bed. How could I have done it? The car was moving very fast, I was on Cross Road, and I had been chatting with my cousin Margaret. She was in the women's army and was in uniform. We had been to a party at Glenelg. We had gone into the windscreen when I tried to brake. There was a terrible thud as his body hit the bonnet. I tried to stop shaking, but I was in bed. How did I get home? How could I have come home quietly after that? Had I seen the police?

Gradually I made myself wake up more. As I started to really wake I began to think perhaps it was a dream. If only it was! I gradually made myself shrug it off and put on my reading light. I was still trembling. I was home in bed. Had it been a dream? Perhaps it was only just that?

If I had just got home, it must have happened only a short time ago—the car would still be warm. It was a dream, I said to myself, but to make sure, go out to the car and see. I went out to the garage and put on the light. The sight of the car was reassuring, but I was still shaking. Feel the

bonnet. I felt it. It was cold. Then I realised I had been home this evening, I had worked in the studio. I went to the studio. I was right: I had been home, working. So I went back to bed. It seems incredible that I forgot that dream over the next few days—I should have written it down as J. W. Dunne had suggested.

I don't remember how long it was after that, but I went to a party at Glenelg with my cousin Margaret. She was in uniform. We had been drinking merrily. It was very late, I was driving the car, on Cross Road, going very fast. It was near Wunderlich's tile factory; I must have glanced at Margaret. What happened next was in a split second: I felt déjà vu. No, it was not déjà vu, it was the dream! Look ahead! There was a man on a bike and I braked and just missed him. Margaret was upset at me having to brake like that and we slowed down. I wonder if she remembers?

Over the years I've told the story a few times, but I don't think I've changed or exaggerated it. But I feel, now, that I must have 'a guardian angel'. I was protected. I've often imagined the court case. The high speed, firstly; secondly, we had been to a party; thirdly, I had been drinking. Manslaughter. Jail. End of my painting for twenty-five years, and remorse for ever.

There was great excitement in the musical world. Eugene Ormandy was going to conduct our Adelaide Symphony Orchestra. The maestro didn't think it was large enough for his standards of recording, and so it was augmented by stars from the Melbourne and Sydney symphony orchestras. One of these was Melbourne's leading cellist, Harold Beck, brother of my friend Haydn who was leader of the Adelaide

orchestra. Harold was an enthusiastic amateur painter and he and his striking young wife Rhoda came out on a painting expedition with me.

Harold got permission for me to come to the town hall and draw Mr Ormandy at rehearsals. I did a series of drawings, mainly in red conté. It was very difficult: you had to note a pose and then try to draw it. Ormandy's movements were dramatic.

In one drawing I had him with his knees bent a little and he was indignant, yelling, 'I never bend my knees, never never never!' and then added, 'Only when I want a real pianissimo.'

He conducted the Dvorak Fourth Symphony, now called the Seventh I think, and Handel's *Water Music* suite. At one stage he was moving around the cellos making tender kissing motions with his mouth and fingers. He would go to really exaggerated lengths to draw from the orchestra the sounds he needed, but this was only at rehearsal. At the performance, he hardly moved at all, just arm movements and using his eyes. People must have thought him a very restrained conductor.

As there were three exhausting rehearsals, I was able to get a lot of drawings done. At one rehearsal he abruptly stopped everything and yelled at one of the musicians, 'I saw you looking at the clock!' It was 1.45, and the rehearsal should have finished forty-five minutes earlier.

There must have been over a hundred drawings of him, always in a sort of jump suit. I whittled away about seventy-five which I destroyed, and offered the rest to Mr Ormandy, as homage. He invited me to lunch at the South Australia Hotel and over lunch said, 'Now, let's make this a business deal. I can use these for program covers in the States.' Of course I refused this—I was so honoured for him to have

them and use them. I kept one, which he signed, 'To a great artist. Eugene Ormandy'.

Mr Ormandy invited me back to the recording booth and it was fascinating to see how painstaking he was with bringing up one microphone, quieting another. A lot of the effect came from the control room.

———————

The war raged on. Mr Hilbig suggested I might like to help him with his night work for the Air Training Corps. As I had done maths II, I could teach navigation. It was two nights a week. More painting time gone, but I felt it was the least I could do.

The boys were mainly 17 and they all wanted to be glamorous fighter pilots. They were not eager to learn dull old navigation—heaven forfend that they would be relegated to this.

I was given an air force badge to wear in my lapel. So many people rang me, and my parents, saying how glad they were, they'd heard that at last I'd joined up. (I think there were also anonymous phone calls which my mother never mentioned.) The badge was abandoned immediately. I felt I was living under false colours.

TWENTY-SIX

IN SEPTEMBER 1944, the year I had the show in Melbourne, I went up to Hawker at the foot of the Flinders Ranges for ten days. I went alone. You had to take the train for Quorn but get off at Carrieton, and then travel by bus to Hawker.

I had two 24-inch by 30-inch (60cm x 75cm) canvases on stretchers and four 20-inch by 24-inch (50cm x 60cm). They were tied up with straps, face to face and back to back. It made a large bundle to lug about in addition to my paint box which had four prepared canvases in the lid. As well as this I carried the collapsible easel and board with drawing paper and watercolour paper all ready. My watercolour paint box went in the small suitcase with some clothing.

On the way from Carrieton, half-way to Hawker at a place called Cradock, I saw a surreal sight from the bus. It was a small baroque bank building, standing there all by itself in the desert. I made a mental note to go back there. There was another building, which was a shanty-like hotel. There was also a small corrugated iron shed, which I imagine served as an occasional meeting hall.

Hawker was a real outback town. The Royal Hotel was the only one in the town and the licensees were William and Gertrude Currier. (How is it that all these things come back,

fifty years later?) The hotel bar was supposed to close at 6 p.m., but the only policeman was always there and we could drink until about 7, when we had dinner.

The Curriers were very hospitable and several nights we sat up late, drinking—I hadn't laughed so much for years. We told anecdotes. Gert was very funny when she described her arguments with the local priest.

'Now,' she'd say, 'You've studied religion, your Reverence, and you understand it. But when they explained it to me, I just couldn't understand a word of it. It's like mathematics, I'm no good at that either, it's all beyond me!' Both she and Bill were lapsed Catholics.

I played chess with the priest. He was a terrible player. Although he seemed to know the game well, he would fall for my simplest traps, and I had very few. I always won, and then he'd say with his heavy Irish accent, 'Awh! But ye're a mighty fine player, ye're mighty fine.'

Work started before breakfast, and went on with sometimes a break for lunch. For two days I went up to Wilpena. I went on the back of a truck. It was very rough going on the back of that truck; the road was bad and we were really knocked around. I had to hang on to my paint gear and hang on to the truck.

I shared this trip with a chap who was looking for work. Unfortunately, he had only one arm, which made it even worse for him. At one stage he said he wanted a cigarette and I offered him one, but no, he preferred his own, his 'roll your own'. But I said that in those conditions it was impossible and bet him he couldn't do it. It was astonishing to see that he really could do it, and I lost my bet. I'm sure he found a job.

I managed to paint the beautiful hills of Arkaba, which Heysen first painted. I was put up at Wilpena Station by the hospitable Hunt family.

Heysen based himself in Hawker and went up with two horses, one loaded with all his stuff. Hawker is 160 kilometres north of Port Augusta. Blinman, where Heysen also worked, is 175 kilometres north of Hawker. No matter how we may criticise Heysen's work for being too picturesque, some of his Flinders Ranges oils are good. (Does anyone know he was influenced by the Russian painter Yakoleff?)

The boundary riders would come in to Hawker for a 'blow out'. Boundary riders led a lonely life, and when they came to town they wanted some society. If there was a 'blow out' on at the hotel, the whole town knew. Gert said the boundary rider would put down all his pay for a month or so's work, and the 'blow out' would last until it had all gone. One evening was spent talking to a young boundary rider who showed me pages and pages of poetry he had written. His name was Thomas Hood and he was the grandson of the English poet of the same name.

Late one afternoon we had news that a dust storm was coming from the north-west. We were called out to see it. There was a low wall of brown in the distance, behind the nearby hills. It rose in the sky and we saw the almost black base of it. Then the distant hills were obliterated, then the sheds on the other side of the railway disappeared and within seconds it was upon us. We had dashed for the door and actually had to push it shut, seeing the sand coming in at the bottom, as if someone was shovelling it in from the outside. The noise the sand made was terrible. You had to yell to be heard.

It was pitch black and all the hotel lights were on. Later, in the bar, they showed me how the glasses had sand in the bottom of them. There was sand everywhere. I painted the storm when I got back to Adelaide, using a picture I did

at Hawker. The amazing thing was that the sunlight stayed
on the hills, the sheds, the houses, almost until they were
engulfed.

I returned with a lot of work. About half of them have
been over-painted or destroyed. Two of them are in Sydney.
I saw one a few years ago: it wasn't as bad as I had feared.

TWENTY-SEVEN

AT THE end of 1944, there came the good news that the Art Gallery of South Australia had acquired a painting of mine, *The Water Towers*. This was very encouraging. Even better news came at the end of the year. Jac and I received news that the Canberra Art Board had accepted Louis McCubbin's proposal that we become war artists. At last we should be able to work full time.

Jac and I participated in a show in Sydney of seven Adelaide painters early in 1945. It made no waves, but I sold five paintings. Some of them were from the Hawker time, and one of them was *The Dust Storm*, which settled in leafy Neutral Bay.

In an effort to get a toe-hold at the art school, I started a Saturday morning landscape class, with John Goodchild's blessing of course. My aim was part-time teaching—more time to paint. It was my last year under contract to the Education Department. At the end of the year I would be free.

In May 1945, Jac and I spent almost a week at Cradock. There was still only the single-storey hotel and a corrugated iron shed. Of course there was the ruined baroque bank. It was all desert where wheat had once grown.

No power, our only light at night was candles. We took lots of books and worked all day. I was doing a watercolour

and ink drawing of the bank when there was a flurry of a motor car pulling up beside me. It was the manager of the National Bank in Hawker. He implored me not to have the lettering 'National Bank of Australia' in the work. He had been asked to have the bank's name chipped off and had forgotten about it. He suggested putting 'The Farmers' Bank' or some such. I said he needn't worry, it was only a study for a painting. The picture was purchased by the National Gallery of New South Wales. I think I changed the name.

I had blown my candles out one night and was asleep when, very alarmingly, a heavy smelly body fell on me and started to snore. I lit the candle and got him off. It was an old client who was accustomed to sleeping it off on that particular bed. My hosts advised moving the bed a bit as he was bound to stage a reprise, and the next night he fell on the floor.

One evening after supper, our landlady-cook said we had visitors. We went out and the hotel was surrounded by motor cars. Each car had a bottle on the bonnet. It was all my friends from Hawker. What a night we had.

———

Mr Hilbig made me one of the class masters, that is, I had a group of twenty boys I had to record. It was one of the classes, but all I taught was painting. The appointment meant that I had to keep an eye on their attendance, where they lived, and make a report on them at the end of the year. I had care of them.

One of the things I had to watch was their class marks in relation to their intelligence quotient. Few educators were fully convinced of the accuracy of the IQ tests, but it was a guide. If a boy had a low IQ and was getting good marks, it was supposed he was industrious and had a positive envi-

ronment. If he had a high IQ and low marks, then he was lazy or there was an environmental problem.

One of the boys I had to check up on was Laurence Mullen. He was one of my most gifted painters and had a keen appreciation of painting and classical music. He had a remarkably high IQ and yet his class record was very low indeed. He was 15, a lively, likeable boy. When I talked with him about his low marks, I found out he lived at Mile End, near the city. He didn't know where his father was and couldn't remember him. His mother worked as a cook for a mine up north. He had to share a room with several boys he didn't much like.

He had nowhere to do his homework, and no one cared whether he did it anyway. He almost broke down and was near to tears as he told me he envied boys who had been punished—no one could be bothered to even give him a hiding. I was very moved. I said I would try to find better accommodation for him, and in return, would he accept a cut in his pocket money? He had far too much.

Our local church was St Colomba's, Hawthorn, and the parson was Canon Swan. I asked him if he knew of a woman who would like a boarder and let him have a room. He put me in touch with Mrs Lapidge in a pleasant house in Hawthorn. Laurie went to see her and she said she would take him in. I wrote to Laurie's mother, but she took a long time to reply. I just went ahead and moved him.

The principal of the art school gave him a scholarship for my landscape class. It was immensely gratifying to see his class position in school shoot to number one. His clothes were cared for and cleaner, and he was very happy, and I had fallen in love with him, completely, helplessly and, it goes without saying, absurdly.

It was a terrible situation. Laurie had been put under my

care, and now came the most unforgivable sin of all—I was taking advantage of my situation. It was a monstrous folly, and the result would be baffling frustration, as I knew he was perfectly normal and already had a girlfriend.

If Laurie had been a sissy boy, I wouldn't have fallen for him. Because he was a manly tough boy with a girlfriend I found him attractive. Nature had made a grotesque joke when I was thought up, and had placed a maddening series of pitfalls and high jumps between me and my perverse heart's desire.

I thought how lucky the straights are. Every piece of publicity, every refrigerator, every motor car showed a pretty girl leaning against it. It all went their way. Every play, every film, every novel was about boy meets girl. How was it that all this propaganda hadn't influenced me one scrap? I preferred a boy scout leaning up against that motor car, that refrigerator, that three-piece bedroom suite. It was macabre.

Even the sex act is easier for the straights, everything is custom built. What mad random gene had forced me to play such a tricky variation on an old theme?

Charlie Chaplin said tragedy is what you see close up and comedy is the same thing seen at a distance; but it's so difficult to distance yourself.

Laurie wanted to see my studio of course, so I showed it to him. I said (lashing my back more) he could come and paint there if he wished, and he became a constant visitor, to my joy. I was always playing classical music and it was profoundly satisfying to be listening with him. We were both enthusiastic chess players also.

TWENTY-EIGHT

MY SATURDAY morning landscape class was full. One of the students was Mrs McNiven, who must have been over 40. She was an accomplished and well-trained painter. She didn't need instruction but she was terrified to go out painting by herself and was happier with a group. Joe Choate, the art master at St Peter's, sent John Rogers (unbelievably talented) and Michael Shannon. There was Brian Seidel, John Bailey and Pam Cleland—I had a whole flock of them. If it rained we gave up, or I took them to the art gallery.

John Rogers was from Ceylon; his father managed a tea plantation. They visited Adelaide to see their son—it was easier to get to Adelaide than trying to settle him at school in England. Mrs Rogers actually thanked me for inviting John to come and draw a nude female model I had hired. I needed numbers to pay the expenses.

Michael Shannon's mother was a widow and ran their property near Kapunda. A handsome woman, she asked me to call her Kath, something I found impossible. Michael had an ungainly style of drawing, and he made an asset of it by pure hard work and keen sensibility.

It was September 1945. The news of the atom bomb and the capitulation of Japan came. Jacqueline and I must have been the only people in the whole country to be slightly

miffed at the news of the end of the war. It was the finish of our hopes of being war artists: we had just been told to hold ourselves in readiness and now it was all cancelled.

The Society of Arts had an annual portrait prize, and I did an almost life-size portrait of Laurie. It won the prize, the first I had won. Unfortunately Freddie Millward Grey had also submitted a portrait for this prize. He was decidedly senior to me at the art school, and was placed as runner up.

The portrait I did of Laurie was about full length—it stopped at the knees. It was called *Portrait at Middleton*. In the background was a large farmhouse from the mid-19th century. You could see it had also been a shop. The owners of this farmhouse, Wairoa, were farming the land around it, but took in paying guests. Just one paddock to cross and there was the sea, a great open beach with superb surfing. Wairoa had no electricity and we always went provided with lots of candles for reading. It was an ideal base for painting expeditions to Goolwa and to Port Elliot.

It was here that I first shared a bed with Laurie, because the rooms only had double-beds—it was one of the reasons I chose Wairoa. (When I later read *Lolita* by Nabokov I could see my cunning ploys and the 'so-near-yet-so-far' torments all described.)

The farmer's wife served early breakfast in the kitchen. But before that, we would rise and run across the field in pyjamas and dressing gowns, throwing off our things still warm from bed, and plunge into the sparkling surf as the sun rose before us, across from the Coorong.

One of my most ecstatic memories, treasured, kept shining, is of us running naked into those waves. I would always hold back a little, so I could have the joy of seeing before me Laurie's beautiful, golden, young body embracing the sea.

I have destroyed the painting, but studies of the farmhouse survive, and I have kept an important detail, the painting of Laurie's face. It is in my folio, by my desk. Still too moving to frame and be seen too much.

Wairoa, oddly, has become an art centre.

Petrol rationing was still severe and long-distance motor journeys were out of the question. I was longing to get back to the Flinders Ranges. A friend, Fred Sanders, had a huge old Studebaker which he equipped with a charcoal converter. He was an amateur painter and offered to take me on a camping trip up to the Flinders. I wanted Laurie to come with us, of course.

We set off in the September holidays, loaded up with bags of charcoal, camping and cooking equipment, and our painting gear. On the second day, we saw the blue tips of the mountains just suggesting themselves above the plain. We camped outside Wilpena Pound. There was no one there. No campers, all unspoilt.

By this time I was completely besotted with Laurie, but of course could give no indication of how I felt. We usually slept in the car, the front seat went down to make an extremely uncomfortable bed. Fred had a sleeping bag.

My torment and my ecstasy were constant. I was in a continual state of aroused desire. I was literally inflamed with lust.

I tried not to sleep at all, telling myself it would be a disaster if I lost consciousness while I was in this heavenly situation. So I tried to stay awake most nights. Daytime was spent stumbling about bleary-eyed with very painful balls, yet longing for the torture and embarrassment to begin all over

again next evening. The object of my love woke fresh for the day, while I was exhausted. This is what being love-sick is, I told myself.

We climbed to the top of St Mary's Peak and looked down into the majestic pound, which was encircled by mountains. There was a cairn of stones at the highest point. In the cairn there was a bottle with the names of the last climbers. They gave an address in Fullarton. We left our names, but we didn't ever hear from any of the people for whom we left our names. I hope the thread was later picked up again—a nice idea.

The only entrance to the pound was at the Gap, where we had our camp. It made an ideal hiding place for cattle thieves in the early days. They could herd the cattle in and let them graze until the brand marks had grown out enough for them to be sold.

That year was the end of full-time teaching for the rest of my life, I hoped. I was 24. Laurie went up to stay with his mother for the Christmas holidays. I had asked John Rogers and Michael Shannon if they would like to go to Sydney with me in the train, second class of course. We would have gone third class if there had been one.

TWENTY-NINE

MICHAEL SHANNON, John Rogers and I got as far as Moss Vale for Christmas day, stayed at a hotel for the night and went on to Sydney next day, and we found a large furnished room in Macleay Street. This, I told myself, was the vibrating, throbbing, mighty heart of Australian culture. The ideal thing would be to stay as long as possible. Money was the only snag, or the lack of it. I read that milk and bananas sustain the human body, providing every nutritional element necessary. So I imposed this regime on the three of us.

Clive Turnbull had given me a letter to Russell Drysdale and his wife Bon and they invited me to their house at Rose Bay. I was very excited: here I was, going to a famous artist's studio. The house was below the Rose Bay convent and looked down the harbour to the bridge. On the wall at the end of the verandah was a mural by Elaine Haxton. Russell ('Tas') invited me into his studio and we talked about painting. Penguin Books, in spite of the war, had put out a soft cover series of books on contemporary British painting. They had done Henry Moore, Graham Sutherland and John Piper. Tas was heavily influenced by them. He was painting *Burnt-out Farmhouse* when I was there, and was shortly to begin *Albury Station*.

I think he would have liked to have been in the armed forces, but he'd lost the sight of one eye, so it was impossible. His family, a rich Scottish-Australian one, had been opposed to his marriage with Bonnie Stephen, whose father was only a poor country bank manager. They were very happy. The two children, Tim and Lynne, were on tricycles and kept chasing each other through the studio, with Tas and Bon quite unaware of the pandemonium. It was the beginning of a long and happy friendship.

My poor sister had moved to Renmark where she was housekeeper at a large hotel. Margaret was at a very good and progressive boarding school.

While I was in Sydney I received a long letter from Laurie. It was three sheets, and back and front of each were covered with writing. It was very hard to read as there were scribbles diagonally right across every page. He wrote that he was helping to build a garage and an attached pergola, and all about life at Moonta mines. It was some time before I worked out that the diagonal large scribbles were actually writing. Each one said 'I love you' written six times.

Here, at last, was love declared, but I had to pretend to ignore it. He had been advised by his teacher at Goodwood that the school was not suitable for him to matriculate, which he had decided to do. At the age of 16 he was moved to Unley High School.

John Goodchild had managed to get me two days teaching a week at the art school. This was perfect—just enough money to live on and I had a lot of time to paint. I felt that at 24 I was on my way to being a painter.

Having got me on the staff, John had been appointed a war artist and left me stranded, with Freddie Millward Grey promoted as the new principal. Freddie didn't want me in his school, he didn't even like me. But I had to teach there.

I knew there would be some bad fights but I felt I could get support.

On the first day when I turned up at the art school for duty as a part-time teacher we had an awful scene. John had arranged for me to have two full days teaching a week, leaving me five days for work, but Freddie had devised a diabolical timetable for me. He had stretched out the two full days to four half days, and all of them down at Port Adelaide where there was a branch of the school. This meant I would be travelling for at least three hours a day four days a week because I lived in the western suburbs, very badly placed for working at Port Adelaide so often. So all my contriving for more time for painting was foiled.

I went to the director of education, Dr Fenner, a wonderful man. He admired my painting and had even bothered to let me know how sad the department was when I resigned as a full-time art master. Dr Fenner understood immediately. He said, 'You go to Mr Millward Grey, tell him what classes you want, and when you want them. If he makes any trouble, let me know immediately.'

THIRTY

IN MAY, Laurie and I went up to Kapunda, north of Adelaide, and I started on the studies that led me to paint *Kapunda Mines* which was purchased by the Melbourne art gallery. We stayed at a small hotel on the outskirts. It was on the first evening that we really got to know each other.

Our friendship had to be very furtive—at the beginning it was because he was a student where I was teaching. The subterfuge had to continue the next year—he was at Unley High School and I was at the art school. I was only too aware that it could be construed that I was committing a grave criminal offence.

An artist acquaintance of mine had formed a passionate friendship with the son of a well-known Adelaide artist's model. I think he was 15. The mother reported the friendship to the police, and Ken was arrested, tried and sentenced, but before he was taken to his cell, he was flogged with twelve lashes—at the Adelaide jail. I met him again two years later and Laurie and I tried to comfort him, but he was marked for life.

If we went to a film or a concert we sat at the back. We entered when the lights went down and left before they went

up. Of course we had no friends in common—these were pre-Kinsey days in an exceptionally uptight city, and I had to pretend to conform. Think of poor Ken and those lashes.

My work was going well and I was very encouraged. I began to think perhaps I could live as a painter and support myself, as in the same year the Sydney gallery acquired a painting I did at Cradock.

There were two of these, *Wasteland I* and *Wasteland II*. The better of the two was *Wasteland I*, which wound up in the collection of Sir Raymond Phillips in England. When this painting was sought for reproduction, we were told it was unavailable. It had been placed on top of a very heavy wardrobe. Then it had slipped and fallen down between the wardrobe and the wall. The wardrobe is too heavy to move. Perhaps the frame protected the canvas surface as it fell. I wonder if it is still there.

I painted another good picture that year, *The Rifle Range*. It was acquired by the vice-chancellor of Melbourne University, Sir John Medley. He wrote to me saying how much he liked it and invited me to come and see him when I was in Melbourne. I was intrigued to see his handwriting as it was just like my father's. When I eventually met him he turned out to be the same physical type. Later he presented the painting to Yale University.

Now that I had more time to work, my output increased. By 1947, Laurie had matriculated and wanted to be a painter. I thought he was so gifted that it was possible and the best way he could do this was by going to the art school and Adelaide Teachers College, as I had done. He was appointed a junior teacher at Goodwood, where I had been art master.

I was continuing part-time at the art school, despite ferocious fights with my principal. At one stage, Freddie came into my class and looked at my students' drawings, which he was entitled to do as headmaster. But then he saw an explanatory drawing which I had done, alongside a student's drawing. He could see at a glance I had done it, but snidely pretended it was the student's and said, 'This is even worse,' and the student said it was done by me. Freddie pretended to be embarrassed. I banged a book down on a table, it made a noise like a cannon. I marched out of the studio and waited for him in his office.

I told him he could not do this. To undermine one of his teachers was to undermine the school. I threatened to dob him in to the director of education, Dr Fenner. Freddie yelled that he'd go above him, to the minister. I said he couldn't, because the minister was Sir Shirley Jeffries, a friend of my family. I hope he couldn't see how I was shaking, and ashamed of the naked nepotism.

Poor Freddie, what a dreadful situation for both of us. The school only had partitions, so everyone could hear us. The end of our row was dramatic: as I rounded it off, name dropping, my loyal class gave a cheer, and at the same moment Miss Gladys K. Good (she who had taught me to paint a candle) charged in and said, 'Moreover, Mr Grey, you've been infringing on some of my young teachers,' and gave him another blast.

It was a terrible atmosphere in which to teach. Both Jacqueline and I were at the art school, and both of us were itching to get to Europe. Jac was still teaching full time, so when she did pull out of the Education Department she would have all her pension payments refunded, with

interest. I had very little because I had resigned after the four years' bond.

It was during this year, certainly because I had more free time to paint, that more 'studio painting' was done. Working on the spot, *plein air*, was replaced by doing studies, little things like thumbnail sketches, which developed into compositions.

I had realised that Cézanne, for example, would go out and paint his motif on the spot, but then the real work was done back in the studio, making a satisfactory design of what he had done in haste.

THIRTY-ONE

JACQUELINE AND I had a show in Melbourne in 1947. It was at Georges' Gallery, then run by Robert Haynes within the department store. I think the Melbourne art gallery bought *Kapunda Mines* from that show. Anyway, despite that, it wasn't a great success financially for either of us.

We visited Clive and Janet Neild at Koornung School, near Warrandyte. They lived in a house with glass walls, like Gropius—it was the first really modern house I had been in. We were very impressed by the Neilds' philosophy of education. Clive and I talked a lot about T. S. Eliot and he put me on to the *Four Quartets*. He praised it and thought I should read it. I bought a copy as soon as I got back to Adelaide and I have thanked him ever since: it opened a lot of doors. It was, for me, something like Keats reading Chapman's Homer.

The art teacher at Koornung was Danila Vassilieff and he entertained us in his studio dwelling, which was a train carriage converted into a house. We didn't care much for his pictures, ill-drawn children in ill-drawn streets, but they were popular and fetched high prices for those times. We spent an intimidating and boring hour going through an immense portfolio of drawings and watercolours. Most of them were on fragile rice paper. The Cossack had dampened

the paper and then put down blotches of ink or swathes of colour. It was a hit or miss business and most of the time he missed.

Some of them at best reminded us of Miro, but most of them were only too similar to the paintings we had coaxed out of young children. Our problem was that as Vassilieff showed each abstraction, there would be a pause, and you run out of 'interesting', 'how exciting' or 'that came off well', and you can't get by just on approving-sounding grunts.

Things were not running smoothly, and if the carriage-studio was physically off the rails, we went right off them when we were looking at one particularly tiresome sketch and one of us said, 'Ooh, it looks like a Roualt.' This was too much for our Russian's ego and he exploded, 'Why not Roualt look like me!'

This was too difficult to explain and we beat a retreat.

THIRTY-TWO

IN 1946, at one of the Society of Arts exhibitions, I showed a portrait of Karen Skinner, a striking-looking professional model. It was sold at the opening party. While the sale was being negotiated by the society's secretary, I was introduced to Mrs E. W. Hayward. She said she would like to buy the portrait.

It was really frustrating. She was the owner of Carrick Hill, the large house at Springfield, the same mansion I had watched being built. The Haywards had the best private art collection in Australia: two Roualts, a Goya, Vuillard, Renoir and Gauguins, as well as a lot of Augustus John and Stanley Spencer and Australian painters. It would be a great honour to go into this collection. But it had already been sold. Mrs Hayward said, 'Just my luck,' and was complimentary in exaggerating her disappointment.

A few weeks later, Jac and I were at a party given by our good sculptor friend, John Dowie. The Haywards were there. We were handed first lines for a limerick competition. Jac and I were asked to compose a limerick, 'There was a young man called Tuck.' We wrote a suitable rhyme. All the contributions were put together, and then our host started to read them out. They were all clean, clean even with

'There was a young man called Frick', clean even with 'There was a young man from Madras'—all clean. What would happen when our really filthy rhyme was read out? We started edging for the door. As we did so, we noticed two other people quietly moving out. They were Bill and Ursula Hayward. When we got outside we explained why we had to leave. Ursula said they got 'There was a young lady called Hunt' and she said we could imagine what they did with that. We laughed and talked for a while in the street and then all went our separate ways.

Soon after, I was at a concert at the Adelaide Town Hall with Nora Heysen. The conductor was Rafael Kubelik, whom I had already met at Ludwig and Merle Schwabe's house. He was wonderful company and I enjoyed his conversation very much. At interval Nora and I were out on the loggia and we met the Haywards again. They said they were giving a party for Kubelik after the concert—could we come?

I was excited at the thought of seeing the house and all the fireplaces, the staircase and wood panelling I had watched going in. And now to see it with paintings! I had to take the Schwabes home, and after that I tore up to Springfield. Ursula Hayward had offered to give me directions, but I explained how that wasn't necessary, how I'd been there so often.

The party was going by the time I got there. It was another world. It was glorious—the house was full of flowers, lots of tuber roses. The lights were very low, there seemed to be several servants, food was served, and the paintings glowed but I couldn't see them properly. It was all hallucinatory and I'm afraid I stayed too long, but Ursula seemed to enjoy conversation late into the night.

A day or so later I telephoned to thank her and asked if I could come to see the paintings one morning in a good light. She said I could come next morning at 11.

When I arrived I sensed she was very nervous. She had been Ursula Barr-Smith before she married and had studied under Ivor Hele. The Haywards were unusually rich and they were both passionate about painting. Ursula had broken out of the 'old and bold' school of Ivor Hele. They had a lot of Augustus John, including the famous self-portrait. But I think this was Bill's taste more than Ursula's, who was more avant garde.

We soon found out that they preferred the company of artists, writers and musicians to the rather staid local members of Adelaide's establishment. Not many of Adelaide's upper crust were interested in the arts. There were exceptions of course, but they were often conservative about their interests and cagey about their passions.

Adelaide produced quite a few eccentrics and they were welcomed at Carrick Hill. The house was grand but it was immensely comfortable and well lived in. The library was cosy. It was easy to come to the conclusion that very rich people in Australia all lived like this, with a great collection of paintings and a vast library.

The only other house I had visited which was on a grand scale was Anlaby, the Duttons' house near Kapunda, where there was a splendid library and good paintings. Perhaps it was logical for me to think there would be equally grand and cultivated houses in other parts of Australia. It was several years before I discovered how exceptional they were.

I found that Ursula was as devoted to Proust as I was, and the house was overflowing with books. They had no children, Ursula was 40 when I met her. She was extraordinarily

perceptive. She had a Scottish discipline and insistence on good manners but was very kind. She was also very funny and, hating pretence and the pretentious, would enjoy shocking people, often by bringing foul words into her conversation. She knew that having a lot of money brought the owners power and she was very conscious of the dangers of power without responsibility.

THIRTY-THREE

HORACE TRENERRY was a legendary name in Adelaide and people talked about him a lot. Besides being probably the best painter in South Australia he was a great character. We had many friends in common.

I had heard lots of stories about him and knew his work, including his one painting in the Adelaide art gallery, and I'd seen several in the houses of friends, but I didn't meet him until 1947.

When I first heard of him he was living, in real poverty, with a prize-fighter in one of the most magnificent houses in Australia. This was Wonnaminta, which was on the Summit Road, just below Mount Lofty. It was a large 19th century house with a verandah around it, and from Wonnaminta you could see the Adelaide plain to the sea and horizon, and to the east you looked down into spectacular Piccadilly Valley.

It was quite near the Bonythons' summer house, Eurilla. Tren often appeared at the door with a dressed chicken to sell to Lady Bonython. She sometimes suspected, she told me, that they might be stolen chickens, but you couldn't be sure. Kym Bonython remembers that Tren owed money to the butcher in the nearby town of Crafters, and paid him

with drawings and oil sketches on paper. The butcher's wife didn't like them and tore them up.

While he was living at Wonnaminta Tren decided to give a large party and have an exhibition of his paintings at the same time. He went to some of the biggest furniture shops in Adelaide and ordered a lot of furniture on 'appro'. He wanted to see how it looked in his home, and if it didn't go well, it would be returned. Needless to say, everything went back after his party.

After the boxer left him, I was told, he still insisted in living in some style, setting a place for himself with wine glasses and napkin, even though he was alone.

When Tren left Wonnaminta they discovered that the space underneath the floorboards of the verandah was stuffed with bird feathers. He must have raided the neighbours constantly.

Tren had moved to a farmhouse on the Willunga Plain when I met him. It is a most beautiful part of South Australia, resembling Provence or Tuscany. Tren did his best work there. Because he was so hard-up, he painted on cardboard, heavy paper, and old canvases when he could find them. The surfaces he painted on were often pictures that had been scraped down and Tren knew how to use the underpainting perfectly.

When Jac and I visited him, he was mixing his own colours from cheap powder colour he bought in bulk. He complained that artists' oil colours were a cheat and would fade anyway because cooking gas fumes destroyed the manufactured colour. He went on with all this nonsense because I think he wanted to disguise his indigence.

On his window ledge was a clear glass bowl filled with an amber liquid. While it glowed in the light, there was

something sinister about it. 'It's not piss, not piss,' he yelled, 'it's lime juice.' So then we knew it was piss.

Tren, even then, seemed very agitated and nervous, but we had no idea that he was probably already suffering from Parkinson's disease. Shortly after this, we heard he'd been put into hospital. We drove down to the farmhouse and found a lot of scraps and a large Derain-like sketch of pine trees on cardboard. We took these to Ivor Hele for him to pass on to a mutual friend who was trying to help Tren.

There was something so brave and mad about Tren. He knew how to live, but painting was the imperative necessity, and everything was sacrificed to that.

THIRTY-FOUR

MY FATHER had some clients called Pflaum. Ernst and Lillie Pflaum came from Vienna, and escaped with furniture and books and records only a year before the Nazi putsch. He was a heart specialist, and both were extremely musical. Their friends were Carl and Lottie Winter, Martha Rosendahl, Stef and Helen Stevens. On the first Sunday of the month they had a musical evening and Ernst would play records—he would notify everyone of the program.

After the music there was Viennese coffee and chocolate cake. I had some wonderful evenings there, when everyone was listening intensely. One night, even though half of them were Jewish, they played Wagner's Love-Death from *Tristan and Isolde*, and I could imagine something of what they felt in the Vienna opera house when they were young and in love.

Just before I left for abroad I lent them the Menuhin performance of Elgar's Violin Concerto, conducted by the composer, who was then an old man; Menuhin was only 16 and brought a youthful ardour to the recording. It did not really touch them, the first time. They were very well mannered about it, but it didn't work. I felt they couldn't react, although I'm sure they had goodwill towards it, because it came from me, but there was not the same feeling in the room.

Three years later when I had returned from living in Europe, they invited me for an evening and played the Elgar, after Ernst made a short speech. He said that the first time they had not liked it. He then played it again and the atmosphere was totally changed. Being so musical, they went past the bombast and tubas and knew what a strange and powerful work it was.

My other musical friends were Ludwig Schwabe and his wife Merle Robertson, the pianist. 'Schwabbie' had years before founded the New York String Quartet with Jan Kubelik, Rafael's father.

They lived near me and one day, when I arrived there, Schwabbie was sitting in the garden. 'I've just had a letter from Igor.' I knew who he meant. He had lived for a while in Los Angeles.

Schwabbie was taught by Dvorak and he could remember Dvorak talking about his lessons from Brahms and what Brahms said. A direct line through! Students came from all over Australia to study with him at the Adelaide Conservatorium. His students were not to study only music because Schwabbie insisted they go to exhibitions and gave them lists of books to read.

Merle Robertson was known in America as 'The Lioness of the Keyboard' and had met Schwabbie in New York. Ludwig was going deaf, not much, but slightly. Merle came from Adelaide, and she brought Schwabbie to us in Adelaide, to our great gain.

———————

Laurie would come to the studio almost every evening. If I was out at a party, I would come home early so I could see him. We would talk until the very late hours or play chess.

My mother, naturally, could not understand my friend-
ship with this boy from a world so much rougher than hers.
'What do you see in him?' she often asked. Once, when she
was complaining about Laurie's constant presence, she
asked me, 'What do the two of you do in the studio until so
late?' My father quietly said, 'Don't ask, Mildred.'

She couldn't think what was going on, but she must have
known in her deeper mind because she started screaming
in her sleep in the most anguished manner, hideously des-
perate screams. 'Oh no! *No! No!* Not my Jeff, *no!* NOT MY JEFF!'
I could hear my father trying to comfort her. There was
nothing I could do. It was heart-wrenching. I felt like going
to her and trying to explain.

At one stage I nearly came to the point of leaving certain
Shakespeare sonnets or books on 'abnormal' sexuality for
her to read, but I decided against it. I simply couldn't help
her. I thought of Proust's tragic words 'sons without a
mother, to whom they are obliged to lie all her life long and
even in the hour when they close her dying eyes.'

THIRTY-FIVE

IN THIS year, 1947, the year before I left, Francis Flanna-gan, who had a theatre group, introduced me to a friend of his, Mic Sandford. He was visiting his family in Adelaide. He had been at Oxford and then became a barrister in London. He was the son of Sir Wallace Sandford, a well-known par-liamentarian. His family owed their never obvious wealth to an Adelaide firm which made agricultural equipment, including a milk separator known all over Australia as 'the Sandford Separator'. Their large family mansion was on East Terrace.

When war broke out Mic immediately returned to Ade-laide and joined up. He was put in a camp on the Victoria Racecourse. Just across the street from his tent he could see his old bedroom window and imagine his comfortable bed.

He rapidly rose from the ranks, becoming a lieutenant colonel by the time he was 26. He was appointed liaison officer for General MacArthur and so divided his time between Melbourne and Washington when MacArthur was stationed in Melbourne. Earlier, he'd been at the evacuation of Crete, and then in Egypt. He spoke fluent French, German and Italian.

After the war, like so many bright people, he joined the Anglo-Persian Oil Company, which later became the

133

Anglo-Iranian Company and then the British Petroleum Company, known as BP.

At the time I met him he was living in Hamburg but said he would be in London when I arrived next year. He had already bought two paintings of mine from John Martin's Art Gallery and, whenever I failed to prevent him, went on buying my work for the next twenty-five years.

I was now becoming very restless. I wanted to get back to Europe. I told myself that my passionate affair with Laurie must crumble as he grew up and matured. I should have known better. Some people are never sexually focused and Laurie turned out to be one of them. When I came to that curious part of Proust's *A La Recherche du Temps Perdu* where Charlus and Jupien are in a sado-masochistic brothel, I was amazed and read it to Laurie. He was immediately violently aroused. It was the first intimation of what we now call an SM streak. How could I know that in ten years' time he would run a 'sado-maso' shop in Soho? An undreamt-of future for an Adelaide boy.

Jacqueline and I had long talks about the necessity of getting to London and Paris. I had decided that next year, 1948, I would definitely leave, and Jac was thinking the same. We had to see more old masters, we had to see contemporary painting in London and in Paris. We would stultify if we stayed in Adelaide. It is hard for young people to realise how cut-off we were in those days.

Ursula and Bill Hayward were in complete agreement. It was easier for them to go when and where they wished but they understood our needs and encouraged us to seek wider fields. They said they would be in London at the same time.

THIRTY-SIX

I HAD one last summer holiday with Laurie. We went to Robe, where I had some distant relations at Lakeside. I arranged for us to be taken down on a truck which was going there. It was a market truck that took fresh vegetable products from Robe to Adelaide. These trucks usually returned to Robe empty. We loaded our bicycles and gear on the back and sat with the driver, going along the Coorong, a day's journey, and another world when you get to Robe. I had already done some work there and found the place very attractive.

My relations let me have the stable there. Laurie and I had stretcher beds, some packing cases, all our paints. A primus flame cooker and some plates and we were ready for a productive month.

The stable was some distance from the main house, Lakeside. We took the upstairs floor, which was very picturesquely reached by a giant ship's gangplank. The stable looked over a lake which was very beautiful. We would sometimes bicycle to the ninety-mile beach and sandhills. We could swim there without costumes and sunbathe. Now and again we would dress up a bit and go and eat in the hotel dining room.

The Robsons, who owned Lakeside, were related to Dawn's family. Their daughter, Toss Jamieson, became a good

friend. She had been to school with Ursula Barr-Smith and, like Ursula, was an Adelaide rebel.

At this time I may have hoped that as Laurie inevitably became more heterosexual, I might too. I had met Judith Anne Ingoldby at the art school and was immediately drawn to her dark charm and vivacity, and her style. I had been to see Dr Carl Winter, who was a friend I knew through the Pflaums. He was a psychiatrist and I told him all I could, that on some occasions, admittedly only a few times, I had found that girls could 'turn me on'.

After several weeks of three sessions a week, some of them very distressing, he gave me his opinion. There was every chance of me leading a so-called normal life. He was well meaning, but mistaken. I was foolish and dishonest with myself to nurse these vain hopes.

I imagined this month at Robe as a last fling and a farewell to Laurie. I don't think I had ever been so happy as I was with him at that place.

At the height of it I developed asthma for the first time. I thought I was drowning. I was very frightened and was taken to the hospital at Kingston. Toss thought it was infantile paralysis, then prevalent. She sent her daughter Heather away. Of course it was a reaction to the stable, even though a horse hadn't been near it for years. It can be psychosomatic as we all know.

I had decided that once our holiday was over I would never see Laurie again. To make the break easier, I flew from Naracoorte to Melbourne and stayed with Michael Shannon and John Rogers. I left Laurie to take the bikes and the gear on the truck back to Adelaide. It was the finish of love for me, for the rest of my life. I was sure of that.

Laurie was to start at the Adelaide Teachers College in the next month, February 1948, so things were all lining up for him. At Robe he painted some good landscapes in oil. I did not suspect that he, too, was broken-hearted when we separated.

I stayed in Melbourne a few days and then flew back to Adelaide. I felt unreal and curiously numb. Laurie had left all my gear at home in the studio. It looked dull and strange. I was broken-hearted and it was my own doing. While I realise that it is physically impossible to be 'broken-hearted', the pain and the tenderness I felt where the heart is, was real. My parents didn't comment on Laurie's absence from the scene. They were happy that Judith Anne had supplanted him. Of course she hadn't.

Perhaps Judith Anne may have felt some unease about my friendship with Laurie. If she did, she didn't show it. Anyway he'd gone and I pretended not to be interested when I heard news of him. I was trying not to think of him, unsuccessfully. I had to be careful not to read poetry we had read together or some music which was too evocative.

Besides the beginnings of paintings from Robe, and a few finished pictures, there were lots of studies. In a desperate burst of work I managed to get together quite a strong exhibition, for early May, at John Martin's Art Gallery.

I hadn't had a show in Adelaide since 1945, three years before. Jac and I had had that unsuccessful show in Melbourne, in 1947, about six months before I went to Robe, so I had accumulated a good stock of pictures.

The show in early May, just before I left Australia, was very successful. Adelaide people turned up in force and loyally supported me. It was very gratifying and I could see that I could keep myself for well over a year. I trotted out lots of little sketches in oil and gouache that I had in a

portfolio and some of the buyers of these were old students. The best buyers, to my mind, were people I didn't know. I still felt that when I sold a painting to friends they were perhaps doing it to help me. One hardly ever feels happy with a painting: they are all of them either disasters or have things about them which should have been done better.

A whole exhibition is not really very thrilling when you see all your failures there lined up for you. Flaubert said, 'No work of art is ever finished—it is just abandoned.' I worked hard, right up to the opening of the exhibition. I then stopped work, and it was going to be a long time before my painting was moving again.

It was only a few weeks, but it was such a strange period of my life. I felt completely empty—I was without the pleasure of work and I saw nothing of Laurie. After those years of his company I missed him terribly.

With no motive to do anything except go to parties with Judith Anne, or with Jac, I took to spending the day in a sun room in the house. It faced north and was always pleasantly warm even in winter and I lay there on a bed, more or less all day.

I discovered that the body and mind can be controlled at a stage between waking and sleeping, and I could be conscious in an in-between state where you are entertained by fantasies. It was like being on drugs but these were self-induced. I could see that I could all too easily become a sort of vegetable.

THIRTY-SEVEN

I WAS ready to leave and was arranging my berth with a definitely one-way ticket on a P&O ship. About this time, I met a clairvoyant at a party given by an Adelaide musician. She was aptly called Claire. There was no 'sortilege, or tea leaves—playing cards, pentagrams or barbituric acids.' We had a gin and tonic and chatted.

Claire said she didn't think I would marry the girl with whom I was friendly at that time, that I was about to go on a very long journey, and that I would return to Australia after a few years. And she could see me working in an art gallery. She said she had some difficulty here because the art gallery had no walls.

I said that I didn't know about any marriage, and that anyway I had told all my friends I was going to London, so the long journey came as no surprise. As for working in an art gallery without walls, I wouldn't want the position and anyway you can't hang paintings in the air. I'm afraid I wasn't very responsive to her interest in me. Quite patiently but firmly Claire said, 'No, not just to England. You are going on a very long journey.'

Soon after I had met Claire at that party, my uncle George suggested that he could find me a place on a cargo ship as a supernumerary with a symbolic title like 'assistant

wireless operator'. My uncle was George Edson, my mother's oldest brother, and he was the director of immigration and customs for South Australia. In this position he knew many ship's captains and it would be easy for him to suggest a post for his nephew.

So I was quickly dissuaded from spending my money on even the cheapest P&O ticket to London—that fare money would keep me in Paris for several months—and I waited in Adelaide until Uncle George had news.

I had packed an absurdly enormous amount of luggage, even my large studio easel, as I was sure I was going away for a long time. Then Uncle George telephoned to tell me to get myself and my gear to Melbourne to meet a ship's captain poetically named Windus. I was to meet Captain Windus at the bar of Menzies Hotel and then I could talk it over with him and he would sign me on. It was so easy, so simple.

At the Adelaide railway station there were lots of family and friends and students to see me off. It was very moving. I had a sleeper on the comfortable Melbourne Express. Everything seemed to be going to plan. The next afternoon found me looking around the 19th century splendour of Menzies Hotel and I headed for the famous bar.

So my first meeting with Captain Windus started off in quite some style, though from then on it was downhill all the way. Captain Windus was in his forties, a lean, rather tense man I thought, even then. He came from Auckland, where I think he had a wife and family. The ship belonged to the New Zealand Steam Navigation Company.

Captain Windus and I seemed to get on well enough; we even exchanged some jokes. I remember he told the one about 'from the womb to the tomb' which I pretended I had not heard before. He suggested we go around to the

shipping company's offices where I would be signed on. It was nearby and on the way he remarked it was to be a very long journey with stops at Wellington, Panama, Philadelphia, New York, Boston and up the St Lawrence to Montreal.

My uncle had already hinted that I was lucky to have such a lengthy and interesting trip via the United States and Canada. So I had stocked up on a large supply of paints, enough for me to paint almost an exhibition—not impossible in three months, working every day with no distractions. I had a good stock of canvas, of course.

Walking around to be signed on, Captain Windus suggested I might become bored with nothing to do. He also said they were short on crew. He had forgotten—or maybe did not know or care—that I was a painter, and perhaps would I be willing to do some work? I foolishly replied, with false enthusiasm, that I would be very happy to help out at anything, in any way, and he grimly replied 'good'. I ask myself now why on earth I didn't say that I hoped to be working hard on my paintings.

And so I found myself signed on as the pantry boy. After this we talked in the street outside the office and he gave me directions to find his ship, the *Kaipara*, and told me to be there next afternoon. I said something civil about how pleasant it had been to talk with him and I remember him saying ominously, 'Probably the last time.' In my ignorance, it seemed an odd thing to say, but I had no forebodings and his words did not prepare me for the horrors awaiting next day. My ignorance was real; I had been riding high and did not realise what a protected life I had led.

THIRTY-EIGHT

I WAS at the Oriental Hotel again and Miss Sherrin got one of the hotel cars for me, as I had too much luggage for a Melbourne taxi driver, and the rather grand Daimler that deposited me and my things on the wharf by the *Kaipara* put me back a long way in the crew's eyes.

I was taken to meet the chief steward, Mr Hastings, a rather raffish, pleasant-looking man, but like the captain, he seemed a little strained. Perhaps it was because of sailing time. Most of the men on the ship were from Liverpool and there was a big obstacle with the language. I knew a bit about accents, of course, but I had never heard anything like the Liverpudlian one. It was so thick that I couldn't understand what they were saying to me and strained to hear.

They must have thought I was very stupid and slow on the up-take. I could feel that there was something clubby about their speech, they were part of a group, a vulnerable group I supposed, and the more vulnerable they felt the more impregnable their accent became.

I could understand Mr Hastings well enough—even though his accent was strong—but initially Harold, my immediate boss, was incomprehensible. I would try to guess what he said and try to look as though I'd got it.

At first, I was shown a tiny metallic box over the screws in the stern which I was to share with the galley boy. This chap was a fellow victim of that pre-jet, pre-multi grant era when getting to Europe was really important and unusual. He had just graduated from Melbourne University and was going to Oxford. As he was 22, he was a much more suitable age than I was at 28. His cabin was so small that there was hardly any room to stand, let alone put up an easel.

I went to Mr Hastings and complained. My high-handed rejection of the cabin must have seemed more than faintly ludicrous, like some shrill person being tiresome and petulant about the accommodation in a tenth-rate hotel.

Anyway, Mr Hastings obligingly put me in with Harold, the second steward. This was really coming up in the world because it was much larger and more comfortable. It was amidships and even had a writing desk. But I didn't think there was enough room to paint. I still hadn't tumbled upon my real situation and had no idea of the indignities awaiting me.

My luggage, like the Lord's raiment, was divided; the large trunks went into the hold kept for the crew. But I still had a lot of baggage, and there was my painting gear, and the large number of canvases I had pathetically prepared, thinking of all the pictures I could paint in the next three months. These hopes were being quietly and steadily quelled.

Harold was a slight, skinny chap. He had heavy eyelids and a half-open mouth revealing displeasingly dirty rabbit-like teeth. He had married a Liverpool girl about a year before. After settling me in, Harold conducted me to the appallingly foetid and badly lit place in the bowels of the ship where I had my wretched post at a small, hideous pantry sink. It was desperately squalid and filthy. I had to

wash dishes for about eighteen men, all the officers. There was an officers' dining saloon (which I never saw the whole time I was on the ship).

The work was dispiriting, though it might have been supportable if I had only to do the dishes. But then Harold showed me three bathrooms, each with several lavatories, all of which had to be kept spotless. They were very dirty and I noticed shit in the most surprising and capricious places. I could hardly believe what was happening to me, one horrible thing unfolding to reveal another, even nastier.

After I had taken in all this, I was dismayed to learn that I also had to clean the three main corridors, called alleyways. This meant sweeping, scrubbing on my knees, washing and rinsing and polishing not only the floors, but the bulkheads, which is what they called the walls. Washing the walls was called 'squeegee-ing the bulkheads'. I had no idea how to scrub a floor. There is a technique and I had to be shown; it had to be done very systematically. I was stunned.

As I was dejectedly washing dishes on my first evening, Harold sidled up to me and whispered, 'Yarnot fogging woonuvuz. Ahbet yahgott oondred fogging pun inna fogging bank.' The word 'fucking' was inserted constantly and remorselessly, making the simplest sentence long and difficult to understand.

It was distressing and daunting to consider that for three months this sort of conversation was to be my lot, an almost total lack of contact with people who thought of me as not 'one of them', which I suppose I wasn't. I hadn't met up with anything like this in relatively democratic Australia.

THIRTY-NINE

LOOKING BACK on it, I think Mr Hastings was very understanding with me. On my second day I was called to his office and he shouted at me that 'the foggin' shithouses are a foggin' disgrace'. When I protested that I had cleaned them, he then took me to the lavatories which I thought I had cleaned and showed me all the skid-marks.

Clever Dr Crapper in the early 19th century invented the flushing lavatory. I had exalted this as a great step forward, along with the keystone, the wheel and electricity. I was mistaken, naively assuming that it was an effective self-cleaning service. Mr Hastings showed me a lavatory brush and cleaning powder, and in his immaculate uniform he energetically and stylishly cleaned it himself, explaining how it should be done. All the skid-marks had to go. I learnt at that moment that if you want someone to do something disagreeable or difficult, show them you don't mind doing it yourself.

Four meals a day were served. Breakfast was an elaborate affair with fruit juices, cereals, all types of egg dishes and bacon, sausages and kidneys. The rest of the meals—luncheon, high tea and dinner—were all quite ambitious, even if the standards were not high. The bread was really weird. To begin with, it wasn't even like bread—it was like a sort of

cold, dry suet pudding but it had a repellent and sinister grey colour to it. Tea was served at 4.30, so no sooner had I finished cleaning up one meal than I had to start on another. So I had to contrive the time for cleaning the bathrooms and lavatories. Any hopes of painting were fading fast.

At the end of the second day, I was completely exhausted by the sheer physical work. (I was so tired I wondered if I had a serious heart problem.) I had not sat down from 6 in the morning until 10 at night. There was no place for us to eat and no food was kept back for us. We took from the serving dishes when they were returned from the invisible dining saloon to the pantry, and we ate standing in the pantry. Sometimes, from my lowly post, I would eye something going off to the mysterious dining saloon and think it not too bad, and pathetically look forward to the leftovers. Imagine the disappointment when anything desirable had been all gobbled up; I was learning about what unions fight for.

There was a third steward called Smith, a 'callow youth', silly as a wheel and tall and thin; he could be both servile and aggressive at the same time. He had the most hideous enormous member, of which he was proud, and he liked to display it. On the ship each person had to wake up someone else. I had to wake Harold, and Smith had to wake me. On my first morning I was awakened to the day by the unspeakable Smith hitting me about the face with his disgustingly grotesque cock. He thought it was very funny.

The seamen were all quartered over the stern and they had their own mess, served from the galley. This was not my field. Their dishes were cleaned by the galley boy whose cabin I had rejected.

As well as the dishes for the four meals every day, the bathrooms, the disgusting lavatories, the alleyways and the

bulkheads, not to speak of cleaning the humid and dank pantry itself, there was the slop bucket.

This bucket was quite a large affair; it was heavy even when it was empty. Into it I had to put all the plate scrapings. If a dish was not very popular in the dining saloon, the bucket could be very heavy. On my first day at sea I lugged it to the nearest deck and chucked the slops over the side. I was caught red-handed; I was told it was a great crime. After that I had to carry it aft and empty it over the stern, sometimes two or three times a day.

This meant very carefully carrying it down the length of my clean and lovely shining alleyway, then right across the aft hold deck to the stern crew quarters. There I had to haul it up a vertical companionway, then across the stern deck above the crew's quarters, and empty it into the swirling wake. It was extremely difficult to lift it over the rail standing on a swaying, shuddering deck, and desperately tricky at night after supper. If there was a tail wind, you had to be quick-smart.

It had become quite obvious that being able to paint every day was absolutely out of the question.

There was lifeboat drill one morning, before our arrival in Wellington. We were placed in several lines, all wearing our lifebelts, and Captain Windus inspected us. What a motley lot we must have looked. It was the only time we did this.

I saw a sympathetic face; we glanced at each other. There was some sort of faint smiling recognition, although I couldn't think how. After the drill, we spoke for a moment and introduced ourselves. His name was Freddie Inglis, about my age, ruddy faced and very pleasant. He was a supernumerary and was signed on as 'assistant wireless operator'. He occupied the pilot's cabin—he had taken my place!

As we neared Wellington, I formed a desperate plan to desert ship. I had had enough; it was too much, and I was convinced anyway that I was physically incapable of that cruelly heavy work. I asked the bosun, who was becoming a friend, if he could have my things ready and he agreed to help me. He might have felt sorry for me: I had whinged and whined a bit about my wretchedness.

After we had berthed, I found a telephone booth in the docks, and located a marine lawyer called Leicester. When I told him what I was planning, and asked if he would help me, he was very sympathetic but urged me not to leave the ship.

From Mr Leicester I learnt, for the first time, of the enormous number of desertions from British ships, both in Australia and New Zealand. In the circumstances the two countries were forced to be severe with any deserters. He thought he could spare me a night in jail, but assured me that he could not save me from a conviction, and this was a serious matter and would be stamped in my passport. I was well and truly cornered, legally trapped with no way out, virtually imprisoned on the ship—with, I was to discover, a half-mad head jailer.

FORTY

S O I resigned myself. I would just have to put up with the vile squalor of it all, but for so long! I felt dejected and wretched. It would be a long time before I could be painting again, that was obvious. (And what about my health?)

Besides the bosun, who was, unbelievably, called Mr Hawkins, I had made another friend, Lin Jackson. He was the second cook, and had joined the ship the day we sailed. He was escaping from the police, on bail on a charge of larceny. He was about 19, dark and good looking, and wanted to get to Paris to join the Foreign Legion, where the Australian police could not touch him. Although he had never cooked anything in his life, he had falsely declared he was a trained cook and that he had lost his references. He confirmed what Mr Leicester had told me about the desertions.

The chief cook of the *Kaipara* had jumped ship in Melbourne, along with several other men. Jimmie the second cook had become chief cook and Lin Jackson second cook. It was his job to bake the bread—no wonder it had been diabolical. And no wonder Mr Hastings seemed so strained, and of course Captain Windus must have known about the desertions. I realised I was doing two jobs instead of one, possibly more.

The *Kaipara* had very graceful lines; in the bows it almost looked like a yacht. It was painted white with a deep yellow ochre funnel. 'Amidships' was not really amidships at all but placed well aft.

The ship was about 8,000 tons and was nothing other than a huge floating refrigerator. It was loaded with frozen sheep and rabbits. In 1948 the food situation was desperate in England; I romantically imagined there was something heroic about the gallant *Kaipara* bearing food for a starving Britain. There were no less than seven refrigeration engineers on board, and not only a chief engineer, but a chief refrigeration engineer, all given the rank of officer. Perhaps it was these chaps who had such macabre and unorthodox excremental habits, I wondered.

Before taking on the meat in Melbourne, the ship had been in Port Pirie, South Australia, where it had loaded on board a large cargo of lead and zinc ingots—these made the ballast. By the time the ship left Port Melbourne it was obviously dangerously and, I was told, illegally low in the water, and one could feel the diesel engines straining to push the enormous mass through the sea. We also had a slight list but they reckoned this would go as more oil was consumed. There was a surprising amount of oily soot from the stack which fell everywhere—that caused part of my labours and was the reason I had to use so much carbolic acid.

After leaving Wellington, instead of sailing directly across the Pacific Ocean for Panama as I had assumed, we learnt that the ship had to head south into the Antarctic Ocean. This was frustrating as it meant delay. I was even more depressed.

I had noticed the refrigeration engineers up on deck lowering their thermometers on long wires into the cold chambers. They did this twice a day and there was a general air

of apprehension. The lead and zinc in the ballast had been on the wharf at Port Pirie all the long hot Australian summer and had absorbed and retained a tremendous heat. This heat was fighting the refrigerator engines and there was a serious problem. The refrigerators had not yet reached the low temperatures needed to keep the meat fresh.

So enormous sums of money were at stake. It was hoped that the cold waters of the Antarctic would help lower the temperature of the heated ballast. But it meant a longer time at the sink and down on my knees on those floors. My despair deepened and the slop bucket seemed more unmanageable than ever.

FORTY-ONE

'AND SOUTHWARD aye we fled.' It was becoming noticeably colder and rougher. The tossing and swaying of the ship made my work difficult. The sink could only be half-filled or else the water would spill everywhere. A bucket of water had to be held on to with one hand while I scrubbed the floor with the other. A dish could not be left on the draining board or on the pantry serving table. A ship in heavy seas makes a lot of noise: squeaks and moans and thuds.

One would expect sea-sickness. I had been at sea several times before and I had been sea-sick. But if you are busy working you seem to be spared. Also, if you are constantly seeing the waves and being on deck, you understand the movements of the ship and make allowances for it. In the whole three months, no one was sea-sick, nor, oddly enough, were any of the thirty-five crew ill. There was no ship's doctor as there were no passengers. I supposed Mr Hastings was equipped with some medical knowledge and drugs but he was never called upon.

The only person who may have been ill was Mr Devereaux, the wireless operator. I found him very pleasant to chat with. He was certainly the oldest man on board, and was going to retire when we reached Liverpool. We were

talking on deck one evening and I told him how desperately miserable I was with the unpleasant heavy work I had to do. He rounded upon me with passion, saying that I was young, I should accept it all as an adventure and stop grousing. He was right of course and I tried to take his advice. When I mentioned his name to Harold, who had to clean his cabin, he said, 'Disgusting vile old bastard, dirty old thing, always pissing in his bed.' I realise only now that perhaps poor Mr Devereaux was suffering from a diseased prostate.

I had managed to make contact with Freddie Inglis, the usurper of my place. His family had interests in the New Zealand Shipping Company and Freddie had a post in the London office. I imagine he had gone to Australia and New Zealand to see over the company's offices and learn something about the management of that part of the firm. It turned out that we had some mutual friends and we both had a discreet supply of whisky and brandy and books. He dined with Captain Windus but already we had had a few evenings in his cabin, and we had a chess set—a great blessing. His pilot's cabin became a haven for both of us.

We were a few days out from Wellington when I committed my first offence, for which I was logged. It had become much rougher and the ship was rolling, pitching and tossing most alarmingly. I found the storm exhilarating.

One night when my work was done and my slop bucket emptied for the last time, I made my way in the dark up to the bow of the ship. There was no engine vibration here, away from all the noise. It would have been quite silent except for the sound of the waves swishing against the sides of the plunging vessel. It was another world. I clung to the bow exulting in the dark, mysterious splendour of it all.

I had been missing music; there were no cassettes in those days and I had no wireless set. So I started to sing at

the top of my voice bits of Bach and Wagner, and then I got stuck into Brahms, the Double Concerto for violin and cello. I thought I was particularly good at doing this work—very difficult with only one voice.

A few months before—those palmy days!—I had driven Claudio Arrau and Rafael Kubelik up to meet Hans Heysen in his studio at Hahndorf. It was luck to find these two great musicians in Adelaide at the same time. Our journey to Hahndorf was hilarious—we did a complete rendition of the Brahms Double Concerto. Raphael was the orchestra and Claudio and I were the violin and cello. There were lots of pauses from the orchestra, 'No, it must go like this,' and so on. Now my solo version was enriched by the coaching from these two men. It would have sounded ridiculous, certainly, to someone who didn't know the music, and absurdly silly anyway.

The sound of my voice must have reached the bridge, despite the distance, and above the clamour of the storm, because my ecstatic private world was suddenly shattered by an abrasive and intruding 'son et lumière' with a dramatic spotlight on me and an alarming loudspeaker voice ordering me to return.

Back amidships, Mr Hastings and Harold were very glum: 'You're going to be logged for this.' I could see they thought I was a bit mad. The idea of being 'logged' sounded formidable.

Next morning I was escorted up to the captain's day-cabin. It was, or seemed to me, luxurious. A large bright space, carpet, chintz-covered easy chairs, cushions, curtains—quite unlike the dank world in which I dwelt.

An angry Captain Windus was very different from the man with whom I had chatted in the Menzies bar. I immediately apologised, of course, and began saying (conversationally, I

dare say) that I had no idea I was breaking a ship regulation, but he very roughly shouted at me to be silent and ordered me to stand to attention, which I immediately tried to do of course—rather difficult on a floor which was heaving. I was shocked at his manner; it was unnecessarily rude.

Behind Captain Windus was Freddie, seated, pretending to look at a magazine, and trying to keep a straight face. Yelling, Windus asked me what I was doing up in the bow and I stated that I was singing. I could see that he also thought I was barmy. He told me that the forward decks were out of bounds to me and that I would be punished: he was docking me one month's pay. He then shouted that I was dismissed.

FORTY-TWO

THAT DAY and the next we all knew that the ship was in serious trouble. The waves had become so great that, unbelievably, they were much higher than the ship. I hadn't realised that seas could become so frightening. The vessel was dwarfed, it was a miracle that we were not overwhelmed. The ship was running along in the huge valleys made by the sea, but now and again a colossal wave would wash right over the aft or forward hold deck. Then, another horror, sometimes the whole vessel seemed to slide down the slope, sideways, listing heavily. It was terrifying emptying my slop bucket—I had to watch the seas and make a dash for it, or be washed away. I could not believe it when I saw whole parts of the ship submerged; we were sinking, it looked like.

The bosun had explained to me that had the ship tried to head into waves of such gigantic size they could break it in two. This could happen when the fore and aft sections of the vessel were supported by the crests of two waves, and a valley, a space, was made amidships. No keel could support the great weight and a loaded cargo ship snaps in two like a stick of celery.

That night the hurricane was at its height. In the stern, the bosun and his friend Tommy and I spent that fearful and unforgettable evening in the ship's carpenter's cabin;

he was known as Chips. On his bulkhead Chips had rigged up an indicator which worked simply by gravity—an arrow and an arc, a homemade inclinometer.

We have all heard of ships which disappear without a trace and now I realised we were facing that situation. It could very easily happen and in these seas getting into a lifeboat was unthinkable.

It was absolutely terrifying sitting there tensely and silently, and every now and again hearing the hard clanging clatter of the propellers as they were lifted right out of the water—we were over them. It was like being seated on a bucking horse in slow motion. It was frightening to watch the arrow arrive at 'Death Roll', then a long pause, then it would slowly go over to the other 'Death Roll'.

While we were seated there, stunned, gazing at the 'Death Roll', there was a dreadful crash and a shuddering of the whole ship. It seemed to pause. We remained holding on to our seats. Then the arrow slowly moved across again. Later, we learnt that a colossal wave had smashed in the starboard bulkhead of the bridge and one of the two lifeboats was washed away. It is amazing we survived, and that we did not feel more terrified.

In the morning the hurricane abated and we were informed that we were forced to return to Wellington for repairs. It had been a nightmare, and Freddie and I were very despondent at this further delay. He was wanting to return to his fiancée, Penelope, and I was just wanting the whole awful thing over and done with. It was upsetting knowing we were going back on our tracks.

In Wellington it was amazing how quickly everything was restored, all in practically twenty-four hours. So we headed south again, as the refrigerators were still being overworked. I became quite cunning with my chores; I discovered ways

of doing them quickly and more efficiently. There was a daily inspection by Mr Hastings and a weekly one by the captain. (My hypochondriacal fears for the wear and tear on my human frame were in temporary abeyance.)

The captain of a cargo ship leads a lonely life. The voyage from Wellington to Panama, for example, took twenty-eight days. Once at sea the captain has practically nothing to do. The mate runs the ship and the captain usually dines alone. I had already known a few ship's captains and they had all sorts of hobbies, like wood-carving, book-binding, tapestry, embroidery—anything to help them pass the time.

FORTY-THREE

CAPTAIN WINDUS was fortunate to have Freddie's company for meals but it could not have been easy for Freddie to spend so much time with such a strange man. I think that the evenings Freddie and I passed drinking, chatting, exchanging books and playing chess helped us both to keep sane. I was also able to give him bits of gossip about the crew as I picked them up; he was cut off from that side of it.

We had some close shaves. Freddie would announce that he was having an early night and retire to his isolated pilot's cabin. Then I would turn up and, as a rule, we would talk quietly or play chess. One night there was a knock at the door. It was Windus and he wanted to speak to Freddie 'for a moment'. Freddie, at the door, said that it was 'inconvenient'. There seemed to be some insistence in the captain's voice but he went away into the darkness.

Now that is all so long ago I think I was lucky to have had physical work to do. Had I been in Freddie's position I do not think I could have dealt with the situation as he did. For Windus, Freddie was almost like having one of the owners of the company on board. I couldn't ask Freddie too much about that at the time, it was too close to the bone. As I later learnt, Windus was a troubled and tragic figure.

Fortunately, I was getting to know the crew. My relationship with Harold, my boss, my cabin mate, seemed to be settling down and, as I shall relate, I became accepted as 'one of them', contrary to what he had whispered on my first day. The unspeakable Smith had abandoned his novel and repellent way of waking me. The bread was much better: Lin was learning.

I often spent a cosy evening with the bosun. Mr Hawkins had been a bosun on the *Hood*, the great battleship in the Second World War, and told me he had trained hundreds of midshipmen. He was a stocky, swarthy man in his mid-forties. He had never married, he was always far too involved with the boys he trained. His young friend, Tommy, one of the crew, was one of the most beautiful youths I had ever beheld. He was 19 or 20 I suppose. I asked 'the Bos' how long he and Tommy had been together and he told me it was now five years. He was helping Tommy study to be an officer and then, he feared, it might be all over—very difficult to get jobs working on the same ship. The bosun was respected by everyone and I never heard a snide remark about his friendship with Tommy.

Near the pantry was quite a large empty cabin with one bulkhead occupied by a huge full bookcase, and there was a long table and chairs. This library had been earned dearly, I was told, at the cost of several strikes. It was there for any member of the crew who wished to better himself, and study, and an officer was bound to attend him and coach him. The library was always empty. Tommy was the only one to make use of the books but he always studied with the Bos.

Sometimes I would spend an evening with Lin Jackson, whose criminal life, laconically told, was always diverting. I realised he was a natural crook, and just as I thought of myself as a painter, he was a crook, his father was a crook,

and he was proud of some of his father's crimes. The bad thing was to be caught. Lin had no desire, ever, to 'go straight'. He despised the respectable life.

Lin told me how once he had seen his father after more than a year's absence; he just met him accidentally in the street. His dad invited him up to his room to meet his new lady friend. They had a drink together and, as they all got along so well, Mr Jackson suggested that Lin should stay and have lunch. 'I'll go down and get some sandwiches and more beer,' he said. While he was away, Lin took the lady friend to bed—'nothing like a good quickie,' he said.

But by the time Mr Jackson had returned they were back at the table chatting. Mr Jackson handed the sandwiches around and poured more beer. Lin bit into his sandwich—and yelled. It was full of the hottest mustard and chilli sauce. 'That'll teach you not to fuck my lady friend while my back is turned, you little bugger.'

'How we laughed,' said Lin admiringly.

After we had been at sea for a week or so they were saying, with much mirth, that buggery was condoned once we had all been at sea over fourteen days. I am sure this was only a legend. Nevertheless, we played up to it and would be casting amorous glances at each other, particularly Lin and I, murmuring, 'Only three more days to go, darling.' In the whole time I was aboard, with the exception of the bosun, I did not see any signs of homosexuality. There was always a great deal of laughter, particularly among Jimmie the cook and Lin and me. I can't think now what we laughed so much about; perhaps it was the absurdity of our situation, all packed tightly together in an immense space. I have heard prisoners of war tell how they all laughed so much together. Our hilarity and mirth seemed absolutely natural, and I suppose it was therapeutic but that didn't occur to us.

My time working on the *Kaipara* taught me several things, other than how to clean lavatories and scrub floors. I have learnt that when you are in a restaurant your relationship with the waiter must be conducted very carefully; extreme politeness is fundamental. Even servile fawning is better than any friction between you or your friends and the waiter. He has it in his power to bestow all sorts of unspeakable horrors upon you. I have been behind the scenes and I know what I am talking about. Never argue 'this asparagus is not fresh', or 'this pasta is overcooked'. Go quietly.

One of the refrigeration engineers was difficult with Smith and Harold. They were always coming back from the dining saloon complaining about him. I overheard them deciding to add a little piss to his soup. I did not see it done but I imagine it was. In their vendettas they were not confined to urine, saliva always being readily available. After all, it was their only vengeance—they couldn't argue.

A particularly surreal thing happened when we reached the International Date Line. One became accustomed to the diesel engines which made a deep throbbing hum, the pistons went thump thump; there was always this mechanical pulse, rather friendly. On the date line, the engines broke down, and it was nearly twenty-four hours before they started again. So we were becalmed. It was a Monday. For nearly a day we didn't move, neither in time nor in space. When we moved again it was Monday all over again.

The refrigeration chambers had at last reached the right temperature so the ship could start heading north. We ended up doing a giant loop and coming up off the coast of South America. The weather was better, there was sun.

Sometimes a few of the engine-room greasers would come up on deck for a breather. They would stand about, covered with black oil stains. One of the greasers was

pointed out to me, a burly, short, red-faced tough with such large pectoral muscles they suggested female breasts. I was told that he was well known and welcomed at certain ports where he would go to a brothel, put on a wig and get into drag, and was much in demand. With my Adelaide background this was difficult to believe at the time and easy to dismiss as ship's gossip. Today, I am not so sure.

By now, I was really cheating at my floors and my lavatories and my bulkheads and I had become a dab at doing the dishes. I could use a scrubbing brush like a violin on those lavatory floors. The tiles were a black and white mosaic with an insistent and relentless houndstooth pattern. I could swish in behind a lavatory and use the side of my brush like a virtuoso. Mr Hastings gave me approving looks, not because I was good but because he was pleased that I was able to pass it off, and he was polite enough to pretend I was successful. (I was also feeling very healthy and I vaguely wondered if the physical work, far from being debilitating, might actually be good for me.)

The weather became much warmer as we went further north. One evening, late, I was slipping quietly out of Freddie's cabin and I happened to look down on the aft deck and saw the unexpected and intriguing sight of Lin Jackson and the chief refrigeration engineer talking in the shadows. They did not see me and after that I saw them several times. In the pecking order of a cargo ship an officer would not be talking with the second cook. I was sure their conversations were caused by lust for money rather than for the flesh but I couldn't think what it could be. How can you have a black market on a small cargo ship? I couldn't imagine what they could be planning.

After so long at sea it was cheering to see the gulls appear again, hovering over the stern when I emptied my slop

bucket. We were nearing the coast. Then one day, looking over the side, I saw the arresting sight of the branch of a tree floating past. It gave me a tremendous, galvanising shock. I hadn't seen any vegetation for a month. It made me gasp, it was a shock to see something from land, a natural form.

As we were nearing Panama, Freddie told me that there was a very serious problem and Windus was in a dilemma. Grave miscalculations had been made about our consumption of oil. No allowance had been made for the high specific gravity of the lead and zinc ballast and how it could retain, for so long, that accumulated absorbed temperature from the long spell in the sun at Port Pirie.

It was now very doubtful that we had enough oil to reach Panama. We could go into Lima and take on oil, but berthing fees were not accounted for, and it would delay us even more, at least two or three days. Windus, in a quandary, had asked Freddie what he thought of it; was it worth the risk to try to make a dash for it to Panama?

Neither Freddie nor I wanted to prolong the trip but, of course, Freddie didn't feel he could give an opinion. I had a little knowledge of navigation. This was acquired when I studied trigonometry at school and then when I taught the subject during the war, in a very amateurish way, in the Air Training Corps of the Royal Australian Air Force. We talked about it and decided to ask Mr Devereux, the wireless operator, for a history of the weather in this zone for this time of the year. It was established that bad weather was unlikely and there were no disturbances around to generate heavy seas, and it should be plain sailing.

So the pantry boy and the assistant wireless operator decided to recommend to the captain that it might be worth making a dash for it—an unusual thing, surely, in the history of navigation. It was an unbelievable situation. And

that is what we did: we took the chance and headed straight for Panama.

The approach to Panama was sublime. A calm Conrad *Lord Jim* sort of sea, with dramatic little islands covered in lush vegetation and the glitter of tiny white houses. I can't remember us berthing at Panama and taking on oil; I must have been at my labours. But I learnt that when we arrived we had about an hour's supply of oil. So it was a near thing. The assistant wireless operator and the pantry boy had calculated well and we had been lucky.

FORTY-FOUR

WHEN WE entered the canal it was curious to see that the engineering had a distinctive early 20th century style to it, almost Art Nouveau. It was also moving to remember that Paul Gauguin, who had admired the 19th century architecture of Melbourne, had worked as a humble labourer on this canal (I was not alone!).

In some narrow parts of the canal, the ship almost brushed the foliage, and exotic vegetation flourished which were hothouse plants in South Australia. After crossing Lake Gatun we came to the first of the descending locks and the extraordinary sight of actually looking down on the distant ocean, the other side of America, and thoughts of 'stout Cortez'.

That evening we berthed at Cristobal and it was a joy to be ashore after four weeks at sea, the first time since that sad and desperate conversation in the telephone booth on the wharf at staid Wellington. Cristobal was a revelation—my first encounter, as a grown-up, with Latin sleaziness, and it appealed to me instantly.

Windows were casements, instead of sliding up and down. Some windows even had, absurdly, shawls and materials draped from them. Balconies had flower pots. There were outdoor bars and South American music, noise and

confusion in the streets, the heady Roman Catholic smells of incense and garlic, and high density living. It was my first contact with Mediterranean culture for over twenty years, and how it fascinated and stirred me, and has done ever since.

Our first port of call in the United States was at unalluring and flat Protestant New Norfolk, Virginia. No garlic here, and I saw, for the first time, the odious reality of racial segregation. Once we were in port I discovered my work was much lighter as all the officers took the opportunity of dining on shore, so there was little for me to do in the evenings. I was free as soon as we had eaten and quite often even earlier. I went for several bus rides and noticed that public conveniences at bus stations all had double facilities, with one clearly labelled 'COLOURED'. This was 1948 and I was outraged. In the buses, I found that the back was reserved for 'coloureds' and the front for whites.

It was deeply shaming to see the bad behaviour and sloppy deportment of the white 'trash' in the front and the quiet dignity of the black people at the back. As a protest I went and sat with the blacks. But when I talked with them, they told me that my action could cause resentment. They pointed out, rightly, that I was free to choose and they were not, so I had to give up. My indignation was righteous but I could not help wondering if perhaps had I been brought up in these circumstances I might have grown up accepting them unthinkingly.

A few days later the ship entered the Delaware River and berthed at Philadelphia. I had friends here to whom I had written. The conductor Eugene Ormandy was one. The pianist Alison Nelson was another. Alas, Mr Ormandy was away on tour but I saw Alison. A young Adelaide pianist who was studying there at the conservatorium, I was very fond of

Alison. She and her sister Kath invited me to supper and I set off, on foot, for their flat. As I got nearer, I realised I was entering an entirely black quarter. I saw a policeman and showed him the name of the street and he pointed the direction for me, saying, 'It's down there, but I wouldn't go there if I were you. We never try.'

It was a hot evening and the streets were full of blacks. They were dancing and singing, and the whole thing looked like a huge cinema set for a musical extravaganza. I even saw a big fat 'red-hot mamma' dancing and laughing. When I told Kath and Alison what the policeman had said, they said it was ridiculous—they were never bothered and had made friends in the area.

The Philadelphia Museum of Art quite knocked me out. It was the first really major collection of paintings I had seen as an adult, and to add gilt to the gingerbread there was a special Cézanne exhibition put together from United States collections. I could hardly believe my good luck.

After Philadelphia the ship went to Boston, and from Boston, seemingly illogically, it nicked back to New York, I suppose for cargo reasons. This sequence firmly convinced the crew that the cities of the eastern United States coast were, in order, Philadelphia, Boston with New York up at the top. It was no use arguing with them. Of course men like the Bos and Mr Hastings knew better but it was amazing to find they could not read a map. I don't think there was any illiteracy but some of the men were pretty close to it.

The other odd thing I noticed had been often remarked on before but it is so curious perhaps it is worth stating again. When at sea, the men really longed for the day when they would next see land: 'Only three days and we'll be in port'—that sort of thing. In port, they soon became bored and after two days were restless, counting how many days it

would be before we sailed. And when we sailed, there was always a general and genuine feeling of elation. A sailor's life is a strange one; a ship protects one from the world, and many of them remain very simple people. In a sense, I envied their protected lives where everything was found for them.

In Boston, my colleagues Harold and Smith indicated that I had, at last, been accepted by them and I felt they considered me 'one of them'. They invited me to go out 'queer bashing' with them. It was a touching gesture of friendship.

We were to go to bars frequented by queers and flirt with them. You then picked one up and took him into a lavatory where you shut the door and bent him over the lav to indicate your desire. You then, with one hand, pushed his head into the lavatory bowl while at the same moment with the other hand you flushed the cistern and then like lightning went through his pockets and took his money. I gracelessly declined the invitation, saying rather priggishly that I thought I wouldn't be any good at it—it sounded too complicated for silly old me. But I must say I felt sincerely complimented by their invitation; it was a turning point in our relationship.

It was very warm in Boston and I found Beacon Street one of the most charming streets I had ever seen. I had a great stroke of luck—on the first evening there I was looking at the fine Georgian architecture and I paused outside a window. I heard Debussy being played on a piano and it was magical to hear it on a summer's night. When the music finished a voice said, 'Did you like that?' and I thanked the face at the window and said I was on a ship and hadn't heard any music for ages. We both enjoyed the Carson McCullers situation and I was then invited into the house. My host turned out to be James Mason, not the actor, but better, a director of the Isabella Stewart Gardner Museum, affectionately

known in Boston as 'Mrs Jack Gardner's palace'. In the Gardner Museum, beside the very famous old masters is the remarkable *El Jaleo* of J. S. Sargent, a superb and beautifully composed early work. His masterpiece, at 26.

I learnt that the Boston Symphony Orchestra was giving a concert one evening and so I went to that. It was Koussevitsky conducting, not my cup of tea (I thought him too commercial) but at least I would have the heavenly healing sound of a good symphony orchestra. This was the occasion of my second logging, a very serious business. The concert was on our last evening in Boston.

We always had to be on board one hour before sailing time. Sailing time was chalked up by the companionway. I had observed that at Cristobal, at New Norfolk and at Philadelphia the ship had always sailed precisely one hour after the stated sailing time. The time of departure from Boston was given as 11 p.m., and the concert did not finish until 10.45. I got a taxi and swanned up just after 11 p.m. To my horror, the companionway was gone and the ship's engines were working. I spied a plank extended out from the crew's quarters at the stern (my friend the bosun!) and I shot up that plank in the nick of time.

Harold said that the 'Old Man' was going to see me in the morning—he was only called that on grave occasions. So there I was again, on the mat, in that pretty day-cabin, but this time Captain Windus was almost screaming with fury. I was wrong, of course, and he was right but his fury was excessive. There was Freddie, again, seated behind him, and me trying not to catch his eye. No laughing matter this time.

The captain yelled that I was to be logged again and another month's pay was gone. (It seemed unfair—I worked so hard for so little and now it was almost nothing.) Windus, surprisingly, asked me why I had been late and I told him I

170

had been to a symphony concert. 'A likely tale,' he shouted. (I wondered what he thought I was more likely to be doing—poofter bashing?) He then yelled that if there was one more misdemeanour, he would have me declared an undesirable and I would be unable to enter the UK, and what, he asked, would I do then? I thought it was inconceivable I could be listed as undesirable and the thought of working my way all the way back to Australia was too appalling. Although I was amazed and alarmed at Windus thinking like this, I said I felt he would not succeed and, because this serious threat really worried me, I added, imprudently and impudently, something about him possibly overstepping his powers. At this, he became frenzied and I could see he might go out of control. He ordered me out. He was shaking.

That evening, over a drink, I told Freddie I thought Windus had become hysterical. His unexpected and dramatic threat had distressed me, and for the first time I began to wonder if perhaps he was insane. After a few drinks, I began to feel better, but it is a weird feeling to be completely in the power of someone you think might be mad. I did not want him causing my family any trouble.

The next time there was an inspection, Captain Windus came through the pantry, attended by Mr Hastings. We stood, as usual, to attention at our posts. He paused before me and, without looking at me, his eyes came to rest on a drawer alongside the sink. We were all in our shabby clothes and when someone is in an immaculate uniform, attended by a chief steward in a spick and span get-up, in a very confined space, it seems like royal presences from a higher sphere. Windus continued to look fixedly at the drawer and no one spoke. Dead silence. Quite suddenly he leapt forward and pulled the drawer of knives and forks wide

open and sprang back as if there might be a tiger snake in
it. He regarded it from a safe distance and then proceeded,
leaving it wide open. It felt like an assault.

FORTY-FIVE

THE SHIP was to berth in Brooklyn, New York, for about a week. I went to Mr Hastings' office and told him there were a lot of museums and exhibitions and friends I wanted to see. If I paid the dreaded Smith to do my work, could I leave the ship for this time? Mr Hastings agreed. My joy at this temporary freedom was intense.

I took the underground to Times Square because it was the only place-name I knew. From there I got a cab and asked to be taken to a hotel as near as possible to the Metropolitan Museum of Art, where I hoped to spend most of my time. The cab dropped me at the Stanhope Hotel. As I walked in, I saw immediately that it was far too grand and too expensive, but I had led such a deprived, not to say macabre, life for almost two months I thought I could indulge myself for the first two or three days.

There was an unexpected problem about booking in at the glittering, elegant reception desk. My hands really looked grotesque, they were quite black. They were covered with tiny pitch black lines and no amount of scrubbing could lift these ingrained telltale marks. The hotel reception clerk was unbelievably lofty and I had to try a sort of

eye-to-eye hypnotism to prevent him noting these betraying emblems of manual labour. I don't know if I got away with it.

It was my first brush with American grand-luxe, and by the time I'd been booked in and escorted to my suite they had been able to place a vase of roses on a table. This had an envelope by it with my name hand-written and a 'personal letter' welcoming me to the hotel. I admired the thought and was amazed it was done so quickly.

The suite was handsome but when I went into the bathroom I was immediately piqued to find the same black and white, remorselessly insistent, houndstooth tiles which I had been scrubbing for so long. What a disenchantment; my Via Crucis was haunting me.

Three days at the Stanhope was all I could run to and the last day was my birthday. It must have been a Sunday because I sybaritically had breakfast in bed, the vast silver tray on wheels and the tome-like *New York Sunday Times*—what a wallow! And the Metropolitan Museum just across the street opening at 10.30.

After that, it was back to reality, whatever that may be in New York. A friend found me a small room in a downtown hotel, unsuitably called The President: no flowers, no allure, and breakfast came in a cardboard box, but at least the bathroom tiles weren't evocative.

The Adelaide *Advertiser* had a weekend section and occasionally I had contributed articles on painting in pathetic attempts to make more money. When I was leaving Adelaide, Clive Kelly, the editor of the weekend section, gave me a letter of recommendation, a sort of reference. Louis McCubbin, the director of the Adelaide art gallery and a good friend, also furnished me with a letter.

Frank Lloyd Wright was already very well known, and

I'd heard that he had designed an art gallery for the Guggenheim Collection, which hadn't yet been built. In those days the collection was housed in two places, the Museum of Non-Objective Art, a brownstone house near the present museum, and in Mr Solomon Guggenheim's New York home at the Plaza Hotel.

I went to the Museum of Non-Objective Art and liked it very much. Every work was abstract, nearly all geometric; this was just before abstract expressionism. The paintings had to be entirely non-objective, no association of a shape to an object was permitted. The walls and carpets were grey, the frames were uniform and grey and the attendants were dressed in grey. Abstract music came filtering through grey speakers—Bach, Mozart and musique concrète, but no romantic music. It was very effective.

There were splendid canvases of Kandinsky, Malevich, Moholy-Nagy, Rice-Pereira, Miro and Arp. Several Mondrians of course, all late. No Picassos—he had painted almost no purely abstract pictures—but a lot of canvases by Max Bauer. I had never seen the originals before.

I made myself known to the management and produced my letters. The effect was perfect. The assistant director conducted me around the museum. I was shown the model of the proposed museum and they gave me some splendid photographs and plans of it; it all looked so handsome, so exciting. I still regard it as a marvel.

When we came to a powerful Léger, I noticed a rather disturbing shape lower right—it resembled a bottle upside down. I remarked on this to my guide, who said with sardonic humour, 'The countess declares it is abstract but I, like you, regard this as a heresy.'

'The countess' was Hilla Rebay and she was director of the museum. A number of her paintings were in the collec-

tion and, as I mentioned, a great number by Max Bauer. When I remarked on this, I was told, 'The countess considers Max Bauer the greatest man who has ever lived and the greatest man who will ever live.'

The director of the gallery was very kind and invited me to a party given in a luxurions apartment on the top floor of the gallery. There was a white grand piano and I went over to try it. Before I lifted the keyboard lid my friend whispered, 'The last person to play that was Kandinsky.'

Mr Guggenheim had bought a great many paintings from Kandinsky and over the years they had become friends. Kandinsky was working in Germany, then, in the thirties. After he had sent a batch of paintings Mr Guggenheim asked him what he wanted for them. Kandinsky wrote, 'Just send me one of those beautiful limousines you American millionaires go around in.'

A handsome Cadillac convertible was sent to Hamburg. Goering heard about the car and ordered it to be sent to him instead. They showed me the photograph of Goering in the motor car paid for with Kandinsky paintings.

The next evening I was invited to a reception given in Mr Guggenheim's vast apartment in the Plaza Hotel. It seemed to take up an entire floor. One room opened up into another and the walls were covered with paintings. A lot of these painters, like Oscar Schlemmer, Max Beckmann and Otto Dix, were figurative. I remember a great number of Kandinsky watercolours; there were so many they were placed low, above the skirting board, and all these were in the process of being catalogued. In the centre of each room was a table and on these were folios of drawings by all the great names, all still uncatalogued. There were two charming, badly dressed women there who were introduced as the Misses Whitney. I suppose they were, later, the bene-

factors of the Whitney Museum.

When one sees the Guggenheim Museum today, one wonders what has become of all those drawings, all those Kandinskys. I was able to do an article published by the Australian Associated Press. I was well paid and it was, I believe, the first thing the general public in Australia heard about this museum which has since become so famous. Initially, I was bowled over by the genius of Frank Lloyd Wright; having visited the reality many times I'm not so sure.

The Museum of Modern Art was one of the first things to see in New York; you could see the *Guernica* easily, it was not so famous then. I had a friend at the MOMA, an attractive French girl, and I told her I wanted to see a Sartre play which was on Broadway, *Angels are Prostitutes* (I was always the dogged cultural eager-beaver). She said I could see that in London or Paris but what I couldn't see anywhere else in the world was the Radio City Music Hall. So instead I saw the Rockettes and the most lavish theatrical effects on that huge stage.

At the Rockefeller Center next door, I was astonished to see very impressive ceiling decorations by the British Royal Academician Frank Brangwyn. His *Pont d'Avignon* in the Art Gallery of South Australia was one of my first boyish loves. Here he was doing vast trompe l'oeil decorations. You seemed to be looking up at colossal figures, heroic workmen. It resembled Soviet art, as did Diego Rivera, and this was the heart of capitalism.

It was unbelievably dispiriting to have to return to my squalid job after the glitter and stimulation of New York. In no time I was back with the dishes, and Harold and Smith, and down on my knees scrubbing away amazing masses of new dirt and new shit which I thought I had paid the vile Smith to keep at bay.

FORTY-SIX

THE SHIP made a long journey up the St Lawrence River to Montreal. One morning I awoke to the strong and delicious scent of pine woods filling the cabin, so strong I sat up and eagerly looked out the porthole expecting to see a wooded river bank close by. Instead we were still in what appeared to be the vast open sea. Gradually, during the day, distant coasts appeared each side until by evening we were in a fine river.

There seemed to be no great collection of painting in Montreal, there is no memory of any, but one evening I went alone to see Charlie Chaplin's *Monsieur Verdoux* and I found it strangely disturbing and stimulating. Monsieur Verdoux had been condemned to death for all his crimes. Just before his execution the priest said, 'May God have mercy on your soul,' and Verdoux replied, 'I suppose he will, it is his.' I remember walking the French-looking streets for hours that night, and thinking I had sorted a lot of things out. They were political things. I had been a total innocent, not to say naive, and the film assured us there was no justice in this world.

Our last port of call before Liverpool was Boston again. This time there was no Boston Symphony Orchestra, but a strip-tease show which Freddie had found out about. We went to the old Harvard theatre, just known as 'the Old

Howard', and we had good seats. The ladies were huge, statuesque, mainly blonde. Even when they were fully clothed you could see they were beefy.

The stripping took up the whole evening. At first the girls just danced and sang, and only at the end of the number did they throw away hats, coats, gloves and scarves. Then we had a comedian, a little comic turn. When the girls came back, they were as they had left the stage and, after another number, they only took off the tops of their dresses. It was a real tease.

Then there was a juggler and after that the girls, and so the show went on to its inexorable and unexpectedly lascivious climax. It had not occurred to Freddie that I wouldn't find these ladies exciting or alluring. In fact I don't think he found them so, initially. But as the show proceeded, it was amazingly arousing. It was the apparent reluctance, the reproachful glances—a sort of 'Oh, must I, really?'—and an almost anguished manner that was the turn-on. It was genuinely and beautifully obscene, a triumph of style over content. The girls were undeniable 'artistes'.

One girl had huge tits to which she attached tassels. By controlling her pectoral muscles she was able to swing these tassels clockwise, then anti-clockwise, and then the virtuoso act of tassels flying in opposite directions, to tremendous and merited applause.

That unforgettable show in Boston was the last night in the United States and the next morning we headed for Liverpool.

––––––––––

We had been informed that cigarettes were rationed in Britain, and that they were expensive on the black market. They were very cheap and plentiful in the United States, so

I stocked up with an enormous supply of my favourite brand in Boston. I bought so many cartons of red Pall Mall that they made a mass about the size of a small cupboard. I had overdone it.

Despite being so asthmatic, I was an enthusiastic and devoted smoker. As I enjoyed it so much I could see the London future looming with little or no money, because of no abatement of my self-indulgence. In fact, with poverty ahead, smoking was going to be a great solace.

Unfortunately, after I had acquired all the cigarettes, Mr Hastings told us that persons entering England were only allowed two cartons a head. I would be obliged to somehow smuggle my hoard and Mr Hastings told us the ship was going to be subjected to a rigorous customs search.

I wrapped them all up in heavy tar-paper, very rigid, and made them into a large sort of box. But where to hide it? Not in the cabin—you would be fined. In one of the lifeboats? They would search them, find the cigarettes, and confiscate them.

With my oil paints, I painted my treasure exactly the same colour as the aft mast and stencilled '120 volts' on it. I decided that, with bosun's permission, I would lash it to the aft mast when the time came in a place where all could behold it.

I was really fed up by this time, but now there were only eight more wretched days to go and it would be over. How I counted the days!

As I worked, there was a grey bulkhead immediately in front of the sink, a few inches from my face. The pantry had no porthole, no air. I had tried pasting a Matisse print on the bulkhead opposite my eyes but there was so much steam it wouldn't stay put.

On that last lap, I wondered if perhaps I was going off my head. One evening in the pantry, I remember Harold

quietly staring at me with those sad drooping eyes, sagging jaw, his mouth open a little, just regarding me as I worked at my sink. I don't think he was thinking about me, it was simply that I happened to be the object on which his vacant gaze came to rest. He had just finished drinking a can of beer and the empty can was in his hand. As he watched me, he put his two hands together and with a contorted face crushed the can in his hands. Did this symbolise something and was I going mad and cracking up?

The night before, I'd had a diabolical nightmare. I dreamt I was still on board the ship and it was all so insupportably hideous that I made myself wake up, knowing that when I did I would be snug in some comfortable bed in London or Paris and all would be well. But it made me quite desperate to wake up into the very nightmare from which you were trying to escape. Is this the way one becomes a loony, I wondered.

Although it was August, it was cold and grey crossing the Atlantic. As we entered the Mersey my relief was profound. I felt elated at the sight of welcome and impressive Liverpool and I could see, longingly, the Adelphi Hotel. I had survived the ordeal. I was to be allowed into England. My health was good. (I was beginning to suspect I did not have a bad heart after all.) 'The horror of it all' was over. Or so I thought.

Freddie and I said our farewells and planned to meet in London. He showed me a book Captain Windus gave him as a parting present. It was inscribed to Freddie and underneath that Windus had written, 'We must by all means preserve our sanity.' Freddie made no comment and neither did I, but I remember reading those lines with unexpected compassion and I can still visualise that small tight hand-writing.

The pilot's boat came while we were in mid-stream and lucky Freddie and Captain Windus went ashore in the little launch.

There was an anti-climax. We were not berthed for another two days.

We had a customs search; the crew called them 'the scavengers'. I had already lashed my large 'box' to the aft mast. What made it look particularly convincing was that I had painted the ropes with thick, quick drying artist's oil colour, which precisely matched the mast colour. With a bit of distressing it looked as if it had been up there for ages. It was jammed between the mast and the ladder, very obvious, all could see it, and everyone enjoyed, and I hope admired, my criminal efforts; for me, it was a piece of trompe l'oeil.

It was the most thorough going-over conceivable. I had no idea what they were looking for. I supposed it was drugs—after all, we had been in Cristobal. They went through our things, even inspecting the mattresses. Lin Jackson told me that they thrust long stilettos into the galley flour bins. They looked up in the crow's nest, going up the ladder of the mast and passing my treasure trove a few inches from their eyes, and they had the covers taken off the lifeboats. They ripped open some carcases in the cold chambers. Even after all this we did not move. It was very frustrating.

Then we were informed by Mr Hastings that we could still be here for a long time, nobody was to leave and the ship would not raise anchor. A huge number of sheep and carcases were missing and until they were found we would be kept on board, like prisoners.

I had discovered that all the officers were given small personal holds, and refrigeration engineers were even allotted small, private refrigerated holds. Those curious conversations in the dark, in mid-Pacific, between Lin Jackson and the chief refrigeration engineer came to my mind.

Freddie had told me that there was always a great deal of thieving and that it was expected and accounted for by

insurance. These thefts must have been unusually grave. Judas-like, I told Mr Hastings of those nocturnal meetings I had glimpsed. Of course I couldn't hope to restore the stolen cargo to its owners, but I could hope that Mr Hastings might hasten our release. And so it happened; we were freed.

My next problem was to get The Box through the dock gates, where you had to pass a policeman. Mr Hastings said it was very simple. When your taxi stopped at the gates you handed your passport to the policeman with a five pound note in it. I said it was unthinkable, you simply didn't offer money to a policeman, and Mr Hastings shrugged his shoulders and told me I would lose my cigarettes if I didn't. I managed to do it, in the evening light, and in the taxi. I didn't see the fiver being extracted; all I saw was a hand returning my passport and I heard a voice, 'Pass, thank you, sir!'

About two years after my ordeal on the *Kaipara*, Captain Windus was reported missing at sea. The ship was two days out of Auckland and his body was never found.

Years later in Sydney, after I had given my weekly broadcast on the ABC, I was going home by way of the Woolloomooloo docks and I saw the *Kaipara* berthed. I walked straight on board. Dressed as a toff in my ABC get-up, I knew I could go anywhere with no questions asked, provided I walked firmly and looked as if I knew where I was going, which I certainly did.

I had a good look around, but sadly I saw no one I knew. Nothing had changed. I looked into my old cabin, glanced at the galley, saw those bathrooms. I looked into the never-before seen officers' dining saloon—surprisingly large, but grotty. Then I looked into the squalid, dank, hot pantry and there I saw another me, a poor little wretch at my old post. It was like another incarnation.

BOOK TWO

EUROPE

ONE

I HAD suggested myself to the Neaversons, our distant English relations. They had written saying they would be pleased to put me up. The train from Liverpool went directly to Peterborough; it was very fast. Like most Australians, I marvelled at how green everything was along the way. Uncle Herbert met me at the station and coped with all my luggage. He was obviously well known and liked by everyone there. It was September when I arrived at Airedale, the impressive house the Neaversons owned at Dogsthorpe near Peterborough. Uncle Herbert had a large 'N' designed into the grillwork of the two drive gates: it looked rather napoleonic, and the welcome I got was royal but in the family style.

My only memories were from the photograph album and the reality was much better. Auntie Gertie was a wonderful host. I found myself in great luxury, sleeping in the bed usually favoured, Auntie Gertie said, by Lord and Lady MacIntosh.

After a couple of days' rest, Uncle Herbert took me for a drive to his beloved Monk's Wood. It was still unspoilt. We went to the log cabin and I went straight to the mantel shelf. Yes, it was still there, the photograph and the sad, beseeching 'Please don't take me away.'

Uncle Herbert said he had a novelty for me: there was now an inn in Monk's Wood, would I like some refreshment? Of course! So we set off for the inn. He had placed on one of the drives a model inn about 2 feet high. He was bursting with laughter—'But you won't get a drink! Closed today!' He was such a keen teetotaller, he'd even set up a soft drinks factory and was successfully selling his products.

Uncle Herbert had lots of Edwardian practical jokes. If you wanted to note something down, he would offer a pen which had a spring in it and jumped out of your hand. Cushions had squeakers under them so sometimes they made a loud fart as you sat down. If someone bored him he would switch off his hearing aid and announce it wasn't working.

A few days later, Uncle Herbert asked me if I'd like to see the smallest church in England. I said of course I would, but I felt suspicious after the inn in Monk's Wood. We set off and went to Oundle, a picturesque town with a famous school. Out of Oundle we took a road for Great Gidding. The name Gidding signified something to do with 'Little Gidding', the last poem of T. S. Eliot's *Four Quartets*. I felt excited to be somewhere even similar to Little Gidding. Uncle Herbert drove on through Gidding and when I saw the sign for 'Little Gidding' I felt a frisson.

We turned down into a rough road and parked by a farmhouse. Then we walked and left the rough road. We passed some pigsties and came to a chapel with a rose garden in front of it. You had to open a gate. I was tremendously moved and told Uncle Herbert about the poem. We walked over and passed the tombstones to enter the church.

> ... when you leave the rough road,
> And turn behind the pig-sty to the dull façade
> And the tombstone.

...

You are here to kneel
Where prayer has been valid.

...

... for history is a pattern
Of timeless moments. So, while the light fails
On a winter's afternoon, in a secluded chapel
History is now and England.

The chapel is situated on a slight rise overlooking the fen country. It has the feeling of a small church by the sea. It had been restored by 'The Friends of Little Gidding' and I saw Eliot's name on the list.

The church had been built, as well as restored in 1625, by the Farrer family. They were a family of saints. Charles I sought refuge here, which is why Eliot wrote 'If I think of a king at nightfall' in the poem. The entire church was done by the family, including the wood-carving and the embroidery.

Then they kept a constant vigil, with each member of the family taking it in turns to pray.

... You are here to kneel
Where prayer has been valid.

After a week or so of sleeping in Lord and Lady MacIntosh's bed, I felt quite restored. The artist's hands were losing their embarrassing black scars and softening up for drawing and painting masterpieces again. I was longing to get back to work.

TWO

JACQUELINE and I had been in touch already and when I took the train to London there she was at the station with Tom Brown. Tom was studying theatre. Both seemed very happy to see me. They were quite overcome with joy, in fact, and suggested we go immediately and have some lunch.

It dawned on me that they were hungry and that their anticipatory joy was not confined to my arrival. It was food they wanted as well. We had a wonderful chatty meal and when I asked Jac if she was broke, she made a wry face and said there had been a disaster with all that pension money she had.

For some weeks before she left, she and her father Jack Hick—the cowboy—had tried out a system they had devised for betting at the races. They had tried it out, *in theory*, and it worked. You backed a horse, the favourite, and if it didn't win, then you put double on the next race, and so on, until you inevitably won. Each week they had made a fortune but, alas, only on paper.

Then the big day came for the real thing. They went on betting right through the whole race meeting. They didn't win once and Jac lost her entire pension. She had already

packed her things and had her ticket, and decided to go on anyway.

She had come over with a lot of her mother Julie's clothes, as well as some furs and evening gowns—most of them very good and valuable. She was steadily selling them off, living on the proceeds.

The basic wage in England in those days was about two pounds ten shillings a week. Jac was paying two guineas a week at a boarding house, getting only breakfast. She had no cooking facilities, nowhere to paint. I said it was obvious we had to get a flat and share. We needed two rooms, a room each for working and sleeping in. She was hesitant about this but she had few clothes left, so my logic prevailed. We took a furnished flat in Stanley Crescent, Notting Hill Gate. It was depressing and smelt of tom cats. But we had large windows, on the first floor, and could start work. We paid five pounds a week.

The windows in my room had quite splendid and alluring long gold curtains. It gave my half a false opulence. In Jac's room, something had gone wrong with the curtains. Erica, our landlady, had dyed them dark acid green. They were very displeasing and dispiriting. Jac got some calsimine paint, a creamy colour, and she flicked this all over them. It was fifties Jackson Pollock in 1948 and it brightened up her room. Curtains were a necessity in London for privacy and for keeping out the cold.

Our landlady was a young, dark, attractive Spaniard. Her father had given her the whole house with a big mortgage. She had to run it and pay off the mortgage with the rents. She lived in the basement and we became friends.

When my huge studio easel arrived we were away for the day. It had been sent by separate delivery. (The bill was

precisely half what my fare would have been, and it could have come as luggage. So my three months' toil hardly saved me anything.) There was nowhere to leave the easel, so the huge crate was put down in Erica's kitchen yard, completely blocking her kitchen door and all her light. We unpacked it quickly. I could have bought an easel in London for half the freight. Perhaps I was superstitious about it.

So, at this early stage, I think Erica thought we were a little crazy.

After the easel incident I said that we had ordered a baby elephant and could it be left in her kitchen area when they delivered it? Erica was very firm about this. She said she couldn't have any elephants in the place. (She knew about her paint-flicked curtains, but nothing was said, not yet, that would be later.)

Her apprehension was reasonable. On the ground floor below us lived Mrs Bridges, a nice old woman, always bright and cheery, as the English have to be in those grey winters. We would see her in the hall going out shopping. 'My husband is coming over from Belgium this weekend and I'll have to get some food in.' Later we asked how her husband was and she said, 'Such a shame, he can't come at the moment.' This went on all the time. Erica told us her husband had been killed in Belgium in the First World War.

It was the tenant above us who had the cats. We could hear her crooning over them. So much love. She must have hoped they would be continent for long periods as she kept them with her until they were screaming with pain. Then we would hear a frantic rush as they tried to make it downstairs to the door and the heaven of a pavement. Sometimes they didn't make it. The smell was omnipresent.

We received food parcels from Australia which were really needed because in 1948 the English food rationing was still severe. We were allowed only two eggs a week but lots of a strange thing called powdered egg and a pathetic piece of cheese, enough for a normal cheese serving after dinner. Very little meat was allowed. Milk was rationed and a small piece of butter, no larger than a walnut, was to last a week. There were dismal queues for ration books. It was depressing and time-wasting. This was a very different world from the plenitude of Peterborough and we were stuck in it for the winter.

Neither Jac nor I had ever cooked before. Our first attempt at cooking some bully beef from Australia was dramatic. We lit the oven and put the tin in it. Just as we thought it might be ready, there was a terrible explosion from the kitchen. We thought it was a sleeping German bomb. It was our bully beef. The inside of the oven was covered with it.

We made a really repellent dish we picked up on the BBC cooking session: 'Boil peeled potatoes and onions. Put them in an oven dish, mixed up with bits of cod. Mix it all up with powdered egg and milk. Cook in oven.' We called it sea pie; it was filling.

Vegetables were plentiful, but there was little fruit. Cod was ubiquitous. A spokesman for the Ministry of Health made 'sayings of the week' in *The Times*. He stated, 'The nation is fed up with cod.' How true.

On Saturdays or Sundays, Jac would go to Portobello Road to flog the last of Julie's finery. A lamé evening dress got quite a lot and she learnt to haggle.

Jac met a man who had a decorating business. He had been asked to furnish a hotel with eighty bedrooms. Each bedroom had two lampshades and he wanted each

lampshade decorated with roses and flowers of any sort. He provided Jac with a Dutch flower piece reproduction and she worked from that. Her 'studio' was filled with lampshades and I'd look in and she'd say, 'A hundred and three roses to go.'

After the initial great thrill of seeing the old masters in the National Gallery and some moderns in the Tate, we agreed that London was pretty drab. We saw all the private galleries of course; we haunted them. We hardly knew anyone at all. Then it got colder and greyer, a light fog. One day Jac called me to her room. 'Look at that,' she said bitterly, pointing out over the lampshades to the window. There was a dull yellow cardboard disc in the sky. 'That,' complained Jac, 'is the *sun!*'

People wanted to be put up for the night but we had no spare bed. The sitting room, my studio-bedroom, had a horsehair-covered mattress-bed in a corner on which I slept. By the coal fire were two upholstered chairs. There were four dining chairs and a table by the window, which was where I worked. We needed a sofa opposite the fire.

There were lots of vacant allotments, bomb sites. Almost no street was untouched. I found an old battered door on a bomb site and brought it back to the flat. I got some bricks and we sat the door on the bricks and then I bought a cheap mattress and put it on the door and voilá!, a bed and a sofa. It sagged in the middle, so two tins of Bronte lambs' tongues held it up.

It became known as 'The Door', and lots of people, like Michael Shannon, Val Hutton, Max Harris's brother-in-law and Shirley Adams, all spent nights on The Door. It became a well-known, desperate last resort.

The flat in Stanley Crescent had an entrance hall which I suppose had been a large landing when it was a house. In

this lobby there was, mercifully, a huge built-in cupboard. There was a large space above the cupboard where we stored our suitcases.

Everybody who came to sleep on The Door seemed to want to leave a suitcase or bag with us. In no time at all we became a general repository. Some people whom we only vaguely knew would ask if they could leave a bag or suitcase. Quite soon, even though the place had very high ceilings, it was full to the top. We had become an annexe of the notorious 'London Kangaroo Valley', which was mainly in Earls Court.

I had been unable to pay the dreaded Smith the 10 pounds he had earned while I was off the ship in New York. Now that I had an address I wrote to him and said he could come and collect it when he was next in London.

Freddie Inglis and I had been in touch and he invited me to his family's house, where I met a radiant Penelope. The house was in Cheyne Walk and from the Inglis's drawing room there were fine views of the Thames.

We were all talking away when I noticed a tremor, a rumbling of the house. No one else seemed to notice it, and then it happened again. A slight earthquake? I said something to Freddie and he explained that it was the barges going past. They were so accustomed to it they weren't aware of it.

Just around the corner from Stanley Crescent were Justin O'Brien and Peter Dodd. They lived on the ground floor in the front room of a house in Westbourne Park Road. The landlady showed them two large glass panels, one of Chartres Cathedral, the other of Rouen. The panels were framed in wood, and when lowered to the floor they revealed mattresses behind them, so they became beds. On Justin and Peter's first night there, they were comfortably

tucked up on Chartres and Rouen, when suddenly they found the room was brilliantly lit and two rows of about twenty people looking down on them. Their room was just by a bus stop and they had forgotten to draw the curtains.

They moved to better premises at Kew, where I visited them. Justin was working well; he had a show booked at an exclusive West End gallery, the Hanover Gallery. The owners of the house where they lived had two parrots, but one was very aggressive and wounding: I couldn't tell who was the biter.

Smith came to Stanley Crescent for his money. I invited him inside, we were having tea, would he like a cup? He said he would. I invited him to sit down. He was very cup-in-hand and would not speak and would not sit down. I realised I was up against implacable hatred. He was not nervous, it was simply that he resented me, it was the 'class' thing again, and Erica's falsely opulent curtains didn't help.

In those days, in London in 1948, it made a great difference if you were well dressed, with tie and hat—you were better treated in shops and theatres, and especially art galleries.

THREE

THE HAYWARDS arrived in London and were installed in a handsome apartment in Berkeley Street. We were invited there and soon met lots of people. Nora Heysen turned up from Liverpool and took a room very near us. She had a large portrait commission, a whole choir to paint. What a job! She had fifteen likenesses, and she brought them all off.

Although Jac and I had been going to the theatre a lot, we complained we never saw the sets of any production. All we usually saw was a tiny illuminated square of stage, way down there below us. We were always in the Gods, and if an actor went up-stage he disappeared. We never saw a backdrop, but it was better than nothing.

Our first night out with the Haywards was unforgettable. We had drinks at Berkeley Street and then went to a performance of *The Beggar's Opera*, arranged and conducted by Benjamin Britten. Peter Pears was Macheath. We sat in the centre stalls two rows from the front. It was very camp and very good. Afterwards Bill and Ursula took us to a glamorous theatre club where we had a wonderful supper and lots to drink.

I had no bicycle, no secret valley in the hills; instead I went for long walks and swam in various public baths. It was so good just getting all that clothing off. When I walked I

always looked for Laurie, illogically hoping I would see him somewhere. I had heard that he had left the teachers college and run away to Sydney, where he had looked for a job on a ship, without success. I was writing to Judith Anne but it was Laurie I really wanted to see and hold in my arms again. I hoped it would soon ease up, the constant longing for him. I couldn't help hoping he might get a job on a ship and turn up in London.

The Haywards were very good friends. We often went to the theatre with them, seeing at last the *mise en scène* of productions. We even had them to supper at squalid Stanley Crescent. I hope we had wine; perhaps the Haywards brought some. Ursula showed us basic things to do in the kitchen. I was astonished. 'How did you know this?' and she said she learnt a lot in Brisbane during the war when she lived in a flat.

Bill saw Jac's room piled with the lampshades and he was appalled that she was wasting her time like that. He suggested he put her on the payroll of John Martin's store and she could give him some paintings later on. He swore it wouldn't cost him a penny to do this. John Martin's was reputed to be the largest store in Australia, even bigger than Myer or David Jones in Sydney. She seemed reluctant; I think she was overwhelmed, but of course she accepted.

I remarked to Ursula that I hadn't been to Cambridge since I was four and had no memories of it. She said she had a nephew studying there, and why shouldn't we spend a day with him? We met at Kings Cross station and had an unforgettable time. The architecture is enchanting, and as it was such a fine day we took a punt and went boating on the Cam.

After lunch Ursula suggested we have a look at some antique shops and in one of them I found, tucked away, covered in dust, a pretty little pewter coaster, Georgian I

suspected—it would make a good ashtray. I was about to ask how much it was and pay the proprietor when Ursula stepped in and said I must leave it to her, that you didn't pay the price asked, you discussed it.

As I had bought so few things in my life, apart from paints and clothes and books and records, it never occurred to me to bargain for things. My father had assured me that most people overcharge you by 10 per cent and his view was they were entitled to cheat you a bit, but you shouldn't be ripped off too much—allow them their 10 per cent, and no more. Ursula and Bill had told me how, because they were famously rich, they were always greatly overcharged; it was in the nature of a seller to expect more from the rich and it was imperative that the buyers should try for a fair deal.

I now saw Ursula's technique at work. In buying the ashtray, Urs pretended to be interested in some other things, asking the prices, and then when she was in the area of the coaster, asked nonchalantly how much he wanted. He said it was Georgian pewter, and she sighed, she'd be very surprised if it was. In the end she beat him down to half his price and purchased it.

When I gave her the money in the street she said, 'Oh Jeffrey, you really must learn to deal with them—it's so important.' I still haven't, I'm still often ripped off whenever I buy something. Anyway, I had my pewter ashtray and it went back with me to Australia, eventually ending up in Tuscany.

Ursula had become a friend of Stanley Spencer and used to visit him at Cookham. She was nearing his house when she spied him returning from a painting expedition. He was trotting along wearing a long white chauffeur's coat and wheeling a perambulator stocked with all his gear. As Urs said, it looked eccentric but was very practical when you think of it.

Spencer was painting a series called 'The Beatitudes of Love'—all wildly indecent. It was based on the senses, *Seeing*, *Hearing*, *Tasting*, *Smelling*. Ursula bought *Seeing* from him. This showed a huge Hilda standing up on a bed which was covered with a patchwork quilt. She had pulled apart her combination underwear to display two enormous breasts—one was cancerous and larger than the other—and a huge hairy vagina. She had a terrifyingly challenging look on her face. Down in the right-hand corner little Stanley was pulling down his pants to gamely tackle the monstrous Hilda.

Ursula brought it back to Berkeley Street and it looked handsome and arresting. When they were packing up, they felt very apprehensive about customs in Adelaide. A painting of a female nude by Charles Camoin, a good French Fauve, had just been banned from exhibition in Brisbane on the grounds that it showed pubic hair. Nora said that she was going back to Adelaide shortly with a lot of flower paintings; why not include the Spencer with her works? They decided this was the best solution.

The painting came to Stanley Crescent and Nora put it up on the mantel shelf so she could see it every day. When the landlady came to collect her rent, she was riveted by the painting and couldn't speak. Nora liked it because she said the patchwork quilt was so exquisitely painted.

Harold and Rhoda Beck from Melbourne had a flat in South Kensington. Harold was joining the re-formed Hallé Orchestra as leading cello. They planned a tour of the Cotswolds, and I went with them. After a few days there, when they went back to London, I decided to go on to Bristol, and then to hitch-hike around Cornwall.

FOUR

I COMBINED hitching with getting buses and found myself in Penzance. I had heard there was a good hotel almost at Land's End. I took an evening bus there. It was very poetic, I thought, getting on a bus late at night with the direction 'Land's End' on the front. The Cornish accent was much more difficult to understand than the Liverpudlian.

The names were all so exotic: Lamorna, Penzance, Polperro, Clovelly, Marazion, Zennor. The people looked Spanish to me and I was told they were descended from the Phoenicians.

I asked the driver if the bus stopped near the hotel at Land's End and he said it did, 200 yards from it. It was the last bus and he put me down at about 11 p.m. I walked to the hotel: no lights were on, it was so late. When I got right up to it, I saw it was a shell, a complete ruin. I could hear the receding bus in the distance. I had asked the driver if there was a hotel there and he said there was. This is very Cornish, and it is also very Greek. I had not asked if it was open, or functioning.

There were no towns and I couldn't see a farm or house. There was only a dim moon. The only thing to do was to walk the 15 miles to Penzance or hope to find a village. It wasn't cold and I had my big white raincoat on.

After a mile or so, I made out the figure of a man on a bike. When he got near to me he got off his bike and down on his knees praying before me, in the middle of the road! 'Jesus God, Mary Mother! Help me, Jesus!'

It was a policeman. In the moonlight he thought I was a ghost. When he recovered and got to his feet, he told me of a nearby farmhouse which took in paying guests. Even though I arrived at midnight, I was made welcome.

In the morning, a great surprise—although it was a simple small farmhouse my hosts produced a lavish breakfast on a tray in my room. The tray was decorated with local wild flowers. The food was entirely from the farm: home-milled porridge served with cream and then fresh farm eggs and bacon—a far cry from the repellent grey-green powdered eggs of London.

I must have made a hit with the children—they loved my story of the policeman (I had to tell it twice)—because a few days after my return to damp dark London a large box arrived from Cornwall. It was full of beautifully arranged posies of all their wild flowers, and the flat became gay with Cornish colour.

Next day I got to St Ives, which was then relatively unspoilt. I found a cheap hotel and saw an advertisement for the St Ives sketch club, that evening at 8. I had a meal and while I was waiting for the sketch club to begin I walked along the small beach. It had a number of studios along it and at one illuminated studio window there was the reassuring sight of two women clasped in an ecstatic embrace.

The sketch club was fine, with a professional model, and there I met Peter Lanyon, artist and talker. I went back to his studio and we talked long into the night. In early 1949, Peter Lanyon's work was really anticipating the action

painting of the fifties. They were vaguely figurative but the painting was expressionistic and he was very articulate about what he was trying to do.

I travelled with a sketch book, which I still have. I did a lot of drawing in Cornwall, and some watercolours. The sketch book is very evocative, even nearly forty-five years later.

Back in London, in Stanley Crescent, I decided I had to leave and get to Paris. I was fed up with London. For some months I had been looking at the sign outside Victoria Station: 'TRAINS FOR PARIS ROME VENICE BELGRADE ATHENS ISTANBUL'. It was the Istanbul bit that got me. Was it really possible to go to all these exotic places from grimy Victoria?

I packed my things, my paint gear, and got a train for Paris. Jac was still in the flat, with Shirley Adams, so I could leave things there, joining the ranks of all those who had already used us as a depository.

FIVE

THE MOMENT the steamer arrived in Calais, I felt more at home. Buildings had lost that fussy look. The light seemed better. I got on the train and bought a croissant. Was it possible that an ordinary thing could be so delicious? Why couldn't the English make a thing like this? The train set off and as the fields of France sped past I noticed there was much more space between the train and the fence bordering the railway. Everything was in fact more spacious.

Friends had given me the name of a cheap hotel; it had a most misleading name, 'Grand Hôtel de la Loire'. It was very seedy but I secured a cheap, quite large room. There was only one lavatory to each floor and this was filthy. It was not a sit-down toilet, it was *à la Turque*.

It was scarcely possible, I thought, that the next morning I would be in the Louvre and looking at Giorgione's *Fête Champêtre*. There was so much painting in Paris that it was going to take a long time to see it all. I had a delicious and very inexpensive meal at the Café des Beaux Arts, walked the streets in a trance for hours, and got to bed exhausted.

Next morning I was in the Louvre. No one can fail to be overwhelmed and inspired at the sight of the Winged Victory at the top of the great staircase. It was 1949, so the place was not at all crowded. I was able to look at the Giorgione,

now attributed to Titian. I stood looking at it for so long that I told myself I should move, but I'd put it off for five minutes. There was so much to see in it. Gradually, I was able to see the other treasures.

In those days in Paris there were three main museums. The Louvre, the Tuileries, where there was Cézanne and the Impressionists, and the Museum of Modern Art, with Picasso, Matisse, Braque and lots of past Impressionists I only vaguely knew of.

As soon as I had been to these museums several times, I felt I could settle down at a school. I went to the Grand Chaumière, where a Frenchman called McEvoy was teaching. Here I met Moya Dyring, Sam Atyeo's wife, and David Strachan, whom I knew from London. McEvoy, looking at my Ivor Hele trained work, said, 'I'm afraid you've come to me too late.'

Then I heard that the greater painter Léger had an art school. I admired his work very much, so even though it was a little more expensive, I went there. I was economising by cooking primitive meals in my room on a little gadget called an *alcohol blanc*—I could boil eggs in my coffee. It gave them a curious colour but they were edible.

At Léger's school we usually had two models. The teacher was a woman who was said to be the master's mistress. She was always insisting that we should regard the shape made between the models and look at it as an area. I think this was in order to push us towards composing the surface as opposed to just drawing a model in the middle of the sheet of paper. It was good teaching.

At the end of the week the master himself would appear. He looked as though he had just come from a racecourse, but he was impressive. With authoritative grunts he would indicate where we should work at our painting. We had the

same pose for the two models for a whole week, so there was ample time to work at the composition. Léger *did not* think Hele had ruined me.

I made a friend at Léger's, a tall melancholy Egyptian boy; he was talented I thought. He asked me to come and stay with him and his family in the country in the Nile delta. How I should have loved that, but of course I didn't have the fare.

The opera must have been cheaper than in London, or perhaps it was the rate of exchange, but I was able to go a lot, and sit in decent seats. The Paris opera did a really splendid production of *The Mastersingers*. John Goodchild, my principal at art school, was visiting Paris and I got seats right in the centre stalls. He was quite knocked out. I suspect he didn't know much about opera, and Wagner was only just beginning to dawn on me. I had seen some good productions in London, but not a *Mastersingers*.

I was queuing up for seats for an Ecole Normale concert of Bach one evening and I fell into conversation with a matronly blonde French woman with her hair in a large golden bun. We were allotted seats together and we struck up a conversation. Françoise was about the same age as me and she had a genuine passion for music. We had a cup of coffee after the concert. She told me about a concert which was coming up, so we arranged to meet again for a recital at the Théâtre Marigny.

Concerts and galleries were cheap but I soon realised that food was expensive. There wasn't as much saving in doing your own cooking in Paris as there was in London. Meat was very expensive as were sugar and fats. At night there were hundreds of people who were homeless in the winter and they slept on the footpaths over the grills of the

Métro in an attempt to keep warm, as the Métro was heated. If the day was warm enough to eat outside, I found it embarrassing to notice hungry people hanging around and watching you. Imagine the torture of being hungry and smelling food.

In one restaurant on the Boulevard St Germain, the outside tables were placed on raised platforms, slightly higher than the footpath, so the heads of passers-by were at the same level as the table. It was very disconcerting to be sitting at table one evening and suddenly discover a human head on the cloth at the end of the table, just by the pepper and salt. And the head's mouth opened and said, '*J'ai faim!*' The head was quickly shoved away by the waiter.

This must have happened in other places because very soon glass screens became ubiquitous. It stopped heads popping on to tables, to be substituted by faces pressed up against the glass. No wonder that the rich in Europe live behind high walls.

This wasn't the depression which I remembered so well; this was a result of the war, and the French were more brutal than the English. In England food subsidies and rationing had helped the poor. There wasn't much of that in Paris.

I began to think about politics and economics again, asking myself questions and trying for some answers. I didn't think I was very bright or well informed about these things, but I started to form a sort of political belief.

One evening, when we were going to a concert, Françoise asked me to collect her from where she worked. It was the grand offices of a famous chocolate manufacturer in the

Champs Elysées. Françoise had told me where to go to find her. The building was deserted, after office hours, not even a cleaner to be seen. I entered a lobby and then I heard her calling me. I went into a posh office and there was Françoise at a huge desk. I could see she must be a powerful executive to have such an elegant office.

We talked for a while, then she started looking for her handbag and she asked me to wait there. I could see her through the door. She went into an enormous room filled with rows and rows of tables and chairs, each one with a covered typewriter on it. Françoise ducked in underneath one of these anonymous desks and got her handbag. I pretended I hadn't seen this manoeuvre but it occurred to me that she might be rather keen on me to get up to these subterfuges.

I had told her I had a girlfriend, Judith Anne, who was in Australia, and was coming over to Europe soon. I suppose I should have told her about Laurie, but people weren't so liberated in those days, let alone a Frenchwoman.

Françoise had arranged tickets for a string quartet concert—she had a friend—and we got in free. After this concert, she invited me to have a cup of coffee, but not in a bar, in her apartment. She lived behind Les Invalides in a walk-up apartment, but it wasn't too bad—there were even two rooms. She left me in her small living room, presumably to get the coffee. I was also hoping for a sandwich. After a little while she called me to come in to the next room.

She had arranged her hair all around her on the large bed and she lay back smiling; she was completely naked. It was a truly magnificent sight but it wasn't a turn-on; neither my desire nor my gallantry were adequate for the occasion. I apologised, complimented her, then left. I didn't get my cup of coffee.

This wasn't the end of our friendship although it should have been. The end was caused by a much graver sin of omission.

Despite working every day at Léger's and drawing at night at the Grand Chaumière, I managed to paint several pictures. I even painted about three which I kept and took back to London. I had nosed out some good areas around the Paris flea market and had even managed to get wet canvases back in the Métro, which required much more fortitude and contriving than on the Adelaide trams.

Michael Shannon had written. He had worked his way to London but he came directly via the Suez Canal and was washing dishes and peeling potatoes for a mere month, not the long Via Crucis I had endured. I was looking forward to seeing him very much.

Michael cabled to the Grand Hôtel de la Loire that he was arriving in two days' time on the boat train. This arrived in Paris at about 7 p.m. Françoise's influential friend had managed to get a box at the opera the same night; a great treat, it was Norwegian soprano Kirsten Flagstadt in *Tristan and Isolde*. I told Françoise about Michael arriving and she said there was room in the box and that Michael was welcome.

Life must have seemed pretty good to Michael that day; he came to Paris and was welcomed at the station and then whisked off to a box at the opera. I was bursting with my new theory of social philosophy, I couldn't outline it in the taxi and there was no chance at the opera; at the first interval we all talked about the performance. My theories were all bottled up and about to explode through lack of expression. As

the last act began, so slowly, and long before the Liebestod, I whispered to Michael asking if we could leave, and we did. Françoise was left alone to hear that tragic finale by herself.

Michael and I walked the streets for hours, with me expostulating my theories. These profound thoughts, I later discovered, were pure eugenics, and if carried to their logical conclusion would be a form of fascism a little to the right of Hitler's Nazism. In my political innocence, I thought this was a logical continuation of the theory of evolution, the theory of eliminating those who could not adapt. I had not realised that we humans are not wise or worthy enough to make these decisions.

Two days after this I received a really terrible letter from Françoise. She called me an ignorant Australian pig and asked why didn't I go back to my Australian pigsty. The fine pearls of Europe were wasted on me. She had reason. It was the end of a non-affair.

Although everyone said that the last winter had been mild, even though it was May I had begun to think something must be done to avoid another one in London, or northern Europe. But where to spend it? I was longing to go to Italy, and southern Italy would perhaps be good for the winter. So Michael and I set off for Italy, going by way of southern France. I wanted to see Aix-en-Provence and Michael had some friends staying in Toulon.

SIX

I SHALL always remember the train journey because the character of France changed as we went south, and even the people getting on and off seemed to change. Of course we were on a cheap, slow 'milk' train, so there was a chance to talk to the other passengers, despite my poor French.

Michael had the friends in Toulon he wanted to see, and I wanted to go to Cézanne's studio in Aix, so we parted company for a day and a night, arranging to meet in Toulon.

When I left the station I noticed a Mediterranean atmosphere—life seemed more relaxed. The tight orderliness of the north was relaxed, wooden floors and carpets replaced bare tiles, cluttered windows with lace curtains now had simple proportions and shutters. I went straight to the Cours Mirabeau, found a modest hotel and left my gear there, then went to seek the bar which my shaky researches indicated Cézanne went to every evening, after his day's work. I sat there and had a glass of wine.

It is a great green cathedral of a street, with stone fountains splashing. Today it is quiet and peaceful, but I imagine that in Cézanne's time it would have been very noisy indeed, with the clatter of iron-rimmed carriage wheels on cobblestones.

'My father, not I, was the genius,' said Cézanne. 'He died, leaving me a millionaire.' Apart from his early days away from home, Cézanne was able to lead a privileged and protected life.

His wife Hortense, and his son Paul, had more or less left Aix in his last years, and Cézanne was often lonely. Here at this bar he could enjoy the conversation of old friends and accept the tributes of the young; he was already quite famous by 1900, six years before he died.

'My wife,' declared Cézanne, 'likes only Switzerland and lemonade.' He was much too well mannered to add that she was a chronic gambler, and was always soliciting him for money.

Hortense, when she did turn up, may not have been very good company for him. She once told Matisse, who admired Cézanne above all others, 'You understand, Cézanne didn't know what he was doing. He didn't know how to finish his pictures. Now, Renoir and Monet, they knew their craft as painters.'

After so many visits to Aix-en-Provence, these journeys, these pilgrimages, become mixed into a general memory of the place. But two of them remain clear and stand apart.

One was when I went around the environs of Aix in a motor car with a book of reproductions of his work. It was then still possible to locate the master's 'motifs', as he called them. The Bibemus quarry, the mill stones, Gardanne, views of the valley of the Arc, even the viaduct built by Zola's father. Today huge blocks of flats obscure the view of Aix from Cézanne's studio, but the studio is there. The Jas de Bouffan, his home, is there too, but you can only see the villa through grilled gates, and you get just a glimpse of the avenue of chestnut trees, the painting of which is now in the Frick Museum.

But the visit that remains most vivid was the first time I went to Cézanne's studio. As I toiled up the hill, up the Chemin des Lauves, I thought that this is the way he took every morning, after he had been to mass. I found the place, the gate was closed. A small brass plate announced,

MINISTERE DES BEAUX-ARTS

ATELIER PAUL CEZANNE

SONNEZ

and so I pulled the knob and heard a bell sound somewhere inside the wall. I had arrived on the dot of the opening time. I eventually heard shuffling steps on the gravel, and the door opened slightly. An aged crone examined me in what seemed a slightly menacing way. After a long suspicious pause, she permitted me to enter the little garden.

I followed her into the house, which had two floors. In the entrance hall she produced a book of tickets and I bought one and then she ushered me up the staircase to the studio. It seemed to be an unbelievable privilege, as I climbed those stairs, and in a few moments I was standing in the studio of the master. I took a chair and settled down, trying to take it all in, watched over by the hawk-like old woman.

I was the only visitor at that hour, so I had the place to myself. Cézanne was not then, in 1949, as celebrated as he is now. He has always had great respect and affection from painters, but his work, in those times, didn't appear as immediately seductive as that of Renoir, Van Gogh, Gauguin or Lautrec. In fact, I believe that in the forties Renoir's auction prices were often higher than Cézanne's.

Cézanne commissioned an architect to design the building, but supervised all the details. The villa Jas de Bouffan had been sold after his father died. Cézanne's studio had been at the Jas, so he was obliged to find or build a studio.

The large studio window faced north of course, away from Aix. The whole room was imbued with a wonderfully diffused pearly light. I noticed a tall narrow window coming down to the floor, to allow the passage of large pictures. Had he some big *Bathers* in mind when he built the place? Or was it put in later? There were some high southern windows, with what appeared to be the original curtains, so Cézanne could control the light.

In the silence, and the glowing light, I began to notice some old friends. There was the ginger jar! Then I saw the putto. Each item induced a shock of recognition. There was the table with the scalloped apron, that playful piece of baroque line he introduced into so many of his still-life compositions.

The old caretaker had done her work well, everything was dusted. The beautiful little blue vase, there it was, just as he painted it. After a while, she appeared to trust me enough to leave me alone because she shuffled away and I had the place to myself. Every now and then she would turn up with a visitor, who would stay for a while, and then leave me to meditate and soak it all in.

The wax fruit and paper flowers were still there. Cézanne took so long, painting and repainting, that real fruit would rot and flowers fade. There were shelves around the walls, upon which rested the skulls and the bottles whose forms we would come to know so well. I was also thinking, seeing the drapery, of the great pains he took in setting up his still-life subjects. He made so many variations, using the same objects, always investing his composition with his own unmistakable sense of grandeur. All these objects were evoking so many of his paintings. I noticed the white fruit compote: I think he must have been very fond of it, it served him so often.

I seemed to be just getting into my stride with all this when the old woman reappeared and announced that she was closing. They kept museum hours, she said, but I could come back after the luncheon break and she assured me I could use the same ticket.

So I went for a walk and bought a baguette and cheese. There was a big surprise up at the highest point, Les Lauves, as I instantly recognised the magnificent view which Cézanne loved to paint. The valley of the Arc lies below and the plain sits at the foot of the majestic Mont Sainte-Victoire. I then understood why he built the studio on that site—he didn't have far to go. In 1949 you could still see the viaduct through the pine trees, and these pines could have been the same trees that he painted.

It was here, only a few hundred metres from the studio, that he was overcome by a rainstorm, a deluge which drenched him, but he had insisted on going on working. Already weakened by diabetes, he developed pneumonia, which proved to be fatal.

The mass of Mont Sainte-Victoire is very imposing. It lies due east of Aix, so the silhouette seems sombre and stark in the morning light. In the afternoon it becomes lit up and acquires a lively glitter. The studio was then on the outskirts of Aix; today it is, amazingly, dominated by large buildings and the whole area is really a suburb of Marseilles.

My return to the studio was almost like a homecoming—all the familiar things. I picked up where I left off, and now became engrossed in the teapots and coffee pots, the white tureen, the crucifix. Most interesting of all were the prints on the walls—some of them, I suspect, put there since he died, but perhaps they had belonged to him.

I was very moved to see Poussin's *Shepherds of Arcady*, one of my favourite pictures and one I know Cézanne admired

very much. (The resemblance between Poussin's Monte Soratte north of Rome and Cézanne's Mont Sainte-Victoire is remarkable—a happy coincidence?)

We also come to know the man Paul Cézanne through his letters. He was highly educated and, I am sure, an affectionate friend. His letters are articulate, and those to his son indicate a loving and even amusing father. He must have been very hurt when his old school friend Zola wrote the novel *L'Oeuvre* about the failed painter of Aix. What is surprising is Zola's gesture in sending a copy to Cézanne with his greetings. Cézanne's letter of thanks is kind and dignified, but one can hardly bear to imagine his real feelings. He wept; not because of the implication that his work was bad, but that an old friend could be so insensitive.

Although Cézanne must be one of the truly great painters, he was not an accomplished figure draughtsman. The human body defeated him. He was far too timid to have a nude posing for him in the studio, so he had to imagine a lot of the figures in *The Bathers* compositions, and the drawing is laboured and precarious.

These are very human qualities, endearing the work rather than alienating it. The critics are wrong when they say he deliberately distorted his figures for compositional reasons. Cézanne was relieved when he was diagnosed as having astigmatism. Those who think his verticals slope for compositional reasons are quite mistaken; there are symptoms of the same thing in Poussin—things go out of plumb. Cézanne was supreme in being aware of the vertical and horizontal confines of the canvas, and a consistent leaning of shapes is unthinkable.

A lot of Cézanne's working time was spent on the landscapes, and in the studio in the Chemin des Lauves there

are several paint boxes and easels and, when I was there the first time, his cape and greatcoat and the familiar cap.

He worked a lot around Gardanne, where he had a small apartment for a while. Even Hortense consented to stay there sometimes, and when she was not there he resorted to the brothel at Gardanne. But he was regular, just once a week, Friday night, like the mass every morning.

I spent the rest of the day in the studio, musing about him. Cézanne had died just over forty years before, and in the fading light of the late afternoon I was very moved by the place, I imagined I could feel his presence.

Then I heard the caretaker coming up the stairs. She entered the studio and said she was closing and that I must leave. She looked at me and said, 'You love the master, don't you?' I said I did, very much, and added that when I went back to Paris I was going to the bookshop where his son was, hoping for a glimpse of him.

With sudden and unexpected passion she cried, 'Oh him! Why should you want to see him? He only thinks of money, money, money! He has no feeling for his father's work.'

I said that could well be so, but at least he was the flesh and blood of Cézanne, his only child. She looked at me very intensely, and then said slowly and quietly, 'There is also a daughter.'

Suddenly, I saw the hooked nose, the same piercing black eyes, the shape of the forehead, and I realised I was looking into the face of the master. 'Oh, Madame!' I said, and she inclined her head slightly, in acknowledgement, and smiled, accepting the homage.

SEVEN

AFTER MICHAEL had been in Toulon, we met at the hotel there, and went by slow train to Genoa. As soon as we got to Ventimiglia I felt happy. What is it, I wondered, why is it so instantly appealing? Perhaps it was the shabbiness, geraniums in old tins instead of shiny painted terracotta vases. Buildings seemed to have better proportions and even the stains on the walls looked interesting, and beautiful. I had a warm feeling of familiarity—something I feel to this day.

In Florence we stayed at the famous Pensione Morandi. It was very cheap in those days. They gave you a curiously filling sort of porridge for breakfast, and this kept you stoked up for hours. It was here that poor Michael became very ill with influenza. At least the room had a view over rooftops and Michael said it was pleasant enough for 'A Death in Florence', which is how he said he felt.

I indulged in an orgy of paintings. I was in the Uffizi or the Pitti every day, or in churches, or just looking at the city. After several days, I found the monastery of San Marco and saw all the Angelicos. At last I had before me the great Deposition, of which I had been dreaming for years.

Something went wrong. I couldn't look at it. My feet were hurting me, I was looking at a lot of blue and pink and

orange and it meant nothing, and I wanted to sit down. How could I be so frivolous?

It was the first time I had experienced museum fatigue. I discovered that you simply can't absorb so much. The only way to see these things was on small brief excursions.

I reminded myself of the story of the Chinese emperor who loved painting and had an enormous collection. He decided on a day to have a certain painting presented to him. On the day before, he commenced a fast. When the time came to see the painting, he was dressed in his grandest robes, ordered a special tea, and then had the painting unrolled before him.

The Fra Angelico Deposition needs at least an hour's contemplation, and I do not think people can see it properly when they do a grand tour. Of course you have to live near these things in order to see them properly. I gradually began to think that I should live in Italy—a financially preposterous idea, an impossible dream.

———

Rome meant the Vatican and Michelangelo, the Forum, and the classical world. I had been looking forward to seeing the Sistine Chapel, of course. I can't believe how much we walked in those days; everything was done on foot.

Entering the Sistine Chapel is dramatic because you are directed to a small passageway and after feeling so hemmed in you suddenly come across this large space. My first impression was of bewildered awe. The end wall was too dark and confused to see properly. Even since it has been cleaned I find it unsatisfactory. The ceiling, so daunting to any painter, was easier to see in 1949 because there were stretcher beds on wheels and you could move about and

take your fill, lying horizontally; some people had binocu-
lars, lucky them.

I found the Raphael Stanze much more accessible. But it
was all discouraging. How could I possibly measure up to
these super-giants? And what did that end wall of Michelan-
gelo's have to do with aesthetics? The answers came, even-
tually, but they took a long time.

Initially, I had thought I must be superficial to find a
Morandi group of bottles more exciting than the grotes-
queries of the *Last Judgement.* Who wants superhuman art? I
suppose it is being unfair to Michelangelo—he did not want
to do it.

One of the reasons for this trip to Italy was to find a place
for the winter, and I wasn't sure about winters in Florence
and Rome. Surely Naples would be warmer, I reasoned, not
knowing that even in Sicily you can freeze. Because of our
relative poverty, Sorrento and Amalfi and Capri, so fashion-
able, must be too expensive.

So I went to talk with someone at the British consulate in
Naples. One of the staff recommended the island of Ischia
as being unspoilt and he knew an English couple there who
had a pensione.

Going across the Bay of Naples was absolutely rapturous.
The vaporetto journey was an hour, and the Pensione
Valentino was near the port of Ischia. It was owned by Valen-
tine and Dilys Whorewood. They put me in touch with Cap-
itano Taliercio, an Ischitano who had made some money in
America and had a villa to let.

We all set off across the island in a *carrozza*, a horse-drawn
carriage right up into the mountains through biblical vil-
lages, through a mountain pass and there was the sea and a
village just below us, Testaccio, on the southern slope. As

you went through the mountain pass there was a noticeable change of temperature—it was warmer.

We left the *carrozza* in the village square, walked down a lane to the gates of a villa and there was Casa Antica, rooms facing south, a cook and a maid all combined with fabulous views. All this for five pounds a month.

I sent Jac a letter and told her I had found a villa, and it was *pink!* and perhaps we could afford it. I made a tentative booking for September.

On the way back to Paris from Naples, I had five days in Florence. I wrote to Judith Anne from a restaurant and told her about Ischia, how I was hoping to take a house there with Jac. I felt that it was only fair to inform her that 'I was not the marrying kind' and that I was fairly sure that my desires led me elsewhere. I didn't want her coming to Europe with hopes of an involvement with me.

I returned to Paris for another stretch at Léger's and by the end of May was back in London and back to Blighty.

EIGHT

AFTER THE glamour of Italy, Stanley Crescent was the pits. The number of suitcases on top of the cupboards in the entrance hall had reached the ceiling—we had become far too well known.

I went to the bank. I had very little money left. I looked along the counter and there was Nora Heysen. The English Scottish and Australian bank was not a popular one with Australians, and we regarded it as a coincidence. It was also a coincidence, we found, that we were both nearly broke.

I said we mustn't get depressed about it and why don't we go and have lunch at the Savoy to cheer ourselves up. As we were going in, Nora said she had a student friend who was at the Westminster School of Art with her. He used to work as a waiter at the Savoy, and he said the head waiter could size you up at a glance, and doubtfuls were put near the pantry. We had an elegant and delicious last fling, but the head waiter put us fairly near the pantry.

Mic Sandford turned up; he was in a friend's flat in Oxford Street. It was so good to see him again. He said he was going to settle in London and was leasing a grand house in Tufton Street, which belonged to a friend he referred to as 'Lyle'. There was a large studio, would I care to move in?

Mic said he was getting ten pounds a week from BP and between us we could live in style.

As there was no money coming in I would have to find a job. And what about Ischia? It began to fade.

I was still in Stanley Crescent and about to move to Tufton Street when I looked through the advertisements in an educational publication and answered one for the Wimbledon Art School. The headmaster telephoned and said he would like to come and see me as he was coming into London. So we quickly tidied up the flat. He was a pleasant serious man, academic, very much the Stanley Spencer school, so I told him about the beautiful indecent one in Nora's flat across the street. He was intrigued, but more importantly he said he'd take me on for three and a half days a week.

This was perfect. I could still work and would have the big studio at Tufton Street. I wrote to my parents telling them that my money had come to an end, but they would be pleased to know that I had a part-time job at Wimbledon Art School. They wrote back a marvellous letter.

My father said that I had gone to Europe to work among the great paintings of Europe and that my time would be wasted teaching at Wimbledon. He also wrote, quite unrealistically, to advise that when in Venice, never to go by waterbus, use only gondolas—the only way to see Venice.

In his time in Europe, there were so few tourists that they could afford these luxuries. I'm sure it was cheaper then. They offered to send me (advance me) a monthly sum, and in this way I could go on painting. This was great news. I reasoned I could pay them back when I had an exhibition in London, so I didn't take the job at Wimbledon.

Since then, I've realised that this was a clever move on

the part of my parents, because I didn't intend to return to Adelaide, except very definitely as a visitor, and the return half of my ticket would always be in my pocket.

They, on the other hand, wanted me back in Adelaide, where they hoped I could become one day perhaps principal of the art school or director of the art gallery, and be happily painting at weekends, in between spending time with my wife and children. I have seen this happen so often—a dire situation for a painter.

Harold and Rhoda Beck's flat was quite near, and one evening there I met Sylvia Fisher, whom I'd just seen and heard at Covent Garden, and had heard at concerts in Australia. I liked her enormously, she was great fun.

She had a very frustrating career. Bernard Heinze admired her marvellous voice and her musicianship and had recommended she try to work in England in 1937. By the time she organised herself, delayed by concert engagements, it was 1938–39 and war was imminent. So she didn't go to England until 1946.

Her first audition was at Covent Garden, with Sir Thomas Beecham. She was asked to sing Mozart's 'Queen of the Night'—not her style at all, but of course she did it. When she had finished, Beecham said, 'This is nonsense. I know every great soprano voice in the world. Why haven't I heard this before?' She was engaged immediately.

In 1948 Carl Rankl asked her to do *Rosenkavalier*; she was the Marschallin of course—it was a lifetime's dream come true. Sylvia had floated around in the expectation of it for several days before. Later she told me that as she was going

in to the theatre, in an entranced state, she heard a violinist chatting to another musician, 'What are we doing tonight, Bill?' and his friend said, 'I dunno, I've forgotten!' Sylvia complained, anguished, 'How could they *not know*? What an attitude to have!'

She secured me a house seat, and it was one of the great musical experiences of my life. Elisabeth Schwarzkopf— known in the business as 'Betty Blackhead'—was a handsome Octavian. On the first night, Sylvia was magnificent. She had round after round of applause, the stage was loaded with flowers, the audience was on its feet and wouldn't let the singers go.

Of course I wanted to see Sylvia afterwards, but I thought it best to wait for a while. I imagined the tight crowd in her dressing room. When I did turn up, she was alone and cried, 'Where have you been?' I told her I thought it best to wait.

Sylvia said, 'Callas told me it would be like this. It happened to her too. No one comes because they think everyone else will be there!' What a good thing I had suggested, very hesitantly, that we go and have supper afterwards.

As we came out of the stage door there was one of those miracles which happen in London. It had snowed, quite heavily, and the place was transformed, and still, silent. I found a large plank in the market alongside the opera house and I said, 'Come on, Syl, here we go!' She was squealing with delight as we slid down to the Strand.

Sylvia was touring Australia, doing Florestan in *Fidelio*, when she received a request, a long telegram which she showed me. It was from Benjamin Britten. He was recording *Peter Grimes* and Britten wanted her as Ellen. I saw his words: 'YOU ARE THE ONLY ONE WHO CAN DO IT AS I WANT IT.'

Recording was to be in about three weeks' time, in

London. Sylvia calculated that her last engagement was in Perth, a week before the recording, and she said she couldn't do it in that pre-jet era—she would not be rested enough. When I suggested she talk to the opera company and ask for a replacement for Perth she was indignant that I could think like that.

As far as I know, there are, amazingly, few recordings of this magnificent voice, mainly remembered in the hearts of people who heard her. There was a strong conspiracy against her. Walter Legge was the producer for Columbia—and the husband of Elisabeth Schwarzkopf. Between them, they prevented Sylvia from recording. There is a book on this, *Elisabeth Schwarzkopf* by Alan Jefferson (Gollancz), and the conspiracy is now exposed.

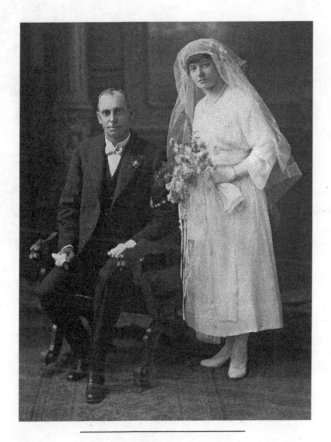

Wedding in Adelaide in 1920.
Dad was already keeping a mistress.

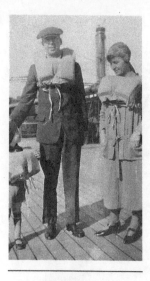

1925 – the first trip.
Life-boat drill – less alarming
than the emergency demos on
a Jumbo.

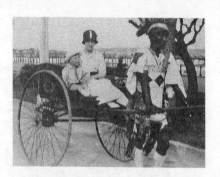

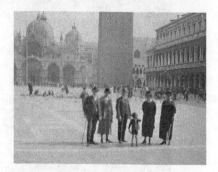

TOP A nice racist ruling-class snap.

CENTRE A small figure with the family.
Note how deserted St Mark's square
in Venice was then.

BOTTOM On Lake Lucerne, and I still love
that ferry.

In Colombo with Uncle Syd Neaverson. Men were going to give up those moustaches when Hitler appeared.

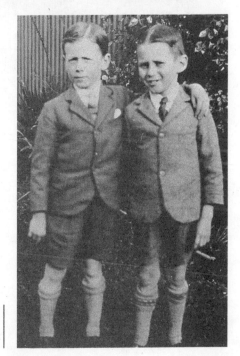

In our Sunday best, me and my cousin Max Edson on the right.

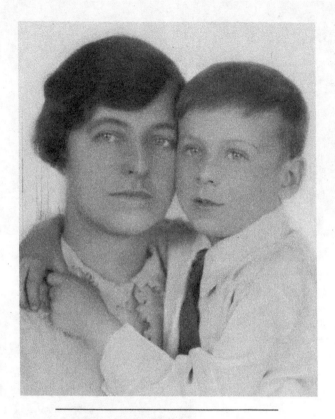

Mother and me at six. I am pressed up close,
probably because the photographer suggested it.
Ten years later I was trying to move as far
away as I could.

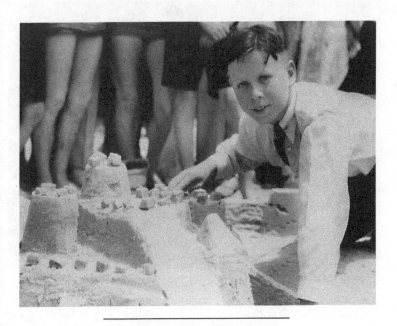

Champion sandcastle builder, 1933.
Note the obligatory school tie. Within a
few seconds this castle will be destroyed
by a lot of little boys with no ties.

The staff at Goodwood Boys
Technical School, 1943. The art
master is on the left, front row.
I sat it out for four years.
My admirable headmaster, Paul
Hilbig, is in the centre front, and
my best friend, Ron Phillips, is at
the end of the row two on the right.
It was a happy, tight little ship.

Laurie on the right, with Brian
Seidel and Tony Tyne on the
beach at Glenelg in 1947.
Laurie and I were trying not to
see each other at this time.

Laurie – a detail of a large portrait which I cut up. It won a prize, the first (and second to last) I ever won.

The artist being international in 1949. Photograph at a London kitchen sink, taken by Judith Anne.

Judith Anne, taken by me, in London, in 1950. She is in the mirror and someone behind is bringing us a cup of tea.

Attilio in Adelaide in 1951, after he had defected from
Mrs Dutton and just before he became a hero.

Jac and me outside her house in Adelaide in 1951. Not much Adders angst showing here.

The Drysdales in London, a sweet birthday thought from Bonnie – about 1955. Lin is still with us.

Mother's second wedding
in 1960. Everybody is very
happy for quite different
reasons.

1960.
Mother becomes
Mildred Millington.

Skyros in 1964 with Lennart.
It was fashionable to have a Scandinavian
lover in the sixties.

Mic Sandford and me at his villa Il Baìco,
in 1965. The president of BP Italiana is
still fairly slim; corpulence was on its way
for both of us.

Very much a posed photograph. Ian trying to
be butch, Jean Bellette looking saucy, I am
serious and Paul, as usual, is about to speak.
Spain, 1965.

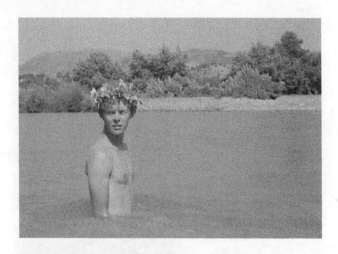

At Olympia, Greece, 1967. Ian, paganly bedecked, is swimming in the sacred river.

Halcyon days at Villa Il Bacìo, 1968.

Ian with the first Oliver, in Rome in 1968. My addiction for pugs went back to 1927.

La Posticcia Nuova (The New Place). The present house is 18th century; the oldest walls are 16–17th century.

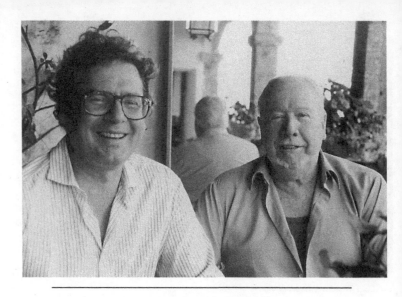

I gave up trying to be a jump ahead of Ermes years ago.

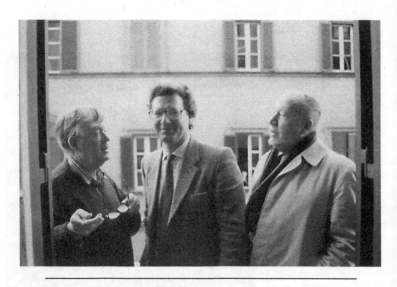

A treasured photograph of Justin, Ermes and me
on Justin's balcony in Rome, 1994. You can see that
Justin had no view – he rather disliked views.

NINE

MIC SAID he had worked so hard in Germany he was taking a holiday in France and Italy. Would I like to be a caretaker at Tufton Street while he was away, and then we could work out a *modus vivendi*? He had a very old Rolls Royce, which he had picked up in Berlin. Someone had changed the wheels and put large American Cadillac balloon tires on it, so it looked rather strange. But it inspired affection and it went well, and had cost him next to nothing.

Life changed considerably when I moved in to Tufton Street, which was a perceptible step up from Stanley Crescent. Indeed, it was, by coincidence, Lord Stanley's London house.

Mic was away when I moved in, and I asked about and found the most marvellous housekeeper, a Bavarian, Caroline Dicks. She was the most gifted cook I have ever known, and had been cook for Sir Alexander Korda, the film magnate and for Binkie Beaumont, the theatrical entrepreneur.

While I was living alone in Tufton Street I noticed a very pretty rat in the kitchen. He was not a sewer rat, he was a country rat, honey coloured with a white belly. He would sit up on the draining board and regard me, washing his pink hands. We all have a loathing for rats, but this one was attractive and learnt to follow me around the house.

When Stanley furnished the house he had ordered different coloured wall to wall carpets (blue, red, green) for each floor—it was all very modern and not unpleasant. My studio was on the top floor—a green carpet—and quite often my little companion would sit by the door watching me work.

John Allen was a friend of mine, a musical lawyer I had known in London for some time. The newspapers had a lot of publicity about Marlene Dietrich's coming visit to London. I told John we ought to try to get seats for her show; he said it would be very easy, as he was an old friend of Dietrich's. I was so overjoyed at this that he said, 'She is very good company, you'd like her, and she would like you. I'll arrange a supper, I'll telephone you.'

Then Caroline Dicks came and moved into a room on the ground floor. She immediately stocked up the kitchen and made the place comfortable.

I heard a terrible scream from the kitchen. '*Mein Gott, Seer, there is a rat!*' She was hysterical. I told her all about him. She had frightened him so much he had gone up to sulk behind the hot water system—he used to do that. Just a little milk, I said, and some bacon left out every night and he would be happy; he was not dirty at all.

Caroline was in a terrible state. She would not stay, she was going; it was the rat or her. So I called the London City Council asking if they could send a rat man soon.

I had been on tenterhooks for several days, waiting for John Allen to ring about Marlene, and I had made a few calls, but there was something the matter with the telephone line. So I called the telephone company.

The telephone man and the rat man arrived about the same time. The connection was out under the footpath, in a box covered by an iron hatch, which was lifted aside. They

showed me a brilliant rat's nest in the box. He had chosen threads from all the different carpets to make a variegated, brightly coloured nest. No Mrs Rat or children were to be seen. The telephone wire had been almost eaten right through.

The LCC rat man had the largest handlebar moustache I've ever seen. I didn't want to know how he dealt with the situation, but he did.

I rang John Allen. 'Where were you?' he said. 'I tried again and again to raise you.' I explained the domestic tragedy, but even more tragic was that I missed out on Marlene Dietrich. John said he had told her all about this young Australian artist who admired her so much and was dying to meet her. For the meal I missed, he said she was wearing a beautiful green dress with green jewellery and a green cigarette holder— she looked fabulous.

I took Caroline to a show at the Royal Academy, where I was showing a painting. She was excited by the portraits, saying 'I haff cooked for him', and then searched for portraits of people for whom she had cooked, and saw nothing else.

When Mic came back, he was amazed and overjoyed with Caroline; we were both greedy, and Mic embarked on a series of dinner parties where I met some of his military friends. One supper party was for four generals, including General Sir Gordon Grimsdale, who was Mic's superior in the North African campaign. He told how when he made a visit to Mic's regiment, Mic met him with car and driver at the air base. They sat in the back of course and Mic gave directions to the driver.

'Go on ahead for another mile, Darling, then turn left.'

Gordon: 'Mic, one day you'll go too far.'

Mic: 'His name is Bill Darling!'

One of the generals, Sir John Latter, took a shine to me,

and later asked me to go and live with him at Leeds, where he was vice-chancellor of the university. I would have a studio and be free to paint full time. It was good having the offer, and sad I couldn't accept it, but I detected a whiff of masochism in the air.

John Gielgud lived just around the corner and he mentioned he had a piano. I asked if I could go around and practise sometimes. He also had a modest collection of paintings. It was impossible to practise, as he seemed to enjoy my company, and wanted to talk, and his conversation was too good to miss. He was playing in *The Lady's Not for Burning* at that time. He gave me house seats, and we would have supper afterwards.

The leading role in the play was very demanding, both emotionally and physically. I was surprised that John seemed so fresh after such a strenuous performance. He explained that only amateurs could expend energy, physical and mental, on a role, because they would be doing only a few performances. The professionals, who would play a role like that six nights a week with two matinees, for a long season, had to learn to conserve their energy. He said he really felt the emotions at rehearsals, and noted what his body did, and often planned his movements.

From then on, John insisted, it was technique, and while he acted the emotions he was as cool as a cucumber inside. He said that, in fact, in the middle of his most impassioned passage, he found himself musing on the curious dish I had told him of, so popular with Queensland truck drivers—a fried egg on a grilled steak. He said that quite often simulated or acted emotions were more convincing than when the actor was feeling 'the real thing'. (When he ordered his dinner he asked the waiter for a steak with an egg on top.)

These professional confessions were absolutely in line with what my cellist friend Harold Beck told me. Da Vinci, who sketched a hanging, has written similarly on painting.

About six or seven years later, I met John again in Sydney at a party at Mervyn Horton's house. I was pleased to see him, but gathered, in spite of his good manners, that he couldn't remember me at all.

Through James Pope Hennessy I met Kåre Tveit, a handsome Norwegian of my age, and I fell for him. I had a very happy London summer with Kåre. I took him to Airedale and Uncle Herbert liked him, and from somewhere or other miraculously produced Norwegian flags, which he put about the place. We took Kåre out to Little Gidding and showed him the local sights, and to Stilton, where he saw the famous cheeses being made.

Justin O'Brien's show was at the Hanover Gallery, and Kåre and I went to the opening. Kåre was an accomplished painter, and I liked his work—he painted in the style of Derain, but more freely—his colour sense was much more 'modern' than mine I thought. Kåre was very impressed with Justin's work, and I was pleased that he liked Justin's Byzantine style. But Kåre was puzzled that Justin used so much red, and stated that artists who painted with a lot of red were sex-starved—a Scandinavian theory I had not known.

Kåre invited me to stay with him in Oslo, which I did at the end of the summer. How fickle I was; it was only eighteen months since I parted from Laurie.

I took a ship from Newcastle, and arrived at Oslo. Kåre had a lot of good friends there and they were very hospitable. Everyone said very earnestly, too seriously, how good I was for Kåre, how happy they were, and I would steady him up a bit. It was a bit disturbing and I felt slightly uneasy.

Norwegian is a curious language for English-speaking people because they seem to make all the same sounds as we do. If you are in a bus and two Norwegians are talking clearly, I swear you wouldn't notice it. Could it be that the two languages are phonetically similar or the vowels sound the same?

All of Kåre's friends seemed to speak perfect English. One of his best friends was producing *The Doll's House* the next evening at the Norwegian State Theatre (he was one of the most earnest in saying that Kåre needed someone like me), and he gave us two tickets for the production.

I thoroughly enjoyed the Ibsen play, even though I didn't understand a word of it. Of course I had seen it a few times, and read it, so I knew what was going on. But during the performance I completely forgot that I didn't understand the language and had the curious feeling of a complete rapport. I became totally involved in the production and was able to assure myself I'd seen the very best performance of all.

One of the houses we went to was owned by Sonja Henie, the famous skater and film star who married the shipping magnate Wilhemsen. I have never seen such a large collection of Matisse: it was amazing. I was sorry not to meet her; she was away skating I suppose.

Norwegian contemporary painting was very high key, vivid colours, like their folk art. The colours were mainly primary ones—easier to distinguish in those long, ill-lit winters.

The Viking architecture had an oriental appearance, because of the use of timber, which gradually sagged at the gables, defects which became imitated and exaggerated. It was, strangely, often like a pagoda, and the Viking decorations often featured dragons.

My Song of Norway turned out to be a Scandinavian

dirge, alas. Kåre was an unbelievably heavy drinker, and very wanton. Our stay in Oslo had become a drunken rout.

He said he could dry out if he stayed with his family at Arendahl, so after a day's train journey I found myself in a very staid Norwegian village on a fiord. There was nowhere to work. I felt I had been imposed on his family, who were all very kind to me—but we couldn't talk to each other. Kåre insisted on drinking every night in various bars in the town. What I had taken initially for Nordic zest for alcohol was, I'm afraid, just ordinary old dipsomania.

Life was not very exciting in scenic Arendahl. The papers in England had been full of Winston Churchill's illness and, when I left, people thought he might be dying. One morning in Arendahl I noticed all the flags in the town were at half-mast, but when I asked about it, I was told the ferryman's wife had died.

The winter aurora borealis began to appear. The light was fading earlier every day, and I felt I should fade, too. I felt trapped. It was a full day's journey from Oslo, which was a long way from anywhere. Then another full day's journey down the Swedish coast to Copenhagen: too much.

I found out it would be cheapest to hire a flimsy plane and get across the narrow strait of the Skagerrak and land myself in northern Denmark. There was a bus to Kristiansand, where I put up at a hotel called the Waldorf Astoria. The aeroplane agent's office was in the hotel, and I confirmed the next morning's flight. I was the only passenger.

That night a blizzard raged, and the Waldorf Astoria, which was a small two-storey hotel made of weatherboard, shuddered and creaked all night while the wind howled. After breakfast, I was told that although the storm had abated, it was still rather risky to fly. If I still wished to fly, I

would have to sign a document declaring I had been warned of the danger and would not take action against the owner of the plane, who was the pilot.

I waited in the hotel lounge. I wrote to my parents saying that in the event of my death I wanted copies of Eliot's *Four Quartets* sent to various close friends I listed. At about 11.30 a.m. a truly alarming figure appeared at the other end of the lounge. It was clothed completely in black—helmet and goggles and leather jacket, pants and boots—all black. The figure slowly raised one arm and pointed it at me, and then beckoned me. It was the Angel of Death.

Kristiansand is in a fiord, and at the end of the fiord is a small piece of land from which the plane is supposed to take off. When all my luggage and I got into the tiny plane, I felt very queazy; it was an ancient Focke-Volff, and it had been lovingly restored. Little hands at home had sewn patches of oiled paper in places all over it. A few wire struts looked slack, and some were new and bright green.

I was given goggles and a helmet and sat behind the pilot, well strapped in. As we took off, going towards the water, the nearby sides of the fiord seemed vertical. The fiord was very twisted, and as we skimmed the water I realised we were heading straight for the cliff in front of us, but the pilot managed to turn and avoid it, just. It was a tortuous and terrifying take-off, and there were violent cross-currents of air as we passed valleys on each side.

It was about fifteen minutes of hellish dodging until we were clear of the fiord, and then I could see the Skagerrak with lots of shipping below, and the coast of Denmark ahead. The whole distance was only about 160 kilometres: no wonder it was cheaper than the long train journey around the Baltic Sea.

We landed on a lavishly made airstrip at Aalborg, built by the Nazis, the pilot said, just in time for their last take-off. I got to the rail head at Friedrickhavn, slept there, and boarded the Scandinavian Express early next morning. From Friedrickhavn all my luggage—there was a lot because I was going to winter in Italy—went to St Petersburg. It was to go to Rome, but it went east instead.

TEN

IT WAS a dull train journey to Amsterdam where I had arranged to meet Michael. The train ran through Germany to Holland. Just as we were nearing Hamburg I went to the dining car for breakfast. Dining cars, in those days, were one of the real joys of train travelling, and the Scandinavian Express was a famous train.

As breakfast was served, we were nearing Hamburg. I was amazed to see before me a lavish plate, coffee, cream, rolls and butter, and eggs and bacon, a week's ration in Blighty. Here was a country which had been defeated. At the same time, outside, I saw the appalling ruins of Hamburg. There was not one whole building, everything was either razed or damaged, but train food was abundant.

As we passed through this lacerated city I thought how I had helped its destruction, and I bitterly regretted my moral cowardice, in teaching those air-force boys. It was worse destruction than anything I saw in England.

Michael and I had arranged to meet by *The Night Watch* of Rembrandt in the Rijksmuseum at midday. He was there on the dot. We had an enormous meal that evening and I told him about the disasters of Norway, how Kåre turned out to be a dipsomaniacal sex-pot and how I was

looking forward to the relaxed non-neurotic boys of the Mediterranean.

Michael became very angry. He said I was a poseur, that I was only assuming the role of a homosexual because I thought it was 'arty'. He informed me I was straight and was still in love with Judith Anne, and advised me to forget all this nonsense of Norway, it was wishful thinking. When I assured and warned him that I really was looking forward to the flesh pots of Ischia he simply didn't believe me. It was a bad evening.

He was very different from Jacqueline, who was so wise and accepted things with equanimity. Provided every one had good manners she would never carp, but Michael seemed to be really outraged.

Anyway, I had warned him, and I hoped he would calm down. Jac and I couldn't afford Casa Antica by ourselves; we needed a third to share expenses. Michael was all we had. Justin O'Brien, in London, hadn't been interested. (He regretted it later.)

Michael and I joined Jac in Paris. Their accumulated luggage was so immense that we had to put it all in the goods van. (Mine was in St Petersburg, but I didn't know that.) The train stopped at Domodossola for a complete customs inspection. Everything was put out on the platform, great heaps of it.

At this point, someone heard that Beniamino Gigli was on the train. Everyone called for him to sing. He was elated to be returning to Italy, and he sang there and then, out on the platform in the alpine sunlight—a wonderful experience. We all cheered him and clapped like mad.

The customs officers, too, wanted to hear Gigli sing, and so all the luggage was left on the platform. It took three days

waiting in Rome before it turned up, an irritating price to pay for an unexpected pleasure. Amazing to relate, mine turned up too.

Jacqueline had never been to Rome, so as soon as we had settled in at the Hotel Rex in Via Torino, we set off for the Vatican. She was so thrilled to think that at last she would see the Sistine Chapel.

We arrived in mid-afternoon and they were just closing. Next morning we had to go to the station for our lost luggage, but it hadn't turned up, so we went straight to the Vatican. It was a Roman Catholic holy day, and the museum was closing at midday, just as we got there.

The third time, after another fruitless search at the station, we got to the Vatican at about 11, to be told that it was a total holiday. On the Vatican steps Jac sat down and wept. She really did. Jac said she'd never see it, she was fated not to.

When she finally got there the next day we found ourselves in a queue in that narrow little passage which leads into the Sistine Chapel. A limited number were let in at a time. There was an Englishman and his wife in front of us. Just as they were about to enter we heard him say to her, 'I'm going to give you five minutes to look, and then I'll ask you questions.'

It entered our repertoire.

Even though it was September, it was still hot in Italy. I wondered why anyone would want to live up there in Norway. Kåre said if a good commission he was hoping for came off, he could join us in Ischia. We were looking for more people to share the place, there was plenty of room.

My Song of Norway was sung, it was a brief one, and it was cathartic. The grief of missing Laurie was more acceptable now, it all seemed further away.

We were looking forward to a productive winter and Stanley Crescent was a thing of the past. Neither Jac nor I felt sure about Michael—his boiling-over in Amsterdam could presage further difficulties. Poor Michael, perhaps he sensed that we needed him to help with expenses. Perhaps he felt like the odd man out: three is a difficult number when you travel.

ELEVEN

THE PORT of Ischia is an extinct volcano; it is circular and of great beauty. Jac was enchanted by the place, and after tremendous chaos and confusion we were installed in two *carrozzas* and set off across the island to our 'winter residence', Casa Antica.

It was all perfect. The house was awaiting us, and Capitano Taliercio had found us a full-time housekeeper and cook, Angelina, very young. The whole thing was so grand, and even though we were so poor, we felt we were 'instant upper class'.

Casa Antica lacked all mod cons. There was a flimsy electric light system, so frail that it glowed dimly, but mainly it oscillated, often going out for a long time. So we found candles more reliable.

There was no plumbing at all. Does anyone living in a city know the work this means? The well was in the courtyard from which you entered the house, and it served all our needs. Angelina had to draw the water and put it in huge earthenware jars in the kitchen. Each bedroom had a marble-topped washstand with pitcher and basin. We all had large sponges.

Every morning Angelina would deliver hot and cold water to each washstand, and then, at the far end of the

terrace, she would replenish the huge jar in the lavatory. This large jar had a jug, which was used for flushing. We never asked where the drain went—you can be sure it was not a long drain—but it must have been far away enough because we had no unpleasant reminders.

The lavatory pedestal itself, which I leave to last, was a low porcelain one, but enamelled into the porcelain, staring up at whatever presented itself, was an immaculately painted eye, an implacable eye.

We quickly settled down to work, but no work at night, as there was often not enough light. A small candelabra was suspended from the domed ceiling of the sitting room. It only had four candles, but lots of crystals. It was really amazing how much light it gave—we could even read. I realised that before electric light, if you were rich, you could have plenty of artificial light. Only the poor were in the dark.

The view from the terrace of Casa Antica was immense and fantastic. We looked down over the flat roofs, and then there was a long beach with cliffs, all deserted. At the end of this beach is a tiny picturesque village called Sant'Angelo, with the peninsula hump Island of Sant'Angelo. We were told that a German writer called Thomas Mann had lived there.

Then we heard that there was an Australian painter called Donald Friend living in the village. Donald turned up with his beautiful young Pakistani friend, an effeminate prince called Omar Ali. I had met Donald in Sydney, with the Drysdales—he was very close to Bon.

Donald and I, and Omar, made lots of friends among the boys of Porto d'Ischia. Omar cultivated the football team, 'the most beautiful football team in the world' he declared. He gave them all a grand dinner in the one restaurant in Porto d'Ischia, and read aloud to them Oscar Wilde's *The*

Critic as Artist. This must have been a pretty surreal sight—they hadn't a word of English.

One evening we gave a dinner party at Casa Antica and Donald and Omar had to stay the night—it was so late, and no means to light them on their way. In the middle of the night Omar started chanting Pakistani hymns in his sleep. It was very loud and strange. I sensed that underneath all his pansied froth and bubble, he may have been religious.

Omar was a trial. He insisted on people giving him his probably *soi disant* title, 'Your Highness'—'*Altezza*' they'd say, and the women, in remembrance of things feudal, would bend a knee. Omar coolly accepted all this as only his due; one of the vainest and silliest people I've ever had to put up with.

Every week or so we had to go over to Naples, for paint and canvas supplies, and sometimes to the bank, if money came through. This was always an excuse to spend as long as possible in the great Naples Archaeological Museum. The museum had a stabilising and also reassuring effect on me, after Léger.

It was not reasonable to suppose that 20th century painting was 'going abstract'. Even Malevich went back to realism, albeit a corny folksy sort. But the great works in Naples declared, loud and clear, that realism had been around for a very long time.

The most powerful, impressive image is the large Alexander Mosaic, from the House of the Faun. Its provenance indicated there were probably many other versions of it in Greece and Egypt. The mosaic must have been a faithful copy of one of the Greek masterpieces of the 4th century BC. I used to think the original was painted but I

now think it was probably a mosaic. From this work you see that the narration is vital, and realism is essential. You notice a Victorian earnestness where the dying warrior sees his face reflected in the brass shield; a heroism in that Alexander's glance goes right across the composition to his enemy's face.

The similarity with Uccello's *Rout of San Romano* is remarkable but meaningless, as the Alexander Mosaic was only discovered in 1831.

Even more surprising for us, because it was painted, was the great frieze in the Villa of the Mysteries at Pompeii. Here were Poussinesque, Ingres-like figures painted 2,000 years ago. It was amazing. Very little had been published on this.

In the Naples museum you see the lovely conté-like Roman drawings on marble, 'The Knuckle Players', which Picasso saw when his wife was dancing for the Russian ballet. He admired and emulated these drawings. They presage David and Ingres. Is it possible they could have seen them? But the works which really surprised and enchanted me were the small mosaics— most of them in perfect condition.

I have four works which I consider my great favourites. It follows that I think they are the most beautiful pictures in the world. They are *The Flagellation* by Piero della Francesca in the Ducal Palace, Urbino; *Virgin Enthroned* by Giovanni Bellini, in San Zaccaria, Venice; *Fête Champêtre* by Giorgione–Titian in the Louvre Museum. The fourth is *The Street Musicians* by Diosk-ourides of Samos in the Naples Archaeological Museum. This small mosaic is perfectly designed—the lighting which is almost Caravaggiesque, the placing of the verticals and horizontals which remind you of Mondrian, even the artist's signature is perfectly placed in the design. It was probably executed in the first century before Christ.

As our paint shop was near the art school and also near the museum, it was all very convenient.

TWELVE

THE FIRST boy I met was handsome and charming Attilio Guaracino. He was near the ferry when we struck up a conversation. Then he introduced me to his friends, Andrea, Pietro, Vincenzo, and some others.

Attilio was, in fact, the madam. They would eye off the people as they landed, and a prospective client, male or female, was then quickly evaluated. Attilio swore he could divine their tastes, and then he would introduce the requisite boy.

It would be a mistake to think they were all homosexual, even though they seemed to indicate they were. They were poor, out of work, handsome and they were bored. Perhaps, looking back, they were, as so many Italians deny they are, bisexual. Anyway, they were all available and the going rate was 500 lire, which was nothing to a visitor.

Local women were completely unavailable; they were usually chaperoned. Italian women never went shopping by themselves, never sat alone in the street sewing. It was always a group. In those days the women faced into the wall. There was no bathing for women. The men went swimming, usually without costumes. When we arrived they were beginning to devise swimming costumes with belts and handkerchiefs.

In 1949, when we first visited Ischia, there was only one motor vehicle, and that was the very old dilapidated bus which went from the port of Ischia to Casamicciola and Forio. It was usually loaded with screaming locals, and on the roof usually screeching fowls.

By 1950 Italians in Ischia were beginning to go swimming, but there was a lot of crossing themselves before entering the 'perils of the sea'. When Jac and I were leaving at the end of 1950 we were rather miffed to see a big shiny motor car and driver in the port. We asked how this monstrous intrusion came to pass, and were told it was brought over by Paul Muni, the famous Hollywood film actor. The end was near.

Alas, among the boys, the one I fancied most was Attilio and he was the only one who was not going to play—he really wasn't interested.

Then, when Donald turned up, of course he met all these boys, and we sensed he was fed-up with Omar. We went to Donald's place at Sant'Angelo; it was a pleasant walk along the beach.

There was a bar at Sant'Angelo in an old wine cave and the fisherman who owned it had turned a fishing boat upside down for the bar. He had hung the walls of the cave with fish nets and hurricane lanterns were strung around. As Donald said, the effect was extremely chic, and anywhere else in the world it would be thought of as sophisticated interior decoration. Places like that have now become a cliché.

There was an attractive blue-eyed boy, not really a friend of Attilio's, to whom I was drawn. He was called Daniele. There were lots of meetings with Daniele, but I never seemed to really get anywhere with him. He was always having to go to see his auntie in Forio, a town on the other side of the island.

The Feast of St Peter was always an important event in Porto d'Ischia. The inhabitants of the island were mainly fishermen, and St Peter the fisherman was the island's patron saint. The procession down the main street was extravagant—as extravagant as the fireworks at night, a gift of a rich Ischitan living in America.

The climax of the procession was the figure of the Virgin. She had a sort of maypole with ribbons spread out and held by the boys we knew, Andrea, Pietro, Daniele, et al. Attilio, for some strange reason was banned from being given this honour. There were rumours of disgraces, even of having been in jail. I was to learn more of all this later.

The notable family in Ischia was the Ambras, and one of the Ambra ladies asked me to excuse her if she didn't acknowledge or greet me in the street. If I was with Attilio, it was impossible, she explained.

One would think that the Catholic Church with its monopoly of virtue and forgiveness would have been kinder to Attilio, but he was looked at askance. For both the Church and society, Attilio was a pariah.

Judith Anne and her mother wrote suggesting themselves for Christmas. Mrs Ingoldby brought a plum pudding from Fortnum's. I had a chat with Angelina and I didn't worry much about what we should have for Christmas dinner. There was no oven. We were always having *pure di tomate*, so I just said 'soup'. We had a chicken and Angelina had found a cauliflower. I didn't write the dinner down; it was enough to tell her, surely.

1) *Zuppa*
2) *Pollo bollito, cavolfiore, patate fritte*

3) Plum pudding, *con* cognac.

I told Angelina to lower the pudding in its basin into boiling water and cook it for two hours. Bear in mind that in Italy in those days a special sweet pudding dish was a cauliflower cake, a *sformato di cavolfiore* with lots of sugar.

When Christmas dinner was finally served, the first dish was some tepid water in which she had boiled the chicken. The second dish was all right—boiled chicken and fried potatoes, plain but edible. The third was a watery brown sweet soup, made of pieces of cauliflower mixed with the gizzards of the chicken, and we discovered pieces of floating plum pudding. It had been taken out of the basin and boiled for two hours.

The whole thing was a disaster. I was cutting such a hopeless figure as a host, and in such an impressive house. Mrs Ingoldby *was* amused.

THIRTEEN

THE VILLAGE of Testaccio, in which we lived, was perched on the edge of a small plateau, and then the land plunged down to the sea. The only public place in Testaccio was a wretched little square with a dark grotty bar full of old men and tobacco fumes.

Just above our village, up lots of steps, was the more handsome town of Barano, which had a church and a town council, and even a cinema. Angelina had to do her shopping in Barano.

We lived on eggs and vegetables and pasta. We had very little meat or fish, it cost too much. Rolls and jam for breakfast, but the jam was terrible, and expensive. Coffee and tea had to be taken carefully because they, too, were expensive. The milk we had came in tins, and across every tin was stencilled 'Donated by the Jewish Mothers of America for the people of Italy'. Wine was cheap. Raphael Cilento, who was head of the World Health Organization, later told us that a diet of spaghetti with tomatoes, oil and garlic, with a sprinkling of cheese, has everything needed for human sustenance.

The cinema in Barano was only open on Saturday nights and it screened bad films made by a film unit engaged by the Vatican to do a series on the 'Lives of the Saints'. It was controlled by the Curia and the film was very worn.

We made a friend of the good-looking, young, blond mayor of Barano, Barone Gianni Giannatelli, and he often dropped in at about 5; he was fascinated by our English habit of taking tea and biscuits. He often dressed in plus-fours for this impressive occasion—which was how he thought of it. After he had tea with us, Gianni would go down to visit his fiancée, Eva, the young schoolmistress who lived in the orange grove below us. Sometimes he would call on us on his way home, about 10 or 11, but often he would stay the night with Eva.

They married while we were away, but Gianni had told me that when Eva went to the altar with him, she went as a virgin bride. Knowing Italian ways, I believed him. Large families were rare in Italy, most of them confined to two or three children, and I have heard Americans seriously discussing what sort of contraceptive device the Italian peasants used.

The picture-theatre was just a large meeting place; if you wanted glamour you found it in the church. Here was the opulence and gilt, chandeliers, velvet hangings, paintings, sculptures, organ music and singing. The villagers must have found it a truly Magic Land.

Gianni told us that as a boy of 12, while he was praying in front of a statue of the Virgin, he began to notice that underneath the blue plaster pleats and folds of her robe, she had a beautiful figure, and he began to perceive her breasts and stomach and thighs. He went on with his praying and realised that he was becoming ecstatic and very moved by the whole thing, and the next he knew he was having a sexual orgasm, his first.

We were all working well, usually meeting at mealtimes, and the rest of the time working, taking breaks and enjoying drinks and cigarettes on the terrace.

One day, Jac said she wasn't going to have lunch, she was staying in bed. Was she ill? No. She was not ill, she just wanted to be left alone. This went on for more than two days; she just didn't appear. I hoped she'd taken some fresh fruit from the kitchen, but she stayed in bed. When I went in to see her, she was not sleeping, she just asked not to be disturbed. She just lay there, with her eyes open.

It was very worrying and on the third day I received a letter from my mother telling me that Jac's father, the colourful Jack Hick, had died. So I went in to Jac's room with the letter and said, 'I know about it. I'm very sorry. I think we should go for a walk and have a drink at the local bar. We have to do something.'

The local bar was not much of a treat, but it was a change of scene for Jac, and something had to break her self-imposed purdah. She had been so close to her father, her grief must have overwhelmed her.

We talked of when he stood for parliament. He hired trucks and people to dispense beer. The signs said 'Free beers for all. Vote for Jack Hick.' It didn't get him in to parliament, but Jack Hick's garage, with the attendants and the owner all dressed as cowboys, became very well known. Prim little Adelaide needed characters like Jack Hick.

Our winter at Casa Antica was proving to be a joy. We had visits from Val Whorewood, whose wife had returned to England, and our mayor was always dropping in. Capitano Taliercio often came with a dish his wife had cooked. We had visitors from the mainland, Donald would come and spend time with us. Mic would often stay with us, making visits when he had to go to Rome on oily business.

Bringing Donald and Mic together again was a wonderful reunion.

Donald recounted that when war broke out in 1939, unlike me, he was totally liable to be called up. To avoid the indignity of being conscripted he enlisted, and was put in an army camp.

He began being subversive immediately. He had a large photograph of his sister Gwennie, which was framed, and was put by his bed. Gwennie always had her hair cut very short, like a boy's, but wore large earrings and heavy lipstick. They were very alike.

When Donald's mates saw it, they'd say, 'Who's that, Don?' And Donald would say, 'It's *me!*'

Mic, in London when war broke out, had returned immediately to Adelaide to enlist. He eventually became a colonel and chief liaison officer for General MacArthur who had established himself at Melbourne barracks after the Japanese had invaded New Guinea. His private quarters were more glamorous, because my friend Countess Myra Stoichesko had donated her luxurious suite at Menzies Hotel to MacArthur—she said it was her war effort.

Though he was liaison officer, Mic's rank made it imperative that he had a regiment. He was made nominal head of a regiment in Queensland and Donald was in that regiment.

Mic spent a lot of his time travelling between Australia, Washington and London. He remembers a lunch at the White House with President Roosevelt, MacArthur and Somerset Maugham—who hardly spoke, he stuttered so badly.

Every now and again Mic would officially visit his regiment, and on one occasion he ran his eye over the names of his men, to come across 'Friend, Donald Stuart Leslie'. He sent for Donald, because, although he had never met him, he liked his work.

It was immediate friendship and Mic asked if he could help Donald in any way. Donald said all he wanted to do was paint. Mic allotted him an entire Nissen hut as a studio, excused him from tiresome military duties like parades and, to the horror of his scandalised fellow officers, invited Donald to dinner parties in Brisbane.

This is how *Gunner's Diary* was made possible.

Months went by, and Donald heard that the colonel was going to pay the regiment a visit and there would be a parade and inspection. Donald decided he would turn up for the parade and managed to get his uniform cleaned up and his boots to shine. The gun! Where was it? He found it, and it looked very dirty, so Donald tried cleaning it up, but he couldn't find any gun oil, so he used hair oil instead.

The great moment came. The men were all lined up, and the colonel, attended by officers, moved slowly down the line. The colonel's keen military eye must have detected an unfamiliar sheen on Donald's gun because he paused, looked at Donald, at the gun, and then lent forward and sniffed it.

'What's this?' bellowed the outraged colonel. 'SCENTED, SOLDIER?!'

———

Quite often we would go to Naples for the day. This involved booking Giuseppe the *carrozza* boy the day before. You had to leave Testaccio in the early dawn and you needed a rug in the *carrozza*. Those early morning trips across the island were enchanting, with Giuseppe singing Ischitan tunes to the clip clop of the horse's hoofs, the sun coming up behind the mountains on the mainland across the bay, the picturesque circular little harbour below us.

We loved the splendid panoramic view from our sunny terrace. There were no wirelesses, no loudspeakers, no traffic noises, no mechanical devices. All you heard was the occasional beating of a carpet and the sound of women singing. The houses were mainly flat-topped and washing was put out on the roofs. The women were usually in black—inevitably in mourning for some relative.

The black figures against the white walls and the coloured washing, all accompanied by the women's songs which sounded like an oriental wail, nearly convinced you that you were in the Middle East. Well, it is said that the Orient begins in Rome and that Naples is the only city in Italy with a European ghetto.

Our first impression of life in Ischia was that they all had innate good taste. The domestic architecture was beautifully restrained, with simple varying blocks of cubes, made of stones, then stuccoed, a splendid use of local materials. The ceilings were made of bamboo poles placed closely over undressed wooden beams. The houses were usually white, and the doors an occasional note of colour.

There were no electric light poles and no television antennas, and because there was no plumbing the women carried water on their heads in beautiful terracotta vases— they walked so elegantly in their bare feet. The washing was carried in beautiful home-made baskets.

It took us some time to wake up to the ugly truth that the peasants didn't have good taste at all. Poverty was what prevented them from painting their houses in gaudy colours and religious customs kept them in black. The women would have much preferred turning on a tap to carrying those earthenware jugs, and as soon as plastic bowls were available it became plastics all the way. The only women, later, to be bare-footed were rich Milanese freaks. And Tes-

taccio was quiet because they couldn't yet afford motor scooters.

————————

Michael wasn't enjoying life in Italy. He painted some good pictures, including a large one of the roof tops and washing, and managed to avoid the picturesque, which was such a trap in these parts. But he was becoming morose. One day Jac walked into his room and he was sitting by the window, all rugged up. Jac said, 'What are you doing, pet?' and Michael said faintly, 'I'm just watching the flies die.'

He was hating life at Casa Antica, and perhaps my promiscuous life in particular. I sometimes, gently I hope, suggested maybe he'd like to meet some of the boys, but he was outraged and indignant at the idea, and would fly into a rage. Finally, he announced he was leaving, and of course this left us in a jam: we couldn't afford to run the place.

I had met Raphael and Phyllis Cilento in London. He had been knighted for his work with the World Health Organization among many other things. They were a marvellous pair, and told me they had two daughters, Diane who was an actress, and Margaret, a painter. I met the young Diane and how beautiful she was, but I hadn't met Margaret. Just as Michael was leaving, we had a letter from Margaret asking if she could come and stay, so it worked out well.

I took the *carrozza* across the island and went to meet Margaret at the ferry. The boys had heard I was meeting a woman friend and they were all agog. When she arrived she had her red hair primly tied up in a plait, and was dressed in a sensible print dress, a plain leather belt, dull stockings and 'sensible' shoes. She didn't look like a sex symbol,

anything but, and nothing like her sister, who was sexually provocative just walking across a room.

By some uncanny instinct the boys knew she was a hot cookie. Attilio was moaning and groaning, 'Jeffie, she *focka*, she *focka*.' I very firmly said, 'Now listen, Attilio, you stop all that. She's the daughter of friends of mine and I'm expected to look after her, and you stop all that fantasising.' The answer came again, 'She *focka*.' But anyone could see she was prim and proper.

Margaret was good company and I brought her back to Casa Antica and it was instant happy families. But the boys took to hanging around immediately. Margaret was soon installed, and in no time she was out landscape painting. She was always followed by a boy or two—they were always hanging around. She did some fine paintings of the area, and a remarkable one of the cliffs above the Spiaggia Marontes—she put it down as none of us could. I would really love to see it again.

Donald was still down at Sant'Angelo with Omar, who bored him more than ever, and he had fallen in love with Attilio, as I had. Attilio was so shining, such a life-force, he was irresistible. He was dividing his time between Sant'Angelo where Donald paid him handsomely for posing, and Casa Antica where he would go for walks with Margaret. Omar left, thank God, and Donald was alone, and lonely, and very jealous of Margaret.

It was a fairly hard time for me. I had plenty of time to work, but there were far too many distractions and work was going very badly indeed. I questioned the validity of what I was painting and it was difficult to avoid the picturesque. I started doing watercolour drawings, heavily influenced by Donald. Donald was always very encouraging to me. He told

me, as he later told me for years, that I was the 'proper painter', and that he was not—he was simply a draughtsman. This was very generous of him, because he has produced, during his career, some fine oil paintings. He commented, 'You know, I just draw like a dog wags his tail.' He was a born artist, and painting was indispensable to his life.

Although I was doing a good series of watercolours, my oil paintings were not good—nothing was moving, they seemed dead. I was so disgusted with them I would paint them out with white and do another on top. I had fearful doubts about my future as a painter—was I doomed to be a lightweight watercolourist?

Jac was doing really good stuff in both mediums.

Things became unbearable with the Attilio–Donald–Margaret tensions, and finally I had to talk to her and she decided it would be better if she went to Naples. With Omar off the scene, Donald came and stayed at Casa Antica for a while, and then he took a place in Porto d'Ischia.

FOURTEEN

WE WERE very cut off at Casa Antica. No wireless and the only newspaper we saw was a Neapolitan one when we visited the port of Ischia. The people at Barano and Testaccio were not terribly literate. Mussolini had built a school, but the church was the main source of education; there was no point in expecting a daily paper.

The affairs of the world went by and we knew nothing— we hadn't heard about the Korean problem until someone told us of it later. Things like the stock exchange and currency variations were completely beyond our ken. We didn't know about a dramatic devaluation of the lira.

On one trip to the bank in Naples I found that the small sum sent me had become what seemed a lot in lire. I had an unexpectedly large amount of money. It was exciting and I bought a huge bouquet of flowers. I didn't know anyone to give it to, so I looked for a really beautiful woman in the main street, Via Chiaia.

When I found her I gave her the flowers telling her I wanted to give them to her because she was beautiful. She did not think I was mad, she accepted the flowers with grace. I wondered what would happen if I made that gesture in London?

When I was in Naples for the day, I usually ate at the same restaurant. It was in the docks area, and not far from the ferries. To save money, I always had *spaghetti al pomodoro*, a glass of wine and some bread. My bill was always 400 lire.

When I was there one day, the man at the next table had pasta, then meat and salad, and fruit, and I saw that he paid 500 lire for all that. After he had left, I criticised the waiter, I said I thought he was my friend, I told him of my dissatisfaction.

He said, 'Look, you are a foreign painter living in Ischia—you must have enough money to live on. Guglielmo here, on the other hand, is poor, his job is unsteady, he has a wife and three growing children. What I do is this: I add just a little to your bill and take just a little off his.' Unassailable logic, I decided.

———

Italy in 1950 didn't look promising for a young man like Attilio—no training, nothing offering but odd fishing jobs. Attilio's father was a tailor and made a poor living from it. The 'Italian miracle' took place in the sixties. Australia seemed a much more attractive place.

When Donald and I were vying for Attilio's favours I said to Donald that I would pull out of the difficult threesome and leave Attilio with him if he would promise to take Attilio to Australia. Donald had much more money than I had, and I thought it was a good idea.

Attilio said that was a *marvellous* idea. Donald would pay his fare and then he, Attilio, would come straight to me in Adelaide. He knew I was going back, inevitably.

Donald liked the idea. He could see Attilio working on his house and garden at Hill End (I found that hard to

imagine). He was already pining, longing, dreaming to be back in Hill End. Attilio did not want to live with Donald, but I explained to him that if Donald guaranteed him and paid his fare, he would be on a bond to stay for two years. Besides, he was obliged to Donald. All this was loftily dismissed by Attilio—'I'll just come to you in Adelaide,' he would say.

Anyway, when they went to Naples to start Attilio's immigration papers and permit, they came up against a complete blank wall. Attilio had been found guilty of a crime and had been imprisoned and there was no question of allowing him to emigrate. Donald had to pay a great deal to get over this hump, and thus there remained the difficulty of allowing him into Australia. Here again my Uncle George, director of immigration, was to be a great help, and the way was smoothed.

Donald and I had an invitation to go to a party given by Chester Kallman at Wystan Auden's house in Forio. The house was pretty grotty, but then Wystan always had a flair for squalor.

You would think that the conversation might have been toned down a bit because they had a man and his wife there who were obviously very square. They came from the outer space world of academe. He was writing a book on Wystan, and they were like pious pilgrims or missionaries, come to worship at a tarnished shrine.

Wystan and Chester rose to the challenge with some inspired and shocking conversation. I had been asking about the blue-eyed Daniele from the porto and it became clear that Wystan was the auntie in Forio. The smiles on

the faces of the pietists became a little fainter and a little tighter.

Chester could keep up a marvellously funny patter while he was cooking. Wystan was going on about obscure performances of Italian opera, which was a relief, after all the extolling of the hidden charms of Daniele. Casa Antica and our little chandelier and Angelina waiting at the table seemed very bijou in comparison with the slapdash splendid style of Chester. As the party finished late we stayed the night.

Breakfast was usually had at Maria's bar, which was the main meeting place at Forio. On the morning after the party we sat out in the street and asked for milk coffee. The milk was late, said Maria, but was expected any moment. A few minutes later we saw a man leading a goat coming towards the bar, and Maria rushed out with a jar. The man milked the goat and Maria poured the warm milk into our coffee, laughing and assuring us how fresh it was.

We received a sweet and moving letter from Michael. He wrote from London. He said he was sorry he was so unhappy in Ischia, but it was not our fault, it was his. He wrote that he was having to face up to his own difficulties when he was at Casa Antica and he found that it was impossible for him to 'break out' in front of us. We would be happy to learn that he was having a wonderful friendship with a young tennis player called Bill, and he looked forward to us all meeting up in London.

———

We had good friends who shared a large farmhouse near Forio. It was graced with the title Villa Lustro: ours was only a 'casa'. They were three Americans and an English sculptress with her Russian friend, Olga.

Charles Owen was a painter, a good one. John Bailey was an architect and Philip Dakin a writer. I believe Philip is still in Ischia; he married an Ischitana and they started a restaurant in Forio called Da Filippo.

John Bailey had fantastic drawings for changing New York. They were extravagantly impractical. He wanted vast Palladian bridges over Fifth Avenue, with trailing plants. It was a grand caprice.

Charles Owen was working on a major still-life painting. He was enjoying the privileges of a Fulbright grant, but one of the conditions was that he had to send a work in every few months. His grand still life was surreal. I was very impressed with the amount of work he put into it, painting and over-painting until the surface had that good crusty look to it. He was pressed for time as he was late consigning it, and it became a general worry. 'Has Charles finished yet?' was the beginning of every conversation whenever we met.

My 'new best friend' was an attractive little blond Italian from Ischia Ponte called Vincenzo. When Charles announced that The Painting was finished and he was going up to Rome for a few days to deliver it to the American Academy, I thought it would be fun to go up with him and bring Vincenzo. But when I swanned up to the Hotel Rex with Vincenzo they were very sorry but Vincenzo had come without papers and they couldn't accept him. I pointed out that he was under 18, but they said he still had to have papers.

I rang Charles and asked what was I to do, and he gave me an address in Via Quattro Fontane. This was 1950, and it was Holy Year. Rome was covered with notices to pilgrims. They gave a list of penances required for special indulgences available only in this year.

To celebrate the Holy Year, all the brothels in Rome had

been closed, officially. My address in Via Quattro Fontane was a 'closed' brothel, and it couldn't have been nicer. It was clean and I found the madam pleasant, and she took to Vincenzo immediately. Our room even had its own bathroom. Its only drawback was that the telephone was in the passage just outside our door. It seemed to ring all night, and I could hear La Padrona saying, 'I'm sorry, but it's Lucy's night off tonight—why don't you try Teresa, you used to like her.' Or, it would go, 'Lisa has a client right now. You can come around and wait, but it could be an hour or so.'

The phone was very busy.

The girls had nothing to do in the afternoons and if we dropped in for a siesta, they would make all sorts of excuses to see Vincenzo and sit him on their knees. They offered to do any mending and darning we might need. I became the confidant of one of the sweetest girls there. She was in the horrible, tragic and classic situation of some whores. She was very much in love, but Mario her boyfriend despised her because of her work, and yet he always needed money, and so she was always giving him everything she earned. What was she to do, she begged me for advice, very hard to give.

Vincenzo was sent back to Ischia, and Jacqueline came up and stayed at a pensione. When we were all in Rome Charles conducted us on a 'Caravaggio crawl'. He took us to S. Luigi dei Francesi and to S. Maria del Popolo, where we were staggered to see such amazing major works.

In those days Caravaggio was not very well known— rather as El Greco was not known until the turn of the century. Caravaggio immediately became an important painter in our eyes. The ever ambitious Berenson only got his Caravaggio book out in 1953.

As well as Caravaggio, Charles showed us the wonders of

trompe l'oeil in Rome—the false perspective of Borromini in the Palazzo Spada, and the deliberately misleading windows on Fontana's Lateran Palace. The climax was the amazing Pozzo ceiling in St Ignatius.

We had a particularly magical evening at Alfredo's, below Tennessee William's Rome flat in Piazza S. Maria in Trastevere. It was right off the beaten track in those days—no tourists even in summer. A popular tune in Europe then was 'Dolce Francia' and an old man with a violin played it to us as we dined. It was a truly enchanting night with the silver ribbons of the violin notes floating over the soft splashings of the fountain; an evening so tranquil that the smoke from our cigarettes rose vertically in the still Roman air.

After spending the winter at Casa Antica, Jac and I decided we would have to leave. It was too difficult to keep it running. As I have mentioned, I had asked Justin O'Brien to come and stay, but he was working for a show in Sydney and planning to return there.

I went back to Paris for a stretch at Léger's school, but by spring I was back in London. The studio I had with Mic in Tufton Street was occupied, and I rented a small house in Highgate. It was a lonely time, after Ischia, but I got some work done.

I saw a lot of Judith Anne and of Jac, but Mic had become my main friend. He was a great help in sorting things out. I still had dreams of a straight life, and Mic, who had been through all this himself, gently helped me accept what I thought was unacceptable.

Just before I was leaving London to go back to Ischia, I

had a telephone call from Erica, our landlady at Stanley Crescent. The curtains, I thought. I asked her to lunch, and Jac too. We were so happy to see Erica, and made such a fuss of her, she wasn't game to mention the ruined curtains.

F·IFTEEN

WHEN JAC and I had been at Casa Antica, we kept up the friendship with Val Whorewood, in whose pensione Michael and I had stayed when I first came to Ischia. His wife had gone back to England and he was selling the pensione. He closed it, refusing to have guests; he was fed up with it. When Jac and I returned he asked us to stay, as friends, not as paying guests, and we were happy to have such good quarters at the port.

It was to be our last summer in Ischia and Jac was really working well. I had lots of models, but my work was still not moving much. I had drawings, but hardly any oil painting. I was toying with the idea of being abstract again, but those I did were failures, I was sure.

At Ischia Ponte is a large castle at the end of a causeway. This was owned by the Colonna family and Vittoria della Colonna, to whom Michelangelo wrote so many sonnets, had lived there. A tower in the castle is known as Torre di Michelangelo.

Ischia is connected with Michelangelo in another, slightly more squalid, way. A sculptor called Pietro Torrigianni broke Michelangelo's nose in a fight over a boy. One of our more notable eccentrics was the Marchese Torregiani, who, despite the different spelling—due to bad printers,

he said—was a descendant of Pietro. The Marchese was pointed out to me in the street. He was going out sketching, with four secretaries in attendance. The first secretary, a young and handsome fisherman, was carrying a canvas stretcher, and the other three secretaries followed, each one being much older as you went down the line. He never pensioned off a secretary it seemed. As they were all pretty rough it also followed that literacy was not a prerequisite for the position.

When I came to know him, I found him a charming and beguiling old roué; he was one of a disappearing species, a real dilettante. He had studied painting late in life, and had gone to Léger's school. But at one stage he wanted to be a pianist, and had studied with Alfred Cortot.

Torregiani had purchased a small hotel on a hill just by the entrance of the port—he had such a retinue of secretaries and servants he needed a large place. He also told me that he had married twice, and had three children. One of these, with his family, was installed in the Villa Torregiani. So Torregiani was a grandfather, if rather an irregular one.

When I complained about how badly my love affair with Attilio was going, he said, 'Love! Love! Don't talk to me about love. If I go for a walk in the pine wood with a handsome fisherman, and he turns to me and says "Take off your pants"—*that*, Jeffrey, is love!'

Torregiani met my friend Gianni Giannatelli in the street; Gianni was walking his handsome mastiff. The Marchese was delighted; he had a bitch mastiff on heat he said. Could Gianni please come to his house tomorrow and they would try to mate them?

Gianni liked this idea of course, and presented himself up at the Villa Torregiani next day, and was ushered through a series of rooms to the *salone* where the Marchese awaited

him. When he entered the room, there was no sign of any dog, but an old lady reclined on a divan. She was dressed in lots of black lace and had an elaborate coiffure, and after a few moments Gianni, to his embarrassment, realised it was the Marchese.

Towards the end of the summer Val sold his house, and we had to move. Donald had found a room in the port, and was desperately trying to get Attilio to Australia. At one stage they went up to London when we were there, but Attilio came back to Ischia to say farewell to his family and friends.

———————

There was a great commotion in the port of Ischia because the most luxurious motor yacht had glided into the harbour and berthed by the thermal baths. It was huge and it was glamorous and we were told it belonged to Sir Alexander Korda.

Attilio and I were admiring it when Bu Faulkner, a friend from Forio, came down the gangplank and asked would we like to come on board and meet some people. So we met Lady Veronica and Celia Byass, great friends of Korda. Bu stumbled off (he was plastered) as the Forio bus had turned up.

The ladies were fascinated by Attilio's vivacity. He told them about the Procida jail nearby, where he had been sentenced for smuggling cigarettes. He told them of the cockroach races he organised—they'd never heard anything quite like this, and urged him to tell them more.

He told them the tragi-comic story of his arrest for trying to get cigarettes off an American destroyer. Attilio had worked for months in Sicily, he dived for pearls for a pittance. It was a hard life, little food and sleeping on the deck. But when he returned to Naples he had some money at last.

His plan was a good one. He wanted to swim out to an anchored US destroyer with a large plastic bag and his money. He then planned to buy cartons of cigarettes for next to nothing, and swim back with his tied-up booty floating, held by his mouth. American cigarettes fetched high prices on the black market in Naples, and Attilio's hard-earned money would be multiplied tenfold.

Unfortunately he confided his plan to his sister. She was married to a policeman, who told the customs people, and Attilio was stopped by a motor launch. His booty was confiscated and he was put in jail. He told the story vividly and he was very amusing, with his droll irony. Celia and Veronica were fascinated. They had never met anyone who had been in jail, it was exotic.

The highest peak on mountainous Ischia was Mont Epomeo, and there was a monastery built into the mountaintop and the monks liked having paying guests. So an expedition to Epomeo was organised. The four of us went up on four donkeys, and a guide with two donkeys carried our overnight gear and the hamper picnic from the yacht.

We feasted and drank, and the beds were not sumptuous but supportable. It was a wonderful night, and the climax was the dawn. The monks woke us in time to see the sun rise over the Alps and light up the Sorrento peninsula, Capri and the spectacular Bay of Naples.

You could see all of Ischia, the coastline of cliffs and beaches, the fertile plains, the olive groves, the pine woods, the terraced vineyards, and I recalled Bishop Berkeley's words: 'Ischia is an epitome of the whole earth.'

I was going out sketching in the port, and the ferry had just arrived. I heard cheering and clapping from the crowd in the street and saw an elderly man in a *carrozza*. As it went along the main street, people ran over to him to shake his hand.

'Who is he?' I asked, and learnt it was Edgar Kupfer Koberwitz who had been the Nazi commandant in Ischia during the war. He was obviously a heroic figure.

When the Ischitan guerrillas had killed five German soldiers at Ischia Ponte, Hitler had ordered Edgar to have ten Ischitani executed for every German shot. Edgar had refused to obey orders and was recalled to Berlin and eventually was sentenced to Belsen.

He survived, amazingly, but his health was ruined. I got to know him, and he knew Thomas Mann well. He said he was a difficult man. An aesthete, Edgar liked my painting, and was passionate about music—a cultivated man.

Edgar and I were sitting at the bar one evening, Edgar drinking tea, when he said, 'Look over there, my dear, isn't that Norman Douglas aged 83 with his little boyfriend aged 14? Am I not right when I say 83 and 14 make 97 which is only three short of 100?'

He introduced me to Norman Douglas—the best conversationalist I have ever had the joy to meet. Norman, an indiscriminating paedophile, was such a scandalous figure that, like Attilio, he was resolutely ignored by the establishment of the island—that is, the Church and the Ambras.

How he talked! He talked of life in St Petersburg in the 1890s, when he was a young diplomat. (I wondered if he had met painter George Lambert's father.) Norman told me that he had sold *South Wind* outright, he needed cash, and it was the same with all his works, even *Old Calabria*. He had no money at all.

He lived in Capri, and came over to Ischia for the hot baths, which were good for his arthritis. In Capri he had a 'grace and favour' flat in a villa, with free wine and cheese, olive oil, anything that the estate produced. But he had to buy bread and any other food he needed.

We could afford to shout Norman an occasional meal just to listen to him. One evening he discoursed on cobble-stones: the paving of St Petersburg, Paris and London, how and why they were different. He loved talking about food, and so I heard some of his recipes from the book *Venus in the Kitchen* long before it went into print. He omitted from the book some scurrilous things about Alice B. Toklas's cooking. Gertrude, of course, never cooked; she was much too macho.

Norman told us about the great city of Paestum, south of Salerno. It was almost entirely unknown in 1950. In fact, although the Greek temples there pre-date the Parthenon, which hardly surpasses them in noble simplicity, they disappeared from history, only really coming to notice after the Second World War, when the Americans drained the malarial swamps.

Jac and I decided to go there and we took a train to Bat-tipaglia and arrived at Paestum in the evening. It was a breathtaking sight. Three great Greek temples on a plain bounded by mountains on one side and the sea on the other, an incomparable effect of majesty and grandeur.

We picked over the ruins, scaling low walls and crossing ditches, and as the sun lowered everything was transformed by the light. There were no houses, only a large hump of ivy and virginia creeper. This proved to be a guest house and restaurant! The *padrone* was a former cook to Caruso, and came from the area. There was no electricity, so hurricane lanterns were placed outside on trestle tables. There were

two other guests, an American archaeologist and his wife. It was a most bewitching evening, with the ruins nearby, the afterglow of the sunset, great oleanders and geraniums and roses growing around us, all wild.

The museum did not exist in 1950, but the archaeologist we met knew of the 5th century BC tomb paintings. They were not exhibited until 1952 and their vitality and beauty were a world-wide sensation.

SIXTEEN

IT WAS late summer. My parents had written that I should now come home. My father must have sensed that I was lotus eating and enough was enough. I would have to go back to Adelaide and face reality, but I had no money for the fare. My parents had sent me the money for my ticket, but I had been living on it for some time now. Jacqueline, too, felt that her wandering days were over for a while, so we looked around Naples for a ship. There was nothing.

With no Pensione Valentino to stay at, we moved to the island of Procida. This is much smaller than Ischia or Capri, but had the great advantage of having a superb and cheap hotel. It would be a good place to wait for a ship, and a good place to work. The hotel building was an old private house in a large garden, and in this garden were a number of elegant pavilions. The garden was at the top of a small cliff and a few steps led down to the hotel's private beach.

It was called Albergo Eldorado and it was well named. We dined under a pergola covered with an immense bougainvillea, so old and so thick that when it rained we had the pleasure of eating beneath the canopy and completely protected.

On our arrival we sat in the garden and asked for two gins and lime. The gins were brought and a little boy climbed up

a nearby lime tree, pulled off a lime and brought it to the table.

Despite this, our situation was not good. The money my parents had sent was running low, Jac had her ticket money in London. We had asked the bank in London to send us money for our train fares up to England, but it didn't arrive, held up by an Italian bureaucrat.

My ever patient parents had again paid for the ship's fare to Australia. This time, not trusting me, they'd bought the ticket in London. We were booked on a P&O ship, the SS *Pinjarra*, which was a cargo and passenger steamer going to Melbourne. The train money had to arrive fairly soon. There was no direct train from Naples to London. You had to change trains in Rome and in Paris. We had all our painting gear and luggage.

Each day of waiting in Procida meant one day more to pay for the Eldorado. Each day we'd go to the bank but nothing turned up. We calculated that if the money didn't arrive soon we'd have only enough to pay the hotel but not enough to get to London. Then the news came: the money had arrived in Naples, it would be in Procida the next day. It came in the nick of time; one more day and we would be caught again.

How travellers' cheques and credit cards have changed travelling! In the forties all you had was what they called a letter of credit. You would often swan up to the bank with your letter of credit, to be told that the money had not yet arrived. Sometimes they lied, and were using your money. Roman banks were notorious for this.

The ferry left at 10.30. We loaded up a *carrozza* with all our things, got the driver to wait outside the one-room bank. From the window of the bank we could see the ferry coming in from Ischia. We had only about ten minutes. The clerk

was very, very slow doing the documents and counting the money. He enjoyed teasing us, I'm certain. We were watching the ferry, and the money being slowly counted out. We got there with moments to spare.

We had to stay a night in Rome, so it was back to the Albergo Rex in Via Torino, and even the Roman taxi driver was amazed to see so much luggage. We had to count the pieces. When we counted, we were one missing. It was Jac's portfolio of paintings. We ran out on to the street but the taxi was just turning the corner. We couldn't see the number plate.

Next morning, we went to the taxi lost property department. Nothing. We reported it to the police. There was nothing we could do. We searched the Rome flea market. No sign. I still hope, one day, in someone's house in Rome, to see one of those paintings. I still hope that one day we shall find them, all Jac's work of that summer.

———————

We got to London the day before the ship sailed. I went to the bank. We were broke again, and we needed money for presents. We stayed with Michael Shannon in Hereford Square.

The bank manager advanced us money for presents and spending money on the ship. We spent all the money on presents. I went back to the bank for more and the manager had a fit.

'Can you allow two people to board a ship with no money for drinks and tips for four weeks?' I cried. 'Yes I can,' he said firmly. He had had enough of us. We boarded the ship, broke. It was not funny.

When we were arriving at Port Suez we got a cable sending us money and a message, 'Have a toast to the bank.' It was from Mr French, the manager. His conscience must have troubled him. I sent him a little watercolour from Australia.

The ship had about twenty-four passengers, and by the time we had passed Gibraltar we had arranged ourselves into little groups. We left in mid-October, and I had booked an Adelaide show so we didn't want any delays.

We were going to Suez, Aden, Bombay, then, interestingly to Alleppey on the southern tip of India, then Perth and finally Melbourne. One of the chefs was Indian, and he was the curry chef, and he assured me we would have a curry every day and not once would he repeat a recipe, each one would be different. After a month we became quite knowledgeable about the spices.

Life was so boring on the *Pinjarra*, I decided to try a little experiment. I had become friendly with a large lady who had been mayoress of Manly at one stage. Although she was a bulky woman, I could see that physically she would have been a fine specimen in her youth. I congratulated her on her figure. Her husband seemed quite a small man by comparison. She confided in me, rather foolishly perhaps, but one of the things she told me was that in twenty-five years of marriage her husband had never seen her naked. (I assured her that had she been married to me I would have insisted on a private strip-tease show.)

My experiment was on human frailty. I asked the ex-mayoress that if I told her a secret, a *real* secret, would she promise not to mention it to anyone, not even her husband? She swore she could keep a secret, so I divulged to her that I had been chatting with the wireless operator, and he had

mentioned that the ship, now in the Red Sea, might have to make a detour up the Persian Gulf to Basra. (This was all pure fabrication on my part.)

Nothing, I said, had yet been put on the notice board because it was not at all certain. But, should we have to go up to Basra, it would prolong our journey by well over a week, and perhaps no chance of being home for Christmas. She swore she would tell no one.

Later in the day, I was walking around the deck, and a passenger from Brisbane beckoned to me. She said she had a secret to relate to me, but I must promise not to mention it to anyone. I promised, firmly. It seems that we would have to take on more cargo at Basra, and we would be delayed over a week. It was going to be put up on the notice board shortly.

The poverty of Bombay in late 1950 was appalling. We saw people dying in the streets, and children being born, and footpaths and roads filled with sleeping figures. This must have been the worst time, because since then conditions have improved enormously.

We were invited to see the Bombay School of Art, housed in a dilapidated building dating about 1900. The students were faithfully copying Braques and Fauve painting without understanding what they were doing. We asked why they weren't painting in the Indian tradition and were told that that was old-fashioned and would be going back to old days.

Worse Indian poverty was to come. The ship was to go upstream to Alleppey and the captain told us there was a magnificent Portuguese-baroque church built by St Francis Xavier. He warned us that it was some distance from where the ship berthed, and that he must leave as the tide began to change. He said he would give us twenty minutes warning, by sounding the ship's fog horn, which would be enough time to get back to the ship. The river was the only

communication the place had, and ships were infrequent. There were no hotels and no guest houses so we should be careful. We were the only passengers enthusiastic enough about architecture and foolish enough to make the excursion.

The church had lost a lot of its furniture and furbishing but it was still functioning and it was very atmospheric. It had the largest punkahs I have ever seen, eight of them, four on each side of the aisle in the nave. They were of heavy leather and intricately decorated. The ropes had gone— they must have been heavy because outside we could see the holes in the wall where they came through. By the hole was a bench for the punkah wallahs with room for about four, and at the end of the bench a circular stone for the foreman of each team. The stone was well placed so he could lash them if they didn't pull hard enough. So while the faithful were praying, in the cool of the church, gently refreshed by the breeze of the swaying punkahs, outside in the sun men were being lashed.

By the time we came out of the church an enormous crowd of children had assembled, all crying, screaming, begging us for food and money. We heard the ship's fog horn blowing above the din, and we headed back to the river.

But we couldn't walk, the children were just over knee height, they were tiny little things made savage by hunger, and they crowded upon us pressing our legs with little hands clutching at our clothing. It was impossible to move, either forwards or backwards. The ship's fog horn was sounding again and the children were screaming.

I told Jac the only thing to do was to kick and when they felt pain they would move. It was an unbelievable situation. We started kicking gently, but found it wouldn't work. You had to inflict pain. Jac was crying with tears streaming down her face, 'I'm kicking little children!'

After some kicking, we cleared a space before us, and then I had the idea of getting money out and throwing it behind us. We did this, and it gave us a chance to start running.

Jac was distressed and weeping about it for several days and the nightmare of it has never been erased from our brains. It was the sort of thing that makes one ask terrible questions about humanity with no answers. It was so upsetting to us we found we couldn't even read books with violence in them. The incident was one of the horrible things in our lives, never to be put away, alas.

I'm glad I have been back to India many times since and it is so good to see that now things are so much better. That experience at Alleppey was one of the worst things I've ever been through. It shattered Jac for a long time. We had led very protected lives, and quite suddenly we experienced naked, savage, uncontrolled hysteria. There was no evil in it, the children didn't hate us. They were simply starving.

Our arrival at Melbourne was in the morning and my parents were there to meet us—they had motored over. It was now only one day's driving to reach Adelaide with the new highway which had been built while we were away.

My parents had arranged for us all to stay with some friends and we found ourselves in the outer fringes of Melbourne. Our hosts gave us lunch; Jac and I exchanged glances—what were we to do all that afternoon? We decided we would go and see the Melbourne gallery, we hadn't seen any European painting for over a month, and took a train to Flinders Street station. At the gallery, Brian Finemore showed us around. After the gallery, we went and had a drink at the Australia Hotel which held fond memories for us both.

When we started to make our way to the station, to head for outer Melbourne, we found pandemonium in the

streets. There had been a lightning strike and all transport was at a halt. We saw motor cars with placards, true Australian resourcefulness—'Hawthorn' or 'Box Hill' or 'Thornbury'—and then we saw a truck with our suburb's name on it, and we hopped on.

The evening before we had been having drinks and dinner on a fairly luxurious ship, it now seemed, and here we were, twenty-four hours later, standing up in a truck with a lot of people heading for East Bentleigh, Melbourne.

———————

Neither Jac nor I were looking forward to living in Adelaide again. It was good to see our families, made poignant for Jac with her father gone. But we kept echoing Mic's words about our home town, 'Adders for angst'. We were going to try to make a go of it, angst or not.

BOOK THREE

AUSTRALIA

ONE

AS I had no money at all, my father rang my bank and asked them to keep me going until my show made some. My friend Mr Laurie had retired. I had a lot to do as the show opened in a few weeks. I took all my watercolours, thirty-three of them, to Mr Speirs in Peel Street in the city. We designed very handsome frames—I didn't think of the expense, not a thought.

The exhibition sold very well, even though I had upped my prices—twenty-five guineas for the largest and ten guineas for the smallest. When I had done my sums I found, to my joy, that I could pay my parents almost all the money they had sent me in the last year, and clear up the new overdraft.

I hadn't reckoned or accounted for Mr Speirs' bill. When I asked him for it, it was tremendous. He said I was such an old client and friend of his daughter, the beautiful Ailsa, that I shouldn't worry about it.

About half the paintings were sold, so I had the other half as assets, ready framed, plus several oil paintings I hoped to show in Melbourne and Sydney. Financially, I was 'back to square one', broke again but at least not in debt, apart from Mr Speirs' bill. As I planned a show in Sydney, I could pay him then.

Having the exhibition, and having an 'opening with drinks', served to put me in touch with everyone. I was soon back in the swim, even though I was convinced it was swimming in a backwater after all my international travelling.

The Haywards came home and Jac and I were there a lot. We all resolved to face hermetic Adders with humour and courage. This was long before John Bishop got the Adelaide Festival launched, and only people of my generation can appreciate how it has changed. I felt cornered; I was determined not to live in Adelaide again.

A black despair came upon me. What on earth was I to do? I resorted to my secret valley up in the hills, and I sat there by the waterfall for many hours and meditated in the way I had been taught. I asked for aid. The answer came— it was loud and clear. I was to work, work without question, and I must be patient. Eliot wrote:

… wait without hope
For hope would be hope for the wrong thing;

and then later it came, even clearer

All manner of thing shall be well
By the purification of the motive
In the ground of our beseeching.

The ground of my beseeching was painting. The sooner I started the better.

Jac and I went to a performance by the Adelaide Symphony Orchestra with resident conductor Henry Kripps at the Adelaide Town Hall. At interval, out on that loggia again, we

were happy to see an old friend, the music critic for the Adelaide *Advertiser*.

I said that the performance seemed a bit ragged. But the critic's wife rounded on me announcing, 'What you've just heard was *world class*.' She had never been further than Melbourne in her entire life.

When we heard that, we realised we were well and truly back: the words 'world class' did the trick. I'd forgotten how often that phrase had been on our lips.

———————

After a day in the city, I parked the car and was walking towards the house when I heard my mother laughing, and a strangely familiar voice. As I came to the side verandah my blood froze. It was Attilio! Mildred was sewing, but laughing so much she had to put her sewing down.

'He's telling me *all* about your time in Ischia,' she said. 'He's a scream!' It was very unsettling and embarrassing, but I trusted Attilio's tact.

Attilio, as he had sworn he would, had left Donald at Hill End and come to me. I thought of Donald, deserted, and how he must be feeling wretched and betrayed. He could easily blame me for this disaster. Donald loved Hill End and had talked so movingly, and amusingly, about it. Now his dream of life there with Attilio was destroyed. We had supper, and then I took him into the city and installed him in Moore's Hotel in King William Street.

The Haywards had a farm down near Willunga, so I took Attilio to meet Ursula. She wouldn't give him a job. She said, not correctly, he was too 'tricky'.

After some manoeuvring I settled Attilio with Mrs Dutton

at Anlaby. Emmy said, 'I'll find him an Italian 'gel' and they can get married in the church here—I shall play the organ—and then they can have a family.' A terrible feudal fate for Attilio. And it turned out to be a disaster.

I was leaving to go to a party one evening when a telegram arrived. It said, 'SENZA MAMMA SENZA PAPA SENZA AMICO IO NON STO QUI VADO SUBITO ATTILIO'. (Without mum, dad or friends I'm not staying here, I'm leaving soon, Attilio.) It was impossible to telephone without speaking to Mrs Dutton, and I didn't want Attilio to leave so soon. I made an excuse at the party and left at about 10 and drove up to Anlaby, about an hour from Adelaide.

As I knew where Attilio would be housed, I went straight to his quarters but I had to pass behind the homestead. I had the lights down and I made the car creep past, but this did not fool Mrs Dutton. I heard a loud marchioness's voice call out clear and strong, 'I demand to know who you are. Announce yourself please!'

So I had to call out, 'It's Jeffrey Smart, Mrs Dutton. I've come to call on Attilio.' That put her back a bit, but it was 11 p.m., a strange hour to drop in. I managed to persuade Attilio to stay on. She must have become fond of him because he told me she had his clothes mended and looked after him. But it wasn't going to work. She let him drive her car, and he damaged it. He fled after a few weeks, for Melbourne, where friends helped him.

Just after Christmas I was down at Denis Winterbottom's at Glenelg and I met an enchanting young man called Noel Lefebvre. He came from Melbourne, but said he was going to live in Sydney, and I told him how I planned to move there. The future began to look a little better.

It was 1951, fifty years after Australian Federation. To celebrate this, a Commonwealth Jubilee Art Prize competition was announced. The prize money was to be 500 pounds, which in those days might have been slightly more than a working man's annual wage. It was a lot of money, especially to someone who was completely broke.

The subject had to have an Australian theme and it was made clear that an Australian landscape simply wouldn't do. The judges were to be the directors of the various state galleries—the National Gallery in Canberra didn't exist then.

My parents lent me their car, and I went up to Wallaroo, which had been an important port for various mines in the area. I stayed at the local hotel, the only one, and did a lot of drawing, sketching and watercolours.

With all this information about the place I returned to Adelaide, and put the studies around the walls of my studio. Gradually, a composition began to suggest itself. I had nearly finished it when I knew it was wrong and I had to start it all over again. My friend and neighbour Basil Lott was a good and supportive model.

The painting was finished just in the nick of time for the closing date. I was so late because of having to do it twice. When I left it at the Adelaide gallery I had to varnish it there, in their workrooms. I literally poured a small tin of high quality furniture varnish over it, chosen because it would dry quickly, and I noticed how astonished one of the staff was. The varnish has not yellowed with time, not up to a few years ago.

With the painting gone, I had nothing to do, and my burst of work was over. The results were not to be announced until September.

Although I was broke, I resisted any idea of being

employed in Adelaide again. But I started on a self-portrait—just to keep the engine running.

The South Australian art gallery offered me a job giving occasional lectures in country towns. At least this earned money and was not a permanent commitment. The gallery had a travelling exhibition and the lecturer was expected to mount the exhibition, arrange an opening and give a lecture. In this way I visited many country towns. I was usually put up by a local family, or failing that, stayed at a hotel.

On one of these lecture tours—I think it was to Peterborough—I was put up by Stella and Stanley Hawker, in their beautiful Belkunda station homestead, near Mount Bryan. They had some good paintings, including a handsome portrait of one of Mrs Hawker's ancestors by Sir Thomas Lawrence.

I gave the lecture in the town hall, and afterwards the ladies of the Country Women's Association arranged a supper. Here I met Mrs Pile again, the mother of my old playmate in Denning Street, the woman who had wronged me and wouldn't permit me to go to her house when they moved to Victoria Street.

Now that I was Mr Importance, giving a lecture, she asked me if she could entertain me. I had to explain that it would be difficult to arrange as I was staying with the Hawkers, whom I imagined were at the top of Mrs Pile's social ladder. Revenge *is* sweet.

The condition of the Lawrence at the Hawkers' house alarmed me because it was marred by fly-spots. I managed to bring it to Adelaide, and under instruction from Louis McCubbin, was able to clean it. The Hawkers then lent it to the Art Gallery of South Australia

A visiting Melbourne man, Will Grenville Spencer, bought two watercolours of mine from John Martin's Art

Gallery in May, so I now had a little money, enough at least to get me to Sydney to look for a job.

Jac mentioned several times that there were some things a woman could not understand until she had had a child. I think she also believed that great women painters are rare for the same reason. She remained in Adelaide and taught at the School of Arts. We kept in touch and I would always see her when I visited Adelaide.

A few years after I had settled in Sydney she telephoned to tell me she was getting married. 'Who is he?' I wanted to know, and she said, 'He is Polish and his name is Gillespie I think.' I pointed out it couldn't be Gillespie and she said it was very like it.

Frank Galazowsky was a good-looking man, and Jac bore two sons and two daughters, and then she resumed painting. She became a prominent figure in the art world of South Australia.

Judith Anne Ingoldby married my old friend Basil Lott, who had posed for me when I was painting *Wallaroo* for the Commonwealth Jubilee Art Prize.

TWO

WHEN I arrived in Sydney the money from the sale of the two watercolours was already disappearing. I had to impose myself on my poor sister, who lived in a one-room unit in Statler Flats, Darlinghurst Road, Kings Cross. It was a heavy imposition. I slept on a couch or divan, and she fed me. She was secretary to a psychiatrist, loved her job, and she had a lover, a nice man, but she said he was slightly unsatisfactory. To my surprise, she seemed to know a great many queens, who were very fond of her.

Money was so short I went straight to the Education Department and managed to receive an appointment as an art teacher. My work was to be three days a week at the Arncliffe Girls Home Science School and two days at Randwick High School. The first two weeks were the worst, as I had to eke out my money to last until pay day. So train fares were a toll, lunches were light.

Arncliffe was very bad. It was over two hours' travelling every time I went. There was no art room, no equipment, no library, and an outmoded, absurd syllabus. I was the only male in the whole school and there was no lavatory for me— I had to walk to the nearest pub, or go back to the station. Where was the teachers union, I asked myself.

The girls were 15 or 14, but physically many of them were

already women. They had to stay at school until they turned 16. As it was, I learnt that after school many of them were out of their uniforms and into flash clothes and make-up and would frequent hotel bars in the city. It was difficult to keep discipline, and the girls would make unsubtle passes at me if I walked past their desks. They were pretty tough.

While I was teaching at Arncliffe, I went to a party in Sydney and was photographed with some chic new friends. This was reproduced in the *Sydney Morning Herald*'s social page. When I arrived at the classroom that morning I felt an atmosphere of awe and respect. On almost every desk was a cut-out from the paper, discreetly placed. From then on I had no trouble with discipline; I was a god from a higher world.

Randwick was much better. The equipment was almost adequate, and the students, mixed sexes, were more serious. There was a lavatory.

———

I had looked up Noel Lefebvre, and we thought we would share a place. We found a boarding house in Elizabeth Bay Road, a pretty house opposite Milano's restaurant.

We had only been in the house for a few days when I had a telephone call from Edith Cutlack, in Adelaide. 'How did you know I was here?' I asked her. Edith said she had rung my mother, who told her I had moved into a house in Elizabeth Bay Road but that she had no address or telephone number yet. 'Of course,' Edith said, 'I knew you would be in the room where my Janie was born; don't you have a good view of Rushcutters Bay Park?' I said yes, we did! Edith had married Basil Burdett, one of the founders of the Macquarie Galleries and the man who organised a great

exhibition of European art in Australia. So the Macquarie Galleries was founded with Adelaide money. It seemed obvious to Edith, who must have been a white witch, that I would be in that room.

In July, in Sydney, I received a disturbing letter from the Myer Emporium, Adelaide. Mr Speirs had sold his framing business to Myer's, and his wonderful stock of frames and mouldings, along with a bad debt in the name of Jeffrey Smart. They were taking action against me and I had to pay immediately.

So not only was I broke, I was being sued by a very powerful firm. I wrote to the Haywards for advice and they said if I offered even one pound a month it was legal tender and must be accepted.

With Noel's wage of twelve pounds a week for working at David Jones, and mine of eleven pounds—less for teaching art than selling shoes in a store—we were able to pay eight guineas a week for a large room. But there was no time to paint. I spent two and a half hours a day travelling when I taught at dreaded Arncliffe. Despite my domestic happiness I was too tired to work at night and there wasn't enough space, with two beds in the room, to set up painting gear.

It looked as if my career as a painter was done for. I could look forward to painting in the holidays and at weekends, and I knew that wasn't enough. Of course it was just a question of money. If I were rich I could have rented a large furnished apartment.

In 1951 there were absolutely no flats to let in Sydney. The rent controls imposed in wartime continued, and no investor would build a block of flats and be obliged to accept pre-war rents.

Ursula Hayward had written to her great friend Vera Fels, and soon after I arrived in Sydney I received an invitation to

a cocktail party given for me by Mr and Mrs Charles Fels. Their large elegant house was like being back in Europe, and I met so many people there. Some of them, like Jim and Nedra Coleman and Eleanora Arrighi, were to become life-long friends.

Deke Coleman was very impressive in my eyes. Not only was he head of the advertising agency, J. Walter Thompson, in Australia, but—a doubtful distinction—his first wife had left him for Henry Miller (Miller's books were obligatory reading then). Eleanora Arrighi and I could talk about Italy in Italian.

Eleanora and I became great friends; we both felt outcasts from Italy. She had two attractive daughters, Luciana and Nikè, of whom I became very fond. Eleanora was a good hostess and gave splendid parties. At one of them I met Katharine Hepburn and Robert Helpmann. They had a funny patter going between them and were both acting in *The Merchant of Venice*, then touring Australia.

Helpmann and I found out we went to the same school in Adelaide. 'But,' he said, 'I was expelled—and I won't tell you why!'

I asked Katharine Hepburn if she liked early Sydney architecture and she said she was really studying it. 'Don't you admire the Greenway lighthouse?' I asked, and she pointed out it was not by Greenway and then gave me a very authoritative run-down on Bligh House and Elizabeth Bay House. She kept lifting the collar of her polo-neck sweater and pulling down the sleeves over her wrists and hands. She felt me noticing this and said, 'I'm so ashamed of my terrible freckles.'

At an art exhibition at the Macquarie Galleries I met Bonnie and Tas Drysdale again. I had had too much to drink by the time I was talking with Bon, and through a lucky slip

of the tongue I was able to cope with her. She started off by saying, 'You don't like me, do you?' and I replied by saying, 'Nonsense; I liked you at first slight' (I meant to say 'sight'). Bonnie recoiled and said, 'Your Adelaide wit is too good for me.' It was years before I told her about that; I had made an advantage point accidentally.

One of the first people I looked up in Sydney was Nora Heysen. She was installed in Elaine Haxton's old studio in College Street. It was in a row of beautiful old three-storey terrace houses facing Hyde Park, all now demolished for the RSL building.

Nora and her husband Robert Black invited me to supper. Nora was cooking jugged hare she said, her mother's German recipe. I put on a tie and my old pinstripe suit to pay her a compliment. The other guest was John Passmore, an old fellow student of Nora's from her London Westminster Art School days.

We were talking shop of course, and John looked at me in astonishment, with my sociable manner and bourgeois clothes, saying, 'Are you an *artist*? You'll *never* be an artist!' We ignored these gaucheries and went on chatting. Nora mentioned the time I worked on the ship, and Liverpool, where we had met again. Hearing about the dish-washing on the ship, charming Jack muttered truculently, 'Perhaps you *could* be an artist.' I wonder what he would have thought of the dandies Derain, Balthus, even Léger, certainly Manet and Whistler.

That evening at Nora's was interrupted by a telephone call from my sister Dawn. She had a telegram telling me I had won the Commonwealth Jubilee Art Prize. I had 500 pounds! There was some publicity about it. Bernard Smith was assistant director at the New South Wales art gallery and he recommended me for a job which had just turned up at

the Australian Broadcasting Commission. This was to give a weekly talk in 'The Children's Hour', which included a segment called the Argonauts Club. There was an audition, and I was appointed and called myself Phidias—easier to say than Praxiteles, whom I admired more.

The ABC paid me five pounds a week, and with Noel's twelve pounds a week I could just afford to throw in the awful teaching. The work at the ABC only needed a day a week, initially; later it became more time-consuming. I had to give a weekly talk about painting, and ask the children to send in paintings for what the ABC called 'The Art Gallery of the Air'. (It only occurred to me later how uncannily accurate Claire's prophecy was in Adelaide in 1948: she had said that in a few years' time I would be working in an art gallery which had no walls.)

I felt very much in the dark about it, feeling it was a weird sort of thing to do. My apprehensions vanished when I received the most heart-warming, moving responses from the children. It was very gratifying and a tremendous stimulation to me. I was morally blackmailed into doing all I could for them.

THREE

NOEL AND I moved into a most beautiful house called Fairlight at the end of Elizabeth Bay Road. It was just a bed and breakfast place, but we had an enormous room with a huge verandah and a fantastic view of Sydney Harbour. I had space and time to work.

Michael Shannon came up from Melbourne and took a room, then Justin O'Brien took a room, and very soon we had a most agreeable life, with the use of a little kitchen which had been a pantry. It was not funny sharing a kitchen with Justin; worse sharing the refrigerator. He would nick some of my food out of it. (It saved him having to waste time shopping—very convenient for him, infuriating for me.) Justin, the dedicated painter, always put off going shopping, if he could. When I attacked him saying, 'In two years you haven't bought any salt, pepper, flour, sugar, tea, coffee, milk, tomato sauce and so on,' he said indignantly, 'There's no need, you've always had them.' Sharing a kitchen with Justin may have been the bane of my life, but his daily company was a great joy. He had a large repertory of anecdotes, which all his friends loved to hear. We would often ask him to tell this or that story; 'Tell us the story of the nuns, Just', we'd say.

He'd straighten himself up, and, embarking, he'd say,

'Do you want the long or the short version?' Most of his stories were against himself, and very funny.

We even converted the little dock at the bottom of the garden into a swimming pool. There was time to paint, which I needed to do to feel sane.

I glassed in the verandah. The far end became a studio, the rest was a large living room. We seemed to be hanging over the garden, with water on three sides. It was blissfully quiet, with no houses on either side. The only sounds were of birds; sometimes across the water we heard the roar of the lions at the zoo, and there was the occasional ship's fog horn announcing arrivals or departures.

Eleanora Arrighi brought Signora Consuela Daneo to visit, the wife of the Italian ambassador. She exclaimed at the beauty of my quarters, but expressed concern at the bad effect this would have on my work. She insisted that the best work was done in garrets; artists had to struggle for a living.

I was sketching one Sunday morning in Woolloomooloo when an unshaven, collarless Italian made himself known to me. He knew me by name; how was this? I had not recognised him as the immaculate white-tie-and-tailed head waiter at Milano's, just two minutes from where we lived. He was Renato Milano and he urged me, in his bad English, to dine again at his restaurant. We couldn't go often—it was very expensive.

We went a few days later and he turned on a fabulous dinner. There weren't many other diners. Then, after a delicious meal he introduced us to the receptionist, who was his wife, and to a waiter, his nephew. They came and sat down with us and he told us his tragic situation.

From Italy he went to New York, which must have been in the early thirties. He was a waiter at a gambling saloon frequented by Dutch Schultz. The gangsters would sit at the

table with piles of money in heaps at their sides. Milano would stick lots of pieces of chewing gum to the base of his tray, place it down on the money, serve the drinks, then back in the bar peel off the notes. When Milano left this job Dutch Schultz said an affectionate goodbye, adding he sure did admire his tricks with that tray.

Milano came to Australia with his hard-earned money and decided to run a restaurant in Sydney. It was 1938 and he knew he had best learn the ropes by working for a while at Romano's, which was a very classy restaurant–night club.

When the war broke out, poor Milano was put in an internment camp on a railway stop between Adelaide and Perth. He was in the middle of the desert on the Nullarbor Plain. Once a day the Adelaide Express would thunder through, detaching a water tank carriage which would run off into a siding. It was Milano's job to supervise the water for the internees. He made a stockade of old sleepers, placed vertically; they served as a fence and as a wind break. He collected rabbit droppings and manured the poor sandy soil in his plot. As he didn't smoke he saved up his cigarette coupons and sold them on the black market in the camp. The money was enough for him to send for seeds from Perth—lettuce, tomato, cucumber—and with his precious water rights he had a profitable vegetable garden going. By the end of the war he had augmented his savings.

In 1946 he started the restaurant, and it took all his capital. He had married. The restaurant was not successful, he was losing money fast, and soon he would have to close. Perhaps if I did some decorations on the wall it would help? He could pay me by letting me eat there. I said I would do some murals, but only if he would change the look of the place.

His food, his linen, his cutlery, the service was all the best. But the restaurant looked truly dreadful. They had very

strong lights, a series of inverted chamber pots hanging from the ceiling. There were twelve little 'Views of Italy' torn from a calendar and secured to the wall with scotch tape at the corners. As you entered, you saw a sea of dark brown plywood chair backs. The chamber pots had to go, and little bracket lamps put in, with weak globes. The coloured photographs went of course, and Mrs Milano was persuaded to buy some bolts of linen cloth in muted shades of pink, green and blue. She had a sewing machine and in no time she had fifty slip-on covers to mask the nasty mock turned oak. There were also little elliptical mirrors with scalloped edges around the walls, alternating with the calendar views. They had to go.

I put the views of Italy back on the walls in the form of brush drawings of Rome, Naples and Florence and by each sketch I placed a small group of tourists—a man and his wife and a child with a priest. They were conversation pieces.

When the whole place was ready it looked splendid. Milano complained there wasn't enough light to read the menus. I suggested the waiters have torches, and then graciously permitted him to turn up the lights a tiny fraction.

The most influential columnist in Sydney in those days was Dorothy Jenner, known as 'Andrea'. I already knew this lively funny woman, and I invited her and Lady Keith Smith—she was a popular figure in Sydney 'society'—to dinner; then I asked William Dobell.

Milano turned on an excellent dinner for the four of us. Anita Keith Smith couldn't believe such a magical place was so near her apartment. Dorothy wrote the whole evening up in her column, with photographs. It was good publicity.

The day the article was published, we walked past at about 9 p.m. and looked in. The place was crowded, packed with happy clients. Milano was beside himself with joy, and the restaurant never looked back.

FOUR

DURING MY second year in Sydney, at the end of 1952, I met an interesting woman who was a numerologist. Pearl Levy could play with numbers, and indicate the most intriguing combinations—a virtuoso performance.

She told me Jeff Smart, the name I was known by, had four and five letters, nine in all, and that was bad. She insisted that Jeffrey Smart, seven and five making twelve, was much better in her world of numerology.

Pearl was quite serious about it. I must have my bank account, and anything I owned, like a few shares I had, and of course exhibition catalogues, all in the name of Jeffrey Smart. Jeff Smart had to go. It went; things were going so badly for me that any change must be for the better.

Those two years of 1952 and 1953 were spent virtually marking time at Fairlight. I did not work hard enough, not because of Consuela Daneo's fears of the ambience, but because I couldn't see any point in painting. Perhaps it was a crisis. I had a show with Jacqueline Hick in 1951 at David Jones Gallery. It sold a little, not well. I didn't know how I wanted to paint.

I had yet to learn that you must go on painting the same thing and not worry about repeating yourself. There is a famous story about Picasso's cleaning woman when he was in Paris. She complained that for five years he had been painting the same sort of picture. She hadn't noticed the changes which became obvious in an edited book.

At this point, Judy Cassab, to whom I had confessed my lack of faith and interest in art, helped me enormously. She believed I had an original vision, and that it must not be lost. She absolutely *insisted* I go out painting with her, and took me to La Perouse and Botany Bay. I don't think she wanted to work there, but she hoped it would move me, and it did. She was a true friend.

The constant expense of having to live in a boarding house meant that Noel and I couldn't save enough money to buy a small house, even a cheap one. At last there came a break. Kate and Bernard Smith were leaving their flat in Ilan Court in Wylde Street. Bernard was the good friend who had referred me for the job at the ABC and his two children were enthusiastic Argonauts. He was going to Canberra. If we took the flat over, on his old blocked rent, we promised him a room whenever he wanted to visit Sydney.

Ilan Court was at the end of Macleay Street and it had a slightly exotic mock Spanish look to it. But the tenants were truly exotic. On the top floor were Sali and Pauline Herman leading a tumultuously dramatic life with outbursts of passionate violence which could be clearly heard. Their disagreements were in French. Below us were theatrical people, Gwennie Friend, Donald's sister, and her friend Fifi Banvard. They rehearsed plays and Fifi had a fine voice when she declaimed Shakespeare. The inhabitants of the ground floor were several ladies who found clients in Macleay Street or sailors from nearby Garden Island. They

lowered the artistic tone but added colour.

Getting in on Bernard Smith's rent didn't come off; we moved in, but the landlord insisted, quite rightly, that the rent should go up. We were trapped again, paying high rent.

At this low stage I made a desperate bid for a small house in Bondi, and with a loan from the bank and from Dorothy Jenner, we moved in. For the next six months, I abandoned painting altogether while doing the house up. It had to be painted inside and out. Noel would come home from selling shoes, get into his old clothes and work. David Strachan was a marvellous friend, coming almost every day to help us.

I had secured a job on the *Daily Telegraph* as art critic. Before I worked there they had no writer on art at all. I had been to see Mr Packer, and I was able to convince him that it was essential that his paper should have art reviews. I created that job. There was no telephone at Bondi and no hope of getting one, but somehow I managed to keep in touch.

The editor-in-chief, E. W. MacAlpine, was very supportive. He liked what I wrote and encouraged me by telling me I was a good art critic. A visit to the editor-in-chief was an experience of privilege. The *Telegraph* building, corridors, lifts, rooms were all pretty grotty, but as you neared Mr MacAlpine's and Mr Packer's offices, glass doors kept the noise out and you came across a carpeted area—the roughness of the reporters' headquarters had gone.

Mr MacAlpine's office, like Mr Packer's, overlooked the park. He entertained me with stories of his early days as a young reporter in Russia. He said that in Moscow he lived with Lenin and his family. In the early twenties, although communism had been established, it had not had much effect on the lives of ordinary people.

MacAlpine told me how hard Lenin worked: he was all day at his desk or seeing people, always doing paper work it

seemed to him. One evening MacAlpine insisted Lenin take a break and they went for a walk along the river. A babushka recognised Lenin and came up to them, crying, 'Little father, little father—it is three years since I had news of my son in the army. Do something about it, Little Father.' Lenin asked the woman for her soldier son's number and wrote it down in a pocket book and they continued their walk with Lenin saying that this meant an extra hour or so pushing people for information.

When Lenin died, MacAlpine had to leave Russia in a hurry, and he went to New York where he stayed with the Trotsky family. Trotsky was so poor that every week or so they had to flee their apartment, not paying the rent; they were what my father called 'moonlight flitters'.

Sometimes, while Mr MacAlpine was talking, a buzzer would sound on his desk. 'That's Frank,' he would say, and continue with his tale. Only when the buzzer urgently repeated itself would he slowly rise, saying, 'I'd better see what it is.'

Mr MacAlpine retired, and it was very different when David McNicoll moved up into that office. He was much more respectful of Mr Packer's imperious calls. I had come in with some copy and we were chatting at his desk. Suddenly the buzzer sounded and he shot out, jet propelled, adjusting his tie, much as I would behave in my lowly position.

———

The last I had seen of Attilio was when he came to Sydney and visited Donald at Hill End. He had only been a few weeks with Mrs Dutton at Anlaby. I had heard she was suing him for the damage to her car. Despite this, I knew she had

become fond of him.

One thing was clear: he was not going to live at Hill End again. For a while he had a job at the Melbourne Zoo and his description of feeding the chimpanzees was one of his funniest stories. He had taken a dislike to the old man of the family, who always tried to attack him. I suggested he soften him up by offering him something nice to eat, but Attilio was indignant: 'I wouldn't give that old bastard anything.'

He then got a job repairing electric light wires on the roads. The next I heard of him was as a headline in the papers, 'HEROIC RESCUE BY YOUNG ITALIAN'.

Attilio was walking along a beach near Melbourne; it was winter. There was a very rough sea and he saw a distant fishing boat overturn then the two fishermen clinging to the side, yelling for help.

Attilio swam out and rescued one of them, brought him to the shore, and then swam out and rescued the other one. For this, he was commanded to go to Government House in Melbourne and was awarded the George Cross for bravery.

Shortly after this, the Italian government launched an emigration campaign as unemployment was still high, especially in the south. It was decided to choose the ideal young Italian who had done well in the United States, Canada, Australia, New Zealand, South Africa and South America to advertise the attractions of these countries. They were to still be Italian citizens, not yet naturalised.

Attilio was chosen as 'The Ideal Young Italian in Australia'. He was flown, first class, to Rome. When the plane landed at Ciampino Airport and Attilio stepped out he immediately hopped back into the plane. He had mistaken the guard of honour for policemen who wanted to arrest him for his slightly questionable exit from Italy. As the flight was going on to London, Attilio said he would miss this stop,

thank you, and go on. It took a lot of persuasion to convince him it was a guard of honour.

In Rome, he was put up at a grand hotel and introduced to the other Ideal Young Italians. They were then presented to the President of Italy who knighted them, individually. Cavaliere Attilio Guarracino was then granted an audience with the Pope, and received a Papal Honour.

They paid his expenses for a visit to his family in Ischia, and on his arrival at the port, at that wharf he knew so well, the vaporetto was met by the mayor and his aldermen, and by the Bishop of Ischia. He was 'raised on the vertical banners of praise', to quote Ern Malley.

As Cavaliere Attilio Guarracino he was entertained by the Ambra family, that very same family who had apologised to me for not being able to greet me in the street if I was with Attilio.

FIVE

BEING AN art critic was not enjoyable, but it was making enough to keep me, along with the ABC job. What I did enjoy was meeting my colleagues, the *Sydney Morning Herald*'s art critic, Paul Haefliger, and the *Sun*'s James Gleeson.

Paul was married to Jean Bellette, whose work I admired. Paul was eclectic as a painter; he knew too much about art perhaps. When I told him I thought being a critic was bad for your own work, he didn't really agree, saying look at Robert Schuman, before gloomily admitting that he ended up in a loony bin.

I saw a lot of Paul and Jean. They lived in Ocean Avenue in nearby Double Bay in chaos. Paul was not at all domestic; he just wanted to talk and drink and eat with friends. He was a sweet man, and Jean loved him, but she had to do absolutely everything. The house was not well maintained. It was difficult to flush the lavatory, for example. You had to climb up on it and pull the lever, as the chain had been broken for years. I made history by remembering to bring some cord. After I attached it there was much rejoicing.

Haefliger was Swiss-German. His father, a director of the huge Germany company I.G. Faben, 'was a friend of Hitler' according to Paul. He wasn't proud of it, it was just a fact of life. Mr Haefliger was tried at Munich and sentenced to jail,

and unaccustomed to such a life, died there. Mrs Haefliger, who was a Nestlé heiress, had left her husband, lived for a while in Japan, and then came down to Australia for Paul's schooling. She had travelled all over the eastern states in a caravan, and is credited with having rediscovered Hill End. She stopped in the dark in some cleared land, and woke up to find herself in the middle of the Hill End football field.

Paul's income as art critic was insufficient to support them, but Mrs Haefliger had permitted them to keep an account at Farmers which also had a grocery department. So, although poor, we could often have parties, caviar, pâté, splendid hams and good wines.

Jean taught art one day a week at The King's School and she had a studio in George Street, so she was a very busy woman running a house and studio and teaching. She was a great character, beautiful, and very funny in her over-dramatic ways. Her blue eyes could flash with love and rage at Paul. Jeannie taught me a lot about painting, particularly about using neutral colour.

Both Jean and Paul, and Tas Drysdale too, would all urge me to 'loosen up'—'loosen up!' they would cry. They hated tight brushwork and when I tried to explain that was *not* what I wanted to do, we would have fierce arguments.

The Haefligers and Drysdale were looking at painters like Manessier, Estève and Soulages in those days. I was searching out reproductions of Hopper, Balthus, Lucian Freud and Magritte, not at all well known in the Sydney of the fifties.

The Drysdales had moved to a large house in Darling Point, and 'Saturday Night at the Drysdales' became famous. Bonnie would cook a large goulash, and drinks were plentiful. It was always a lively time. On one drunken night Paul insisted on arguing with Justin about his Roman

Catholicism. Bon had already asked him to desist, and when he did not, Bon emptied a bowl of spaghetti over Paul's head.

It was inevitable that Donald and I should meet again, and when we did, it was instantaneous friendship once more. The old acrimony and bitterness over Attilio had gone and in no time we were laughing about the past. I went up to Hill End whenever I could. Hill End is an hour out of Bathurst.

Donald was unhappy again, and he became very lonely at Hill End. It was either neck or nothing with Donald. He enjoyed Hill End and his house and garden, but there were too few people there with whom he could relax and talk.

Gwen Eyre, who had the local hotel, was good company, but close friends were few on the ground. When he came down to Sydney he would stay with the Drysdales and then he found there were too many people. He would get very cranky with their son Tim, and Jean Bellette always seemed to irritate him—she was mischievous and sometimes baited him. I loved all that. Donald was very close to Tas and especially Bonnie. They were very funny together, they had their own secret language and private jokes.

Because Donald and Hill End were already becoming well known, there was the risk of casual 'droppers in'. So Donald had devised a good protective service, working at Sofala. A traveller going to Hill End would pass through Sofala. Donald's friends at the Sofala pub were on the watch for anyone sticky-beaking about and trying to find his studio.

Enid Lindeman in Sydney had become Lady Kenmare in London. She was an old friend and admirer of Donald and had written that she was coming to Australia, and could she come to Hill End. Donald had replied, telling her he looked forward to her visit. She did not turn up on the arranged day, and Donald was disappointed.

Next time he went to Sydney he stopped for a drink at

the Sofala pub. The owner reminded Donald what a good friend he was to him. Only the other day this old tart, a real old whore, turned up, with some posh Pommie bloke. She wanted to know the way to Hill End, she was going to see Donald Friend. She was all made up and dressed like a young woman, so he told her Donald had just passed through on his way to Sydney.

Donald had a wonderful sense of the absurd, and we always had lots of laughs. Winter at Hill End was very cold, and one time I was there Donald's stock of wood for the fire got very low. We put on our old clothes and boots and went out in the jeep-truck and found a good paddock full of dry mallee roots. We would take it in turns, one driving while the other one walked and threw the mallee roots into the back. At one place we found so many mallee roots that we parked the jeep strategically and both started chucking the mallee roots in.

I suddenly stopped him. 'Donald!' I yelled, 'What are we doing? We're supposed to be a couple of fancy effete poofies and look at us now! We shouldn't be doing it, it's all wrong for our image!'

Whereupon Donald tip-toed over to a mallee root, clasped his hands together exclaiming ecstatically, 'You're a *darling*,' and picked it up balletically, gazed at it and then airily tossed it into the truck. I started doing the same—'You'll have to burn, dear'—until we both collapsed with laughter. I hope a local didn't see us.

After I won the Jubilee Prize I had a little money left and I wanted to invest it. It was a pathetic sum, 200 pounds or something like that. (I was still paying off the Myer's framing

bill with one pound a month.)

I had read in the paper that there had been uranium finds in the United States and that shares in mining companies with uranium rights had rocketed. It was logical that the same thing would happen in Australia and I asked Bobbie Brasch, a broker friend, to buy into *any* uranium mining company, as soon as it came on the market.

The result was spectacular. My 200 pounds became 2,000 pounds in no time. Of course I urged all my friends into this bonanza, and Paul came into it in a much bigger way. The artists were always talking about what shares to buy, and we noticed that stock brokers talked about what painters to buy. I thought that here, at least, was a way to get rich quick and I should soon be returning to Italy.

With what seemed big money to me (the proceeds from the uranium shares) I next heard of a fantastic share called Shaw River Tin and a wonderful broker called Charles H. Smith. I decided to throw all I had into Shaw River Tin. I went in to see Mr Charles Smith. I explained to him that I was an artist and had made some money from uranium, and now I hoped Shaw River might get me back to Italy. Mr Smith was distinguished-looking—he seemed like a university professor or a famous surgeon.

I could see, at a glance, that here was a dedicated broker, helping to thrust Australian mining into world prominence. On his large and elegant desk I noticed geological samples. He toyed with one rock saying, 'This is from Shaw River. I am assured by my geologists, and they are the best, that this promises to be one of the richest tin mines in the world.'

I could hardly wait to get into it and offered Mr Smith all I had. He said he would buy in, with discretion, he didn't want his new float to be manipulated by ruthless Sydney

speculators. I withdrew from his august presence, feeling my future was secure.

Shaw River slowly increased. Mr Smith had put me in on the float, but only about 500 pounds. The rest he bought early in the piece, and my total investment became about 40,000 pounds, a huge sum in those days. I was rich!

At this point Noel and I were working on the house at Bondi and I was art critic on the *Telegraph*, and we still had no telephone. One night I woke up from sleep and I got the message loud and clear, 'SELL SHAW RIVER, TAKE YOUR MONEY AND RUN'. So next day I went in to see Mr Smith. I told him I wanted to sell, and sell completely.

He slowly took off his pince-nez and looked at me benevolently across the desk. 'I have here, in this office, information which is going to rocket Shaw River shares even higher. You want to return to Italy, Mr Smart. I beg you to wait another week or so. I shall advise you when to sell.' I thanked him and left.

A few days later there was an announcement in the paper that the geologists had advised against any mining at Shaw River. The showings were so low it was not a commercial proposition. The shares plummeted down, and then were de-listed. I lost everything.

I was in the middle of a really low period, not painting at all because I had nowhere to live. Noel and I had separated and we had sold the house at Bondi for no profit at all. But I repaid Dorothy Jenner and the bank.

Then I lost my job on the *Telegraph*. With David McNicoll as my boss, you would think things would be better—he was a friend. But no; sub-editors would cut my reviews, often leaving them with no meaning, and shapeless. I lost interest and became too casual. James Cook succeeded me; he was

better than I had been because he worked at it. When he left, the *Telegraph* appointed Daniel Thomas to my old job.

Living in Sydney, Hill End and Sofala became bolt-holes for painting breaks. I couldn't see how I could paint Hill End and avoid being charming, but I could see that David Strachan succeeded—maybe because he lived there for a time.

Cradock, in South Australia, where I had painted *Wasteland I* and *The Wasteland II*, had been an authentic ghost town, and in a real desert. But when Tas Drysdale painted Sofala in its lush pastoral surroundings, it seemed false that he should block out the green hills around it and make it into an outback town.

Hill End was a ghost town only in the sense that it had once been almost a city. But it seems really rather European with all the large trees that Holterman had brought from Germany. It was picturesque, with unpretentious cottages and the now splendid trees, all in the clear light of a high altitude. But it was not a typical Australian town.

SIX

IF THERE was a Roman Catholic Mafia in the ABC, I may have just glimpsed it for a moment. It was a Marian Year and Cardinal Grazias from India, and Australia's own Cardinal Gilroy, were to say a hundred Hail Marys in Hyde Park. Justin urged me to go with him; he said it would be worth the experience.

The park by St Mary's Cathedral was packed with people; it was evening. The service had started, and I had been hailing Mary for some time, when through the crowd I saw a familiar face. It was an administrator in the talks department of the ABC. He recognised me.

My fee from the ABC 'Children's Hour' was insufficient and I had hit on the idea of a 'Saturday Night Art Review'— it was a good idea too. This was, of course, pre-telly. I had suggested my idea to the talks department, and particularly to this chap. I could see he liked the suggestion, but he was prevaricating.

Next morning I received a telephone call from him; could I come and see him? It was launched! My 'Saturday Night Art Review' was put on the air, and there was a good response.

The work as Phidias was becoming important, too important for me. The number of girls helping me had to be

increased. Once a month I had what I called 'Mailbox Day', a summary of letters received over that time. I only looked at them once a month, to prepare the broadcast script.

At every Royal Easter Show the ABC had an on-site studio, and I had to do my act as Phidias, talk to the children, and then meet a tremendous crush afterwards for autographs. I felt like a pseudo film star, a celebrity. The children would cry out their names—'I'm Agamemnon 18' or 'I'm Poseidon 12'—and I would write in their autograph albums, saying in my unctuous voice insincere things like 'How good to see you,' and 'Wonderful to meet you at last.'

I had had a great fan for many years, Emily Johnson from Longreach. She was remarkable, sending me so much stuff. I had to break a rule and write to her personally. She usually sent me copies of famous paintings. I told her to paint the farm, the kitchen, the cars in the garage, the farm equipment, the dam nearby.

The ABC sent her poster colours and lots of rough paper. The results were prodigious. Emily sent me dozens of paintings. The girls in the office were getting to know her work. She was awarded all sorts of certificates, and still this gifted child sent me marvellous things.

After the Easter show one year I was going through accumulated letters and found one from Emily. She had saved money, she was going to Brisbane to stay with relations. Then she would come down to Sydney and see me at the Royal Easter Show.

She must have been one of the children clamouring around me afterwards, who I had treated with such simulated interest—you simply can't be interested in them *all*. When I read the letter, it made me ill. I went to my boss. What could I do? He said get down and crawl to her, but then he added more helpfully, 'Listen, she had to discover

one day that the broadcasts were not especially for her, that it is a hard world.' But why through me, at her young age?

The next few weeks were very bad. I wrote her a letter trying to explain. No answer. When I went into the office the girls would look glum. 'Nothing from Emily?' There was nothing, nevermore.

In the middle of this bad patch—no love, no money, no home—Justin O'Brien came to my aid. He persuaded the Macquarie Galleries to offer me a show. I had been asking them for years, but they always knocked me back.

Thanks to Justin they relented, and I was promised a show in September 1955. There was no place to work; I was back in a boarding house, sleeping on a verandah (the boarder in the room with the verandah was a stertorous snorer). Justin offered me his studio—he was still at Fairlight. He said, heroically, generously, that I could have his easel. He didn't feel like oil painting, he wanted to do small ink drawings of the Stations of the Cross. I know he lied about not wanting to paint.

While I was working for this show I received a request to paint a mural decoration in the dining room of a mining millionaire on the North Shore. I calculated I could do it in a week. My client's wife wanted a French chateau with trees. I was so broke, and still homeless, I would have painted practically anything they wanted.

The suburb was one of the swankiest I've ever seen, rather like Hollywood. As I carted my equipment from the station I passed mansions in the Tudor style, Spanish mission; they were huge, sitting in large, well-kept gardens. My client's house was extremely posh, a sort of Georgian–French mix-up.

Everything looked unused and I couldn't see any books or paintings anywhere. Mrs Robinson showed me the dining room and the wall above the sideboard where she wanted a line drawing.

She was very beautifully dressed for 9 in the morning and when I complimented her on her appearance she said the frock was Balenciaga, she always bought from him and went to Madrid several times a year for her clothes.

I spotted a large 'tray-mobile' loaded only with liqueurs. Mrs Robinson said that they had every liqueur known in the world, their guests could ask for anything.

When lunchtime came I found the only thing to do was to walk back to the station—the whole place was too refined to have shops nearby. I bought a sandwich at the railway station, and trudged back and sat with the old gardener and ate my lunch with him, sitting on a bench in the yard.

The old man told me that he didn't need to work, but he was so fond of the garden, had virtually created it, that he still came and worked on it sometimes. I asked how his pension was so good, and he laughed and said he didn't need a pension, he had made a lot of money on the stock exchange. I said he must have had good advice and he said he didn't know anything about it. The previous owner had been a stock broker, Charles H. Smith, and he said Mr Smith had made the money for him.

When I talked to Mrs Robinson, she confirmed that, yes, the house had belonged to Charles H. Smith. His children had grown up and he didn't need a large mansion so he sold it to his good friends the Robinsons. She said Mr Smith had developed their portfolios, and they had always been interested in mining.

On my last day there Mrs Robinson greeted me in an even more stunning gown, and she had a little secretive

smile on her face. She said, coyly, that last night she and her husband had had drinks with friends in the eastern suburbs. She had mentioned my name and was surprised to find she was surrounded by a lot of my friends. She added that I mustn't have a sandwich with the gardener, that I must lunch with her in their breakfast room and she turned on a delicious meal.

The mural I painted had a chateau surrounded, like a vignette, with lots of trees and leaves. The top of the mural, reaching almost to the ceiling, was all leaves, done in line and very complicated and, I hope, interesting.

Among the leaves, as in a children's picture puzzle, I had half-hidden the words 'FUCK YOU ALL'.

The show I had at the Macquarie, my first there, was a great success by my standards. The paintings were modest and all fairly small, so easier to sell.

SEVEN

WITH ADVICE from Dorothy Jenner, I sought out a man called Charles Phillips, who owned lots of blocks of flats. I told him I was desperate, furniture in store, nowhere to work. I must have moved him, because a week or so later I was told I could have a ground floor flat at the back of Somerset Flats in Billyard Avenue—and I could have it at a pre-war rent. It was a miracle. I moved into the Somerset Flats in August and the next month the show opened at the Macquarie Galleries.

The least I could do was offer Charles Phillips a painting, so I wrote to him, asking him to go in the day before the opening and to choose any painting at all. It would be a way of expressing my gratitude. He went in to the show, but chose the cheapest little gouache.

The flat was two rooms on the ground floor, but what was the ground floor at the front became the basement at the back of the building, because the ground alongside sloped up so much. I heard that Charles Phillips had offered this subterranean flat to two of his maiden aunts, but they had declined it when they saw it. You could understand why.

One of the rooms, the living room, had no light at all; it was almost pitch black. It was a challenge. The windows were

covered in heavy and rusted cyclone netting. When I took this off it was much lighter.

The black wall outside the windows was made up of old stones. It was part of the retaining walls of the gardens of Elizabeth Bay House. In fact, at the back of the building were steps going up and I am sure that Trollope must have climbed these, walking around the garden when he stayed with the Macarthur-Onslows in the 1860s.

These huge black stones were only dark because they were covered in grime and moss. I removed a lot of the top ones and more light came in. Then I painted those outside my windows white. The most transforming thing was when I installed an enormous mirror from floor to ceiling which reflected the light back into the room. 'On a clear day' (but only by standing on your toes and really straining up) you could *just* glimpse the harbour in the mirror. This mirror cost me almost half the proceeds of the show, but was well worth it, because it both lightened and enlarged the room. Tas lent me one of his very big desert paintings—big pictures look good in small spaces. It cheered me up.

The ceiling was painted yellow ochre in high gloss paint and then varnished; it reflected a lot of light. I planted bamboos and other plants in front of the wall where there was a bed of earth, and the room was transformed.

At night I had the 'garden' illuminated with a light globe hanging outside the kitchen window, and when people came for the first time they'd exclaim, 'What a beautiful flat you've got!'

The large borrowed Drysdale glowed and I felt my dank dug-out was assuming a Medicean opulence. Everyone seems to like the idea of an artist starving in a garret, but you have to really search your art history to find one. I didn't

worry about decorating the other room as it was my work room, my studio, and the first I had had for six years. It was a great joy to be able to get back to work. It was the beginning of a new period in my life.

There were a lot of deserted cottages at Hill End. Many of them had disappeared under the heavy growths of blackberries which are everywhere. Some of them just seemed an enormous hump of deep green foliage, and the blackberry bushes were impenetrable.

I was nosing around a cottage and found a painfully spiky entrance which I managed to enter. Inside, it was filled with rubbish, and I noticed lots of old share scrip, a reminder of how hazardous mining investment can be. But I found a 19th century glass decanter, complete with glass stopper. It had about an inch of rock-like white sediment inside it.

Conveniently forgetting one of the golden rules of Hill End, 'Never take anything away,' I brought the decanter down to Sydney; it would be ideal for whiskey or wine and it looked elegant.

It was midnight by the time I was back in the flat in Billyard Avenue. Before going to bed, I thought I'd put some water in the decanter to dissolve those crystals, leave it to soak over night and see if they had softened by morning. I was in the bathroom as I rinsed the decanter out and I felt it suddenly becoming hot, The next instant it was too hot to hold and it fell into the lavatory. At that moment there was a violent, blinding explosion.

Luckily, I had left the bathroom door open and the explosion threw me back into the hall. There was a thick pall of smoke, and even through it I could see the towels blazing.

The smoke billowed out and I managed to open the door of the flat and escaped, to find everyone coming out of their apartments, in their dressing gowns.

My neighbours Helen and Roger Keyes gave me first aid. Helen was a nurse and she rang for a doctor. My face was burnt and it was becoming difficult to see.

The fire brigade arrived and hosed everything down. The lavatory had been completely demolished and was a jagged porcelain stump. The doctor, a friend, turned up, and instead of immediately treating me, collapsed in helpless laughter at the explosion site. The chief of the fire brigade came out of the building and waved the lavatory seat at the crowd, all in nightwear, yelling, 'Jeffrey Smart is the most powerful man in Sydney.'

All the wise ones wagged their heads and said, 'The golden rule was broken and Hill End has taken its revenge.'

Having a flat, a stable work place, made an enormous difference to my work. One of the two rooms made a good studio. I chose the better room of course, and I soon had things moving. My rent was only 2 pounds 10 shillings a week now, but my income from the ABC was still only 5 pounds a week. This left 2 pounds 10 shillings a week for food, light and gas. The basic wage was about 11 pounds so I was living at poverty level.

There was the odd painting sale, the odd extra broadcast. In 1955 I was getting between 15 guineas and 25 guineas for a painting, but after commission to the gallery I received 10 to 18 pounds. And so I eked out a living. People seemed to think I was rich for some odd reason. Perhaps it was the Italian influence. I tried always to make a *bella figura*. I could

always have a lavish meal at Milano's, but he would never accept any money from me, so I didn't like to push it too far too often.

My mainstay was Mr Watkins's grocery shop. 'Wattie' had been a famous football player and was a well-known local character. His shop (now a chic wine retailer) was next to Milano's in Elizabeth Bay Road. I could run up an account there, and when I couldn't afford to go to the butcher (I had been shown how to make a white sauce), tins of Bronte lambs' tongues and Greenseas tinned tuna or tinned salmon and beef would keep me going. I entertained in style. Wine was bought by the flagon from Doug Lamb, the wine merchant.

As I was leaving his shop one day, Wattie cautioned me, 'You're up to 'alf 'undred now.' There were lots of actors and writers in the area—Wattie must have given credit to some real weirdos.

EIGHT

BY 1956 I was painting much better, and then came the bonanza of television. I had kept my job at the ABC as Phidias, but now Phidias would go on television. I had to go to a television school and learn the trade. It was fascinating and ever since I went to that school I have looked at films in a different way. The cameras were primitive by today's standards, so lighting had to be very fixed, formulated, in the early days. The ABC offered me a good contract with what seemed a generous fee for radio and television together.

In November 1956 I gave my first television broadcast and I was featured on the very first day of transmission. It was a harrowing experience because, in true ABC style, the big well-equipped studios at Gore Hill were not finished in time, and so I had to give my first telecast from a large galvanised iron shed. The walls were corrugated iron and not sound-proof, and we were near the Pacific Highway.

At the rehearsals, which went on for two days, I found I was very nervous before the camera, even on 'dry runs'. I was so nervous it was difficult to control my voice, and my hands trembled.

After the final rehearsal, I had two hours to wait, all made up, all ready. I went down into a quarry behind the studios and meditated to try to calm myself, and I asked for aid. If

I was not going to be any good at it, then it was going to be all for the best. I'd go on being poor, but at least more painting could be done.

The meditation in the quarry seemed to help the trembling and my voice didn't wobble. But as the camera red lights went on and as I was 'on vision' I had the curious feeling I had read about. My knees seemed to turn into jelly, and as I was standing and talking to the cameras I was wondering, at the back of my mind, if I would hold up.

Television turned out to be a lot of work, but the most difficult thing was to think up new ideas for a weekly show. I found myself thinking about it even when shaving in the mornings. I was not surprised to find there was little response from viewers. At the television school they had warned us that television audiences were very passive, unlike radio, where people responded.

After some months of doing television—it might have been a year—a survey had revealed that 'Phidias' Art Gallery of the Air' had beaten 'Lassie' in the ratings. My bosses upped my salary even more. I was making good money.

This success in television was hard-earned, mainly because a lot of time was lost adjusting the lighting for my segment. If I was showing glossy prints of old masters or original oil paintings, as I often did, things would grind to a total halt with the producer calling out 'There is flare.'

In these early days, the conventional lighting was an area light, a back light to avoid cast shadows and a soft spot on the subject. No cast shadows, and no features or objects indicated modelling, or form. Because of my training as a painter, I could tell at a glance as I walked on to the set if we were going to have trouble.

But it was not my place to say, 'This light won't work.' It

happened by trial and error. A lot of my time was wasted in the canteen casually chatting up the lighting man over a plastic lunch or a cup of disgusting coffee. Gradually I got them to understand; even basic things like 'the angle of reflection equals the angle of incidence' had to be dropped casually.

But Gore Hill was also a training centre. As soon as a cameraman or a lighting technician learnt his job, he was sent to Melbourne or Brisbane or Adelaide. So then I would have to start all over again. This went on for eight years.

Two months before I threw it all in, the ABC invited me to give a lecture on lighting to the lighting technicians and cameramen. If only this had happened earlier we could have saved a lot of time.

Since those years at Gore Hill I can never look at a film, whether it is television or cinema, without unconsciously noting where the reflectors must be, where the set ends and montage begins. I can't say it destroys the magic; if anything it is even more interesting.

———————

I was beginning to seriously think that I would be able to return to Italy. It wasn't a question of going over to Europe for a year or so. The aim was to have an income and then buy a one-way ticket.

As soon as I had saved some money, I put it down as a deposit on a house in Paddington. My father said that ten workers' cottages were enough to keep you, but I was more modestly aiming for only four.

When Virginia Woolf wrote, '500 pounds and a room of your own', that was a lot of money. For a painter, even a

small income spells independence and makes a great difference. Perhaps it seems odd that I *didn't* look to painting for making a living. The truth is hard to believe, but I have always been embarrassed when someone buys a painting.

Even though I've seen really silly pictures realising surprising sums, I have always found it difficult to understand why someone would actually pay real money for one of my paintings. So few of them please me. I can understand why Cézanne threw his paintings out the window.

Just around the corner from me, in Elizabeth Bay, lived an old friend, married to a distinguished Sydney designer and artist. He was a member of the board of directors of the largest and most powerful company in Australia. He knew I was trying for financial independence so that I could paint, and he very kindly advised me to buy shares in his company, as many as I could, and quickly. This was in those halcyon days before the expression 'insider trading' was invented, with its connotation of moral turpitude.

As I was going into the city to give a broadcast, I thought I might try to raise some money—I had none to spare—to take advantage of this tip. My bank manager in those days was Mr Caldwell, at the ES&A in George Street. He was not the great blessing that Mr Laurie had been in Adelaide, nor was he the miracle worker that I was shortly to have in Bill Tucker at the Commercial Bank of Australia. But Mr Caldwell was adequate, and I felt I could handle him.

I went to see him and I prefaced my request with some misgivings. I told him I had just been reading my stars in an astrological publication and it said that on no account was I to ask for a loan on this day, because any request would be rejected. I explained the situation and said I needed a large sum, 5,000 pounds, just for a few days, but I realised that it

was useless.

Mr Caldwell was truly shocked that I could believe in the stars. I assured him that these astrological advisers were very reliable and urged him to study them. He was very surprised and disappointed with me and said, 'You know, Jeffrey, just to prove these horoscopes are bogus, I'll lend you that money for ten days.' Feigning amazement and disillusion, I gladly accepted being confounded, and the accommodation.

Just as I was going out the door I heard him shout. I turned around and he was pointing at me, and he cried, 'I'm on to you!' but I said, 'It's too late, you promised,' and got out.

My ambition has always been to have just enough money to be able to be free to paint, to paint full time, and to avoid the anguish of being forced to sell a painting when hard up, even if lucky enough to have a buyer. If I tried to make a name for myself in Sydney, it was solely because it would help sell my work and help me to have some sort of an income.

Perhaps I shouldn't have done all that time-consuming television and working towards having a few houses with tenants. Perhaps I should have taken the risk and just painted. But I still believe the art market is capricious, that it is foolish to rely on selling a painting, and I still feel that I am conning someone when they buy a painting. I have always, or nearly always, avoided selling directly. I've almost always done it through a dealer.

———

Work at Gore Hill became much more relaxing when we started making tapes. It meant you didn't worry so much if something went wrong and sometimes I could make two shows on the same day, saving me a lot of time. It gave rise

to curious situations.

One of these was when I paused by a radio and television shop in the Cross, and the crowd at the window was watching me showing some paintings. I said to a chap next to me, 'Is this any good?' and he looked at me and said, 'It's all right', but he didn't recognise me.

But on another occasion, returning from Gore Hill, I advised the taxi driver to drop me at Kings Cross because I wanted to do some shopping before going down to the flat. I was in a delicatessen and about to ask for some sausages when a woman recognised me and screamed, 'It's Phidias, I've just seen you on telly.' Everyone turned to look at me and, as she was alongside me, I thought it better for my image to order some more stylish pâté rather than prosaic sausages.

Early in 1956 I had a few days staying with Donald at Hill End. The Drysdales were there, staying with Jean and Paul Haefliger. I was going back to Sydney with the Haefligers. The night before, Donald and I had everyone for a party— it was lively, as you would expect.

Next morning Donald and I were rinsing out his eccentric collection of drinking glasses. They were a weird lot, collected over the years, some of them Victorian kitsch, and an absurd one which everyone always wanted: it had 'LITTLE PAM' engraved upon it. We were putting all the clean glasses on a tray, when the leg supporting the bench gave way and the lot of them crashed onto the beaten earth floor; most of them were smashed.

I said, after a ghastly moment—we were shocked—'Oh

Donald, it's like an awful aeroplane accident and losing friends,' and Donald said with mock passion, 'I'm going to miss Little Pam,' and turned tragedy into comedy.

With my bag packed, I was waiting for the Haefliger's car, when suddenly Donald said, 'I think I'll come too,' and he got a small suitcase and threw a few things in it. Then he added, 'I'm not coming back either.' It wasn't just the smashed glasses. He was tired of the solitary life at Hill End.

There were several volumes of his diaries; we made a large parcel of them, wrapping them up well, and we put them up in the roof, through a manhole in the kitchen ceiling. Some weeks later Donald asked his family trustee company to collect them and they were brought down to Sydney. I think they are now in the National Library.

Donald never returned to Hill End.

I think it was Clouzot who made the film on Picasso; anyway this film affected me very strongly. It was made in Picasso's studio, there was an interview and various shots of the master. But most shots were of him at work on a large composition.

They rigged up an easel on a fixed place, and a camera which was completely stable, and the painting filled the screen. Then they took dozens and dozens of shots of the work in progress. You could see each piece of painting, in five or ten-minute intervals, so each correction, each over-painting, every scratching-out was clear.

I had not realised how hard Picasso had to work, and how serious his mistakes could be. Then you would hear him saying to Clouzot, 'It's not right yet,' and there would be

more repainting.

It was a lesson in humility, a hitherto inconceivable side to his character. (The John Richardson book on him is revealing also.) Even after all his work, the painting was still not 'right'. This encouraged me enormously and I worked harder. I made more studies and drawings for my paintings.

Even so, Picasso presents problems for most 20th century painters. Vlaminck wrote, 'Picasso has snuffed out, for several generations of artists, the creative spirit, the faith, the sincerity in work and in life.' Painters like Edward Hopper had to distance themselves from this mighty avalanche of Picasso.

A French critic said of Hopper, 'He resents Picasso because he finds him capricious, although willing to admit that in his capricious images there is power; but it is not the power that Hopper seeks—what annoyed him about Picasso was his "chicness" that would make him sacrifice the fingers in a human hand for the sake of elegance.'

In a really masterly summing up of Hopper's French contemporaries the director of the Louvre Museum, René Huyghe, wrote in 1938:

Bonnard, Matisse, Derain … yours are the names most likely to endure, but will you survive intact! Your lyrical power, Bonnard, your ardent poetry and joy, will they earn entire forgiveness for the inconsistencies you inherited from Impressionism? And you, Matisse, with your prodigious inventions of colour, will they hide the barrenness of your soul? Will your innate sense of grandeur, Derain, suffice to compensate for the note of dryness you introduce into everything?

… As for the magnificent wreckage strewn around Picasso, how the future will deplore the carelessness of the captain! Will people still realize the importance we ascribed, in varying

degrees, to Vuillard, Marquet, Utrillo, Braque, La Fresnaye, Chagall, and sometimes Van Dongen, Dufy, Vlaminck and Modigliani?

These words had a great effect on me, and re-reading them now, fifty years later, I find them prophetic.

———————

By sheer good luck I came by a honey of a bank manager in my last few years in Sydney. Bill Tucker aided and abetted me in my project for independence, showing me some very helpful banking practices.

By 1963, I was feeling like throwing it all in before I cracked up. I was working for an exhibition, teaching at the Tech, doing a weekly radio broadcast in the city and a weekly telecast at Gore Hill.

When I told Bill Tucker I couldn't keep it up—I was 42 and I wanted all my time for painting—he begged me to do it all '*just one more* year'. Then, he explained, you'll be over the cusp and into that world of total independence.

But I did eventually throw it all in, and was glad I did.

My emotional life was a mess. Sydney in the fifties and early sixties was an already liberated place and this pre-HIV time was very permissive. I found out that being promiscuous does not necessarily bring happiness, that one-night stands were not for me.

This was also the time of a group known as 'The Push', a bunch of lively heavy-drinking and loving intellectuals based at the philosophy department of Sydney University. Their meeting place was sometimes The Royal George. Saturday night was definitely the loneliest night of the week if you weren't included in a party where the Push was going after

10 p.m. closing time.

One evening Donald and I were there. We were pursuing two attractive boys who were also hunting in pairs, and the word passed around giving an address over the bridge in Willoughby.

I must have been rather slow with the car because we were late getting to the dull-looking small house, with all its lights on, and lots of noise. The front door was firmly shut and a girl's voice yelled at us through it. 'We're full up, no more. Who's there anyway?'

We called out, 'Donald Friend and Jeffrey Smart.' 'Who?' she screamed, 'Who are you, friends of who?'

Donald chuckled to me, 'You know, any hostess in the eastern suburbs would be overjoyed if we knocked at their door. Isn't this *mad*!' I think she reluctantly let us in.

NINE

EVERY CHRISTMAS I would spend time in Adelaide, and sometimes I was over for Easter. With a broadcast and a telecast every week, it was difficult to arrange a long break, because in the first few years of television you had to go on 'live'. My father was fifteen years older than my mother, and in his seventies his heart became erratic; even I could feel the beat was wrong. Although he was being treated, he became frail and bedridden.

On one of my flying visits, our aeroplane was put on a shelf, and we flew over Adelaide several times. Colonel Light's square mile of inner city surrounded by parks is a beautifully designed place, as is well known. The inner city has a central square, Victoria Square, and four others placed around it. The pilot told us on the loudspeaker, 'Beneath you, ladies and gentlemen, you can see the city of Adelaide, the city of the squares.' Adelaide is reputed to be the first city in the world to introduce traffic lights —I can believe it.

I had a telephone call from Luciana Arrighi, daughter of my friend Eleanora. Could she come and see me, please? She arrived with paintings and drawings. She had been an

Argonaut and was now at the stage of going to the East Sydney Technical College, known as the Tech. Was she good enough to warrant training to be a painter? Did she have enough talent?

I looked at her work and told her she was loaded with talent, but somehow I knew it was not for painting pictures. It was very strange. She didn't seem to be able to compose a picture, something that even a lot of bad painters can do.

There was ability, but she would have to find her own way. Luciana did: she won an Oscar for film design.

One morning I was working in my studio in Billyard Avenue and I had a call from my mother. She sounded very distressed. She said she had received a terrible piece of news, news so awful that she had to see me, quickly, it was urgent— 'I want my son home,' she was sobbing, 'I just want to see my son.' When I asked after Dad she said he was the same.

I made arrangements with the ABC, who were very helpful, and I rang back and said I would be over tomorrow morning. It meant working all day and that evening doing recordings, and lots of telephoning cancelling appointments.

When I rang to say I was coming I asked her if she would be able to meet me at the airport. I was dreading that she was ill, but if she could come to the airport at least she couldn't be too ill. Mildred said she wasn't sure, but she would try to be there.

When I arrived at West Beach Airport I could see her from the plane. She looked well and reassuringly plump, as usual. She was with her brother, my Uncle Nick.

'We'll sit in the back, Nick will drive.' I kept asking, 'What is it? Tell me quickly.'

But Mildred was not going to tell me quickly. She took my hand and composed herself, and then said with difficulty, '*Your father does not respect the vows of matrimony.*' I was so relieved I burst out laughing, asking her what she was talking about.

She was horrified by my callous laughter—it was relief—and said, 'Don't let me think you are as bad as he is.' Thank God she had no idea. I am sure she had closed her mind, and never contemplated my wicked ways.

Gradually, it all came out. Dad was in bed and she was in the garden, then she went into the kitchen to find Nanny sobbing at the kitchen table. Nanny had been with Dad for nearly fifty years and must have also been in her seventies. It seems she was making up his bed and fluffing up his pillows when he made a violent pass at her, with such wildly indecent talk that she had to run from the room.

Mildred went in to my father and sternly demanded to know how he could behave in such a terrible way to Nanny. Under her persevering and insistent questions, and in his weakened state, he broke down and confessed that he had always been a libertine. Poor man, I was furious with him for having told her, but he kept repeating, 'She made me, she made me.'

Apparently, Nanny had been one of his mistresses before he married my mother. Nanny Nicholls had never married, but he had helped her buy a house. Then he switched to her daughter Daphne. As he never went to church much, he confessed that some of his adultery had been while we had been at church, and at one time he enjoyed Daphne while we were inside.

But then more came out. He had kept a mistress for many years, Mrs Johnson at Parkside, where I had been and must have met my half-brother. Before his honeymoon with

my mother, which had been to Tasmania, Melbourne and Sydney, he had made a 'trial run' with Mrs Johnson, trying out hotels and which bedrooms and beds and restaurants were best.

What hurt my mother most was that in the depression years of scrimping and making economies, he was keeping Mrs Johnson all the time.

Mildred went to see Mrs Johnson and demanded to know the truth. It appears that it was all true, but, said Mrs Johnson, 'You were always his Queen'—a very generous statement.

All this tied up with Dad's interest in A. H. Clough, who was also a lifelong and dedicated adulterer, and whose grave Dad visited in Florence. He thought he might be Clough reincarnated. Mum showed me the book of his poems, and the engraving of Clough—there was a resemblance. I have the book with me now, and I agree.

One of her interests, besides bridge, had been the local church, St Colomba's, and she had helped with the altar flower decorations. When Canon Swan called to ask why she did not come to church any more, my mother explained that if there was a God, he would not have allowed this to happen to her. It was very difficult to comfort her.

My father died in 1959. Because of his confessions, my mother had no conversation with him; she was very unforgiving. He had a nurse, Carmen, but I imagine his last few months were terrible; he wasn't in much pain, but he suffered remorse. In his last few days my mother relented and forgave him. I hoped he passed away peacefully.

When the news of his death came I flew over to Adelaide for the funeral. The service was held in the sitting room and Canon Swan read the offices. There were a lot of people. Royce Holland stood next to me. As I related, we had played

doctors and nurses as children, and her father Bertie Holland was Dad's oldest friend.

Practically alongside the coffin, while Canon Swan was intoning, Royce whispered, 'You remember they used to share a woman on West Terrace? I think they were lovers.'

After the service we went to the cemetery. There was no need for a hire car as my cousin Patricia Grove had a handsome Rolls Royce. My mother seemed to be all right because as we glided along she said, 'A knight and a cabinet minister at the funeral service.' (I had slipped her a tranquilliser.)

Dad was duly buried. It is a terrible, surprising reminder of mortality when you lose your father.

Next day Mildred came to me with the very resolute face I knew so well. 'We shall have to exhume your father immediately.'

'What for?' I asked. My mother explained that Dad was buried lying east to west, but his feet were to the west. At the sound of 'The Last Trump', when he rose, he'd be facing the wrong direction.

I said, frivolously, 'If there's something going on behind him, knowing Dad, he'll turn around to see what it is.' (I had no idea she still harboured vestigial Christian beliefs.)

She ignored this flippant remark, and reaffirmed that he must be exhumed, that we should telephone Ivan. He was a cabinet minister and had married my cousin Doff Briggs.

I had to take her seriously, so I said that I'd never known her, in all my life, to be inconsiderate to other people. To dig Dad up at this time would be a very unpleasant task for the grave diggers. 'We must do it,' I agreed diplomatically, 'but we must wait a month or two.' She consented to wait.

But in six months she had married again, a much more suitable union. She married Lindsay Millington, her first cousin, father of Patricia who had the Rolls Royce. He was

recently widowed, and his daughters were very fond of Mildred Millington, as she became. Although the Anglican Church does not approve of a marriage between first cousins, perhaps because they were both 65 they were allowed a church service. It was a real stroke of luck for everyone, and Mildred was happy.

So I had two visits to Adelaide that year: a funeral and a wedding.

———

Mic and I kept in touch. He was constantly urging me to come over to London, not to worry about money, he had plenty, he would back my work. It was a temptation, but I wanted to be independent. Mic had none of these middle-class hang-ups.

He was now working at the BP office in London, and he made several trips out to Australia, mainly to see his mother, but he stayed with me at Somerset Flats. The studio was uncomfortable and had a bad bed and Mic was accustomed to great luxury, but he enjoyed his stays with me. He was popular with my friends and always said, 'Good manners and old world charm work wonders.'

By the late fifties, Mic had been appointed president of BP for Italy and had Toscanini's old apartment in Milan, a grand palace in Rome, and he had acquired a beautiful villa near Florence. Of course I felt very envious of the friends I sent to stay with him; they returned with glowing memories of wonderful times.

TEN

BACK IN Sydney there was a letter from Donald. He had gone to live in Ceylon in a most beautiful place belonging to the architect Geoffrey Bawa. Donald said he was tired of leading an unreal glamorous life and intended to live in Sydney. Could I find him a house? I was overjoyed that he was returning. My real estate agent friend Owen Downing found him a mad little place in Paddington next to Trumper Park. We bought it without Donald ever seeing it and I think he liked it. He settled there in about 1960.

At that time the Drysdales had an apartment in Macleay Street, just at the end of Billyard Avenue. Donald and Justin were near and Mike Shannon had come up from Melbourne to settle in Woollahra, so I had good friends around. I had bought a few shares in Pioneer Sugar, which was Tas's family firm. When we received our dividends, I'm sure that not many shareholders noticed the signature on the cheque, 'G. R. Drysdale', and knew it belonged to one of our greatest artists.

Justin had good friends called the Camerons and Mr Cameron was head of Sydney Telephone Cables, known as STC. Every year they had the STC Ball and Justin, who usually detested dances and balls, loved going to this one. He sat at the official table and always enjoyed it. When the STC

Ball came around one year, Justin complained he had no
black shoes to go with his black tie get-up. I said I had a pair
of patent leather dancing pumps which I never used; they
were very good quality and I'd bought them in a frivolous
and extravagant moment. They fitted Justin perfectly so he
was all set up.

He was living in Elizabeth Bay Road in Chalgrove House
(which we all called Hengrove Hall) in those days. I had just
moved into Billyard Avenue. Some months after this Justin
went through a poor patch. He hadn't sold a painting for
ages, his part-time job at Cranbrook hardly kept him, and
he had the flu.

Feeling wretched, he declared his abject state. He'd just
lent a friend quite a lot of money and he knew he'd never
get it back.

'Look at me here,' he complained, 'I can't even afford
curtains or blinds for my windows.' This was true.

So I said, 'Well, I'm glad I'm not in *your* shoes.'

'I can't even afford to go to the cobblers,' he complained,
and I looked at his shoes, which were terrible old battered
things.

I was about to offer to lend him a pair of shoes when the
cold horror of it came upon me. He *was* in my shoes! They
were my expensive dancing pumps! The ones I had lent him
six months ago. He must have been wearing them every day
since, and to school.

'You monster!' I yelled. 'They're my lovely shoes!' And
with a sly smile of shameless cunning Justin said, 'I thought
you would have forgotten about them.'

Of all the anecdotes about Justin that I had collected,
there was one he never minded hearing again, and it always
gave him a good laugh.

I was visiting my home town and I went to an opening of a Fred Williams exhibition. After the opening, a woman came up to me, and with shining eyes and a smile of pleasure she introduced herself.

'I've just heard that you were here,' she said, 'and I want you to know how much I admire your work. You have opened up a new world for me. You have helped me see the beauty in the world around us.'

I'm sure I was visibly swelling with pride at these sincere compliments and I was saying 'You're too kind', etc.

'And the wonderful way you paint,' she went on. 'I just love the way you paint those angel's wings.'

I was cut down to size. I said I wasn't Justin O'Brien.

'But they said you were the famous artist,' she insisted. 'Who are you?'

I told her, and she muttered something in her disappointment, and moved away.

Because of my job in 'The Children's Hour' I had to seem blameless, and I tried to be discreet. I thought I fell in love twice during this eight-year period. The first one lasted four harrowing years. It was a case of 'the expense of spirit in a waste of shame' and it ended with bitterness.

The other affair was little better. The object of my love was unfocused in his sexuality, and the whole thing dragged on in my heart, even when I left for Europe. It lasted over four years, and they were tumultuous years, with bitter break-ups, ecstatic reunions, a thoroughly tortuous affair. Justin, who was my wastepaper basket and confessor, got really sick of it and would ration my laments to half an hour a day.

On one occasion, when I was convinced it was all over and done with, I felt such despair, such distress that I holed up in my flat, and anguished as I was, I tried to meditate. But instead of meditating, I found myself blubbing, then howling like some poor mad dog. How I howled! There was no question of meditation. I closed all the windows and pulled the curtains to, and went on with this uncontrollable bawling which didn't even sound like me. So I went back to the sofa and tried to think. 'All this might be therapeutic', like voiding, emptying oneself of emotions.

Then a very strange thing happened. As I lay there on the sofa, I felt myself rise and float upwards until I was on the ceiling by the top of the mirror. I looked down and saw, quite objectively, this poor, weeping, wretched figure and felt such compassion for it I decided to return to it. I know I lay myself open to ridicule when I describe this, but Sir Alistair Hardy, in his researches,* has found it is quite a common occurrence.

The Theosophists would say it was my ethereal body leaving the physical. I wonder.

At any rate, I decided to return. I put myself on the list for night work at Callan Park, where I went regularly to conduct painting classes. These were for those poor people who were convalescing from mental illness. They were not well enough to return to the environment which they found insupportable, but too recovered for them to be constantly surrounded by really sick people.

My motives in doing this work were not noble at all, they were self-therapeutic. I showed them how to paint and was able to talk with them about their illnesses. Some of them

*The Spiritual Nature of Man by Sir Alistair Hardy, FRS (Clarendon Press, 1979).

were fine people with dreadful family and financial problems. Helping them to express themselves, and giving them some pride in what they had done, was very good for them, and I think they looked forward to my visits.

I learnt there were people much worse off than myself; some had little hope of improving their situation. I had much more luck, it became obvious. I was helped to do this work by Jim Davenport, and was inspired by the example of Hepzibah Menuhin, who did it with music.

After this experience at Callan Park, I lost my sense of humour with 'loony' jokes; they fall flat with me, it is too tragic.

ELEVEN

THE IMPORTANT art movement of the fifties was abstract expressionism. Paul Haefliger initially considered it lightly, and perhaps rightly, as a wilful plaything. Later the canvas was considered as displaying the battlefield on which the fight to express emotions was won or lost, as the case may be.

Paul Haefliger worked on a long article for the *Sydney Morning Herald* which was published on the leader page. He called it his manifesto.

Some of the work produced was exciting, but I knew it was not for me. We used to have passionate arguments about it, and I remember Jeannie Haefliger ending a long haggle with 'Look, it's so difficult to paint just one good picture, and I am only just learning to do it my way, and I'm not going to change style and try any other.'

Donald responded to the movement by inventing his 'Topo-Diffusionism'—a meaningless send-up—something he took quite seriously after a while.

It wasn't a question of 'liking' or 'not liking' abstract art—we had admired abstract works for years. As a student in Adelaide I had liked Kandinsky's work very much, but I always preferred his hard-edge later work.

What amazed me was hearing 'so-and-so has gone

344

abstract'—it all sounded rather evangelical. So many painters I knew hopped on to this bandwagon. It became thought of as a logical progression. The artist started off as a realist, then simplified and cubed his shapes, and then lifted these shapes out of context and made an abstraction.

Where do you go from here? We know the answers now, but in the fifties abstract expressionism dominated the scene.

I now think of the abstract expressionist movement as a disaster; it is historic, but I believe it is receding in importance. It was a disaster for art instruction. So many painters moved to abstraction that it was thought unnecessary for a student to learn to draw and paint the figure. But there was nothing really new about it. Kandinsky's *Old Forms* was painted in 1914 and is virtually abstract expressionist.

If you look at the influential art magazines of the period you will notice a period of about ten years in which hardly any figurative contemporary painting is reproduced. It became considered as defunct, especially in America.

It seemed impossible for 'avant garde' painting to return to the image. Realism, they thought, was for the fuddy-duddies, and it was not until the sixties that Rauschenberg and Jasper Johns made the return respectable (with Andy Warhol following them always about two or three months behind).

It was probably disappointing for those who thought painting was evolving itself out of existence. But how could they think easel painting, and the painting of an image, could die? Man has been drawing and painting images for at least 20,000 years.

Of course there was Hopper and Wyeth, Francis Bacon and Lucien Freud and Balthus, but they were not repro-duced a great deal in the American art magazines of the fifties and sixties. Australian artists were feeding off

these avant garde magazines. The appearance of every *Art International* and *Art News* was an event. The English *Studio* magazine was too staid.

These overseas magazines were vitally important. We all fervently thumbed through them, reverently believing they indicated what was going on. We didn't realise that art editors listened to some rich gallery directors. Abstract expressionism was a great movement, everybody seemed to think.

It was a glum depressing thing anxiously going through these glossy pages, looking for a figurative painting, hoping for even a landscape, a figure composition, or even a still life—but no, it was all abstract. Some of the titles were very literary, some very pretentious. Julian Schnabel, later on, was to paint what looked like an abstraction and he called it *A Portrait of God*. What nonsense; how vainglorious!

In Sydney, the Blake Prize for religious painting was awarded to an abstraction. I was with Justin O'Brien when we were standing near two artistically pious eastern suburbs ladies. They were looking at the winning work, really puzzled, and one said, 'Let's see what its title is in the catalogue.' Her companion found it and she said, in an awestruck voice, 'It is *The Moment Christ Died*.' They looked at it with even deeper respect. The whole thing was turning into the literary byways of English Victorian art and the *When Did You Last See Your Father?* sort of thing.

The abstractions went on and on for years, and it was a joyful shock one day when I actually saw a figurative painting reproduced in *Art News*. There it was, amazingly, the only figurative work in the whole magazine. I felt like Noah when the dove came back with an olive branch. It came by courtesy of 'the Felix Landau Gallery'. Who could this astonishing pioneer be? How did he come to have the courage to show a figurative work in Los Angeles at that time? A few

years later I saw another realist work reproduced. This came from the Landau-Allen Gallery in New York. I felt this mysterious supporter was moving closer. It must be the same Felix Landau, surely.

In 1957 Paul and Jean Haefliger decided to return to Europe. The Farmers' bill was paid at last, the house was empty, their oriental works given to the Art Gallery of New South Wales. They first went to India to see Paul's sister, and then to Paris. I missed them terribly; now Donald had also gone, it made getting back to Europe imperative. Justin O'Brien was also getting restless. Mic was still asking when was I *really* going to move?

TWELVE

A FAT envelope addressed to Phidias bore a New Guinea postmark. It contained a letter and about twenty postcard-size watercolours. The letter was from a Roman Catholic priest stationed at a New Guinea mission. He wrote that my broadcasts were heard with great interest by the children at his church, and he stated that none of them had ever been in touch with Western civilisation. They couldn't have understood much of what was said because the laborious little watercolours were copies of photographs of English tourist spots.

With permission from my superiors, I wrote that his religious work was not my concern, but I was very concerned by what he was doing artistically, and that it was not only harmful, but arrogant. My letter pointed out that the people of New Guinea already had their own very important art and should be encouraged to continue practising it.

The priest sent a really moving letter, turning his Christian other cheek and thanking me for making his error clear. The ABC sent him huge sheets of paper and pots of the colours New Guineans used. A month or so later we received a large, beautiful mural-sized painting. It was very impressive and for some years decorated the entrance to the premises in William Street.

The year 1961 was darkened by the tragic death of Tim Drysdale, Tas's only son. I had known him since he was a child. He was a wonderful little boy. As he grew older he sometimes became difficult. How are you to know that this is an illness? How were we to know these were signs of schizophrenia? He used to drop in and see me in the flat in Billyard Avenue, often late at night. He wanted to have a soul-scratch, and sometimes we were able to talk well, but he never told me he thought he was ill. I found it hard to believe he had been so monstrous—which he was—with his parents.

When he felt a bad attack coming on, he wrote a very moving letter, and took his life. The day after this Tas and Bon were occupied, mercifully, with police and lawyers. But after that was done, Tas was at a loose end, in despair. He came and spent the day with me. I pretended I had to work and sat at my easel and Tas sat behind me. He was able to talk, and talk, the best thing he could do.

David Strachan and Elspeth Baldwinson were with Bon, and Lin and Bill McLaughlin, Lin's husband, of course. In the late afternoon I had a call from David. He was furious that Tas came to me, and he never forgave me. It was the end of our friendship.

I had an idea for a painting at Taylor's Square; I'd done some drawings there. It was to be a female nude, sunbathing on a roof top. I had a good model at the time, and she posed in my studio for it. The picture came off, it was good, and it was exhibited at the Macquarie Galleries. Most surprisingly, it sold. (Buyers usually steer clear of female nudes for some reason.)

Roy Davies was the head of East Sydney Tech, now known as the National Art School. Davies visited my show and was impressed by my nude. He told artist Treania Smith that apart from the stodgy old academics he didn't know there

were any modern painters in Sydney who could paint the nude.

The upshot was that I was asked if I would take life classes at East Sydney Tech and I began spending two mornings a week there, from the first term in 1962. I taught there for two years, on Tuesday and Wednesday mornings. (*Taylor's Square* ended up in the National Gallery in Canberra where, along with *all* my other works, it is never shown!)

In my life class once the model had taken up her pose, I insisted that no talking or moving about was permitted. This was the most strictly disciplined class in the whole school. If anyone was late they had to wait outside until the model rested. Even with these unaccustomed restrictions, it was gratifying to see the response, and I took it as a great compliment that a queue always formed in the passage outside the life room in the hope that someone was sick and they could sneak in. I really made them work, and they loved it.

Teaching at the Tech was no great strain, and during my second and final year there I couldn't help noticing a very attractive student in the next studio. He was Ian Bent, but I couldn't find any excuse to speak to him and he was usually with other students. He knew I noticed him of course, and he was aware of the attraction between us. It was only in the holidays, at the end of the year, that I met him by chance in Pitt Street, and I asked him to visit me at Somerset Flats, which he did.

He was very nervous, but I found that as a lover he was surprisingly experienced—something he coyly tried to conceal. He had a violent personality and forthright opinions, expressed in quite a deep baritone voice; surprising, coming from a small body.

My plan was to abandon the flat, drive my disintegrating old Ford Customline to Adelaide where someone just might buy it, spend Christmas with my mother and Lin Millington, then fly back to Sydney and leave on a ship that same day.

Unsold paintings were left with Macquarie Galleries and John Brackenreg (painter and gallery director) in North Sydney. I left the furniture in the flat, selling it to L.J. Hooker for next to nothing.

By coincidence, the next tenant was Daniel Thomas. Although curator of Australian painting at the Sydney Art Gallery, he was also art critic on the *Daily Telegraph*, the job which I had created. He must have found a lot of the furniture I left behind distasteful—he is such a purist. The only thing I guess he found acceptable was my dining table. Perhaps he also liked the mirror.

I had a few precious books put in a small crate and sent to the shipping company. The rest of them I gave to my students and Ian Bent took some of these. I also gave him my easel, the one I had taken to England.

In the middle of all this, I had the news that dear little Bonnie Drysdale had taken her life. I couldn't bear to think of Tas. He had Lin and Bill, but it was hard, very hard. There was nothing I could do, I was leaving.

I gave my last telecast and last broadcast in late December, and said goodbye to all my friends. I felt very pleased with myself. The four houses I had managed to buy were all tenanted, with my friend Owen Downing looking after my tiny empire. The rents were enough to keep me and I should not have to rely on selling paintings in order to live.

I was cutting loose; the fact that my four tiny houses were mortgaged didn't worry me a scrap.

BOOK FOUR

ITALY

ONE

THE *CASTELFELICE* sailed out of the harbour three days after Christmas, bound for Naples and London.

When Montaigne wrote 'the journey not the arrival matters', we know what he meant, but taken literally, when I looked about and saw my fellow travellers, my heart sank. I already longed for the arrival.

At 42 I was about the oldest person on the ship. A lot of the girls turned out to be physiotherapists, or if they weren't they were going to study it. The chaps were school teachers, clerks, radio mechanics; no musicians, painters or writers.

The ship was one class and, thanks to Dickie Keep, I was the only person on the ship to have a cabin to myself. There was another bunk, but I managed to get the steward to dismantle it—I had more space.

Just before the first meal was served, and I was looking around, despairing, a young chap came up to me and introduced himself. 'You're Jeffrey Smart, aren't you? I'm Bruce Beresford. We've met before.'

Bruce's companionship and then his friendship made the journey supportable. I hadn't realised how aggressive girls can be. Bruce was very dishy-looking and they would brazenly suggest he buy them a drink but he knocked them

all back. We became so close I felt I should come clean with him and informed him of the true nature of my erotic desires. He was dismayed and completely flabbergasted, and insisted I was joking; his reluctant acceptance of me was touching. I am godfather to his first son, Benjamin.

The food was diabolical. It was vaguely based on Italian cooking, but everything went seriously wrong. When we were in the Red Sea a passenger tried to commit suicide by throwing himself overboard. It was distressing to see him resisting his rescuers, and to lighten the moment we said he must be a gourmet.

The ship stopped at Singapore where my niece Margaret, Dawn's daughter, lived. She had married a very nice Englishman and had a splendid house with good views of what I thought was a pretty dull place.

We then stopped at Colombo, Aden, Suez, then Naples. I had written to Mic, and he assured me he would arrange to be in Naples when I arrived.

It was thirteen years since I had left Naples, so unwillingly, and I was unbearably excited at the thought of seeing it again, if only for a day.

Mic was there on the wharf, with his friend Harold Jensen and their driver. The car was a magnificent Bentley— what a welcome! We put my box of books in the boot, and as we glided through the customs, Mic waved a yellow paper, the guards saluted and passed us on. Knowing Mic, I asked, 'What was that yellow paper?'

'My opera tickets for tonight,' he said. It was the authoritative way he waved the paper, and the car of course.

We had a wonderful day, and lunch at La Bersagliera— quite unchanged—and we arranged to meet in Florence in a few weeks' time.

Justin O'Brien was arriving in London at the same time,

and we planned to go to Paris, buy a car, and then drive down to Greece where we would spend the summer.

We had a little trouble at Southampton where the ship berthed, very early in the morning. Everyone had to queue up with passports for an 'entry permitted' stamp. Bruce was next to me and the immigration officer he got was a displeasing, sniffy-nosed little chap.

Bruce had pulled on an old polo-neck sweater (it was a bit dirty), he hadn't brushed his hair, nor had he shaved for a few days. He looked disreputable.

'And how long do you propose staying in England Mistah ...'—glancing at the passport—'Mistah Beresford?'

'I dunno.'

'Oh, we don't know, do we?'

'And what work do we propose doing in England, Mr Beresford?'

'I'm going to make films.'

'Ah! We're going to make films, are we? How much money would you have in the bank, Mr Beresford?'

'That's nothing to do with you.'

'Nothing to do with me! You wait over there please, Mr Beresford.'

I stepped forward. I'd had the sense to wear a tie and look respectable. Bruce could have been listed 'undesirable'.

'I can vouch for him,' I said pompously. 'He's very famous in Australia, and we don't want his influential film friends here making trouble.'

Bruce was allowed in.

We hadn't been in London for such a long time that several weeks were needed to see old friends and the galleries, and

the National Gallery reminded me of what I had been missing for all those years. Justin and I took a flat just off Sloane Square and we were able to entertain, and see some theatre and opera.

Among the friends who entertained us were Luciana and Nikè Arrighi, the daughters of my great friend Eleanora in Sydney. Ernesto, their father, had been a diplomat–painter, and both of them were gifted. They entertained me in their flat in Kensington, and the living room walls were lined with silver paper. This was two years before Andy Warhol did it. Do young people have an international telepathic link with each other? I often think they do.

Luciana was doing well designing sets for BBC television, and Nikè was an actress, and getting work.

There was a very important, even historic, exhibition on at the Whitechapel Gallery. This was the large survey made by Brian Robertson of Robert Rauschenberg's recent works.

As I have said before, abstract painting and abstract expressionism had ruled the roost for so long that it had become academic, supported as it was by influential curators and editors of art publications.

But here, with Rauschenberg, was a loud declaration of a return to the image. It was a raucous and witty statement, often surrealist, but I felt the drought was over. Rauschenberg's works hooked Art back to the fertile source of all painting: the visual world and, what's more, the contemporary world. It was no longer old hat to be figurative, and Pop was going to be a great liberator. A lot of people were stunned and shocked by it; but it was very important, and good news.

I received a long letter from Ian Bent, about ten pages. In his writing, he revealed himself as very tender and sweet, and he loved me it seemed. This was a great surprise, so

great that I decided to put off replying to him for a while. I had to think about it, it was so unexpected. The relationship had been sexually acrobatic rather than sentimental. Now I was receiving tender affection.

Brett and Wendy Whiteley asked us around to their place, which was quite near. I always liked Brett very much, and had first met him at Hill End when he came to see Jean and Paul Haefliger. He must have been about 18 then. His enthusiasm for painting was endearing. There was something sweet about the way he sent himself up—we always felt relaxed with each other.

Brett had rented Holman Hunt's studio and this is where Hunt had painted *The Light of the World*. Brett was painting his Christie series, and Wendy in the bath. Holman Hunt must have been turning in his grave.

We saw a painting he was working on, *Wendy in the Bath*. Brett had a plumbing pipe with a shower spray attached to it; it was leaning up against the wall beside the painting. He picked up the tube and brandished it, exclaiming, 'Why can't I attach this to the painting? Why not?'

Justin responded with, 'And why not! Then you can chop off one of Wendy's legs and put that on, too.'

This was perfect, logical criticism, and Brett glanced at Justin with a look of shrewd appraisal.

TWO

JUSTIN AND I left London at the end of January and went to Paris for a few weeks. We stayed at the Hotel Racine, in Rue Racine, just by the Odéon. It is excellent to travel with an old friend, you know each other's ways. Justin as a travelling companion was the best imaginable; exasperating but never boring.

Exasperating? I give just one example. When we went to restaurants, he almost inevitably ordered chicken, roast or grilled chicken. He would then pronounce French food (or English or Greek food) to be monotonous. You may say the Spirit of Adventure was missing.

My idea was to motor down France avoiding all the main roads so that we could see the 'real France', staying at little-known towns and eating local foods. I had a guide book and a map, and foolishly expected Justin to navigate for me.

We bought a second-hand Simca in Paris and despite being very cheap it turned out to be a game little car. Unfortunately it had been painted in a hideous unsuitable baby-blue colour. When I had it changed to aluminium in Rome it looked marvellous.

On the first afternoon I said to my travelling companion, 'Let's stay somewhere out of Orléans. What's a good town nearby?' As Justin perused the map it dawned on me that he

couldn't read a map; he wasn't going to be much of a navigator.

Then he told me that the last time he was in France he went with Marion Hall Best, by car. They left from a port in Wales. I said loftily that he was getting mixed up with when he went to Ireland and he turned on me with Irish rage. 'Who made the trip, you or me? I tell you we left from Wales!'

Such disdainful geographical waywardness was challenging. As we went into a restaurant I'd say, 'If you order chicken again I think I'll kill you,' but he usually did order roast or grilled chicken.

When I had been in Europe in 1948, 1949 and 1950, all travelling was by train or bus; the luxury of your own car was impossible. So it was a great pleasure to be able to drive around Europe like this. In 1964 there were few autostradas in France or Italy, and if you kept off the main roads, driving around looking for little-known places and restaurants was a great joy. You can still do it today, but it takes more cunning, and lots of research.

Justin and I drove from France to Genoa and then to Mantua—never seen before by either of us. A very bad road. We stopped the night at Cremona. Next morning we decided to look around the town separately, and meet up at the Duomo at 12.30.

About three years before this, in Sydney, we had been in Milano's restaurant. When we came out, it was cold and raining. Justin had no overcoat of course. Mary Primo said, 'Look, Mr O'Brien, a client has left his Burberry coat here years ago, it's just been hanging up here, why not take it?' Justin did. It was a handsome coat, but it was for a very large man. Justin is not small, but it was far too big for him. It almost touched his feet and he rolled the sleeves up, which gave it the appearance of a dressing gown.

Justin wore it everywhere and brought it to London. It never occurred to me that people would think he looked strange, I had become so accustomed to it.

In Cremona I stood waiting for him and spied him making his way across the piazza, skirts swinging, hands clasped in front, and the fashion conscious young Italians alongside me all burst into fits of laughter.

Justin joined me saying, 'What are they all laughing about?' and I said, 'You! You look such a freak.'

After lunch, I insisted we go to a men's wear shop and buy an overcoat. The old one was so tattered, I said. For a man who has little vanity, Justin has a keen sense of style and he unerringly chose a handsome tweed overcoat. It was appallingly expensive, but when he asked me how much it was in pounds I fibbed and said it was reasonable. 'Get it!' I cried.

We made our way down Italy, staying in Florence, and visited Mic in total grandeur. In Rome it was back to the Rex in Via Torino. From Rome I wrote a long letter to Ian Bent.

Both Justin and I were longing to get to work, so we only visited Sicily cursorily.

Nothing can be more boring than descriptions of scenery when travelling. But I must tell of the remarkable mountains, quite unknown, right in the foot of Italy. This area is known as the Greek Sila and often referred to as 'Little Switzerland'. The Sila itself is a high plateau, ringed with what can only be described as choruses of mountains.

The inhabitants speak a sort of Italian-Greek because they came from Greece hundreds of years ago. The local domestic architecture and the folk art are unique. As far as I know, the area is still unspoilt, mainly because it is so difficult to get to.

We crossed Puglia to Brindisi and by the end of March we were in Greece, at Patras. Justin was very moved to be back there. He had been captured by the Germans in Athens and made a prisoner of war.

On our first night in Greece we dined in a good restaurant in Patras. The walls were decorated with framed and glazed black and white photographs of tractors—twelve of them—we were back to the calendars. Justin said that was very Greek.

At the table next to us was an American couple. They were horrified to see that a little waiter was only about 11. Justin explained he was the 'micro' who looked after napkins, water, cutlery, and was certainly the son of the owner. His joy, his enthusiasm for his job was obvious. But the Americans were talking about reporting this case of child labour abuse to the authorities.

THREE

THERE STILL remained the big important question. Where were we to spend the summer?

Athens would be terrible. My first longed-for glimpse of the Parthenon was as it appeared over some grimy dusty factories and I swerved to avoid a dead dog and landed in a huge pot-hole.

We found a small hotel called the Xenia Melathron, just behind the Grande Bretagne, and I asked everyone I met for suggestions for a summer stay.

Athens was still spared the blessings of television, even in 1964. We heard terrible stories of rich Athenians who had already bought their television sets. They would sit, night after night, watching transmissions from Sofia or southern Italy. There was only static to watch, sometimes some sort of distorted image. But they enjoyed being able to boast next day, 'I've got tired eyes from watching our television.'

With no television to watch, the night life in the Plaka, the old town, was astonishing. There were bands playing and people dancing; restaurants were vivacious. We saw patrons getting up and singing from their tables. There were few tourists, and we were fortunate to see all this before it became false and commercialised.

We stumbled on a most enchanting restaurant at the very

top of the Plaka, right up against the cliff face of the Acropolis. The menu was only in Greek, no English translation—a good sign. The owner must have had a client who was the agent for electric shavers. In the centre of the garden was a giant electric shaver, over a metre high, and it was encircled at the base by geraniums. It must have been used for a trade fair display. It was pure Pop; the restaurateur had never heard of Oldenburg of course.

We were still searching for a summer retreat, and we wanted somewhere unspoilt. Not Mykonos (already fashionable) and not a big town. After a lot of asking about, I was recommended to try Skyros, an island in the Sporades. It was a day's journey, crossing over to Euboea, then to Kimi, where I garaged the Simca, and on to a ship to the tiny port of Skyros, which had two houses. Then on by *carrozza* to a beach called the Molos and a displeasing modern hotel. From there we found a fisherman's cottage, along the beach. The house was almost on the water.

Three rooms, and the fisherman's wife would 'do' for us. No bathroom but a kitchen, and no running water—that came from the well—and no electricity.

We had a fine terrace with tremendous views. It was spectacular. The lavatory was behind the house, on a much used donkey track, and it was favoured by passers-by, not always efficiently.

Despite the splendour of the view from our terrace, within an hour of moving in Justin had washed out some underpants and singlets and with that unerring Irish flair for squalor, had rigged up a clothes line across the terrace.

When I sauntered out of my room to admire the view I was outraged to see the panorama blocked by the O'Brien's underwear, and when I protested and insisted it all come down immediately, Justin thought I was being very prissy.

We both settled down to a long productive summer. Near us was a small house which belonged to Theodoro and Kokalenya, and she was a fabulous cook. She had worked for an embassy in Athens. Every now and again you would see her pottering around the foothills searching for herbs for the exquisite meals she cooked for us. Her two-roomed house was the restaurant, and we ate in the kitchen, near the stove.

When it was warmer, they put tables and chairs outside on the beach, with hurricane lanterns. Everything, except the cooking, was primitive.

The town of Skyros was perched high up above us, a donkey trail needing twenty minutes on foot. In the town there were a few basic shops. One general store, a post office, but no bank. There was the platea, or piazza, with a bar and one eating house, which served unbelievably atrocious food. The main building of the town was the church with a small monastery attached.

Life in Skyros, in 1964, had not changed at all for several hundred years. The only innovations would have been the daily bus from the little port, and an uncertain quavering electrical system, but only in the town. The port was served three times a week, and the bus dated from the thirties. If you missed the ferry at Kimi, you could wait around for two days.

Every evening Skyrosians would walk around the piazza, in pairs, or trios, sometimes a group of young men. Women never walked by themselves of course, and then only with their husbands. It was an evening parade and they walked clockwise, greeting each other. It was a formal and important daily ritual.

There must have been a town Council House but I couldn't distinguish it from the other buildings. Most of the

houses were simple cube shapes, painted white; sometimes you could glimpse a small courtyard garden through a grille.

The bar had a wireless set which usually played Greek music of an undeniably Turkish character, although they all loathed the Turks and swore there was absolutely no cohabiting during the Turkish occupation. The Turkish names of the repellent food must have been sheer coincidence.

As there was no television, life in the platea was very lively, as in Athens.

We quickly learnt that we couldn't give so much as an interested glance at the youths of the town. If you did indicate the slightest interest, they were around you like flies and would follow you about. They were poor and bored, and inevitably bisexual. Rather like Ischia fifteen years before. But they were provocative because they shamelessly flirted with you.

At Easter we attended mass at the largest church in Skyros, St George's. It was a moving service, and the men sang. Everyone had to hold a lit candle, and through the crowd we saw the most beautiful very blond boy imaginable.

His name was Lennart, and he was Swedish, and 20. Over a disgusting meal in the restaurant in town, he told us that his psychiatrist in Stockholm had urged him to go to the Mediterranean. He was interesting, spoke perfect English and we both liked him immediately; he was also very funny. He told us of the horrible room he had in the town and we said, 'Why not come and stay with us. We have a spare room.' And he came that evening and proved wonderful company.

I had done some drawing around Brindisi and I had some ideas about San Cataldo, a beach in Puglia—concrete bathing sheds with flat roofs. There were also a few themes near Athens which I had drawn and photographed.

This was the first chance I had had to work full time for twelve years—since I painted *Wallaroo* in Adelaide. It was amazing how much one could produce. I could see an exhibition forming, but I didn't think about it too much, it was so good to be able to work so hard.

Justin must have been a monk in a previous life, doing illuminated manuscripts. He sat down and started to work after breakfast and he could work all the way through to lunch, a short break, and then back to work until the light failed. He was such a dedicated painter, with terrific staying power. I could work for two hours, or perhaps three, and then I'd have to break; I couldn't work the hours Justin could, my concentration would go.

By placing a chair on the terrace with some fabric over it, Justin was painting a picture of our surroundings, including the panoramic view. The great distant cliffs resembled Gibraltar, the town something like a Calabrian mountain village. (No sign of the banished underpants in Justin's painting of course. I told him my style was more honest; I could put lines of washing in my work.)

It was a productive summer. When the heat arrived, we could take a dip in the water, almost at our feet, to be refreshed, and back to work.

Lennart was writing a play, but he was happy to pose for us whenever we needed a model. Justin did a lot of drawing of the town and of our surroundings.

We discovered that there was an American family living 2 kilometres away, further along the beach—Bud and Sylvia Wherheim. He was a painter and had, like me, studied with Léger. They had three daughters, who had been born in America, and then they moved to Paris and after a year or so took a house in Skyros.

There was a lesson here in linguistics because the girls had picked up English, French and Greek. When Sylvia noticed them playing and becoming too argumentative she would cry, 'Children, play in French!' and she noticed changing the language changed their behaviour.

As the summer set in, a few people arrived, renting rooms from Skyrosians. There were also people at the Xenia Hotel on the beach, down from the town—to be avoided, we decided.

The breadman was very absent-minded and often forgot to leave bread for us. It was 3 kilometres to the nearest shop. I had to keep a look out for him. I thought the word for bread was *psomi* and when I called out at his retreating figure Justin said it sounded like 'piss on me', an odd thing to be yelling at the top of your voice.

I had a letter from Anne and Laurie Le Guay, old Sydney friends. There were coming to Athens—would I like to go on a yacht cruise with them? It would be on a share expenses basis. A few days in Athens, and a trip around the islands would be marvellous, and I contacted them at their hotel, The Plaka, and said I'd be down with Lennart, my Swedish friend.

We drove down and stayed at the Xenia Melathron again. Laurie was impressed that I was staying there. It was old, luxurious, small and inexpensive and he had forgotten about it.

The great trip was not on. Anne and Laurie were constantly bickering (they rowdily divorced later) and I couldn't afford the surprisingly high expenses. Despite the bickering we had a wonderful few days with them in Athens. We found a good restaurant-cum-dance place in the Plaka. The men were dancing up on the stage and, to much applause,

golden Anne danced with them. She had a wonderful figure and nearly caused a riot.

When I got back to Skyros, there was a letter from John Brackenreg in Sydney. He had just sold a large painting of mine for a high price. We could have gone on that cruise. I comforted myself with saying it was better to be working.

FOUR

JOY KOULENTIANOU arrived, an American woman married to a 'big-time' Greek sculptor working in Paris. Joy helped teach me some Greek; she was fluent. It all became different once you acquired even a few important words. She was known as '*Kyria Hurrah*'. '*Kyria*' means 'lady' and '*hurrah*' means 'joy'—from which we perhaps derive our 'hooray'. (I learnt '*tachy*' means 'move', and '*dromo*' means 'way' and so the postman is the *tachidromo*.) I formed a pathetic total of about 200 words as a vocabulary.

Joy was extremely attractive and she often found the admiration of Greeks too indelicate. Their attentions were not subtle, their passes too violent, as one would expect. One evening she was walking back to her house when she was quite savagely harassed by a man who she had thought was a respectable alderman of the town. When she firmly repulsed his attentions, as a last desperate resort he said, 'All right! But if you won't give it to me, I shall refuse to salute you at the evening parade.'

Soon after Joy arrived, her friend Spatch Katsimbalis came. Her husband George was the famous 'Colossus of Marousi' of Lawrence Durrell—poet and writer and friend of Seferis. Thanks to Spatch we met Sara Caruso, Egyptian wife of an Athenian surgeon, and we were told she was the

371

original for Durrell's Justine in *The Alexandria Quartet*. She was very lovely indeed, and I could understand the havoc she wrought.

Joy was passionately interested in painting and sculpture. Towards the end of summer I showed her some of my work and she later paid me a compliment, saying casually, 'You know you're good, don't you?' I was very encouraged.

Brian Dunlop turned up quite unexpectedly. He had become a close friend of Justin's before we left Sydney, and I always enjoyed his company. He was having a difficult time with his painting—he hadn't yet found his personal style.

A real freak turned up, an American drop-out called Stanley Barr. He had taken so many drugs for so long that his eyelids had fallen and he couldn't see properly. He had glasses made with little steel frames which kept his eyelids up. Consequently he was always shifting them in order to blink.

Stanley created a sensation at the bar in the platea up in the town. We went with him, to do some shopping, and then sat and had a drink. The inhabitants of the bar were all men of course, and greedily watched the doings of the foreigners while pretending to talk with each other.

We always collected our mail from the post office, and it gave you immense prestige when they all saw you with several airmail letters to open. Stanley must have designated the Skyros post office as poste restante, because the post-master came over to him and asked was he Stanley J. Barr? When Stanley said he was, the postmaster asked him to collect his mail please, it was blocking up his room, but Stanley said he didn't want it.

The postmaster then appeared with a large heap of mail and dumped it on Stanley's table. Stanley asked for a rubbish tin and without glancing at the envelopes took them

one at a time, tore them in two, and dropped the pieces into the tin, and went on chatting—a great awed silence descended on the Skyrosians.

Stanley talked about mescalin and I became interested because I had read Aldous Huxley's *Doors of Perception* and was intrigued with the Bergsonian implications. All I had ever taken was a little pot, but I felt Stanley thought I was a reformed junkie. He asked me if I'd be interested in going on a mescalin trip with him, and I said I certainly would think about it. Apparently mescalin is best taken with someone else—you need the company, there is less joy going it alone.

In Athens, Stanley had gone to a printing press and had some stationery printed. He had also reserved a box at the Athens general post office.

'Stanley J. Barr MD (Boston)

Psychiatrist: Athens General Hospital

Box 230 GPO Athens, Greece'

and with this he had typed out, and signed, a request to Burroughs Wellcome in the United States for a supply of mescalin.

It is amazing that he could get away with it, and astonishing that it worked. Anyway, he had the pills, and he proposed we 'go on a trip'. I wasn't to think about it too much; he would just turn up one morning.

Sylvia and Bud Wherheim became great friends. Sylvia had been a professional mathematician in Washington before she met Bud. Bud had studied painting in America as well as in Paris. Both of them were in their early forties, and both were convinced atheists, but they weren't aggressive about it.

They recounted an experience they had in Skyros. They took a rowing boat and decided to have a complete day's

holiday, no work, no children, on a little beach they had found which was quite deserted as it was inaccessible by land.

Just for fun, like a couple of children, they decided to build, in clay, a small statue of a 'god'. They finished it, and then put wild flowers at its feet in mock tribute.

A few days later they thought they would row the boat around to the bay to see the spot again. When they arrived, they picked more wild flowers to put at the feet of the god.

They both swore to me that the god had assumed an importance, had such a presence about him, it would be impossible to demolish him.

FIVE

STANLEY TURNED up a few days later, after breakfast. It was about 9.30 a.m. He was rather serious, and I felt apprehensive. He produced two pills and we took one each, and then waited. There was going to be no work done today, I knew that from Huxley's description.

Although it is impossible to describe the effect it had, I am going to try. As we waited, the first thing that I slowly became aware of was a low hum, all around me, a lovely warm sound as if the whole universe could be heard.

Then, gradually, everything went into colour, comparable to when a black and white film you are watching slowly goes into colour. Of course I think I'm always aware of colour, but this was as if I'd been colour blind before. The colour was not exaggerated, it just became more intense, richer.

As this was happening, I began to see space as I'd not conceived it before. A breeze passed through a nearby tree, and I could feel it passing through all the leaves, by every leaf.

I concentrated on the distant cliffs by the sea—always a vast blue mass—and as I looked at these cliffs I could make out the birds settling around their nests. Was I really seeing this? It looked like a 'close up' through a telescopic lens.

Was I the telescopic lens, I wondered. Huxley, who had very defective sight, said he saw things sharply under mescaline.

No words are too extravagant to describe the experience—I was transported into a blissful ecstasy at the wonder of the great beauty of the world. Yes, I told myself, we were already in a spectacular place, but even that seemed enhanced.

Stanley was a sympathetic and experienced traveller for me. He suggested we swim out to a distant reef, always tantalisingly visible, but too far out. I had to explain to him that although I had been a good swimmer, I was asthmatic, and I'd never make it, now I smoked so much.

'Man!' yelled Stanley, 'You don't realise your potential. Just let's try it.' We did. As I swam I noticed I felt every part of my body moving through water. We reached the reef and clung to it and I wasn't even out of breath; neither was Stanley. Okay, I said to myself, it must be your heart, it has affected it. I took my pulse and it was very slow.

I had turned all my paintings to the wall because I suspected my critical judgement would be highly fallible. All I saw was my palette, which looked sumptuous and gorgeous.

We turned the wireless on and were lucky to have the Athens radio station playing Handel. It sounded very slow, majestic. Perhaps misleading, like my pulse? There are several poems I have memorised and always recited to myself. I tried writing out one by T. S. Eliot. When I re-read it afterwards, the mistakes were only the usual ones I make. So I don't think my brain was impaired. Indeed, when Stanley and I studied a rowing boat on the beach, we decided it was built by one man, and that same man had made all the copper rivets himself. The owner turned up and confirmed what we had guessed.

Justin and Brian Dunlop had lunch with us, and I asked Justin if I looked different, drunk, was there anything odd? He assured me I didn't seem at all different.

Unfortunately, there was no one with whom I wanted to make love under mescaline. I have an old friend here in Tuscany and he said he and his wife made love under mescaline years ago, and it was fabulous.

Stanley and I went for a long walk in the afternoon. I could write about that also, but I think too much of this transcendency described can be boring. It was a walk in the paradise garden; not just the beauty, but I thought I understood the history, the growth of each tree, shrub and flower.

Enough to say it was one of the great experiences of my life.

At about 5 p.m., as we were having tea, I felt myself, sadly, coming down. Stanley made joints, which he said slowed it up a bit. By about 6.30 I felt the glory had faded, but I didn't feel depressed about it, only grateful to Stanley, and I could relive it just by thinking of the past splendour.

Stanley said it was a pleasure to go on a trip with me, which was a compliment, but it was luck, too, to be compatible with the drug.

A week or so later Stanley suggested we take another trip, but I couldn't because I was still mulling over that glorious day. Every now and again, for months after, I would receive a split second flash of it. But they became less frequent as it weakened in my blood stream. Anyone can feel this ecstasy, too, I reminded myself, without any drugs at all. I thought how enchanted I had been as a student, those Saturdays, arriving at Port Adelaide.

Stanley was anxious to go on another trip, and he asked Justin and Brian if either of them would try. Justin would not, but Brian, although he was apprehensive, as I had been, felt encouraged by my good experience and agreed to try.

Brian took it, and most unfortunately it didn't work. He said he felt vile, dreadful. We waited, but he felt nothing but despair and anguish. What a disaster. He looked normal, as I had, but he told us, 'I am in Hell.'

It affected him badly for some time; for weeks and then for months, he had flashbacks. Mine had been flashbacks of Heaven, but his were of Hell.

––––––––––

Ian Bent continued to write me long, amazingly affectionate letters, and I was happy to tell him of my experiences in Europe and Greece. Justin said, 'You've got a letter writer there,' and it was true. His daily life at the Tech and his suburban home made him yearn for more exciting Europe and he was trying to persuade his parents to pay his fare. I wondered what his parents were thinking.

SIX

MY FRIEND Eleanora Arrighi had written to me. She had a large apartment, furnished, in Rome, and she wanted friends as tenants—she preferred to let it cheaply rather than to think of strangers using her things.

I had written a letter to Harold Jensen, Mic's friend, describing the kitchen and lavatory in our Greek dwelling. I thought it was a funny letter. It was written to cheer him up; he had been ill, and down in the dumps.

A letter came from Mic. 'Your letter came this morning. Harold passed away last night.' Harold would have been only 32 or 33, he had rheumatic fever as a child, and it had damaged his heart. Mic and Harold had met in Hamburg in 1949; it was fifteen years' friendship, all gone, nothing but photographs and memories.

It was just as well Mic was having to work really hard at this time. He was constantly travelling between Rome, London, Milan and Stuttgart. He had long ago conceived a scheme which would save BP and England billions of pounds a year in lowered fuel costs. Instead of the oil tankers from the Middle East having to pass through Gibraltar and unload at Hamburg, he had designed a pipeline.

The pipeline was to run from Mestre, near Venice, then

go under the Alps and supply the German industry quickly and efficiently. He wanted to build an oil refinery at Mestre. One of Mic's pleas for constructing the refinery was it would increase employment. He was glad the Minister did not think to ask him, 'Employment for how many?', because it was highly computerised. Only seven men were needed, and three of these would be imported technicians.

I hated the whole scheme because it meant a stream of oil tankers going to Venice and an ugly refinery visible from northern Venice. He managed to bring it off despite opposition from ecologists and was decorated by the Queen. I think he should have been punished, not rewarded.

All this was going on when Harold died, so at least he was occupied.

Mic was hoping I'd stay with him at the Palazzo Gangi in Rome, but I wanted my own Roman pad. Winter was coming, and Eleanora's flat had central heating.

Justin also had to find a place for the winter and when I told him how huge Eleanora's flat was, studios for all, he said he didn't like Rome and wanted to live somewhere else for the winter.

Perhaps he was sick of sharing a place with me. I couldn't afford a large apartment like Eleanora's without someone to pay half the rent, so I asked Eleanora to wait for a little while, and explained the situation.

With Brian Dunlop back with Justin, I felt he probably wanted a place which he could share with Brian and work through the winter, free from me and what he alleged were my bossy ways.

Finally, Eleanora sent a plan of her apartment. It was near the Villa Torlonia, where Mussolini lived. It was obviously a spacious flat with four bedrooms and two bathrooms and a huge living area.

I warned Justin it would be a drag for them searching for an apartment in Florence or Naples. In the end Justin agreed he would spend just one winter in Rome, although he stated, 'There is something about Rome I don't like.' He lived in Rome for a long time, sometimes feeling the same thing.

We left Skyros at the end of August 1964, and we had a curious feeling of being thrust out into a cruel world again. I had had the same feeling about Ischia, and decided that islands were not a good idea—they were too sheltering, too isolating, too womb-like. It would be preferable to find peace and isolation on the mainland. Islands, really, are lotus-eating.

Driving a car in Greece was a risky business, but it was fearsome if you drove at night. I tried to avoid any night driving at all. The main trouble was little old Greek ladies. They had no awareness of how dangerous main roads in the country were for them. You would be driving along, and quite suddenly there would be a human body before you. They wore black scarves over their heads, were usually dressed in black with black stockings, and they became invisible.

We were heavily loaded up with luggage and all our painting gear; in addition we were carrying the makings of three one-man exhibitions, carefully rolled up and protected with cardboard.

SEVEN

ELEANORA ARRIGHI'S apartment seemed a long way out of Rome, off Via Nomentana. We were told it was where a lot of diplomats lived. The apartment building was, indeed, next to the gardens of Mussolini's residence. The whole area felt a bit fascist still.

There were large separate rooms for Justin and me and for Brian. Letters from Sydney brought news of disasters with my four tenants, rents on which I hoped to live. Then my real estate agent, my friend Owen Downing, had a heart attack and died. By the time I was in the apartment on Via di Villa Torlonia all the disasters had occurred. I was flat broke, all over again. All those years of working and saving, buying those houses, doing them up, not gone for nothing, but my income disappeared. I had to learn that real estate doesn't work well at a distance.

By now, it was obvious that The Powers That Be, (or was it my saintly protector from Katie Duggan's séances?) were all trying to tell me something.

I think they were saying that I had a God-given gift, and all my wily financial plans, all my hard work painting up terrace houses would always come to nothing until I learned that I must have enough self-confidence to live by my brush.

There were great consolations. Work was going well. We were near the periphery of Rome and I started roaming around these outskirts. It was dramatic: you would be surrounded by blocks of ten-storey flats and the next moment be in open fields. From a distance, the city looked like the battlements of Avila in Spain. A little light industry here and there, strange radio diffusion instruments cropping up in unexpected places. High density living alongside agriculture and light industry with no suburbs.

It became a captivating land and I would return from sketching expeditions obsessed by the things I'd seen, and loaded up with sketches and Kodak reels filled up, awaiting development and exploitation.

Despite all the work, I felt deeply depressed at having no money after my years of saving. It should have been obvious to me that I would have been better off just painting. But I have always mistrusted the art market. Mic offered me money, to tide me over, in such a way that I had to accept. He insisted his accountant in Adelaide arrange it and it wouldn't affect him at all. He had become very rich when his parents died and he said it was absurd for him to be so rich when I was so poor.

Mic turned on fabulous dinner parties in the Palazzo Gangi. This was the Roman home of the family on whom Lampedusa modelled *The Leopard*. The drawing room had a large fresco which looked like Raphael—it was the school of Raphael.

The whole place was opulent, and Mic's servants wore white satin jackets with gold buttons, and a dinner party was a very glamorous affair with Italian nobility and BP executives, and Mic's close friends, and visiting firemen from England.

Charles Moses (not to be confused with Sir Charles Moses of the ABC) had one of the best galleries in Rome, Galleria Ottantotto, in Via Margutta, and he wanted to see my work. He arranged a show; he liked my work very much—always a help with your art dealer.

Soon I had made a lot of friends, and I'm happy to say I've still got most of them. Everybody these days talks about the golden days of Rome in the sixties, and it truly was a brilliant time.

We'd been settled in only a few days when Keith Looby dropped by. He had just moved from Turin, leaving all his communist friends, and was now working in Rome in a studio near the Vatican. Loob was hard-up, but working well. He introduced me to his sister Audrey who was married to Jack Rose, film producer and a director of Paramount. They lived in great style in Parioli, an elegant area. Audrey was amusing, very fond of her brother, worried about his poverty, and tried to help.

Through Jack and Audrey Rose I met Charles and Judy Hassé. Charles was a film editor and Judy a fashion designer. Charles had been, for many years, the lover of Margot Fonteyn, and Judy, before she married, had been a close friend of Roberto Arias, the Panamanian diplomat who later married Fonteyn.

The Hassés had a house in Capri—unfinished, because film work was unreliable—and they also had a flat in Rome.

I was fated to meet them because not only were they friends of the Roses, but their Roman flat was next to Eleanora's newly acquired apartment in the Jewish ghetto. They became close friends and remain so after thirty years.

Out at Cinecittà they were making a life of Michelangelo, *The Agony and the Ecstasy*, and there was a call for skilled painters. The Sistine Chapel had to be rebuilt at Cinecittà

and the ceiling had to be painted as Michelangelo had done it.

Brian Dunlop got a job out there as he was well trained and I am sure they were lucky to have him.

———————

Mic would go up to Florence whenever he could, to his beautiful Villa Il Bacìo. It was a handsome four-storey villa set in ravishing countryside with gardens and olive groves. Mic had filled the house with splendid furniture, fine carpets, lots of books, and a piano in the music room. The house was everywhere lavishly supplied with flowers from the villa's hothouses in the winter and the garden in the summer.

The butler, Bruno, was a good manager, and his wife Graziella a marvellous cook. There were two maids who came in from the village. Mic had a *fattore* who managed the whole place, and two gardeners. It was all pretty grand. It was good to see my paintings on the walls, holding their own, I hope, with the rest of Mic's collection.

I would go up to Il Bacìo if Mic was there, and this luxurious grandeur became my 'weekender'. If Mic was in Milan, it was three hours in the train to Florence where Bruno would collect him at the station. Rome to Florence was also three hours. It was impractical to drive—you would need most of the day—although we sometimes did it, with Tonino driving the Bentley. We usually lunched half-way at Orvieto. But for Mic, with his demanding work, driving to Il Bacìo was an indulgence.

A private company was building an autostrada between Rome and Florence. From the state road, and often from the railway, you could see work in progress. Mic was seeking concessions for BP petrol stations on this autostrada and he

was proud that he had secured several concessions, 'without bribes' he declared. He was always seeing Signore Mario Monti, the minister for public transport.

Then it was announced that the president of Italy, Antonio Segni, was going to declare it open and proceed in a motorcade from Rome to Florence. We were going up to Il Bacìo a few days before, in the Bentley. As we were leaving Rome we approached a barrier, toll gates, carabinieri, and we were stopped. Tonino produced some documents and we were saluted through. We were with Cosmo Rodewald from Liverpool University. As we glided along a completely empty autostrada at 180 kilometres an hour, the first to do so, Cosmo muttered to me, 'Only Mic could do this.'

Italy was even more scenic from the autostrada—no hoardings were permitted; the only signs were those needed for the traffic and I found them beautiful, they were so well designed. That first journey took less than two hours and it was an exhilarating experience. Mic felt that Il Bacìo was nearer now. I think the first autostrada was Milan to Venice, built by Mussolini, and then Hitler followed with his autobahns.

Although the Rome–Florence one was built by private investment, it was designed to pay for itself, give a good return to the company, and then be handed over to the state.

We take autostradas for granted now. But the Italian autostrada, now stretching the entire length of the peninsula, and the RAI Television, have together done more to unite Italy than Mazzini, Cavour or Garibaldi.

EIGHT

CHRISTMAS 1964 and New Year 1965 were spent up at well-heated Villa Il Bacìo, and I came home to the flat to be greeted by Justin telling me the heating had broken down. He forgot to keep it supplied with kerosene—I knew he'd forget—and when he tried to fill it up and light it, it exploded. He wasn't hurt, but he was cold, as I was after five minutes.

It was a bad few days until we were (expensively) reheated again. I had to wear two pairs of socks and fur-lined slippers. The marble floors were icy (marble is cheaper than wood in Italy). The O'Brien got around with bare feet in Oz thongs. It was infuriating when he solemnly informed me, 'It's all right for *you*, but you see *I feel the cold*'!

Ian Bent had persuaded his parents to let him come over in the spring. Brian Dunlop had been a great help, writing saying he could get Ian a job at Cinecittà, helping paint 'the Sistine Chapel'.

My work was going ahead, and just as well. I had very little money again, and my show at Galleria Ottantotto was to open in April. I drove down to Naples to meet Ian off a ship. I remember saying to myself in the car, 'You'll never be lonely again.' The two days we spent together in Naples changed my life, and his.

He took the empty remaining bedroom-studio, as Brian Dunlop had moved in with Looby. Ian's introduction to his new life was pretty heady; after a few days we went up to stay with Mic for a week and Ian was immediately responsive to the beauty of the drive up there and to the splendours of Il Bacìo.

The exhibition in April sold quite well, and I was pleased that there were Italian buyers as well as American. I had enough in hand to see us through the summer, and I was able to pay half my debt to Mic.

In May Justin and I closed the flat; he was returning to Sydney. I planned to spend the summer in Spain, Brian was still sharing a place with Looby near the Vatican. We drove up to Paris—I wanted Ian to see France and the galleries in Paris—and then we came to roost, in June, at Soller in Majorca.

The reason for this was that Paul Haefliger and Jean Bellette had bought a property there, and Jean found us a farmhouse to rent. Brett and Wendy Whiteley were at Deya, nearby, as well as my Roman friends Elaine and William Broadhead. It was also inexpensive and I could make the money from the show spin out.

I was working for a show at the Macquarie Galleries in October, and Ian was working well. His work was very influenced by mine, but we both knew he would find himself only through working and it didn't really matter in what style, as long as he worked.

As well as having our old friends there, when I left I felt we had made some new ones. We had also visited Robert Graves at Deya, and became friends with Domenico Gnoli, the celebrated Italian painter.

We were back in Rome in September after a good summer of work and being with old friends like the Haefligers.

It was that summer of 1965, thirty years ago, that I realised that at last my painting was 'getting somewhere'. An interviewer once asked Matisse if he saw bacon and eggs as anyone else saw them and he indignantly replied, 'Of course I do!' Matisse was not going to embark on a long spiel about how artists see because he couldn't. So when I write that I knew my painting was 'getting somewhere', I cannot say how or where—that must be left to those who can write about painting.

NINE

WHEN WE returned to Italy after our Spanish summer in 1965, there were a lot of apartments to let in Rome, but I soon discovered you didn't go to real estate agents—they were for film stars and the rich foreigners. You simply had to walk the streets looking for *Affittasi* signs—'To let'.

Ian and I stayed at Mic's Palazzo Gangi while we house-hunted. It was such a come-down, leaving Renaissance splendour and looking at dingy empty apartments. The most attractive area, for me, was the old medieval part of Rome, around Piazza Farnese, or across the river in Traste-vere. It was here that we came across an apartment with a roof terrace. It was in Via dei Riari, 70A, and it looked across the narrow street right into the gardens of the Corsini palace. In fact when I had the terrace garden established, Mic called it 'the best flat in Rome'. In the heart of Rome we were looking into about 10 acres of garden and forest. Some of it was used for the film *Adam and Eve* for the Eden scenes, and you could hear nightjars calling each other, it was so wild, in the centre of a great city.

The landscape in my *Spring Landscape*, 1970, was done from the terrace in Via dei Riari. The building on the right, and the terrace, is my studio, acquired in 1968. The radar screens are from elsewhere, but largely invented.

390

The woman is Eleanora Arrighi, not very like her, but she posed for it.

I made two mistakes when acquiring the flat. The first was the rent. It was so low, 45,000 lire a month, that I unthinkingly agreed to pay it. No Roman would do that. On hearing the figure they would exclaim, 'But you can't ask as much as that!' or 'This is ridiculous!' The second mistake was to interview the landlords in Mic's drawing room. The moment they saw the staircase, the servants, the luxury, they said they had miscalculated the rent. It was really 47,000 lire. An extra 2,000 was about one pound a month—nothing.

The landlords were a medical doctor and his wife, and Dottor and Signora Martinelli were very respectable and came from the Nomentana area where they had, no doubt, an apartment as large as Eleanora's. Signora Martinelli was so *bella figura* that she couldn't comment on my princely quarters. I quickly explained that I did not normally live like this and it was all borrowed plumage, but they both passed it off, not wanting to seem impressed. (Most of our friends, seeing the palace for the first time, would exclaim, 'What a stunning place! How does Mic do it,' etc. etc.)

When the day came for actually signing the rental agreement, the rent had been upped again, to 47,500, an extra 500 lire—about one dollar a month. Such unbelievable scrimping and pettiness seems to come with some middle-class Romans. Signora Martinelli wore the obligatory mink coat with a discreet show of diamonds and gold.

I wondered if they believed me when Ian Bent was introduced as 'my nephew'. Probably, like many Italians, they believed what suited them most comfortably, and an uncle at 43 and a nephew of 20 was a possibility, and much more acceptable than 'the hideous reality'.

The apartment was completely empty with not even the electricity turned on, or the gas. The kitchen was a room with a tap and a drain. No light fittings, wires hung from ceilings or poked out of the walls. A water heater, stove and refrigerator had to be purchased and installed. I had to go and pay deposits and fill in forms.

The flea market at Porta Portese was a splendid cheap source for furniture. A sideboard was bought for 20,000 lire. Friends lent us furniture and in a week or so we were both back at work. The flat was long and narrow in plan and we worked at opposite ends, so there was no interruption.

The show at the Macquarie Galleries in October went very well. I had found a good real estate agent—good is not the word, he was a genius it seemed to me. Bernard Quigley's office was in Newtown and that was the area he knew best. He picked up the ruins of my real estate investments and made me independent. I was able to repay Mic and make the flat comfortable, so by 1966 my fiscal affairs were a little better, and I'll try not to bore you with them from now on.

Charles and Judy Hassé would arrange the most magical picnics on summer evenings amid Roman ruins on the outskirts of the city. Ian and I often stayed with them in Capri and because the house was unfinished, we were put up in a narrow bed in the bathroom which was also a greenhouse; it was exotic.

On one occasion, when we shared that bed, Ian became carried away a touch too much and bit me, and bit me where it hurt most, too. There was a stain of blood on the sheet and I was very embarrassed about it, even though I knew the Hassés' coterie of friends were often alarmingly irregular. Anyway, I thought it best to tell her, and it became a teasing point.

After staying with the Hassés, Ian and I were going to Naples to meet Professor and Mrs Patrick Hutchings. He had written to me asking to meet, as he was working on a proposed book about my work. They sounded very respectable and academic—from Perth—and the Hassés and I decided we should try to persuade Ian to look as unnoticeable as possible, no far-out clothes, and could we perhaps have his long golden locks cut just a bit please? Ian agreed to cooperate and Judy took him up to her hairdresser at Anacapri, and he came back far from shorn, but more presentable.

We took the ferry back to Naples next day and met the Hutchings at a bar in the splendid lofty Galleria. Patrick Hutchings had long long locks falling about his shoulders— we needn't have bothered.

A few days later, back in Rome, I received a letter postmarked Capri. When I opened it, a lock of golden hair fell out and on a piece of paper was written:

'THE HAIR OF THE DOG THAT BIT YOU'.

TEN

SIR VAL Duncan was head of Rio Tinto Zinc, and I had met him in Majorca. He asked me if I would go out to Australia and paint his new projects at Mount Tom Price and Port Dampier in the north of Western Australia. I went in September 1966 and painted two pictures, both of them disasters. I think I tried too hard. The rocks at Dampier suggested several paintings later on; perhaps I needed time to digest it all because those later paintings were not so bad. They made the core of an exhibition I had at the Redfern Gallery in London.

This was in February in 1967 and it was a very successful first exhibition in London. The gallery was at its best, and I foolishly imagined I could have a market in England, not knowing that there is not much of an English market at all. The buyers in London are European or American; there are not a great many English collectors. It took several shows at the Redfern, and one at the Leicester Gallery, before I woke up to the fact that art is provincial in the marketing. American artists do best in the States and English do best in London. The big international names do well anywhere.

With computers and fax, today's auction prices are known all around the world in an instant. For example, take a lesser known but good French painter like Marquet. If one

of his paintings comes up for auction in Rio de Janeiro or Denver, that would be known by every buyer in the world.

What is disgraceful is the exaggerated prices being paid for 'names', sometimes irrespective of quality. Art prices are subject to fashion, and fashion can be made by publicity. It's been going on for years. In the twenties the Savage Club in Melbourne paid 10,000 pounds for a picture of horses by Septimus Power. This was an extraordinarily high price for those times, roughly a million dollars today. The foolishness of this was deplorable, at a time when Rupert Bunny's pieces were about nil—no market. On the international side, before the Second World War, Renoir's prices were several times those of the relatively unknown Cézanne. Think of those prices today.

By Italian law, the owner of an apartment is entitled to inspect his property once a year; Dottor and Signora Martinelli exercised their right every year.

There were only two tenants in the building. I was on the second floor and in the flat below the Moroni family were on a blocked pre-war rent. Signor Moroni was a retired waiter and had the noble face you see on the busts of Roman senators. Alas, behind this imposing face there wasn't the intelligence or culture you might expect. They were a rowdy family and all conversations were noisy, and unintelligible because they spoke in dialect. The decibel level was high; they had that prodigious Roman vitality.

They were pretty rough, but well disposed towards us. They must have been a thorn in the side for the Martinellis, being on such a low pre-war rent—it would have been nothing.

We were awaiting our landlords on 'Inspection Day' when we heard the most terrible screams on the landing below. When I opened the door and looked down, I could glimpse the Martinellis and the Moronis. The din was deafening. Signora Martinelli was stamping her foot and gesticulating wildly, all the time screaming at the top of her voice. Dottor Martinelli was actually shouting at the same time. Signor Moroni roared and Signora Moroni emitted loud, sustained, raucous screams. We didn't hear blows, but the emotional violence was horrible. Then we heard the bang of the closing of the Moronis' door, and we very quietly closed ours. Inside the entrance hall, we were both shaking, nervously affected by the naked hatred we had witnessed so close at hand.

Then there were the implacable sounds of footsteps on the marble stairs. A pause, then the door knocker sounded. I tried to compose myself, to stop trembling and waited a moment or two.

When I opened the door I was astonished to see two very calm and dignified persons. The rage, the anguish had gone. They smoothly bade me good afternoon, and smiled condescendingly as I invited them in. They were very patronising. Signora Martinelli smiled indulgently as usual. Dottor Martinelli was usually silent and frostily polite. Signora Martinelli saw our junk furniture and our fake carpets, and a few pathetic pots on the roof terrace. She kept saying '*Che carino*' (how *sweet*) with smiling indulgence.

After we had been in the flat a few days, I tumbled to the fact that it faced due south. This was a real stroke of luck. It meant that for much of the year we could use the terrace as our living room. There was a wall to the north, and this protected the terrace from cold winds. I built a pergola and soon it was covered in vines—*vite canadese* it was called.

Huge pots were hauled up the stairs, with literally dozens of bags of earth. We placed the pots strategically over the main walls supporting the roof. There was water supply from the wash house behind the protecting wall. I brought up electricity and soon we had a virtual Hanging Gardens of Babylon.

––––––––––

As an art student in Adelaide, I saw an advertisement in an American art magazine in 1941 (can't think how we came by that) from a publication by Simon and Schuster, *A Treasury of Art Masterpieces* edited by Thomas Craven. It was expensive and cost much more than a week's allowance, but I sent for it. It was a long time coming of course, with the war on.

Perhaps if I had to name a single publication which influenced me, it would be that book. Piero della Francesca's frescoes from Arezzo were reproduced. It was the first time I saw them in good colour and the appeal was instant—it was like falling in love. There was also a detail from the Signorellis at Orvieto.

So when Michael Shannon and I first came to Italy, Arezzo was an obligatory stop. The Astoria was a good cheap hotel, and we spent two whole days looking at the frescoes. When San Francesco closed after midday, we had to hang around the Cafe Costantino until it opened again at 4.30. The next time I saw them was with Jac, who was captivated by them immediately. We also went to Orvieto for the Signorellis, and stayed in Orvieto this time.

I didn't get to Borgo San Sepolcro, where there are more Pieros, until the sixties, when I was living in Rome. Borgo was a long way off the shorter way to Florence, and I drove

up the Tiber Valley, the long way, as you near Florence. When I got to Borgo San Sepolcro I found that the building with Piero's *Resurrection* in it was permanently closed. You had to go down a side street opposite the cathedral, and ask at a house for the key. Rather like trying to see the *Madonna del Parto* at Monterchi, where you had the same procedure.

On one occasion, when I did this, I had the most amazing piece of luck. Someone had left a step ladder in the large room, and I was able to place it, climb up and sit on the top step to find myself face to face, as near as possible, a foot away, from the face of the risen Christ. It had an astonishingly hypnotic effect. After 500 years I could see every tracing mark, every brushstroke made by Piero—you could enter his mind as he was working on it. I was struck by the sheer force of Piero's faith; the magnetic indomitable will; the majestic, almost indignant, but triumphant face of Christ.

———————

Ian came home one evening and said he had found a beautiful flat at the top of Via delle Mantellate. It was too dilapidated to live in, but would make a perfect studio. The rent was 5,000 lire a month—about two pounds. It had a terrace with wonderful views. On one side it looked into the jail Regina Coeli (Queen of Heaven) and the rest of the view was forest up to the Gianicolo, the highest of Rome's seven hills.

There was a rudimentary bathroom and kitchen. At this ridiculous rent it was worth fixing up. I put in hot water, a telephone, a refrigerator, and new French doors and made a pergola on the terrace. The view into the prison yard was blocked by a bamboo wall, soon covered in plants. My friends were always trying to peep into the jail, trying to part the bamboo wall, fascinated at being able to see into a famous jail.

My landlords were very different from the owners of the building in Via dei Riari. They were called Manciante and lived in the old part of Rome, not far from the Spanish Steps. As their name indicated, they came from Spain, from La Mancia, and when the Inquisition was at its worst they were persecuted because they were Protestants. They found a peaceful haven in Rome, the very centre of the Church.

When I suggested upping the rent from 5,000 to 10,000 they were very diffident about it, saying the flat was in such a bad condition they felt reluctant to take any rent at all. They were not well off, and couldn't afford any maintenance on the building. Over the years, I managed to persuade them to take a little more, every year or so.

It was wonderful having my own studio, separated from the flat. I would go up to it every morning, buying bread and cheese and ham on the way, and have a wonderful day of undisturbed work. I put a radio-record player in, and during the next four years I had some very exalted moments there, and did some of my best work. We also gave some good summer parties there, even dinner parties.

The peace of the place was sometimes broken by a woman's voice crying out high up on the Gianicolo above the woods. You would hear 'Mario, Mario, Mario!'—I thought it was like a line from *Tosca*. Then sometimes from the depths of the jail you would hear a man's voice yelling 'Paola, Paola, Paola!' in response. If a shrill voice from the Gianicolo was too persistent and irritating, I would go out on the terrace and yell out in my best Roman accent, 'Gone to Procida!' (This was the huge jail on the island in the Bay of Naples.) It was usually efficacious.

As a boy in Adelaide I had a series of pug dogs, three altogether. Once we had the garden going in Rome, I bought a most beautiful pup from the Rydens Kennel in England. He

was black, and exceptionally handsome. I called him Oliver. He was the grandson of a very distinguished dog, the world-famous Archibald of Rydens.

He was still very small when I took him for a walk near the Piazza di Spagna. I then went into Via della Croce and someone stopped me to admire Oliver, and was exclaiming about him, saying '*Che bello, bello! Che razza?*' and I told her it was a *carlino*, a pug, and his name was Oliver. While she was admiring him, some others stopped, and there was an instant crowd, pushing in to see what it was all about, with people crying 'Oliver, Oliver'. The windows of Valentino's opened up, they wanted to know what the commotion was, and they took up the cry, 'Oliver! Oliver!'

Oliver really did stop the traffic—it was before it became a pedestrian zone—and soon the police appeared and moved everyone on—still saying 'Oliver, Oliver'.

I wonder if Valentino heard the cries and saw Oliver, and if that's why, shortly afterwards, he had a little pug called 'Oliver' printed on his tee-shirts.

ELEVEN

WHEN I first lived in Rome, I could drive my car to the bank in the Piazza di Spagna, park it, tipping the chap there, and do my shopping at the art shop in Via del Babuino. Life was easy and civilised. You could pay bills by posting a cheque to the gas or electric light people. Gradually all this changed. With the advent of the jumbo jet the Rome we knew was finished. The streets became crowded with tourists and we felt we were living in an open-air museum. Restaurants became expensive, and they began to change the menus to attract tourists.

When friends from Australia rang and asked me for some names of little-known cheap restaurants they soon became spoilt. I was even so idiotic as to take a Sydney columnist to my local trattoria, and he wrote it up and that was the end of that trattoria for us.

The days of paying gas and light and motor car registration by cheque were gone. You had to have cash and fill in a tortuous form *il vaglia postale*, which meant queuing up at the bank for money and then queuing up at the post office to pay with a *vaglia*.

Gradually, I noticed my friends were leaving, some of them moving to farmhouses in Umbria or Tuscany. Mic was spending less time in Rome. My American artist friends were

moving up to Tuscany. But I didn't need a place in Tuscany, as we could stay with Mic whenever we wanted a break.

The yearly inspections from Dottor and Signora Martinelli became rather sullen affairs. She stopped saying, '*Che carino*', and we heard her saying, '*Ma guarda come hanno fatto qui*' (Look what they've done here). The terrace garden reduced them to a complete resentful silence. One day when they went back to their huge, gloomy apartment out on the Nomentana, they must have decided that life in Trastevere was more interesting. It couldn't have been just because we even had a famous Italian film star living in the building next to us, Giuliano Gemma. There were often teenagers hanging around our door hoping to catch a glimpse of him. It was now fashionable to live in Trastevere.

Our street had now become one of the most chic addresses in the city. We had a Roman prince, two marchesas and the son of an English lord. We also had a good Roman painter, and the widow of the last head of the Rome Conservatorium. My garage, at the end of the street, became crowded with expensive cars and they didn't seem so interested in looking after me, their old client with a cheap old Ford.

The piazza of S. Maria in Trastevere was no longer a haven of peace and good food. It was crowded with honking tourist buses and raucous amplifiers playing muzak while huge groups of bewildered Japanese tourists gazed uncomprehendingly at the strange church with gold mosaics. They couldn't hear what their guides were yelling, even in Japanese, because young Romans on noisy motorbikes would dart around those terrified tourists who fearfully held on to their cameras and handbags.

Our landlords became quite hostile, and stated they would not pay for any maintenance. By a new law, our rent

could only be increased at a low rate, and we found out that it would be very difficult for the Martinellis to dislodge us; it would take years for an eviction order to be put into effect. But how unpleasant could it be, would Signora Martinelli scream at me?

Even though we wouldn't have been evicted, Rome, as we had known it six or seven years before, had become too swanky for us. It was really Ian who decided we should move to the country. I was still quite content, with my studio and the friends who stayed on. Even more left later (and I was very happy when we did eventually move).

Initially, I think the real reason we left Rome was economic. I couldn't afford to buy an apartment there. Prices had increased amazingly, just in those few years. Conversation in Rome was often 'Have you heard what so-and-so had to pay for a place?'

We then discovered, to our dismay, that the Martinellis really *did* want to move into our flat. They wanted to betray the bourgeois splendours of Nomentana for La Dolce Vita of chic Bohemia.

When we would stay with Mic at his villa near Impruneta, we occasionally looked around, rather frivolously, for a farmhouse. They were well maintained and some of them were very cheap. Later, we started looking more seriously and then met up with a Tuscan real estate agent, Nello Berlingozzi, a tough little chap who realised we didn't have much money. We must have looked at about thirty farmhouses during this time.

In 1970 he showed us an old farmhouse called Posticcia Nuova. We liked it immediately and paid a deposit. It had no electricity, no water, it sat surrounded by rubbish and had two enormous concrete silos in front of it. But it faced due south.

The tenants, for several generations, had been throwing old shoes from the windows. We must have picked up over a hundred remnants of shoes—they filled a large bag. There were also dozens of bottles, mostly broken, all around the house.

Watercolours and engravings of bucolic Italy in the 17th and 18th centuries are very glamorised I decided, and the squalor of rubbish is glossed over. There is a lovely Corot of Rome on the Tiber at Trastevere. I know the exact spot, and Corot has painted the heaps of rubbish between the river and the houses. Imagine the smell! But in the painting, the rubbish is done with tiny dots of muted colour. It does not occur to the viewer that it would be rubbish.

I foolishly agreed, over-optimistically, to pay the rest of the purchase price for the farmhouse after six months. This was October 1970. I took lots of photographs of my new acquisition, and with every shot I assiduously tried angles so that the silos didn't show, and no rubbish of course.

The years at Via dei Riari had shown me what a great difference a southern aspect makes to one's daily life. You have a low sun in the winter, and in the summer, when you don't need it, the sun is high and does not enter your terrace or verandah. Guilford Bell, my architect friend, confirmed all this and he even used to adjust the overhang of a roof according to the geographical latitude of the site.

Accordingly, I purchased a compass and took it with me when I went searching for a farmhouse. To my astonishment, I discovered that most Tuscan farmhouses, when they had a loggia, almost invariably faced due south. This was not for any airy-fairy hedonistic reason. It was purely practical. A loggia which faces south can be used for drying tomatoes, onions, olives, and of course washing, and it saves heating expenses. Guilford said that when he studied architecture,

this important fact was not taught to students, but was well known by the Romans.

The builders of Posticcia Nuova knew precisely what they were doing. In mid-summer the loggia is shaded, and the sun hits the parapet at precisely the mid-point of its width. In winter, the sun enters quite deeply into the house. All the loggia is flooded with sunlight, which even penetrates two metres into the rooms. The house is protected from the north winds by a hill behind it.

We bought Posticcia Nuova on the third of January 1971, and did all the signing of documents at Montevarchi. I'd often passed through Montevarchi, driving between Rome and Florence in the pre-autostrada days, and thought it an unattractive crowded Tuscan town with inevitably blocked streets. Who could possibly want to live here, I wondered? (Never dreaming that one day it would become my main town for shopping.)

Now that it has become a byway, with the heavy traffic some kilometres away on the autostrada, the main street is a shopping mall, which it was years ago, and it has become once more an attractive Tuscan market town, and Signor Smarta is recognised everywhere.

The vendors were Genoese and we met Avvocato Oneto, the owner. The house was too rundown to live in, but we decided to put some sticks of furniture in it and spend a few days there now and again.

When Avvocato Oneto decided to sell, he moved his tenants into a new house in the village. We had already met them, Benvenuto and Emilia Lamioni, and I arranged for Benvenuto to come and tidy up the land a bit, and Emilia said she'd clean for us.

The sale of the house dragged on all afternoon, so much legal work, so many documents. Avvocato Oneto, as well as

being the owner of the grand villa in the village, was also a lawyer, and he was punctilious about every detail. Just as well, as it turned out. I wanted to put it in Ian's name, to save death duties when I died, but Avvocato Oneto insisted I had what is called *L'usofrutto* which means rights to the place during one's lifetime.

We were determined to sleep there that first night, but it was dark by the time we arrived at the empty unlit house, and it was midwinter. We came up the newly gravelled drive with difficulty and pulled up outside by the concrete silos. The car was low on the ground, loaded up with mattresses on the roof, blankets, boxes of candles, a few collapsible tables and chairs and plates and mugs and some food and a few clothes.

The key had been given to us at the notary's office. It was rather a solemn moment. When we arrived at Posticcia Nuova, we climbed up the stairs, holding torches, and I unlocked the big kitchen-living room doors, and as they flung open we beheld a giant brilliant fire blazing in the fireplace. What a welcome!

Out of the shadows came Emilia and Benvenuto, whose home this had been, and who had thought of this wonderfully kind thing to do. One of those things you never forget.

Living without electricity is interesting, if inconvenient. We could read in bed with a few candles and silver foil acting as reflectors. Cooking was no problem, as the *bombola* of gas is ubiquitous in Tuscany. There was a broken lavatory, and one tap for unreliable water from a small cement tank.

TWELVE

THE LEICESTER Gallery show in London was amazingly successful. Buyers seemed to turn up from everywhere—Holland, Switzerland, the United States and, of course, Australia. There was going to be enough money to pay for the house. But by the time I had paid the purchase tax and the agent's commission, I was completely cleaned out again.

While we were in London, Ian had been searching for another dog. He found a breed he liked very much, French bulldogs, and bought a beautiful pup called Albertino. He was immensely endearing. Oliver had my heart, of course, and that was that. But I became very fond of Albertino with his almost luminescent white coat and ever-ready pink ears. He could look at you in a weird way, sometimes a sort of absurd leer would come over his face. Oliver and Albertino got on well with each other, each seemed happy to be friends.

At this stage, in 1971, we had three places: the flat in Via dei Riari, the studio at the top of Via Mantellate, and the beginnings of a country house in Tuscany.

At the end of 1970 we went out to Australia where I showed in Melbourne. This show was made up of some new paintings I had done, and the few that hadn't sold in London. It, too, went very well, and I had enough money to

last a year or so, but not enough, alas, to renovate the house in Tuscany.

On the way back from Australia we travelled a lot in Iran. We based ourselves in unattractive Tehran, and flew down to Isfahan to see the marvellous Muslim architecture there. Next, to Shiraz, and by a very rough road to Persepolis, one of the most splendid sights in the world. Although only the foundations remain, you can easily imagine the magnificent palace and the great approach, and from the ramparts I could see, over 2,000 years later, signs of the vast irrigation scheme which helped make the area so rich.

––––––––––

Arthur Koestler published *The Roots of Coincidence* in 1972, and when I read it, a few years later, it confirmed some uneasy and untidy ideas I was forming in 1971, the year I moved to Tuscany. Perhaps if the facts are simply told, the reader can judge.

Behind the apartment in Rome in Via dei Riari is a street called Via delle Mantellate. My studio, looking into the woods and the jail, was right at the top of Via Mantellate. In this street was a place known as 'The Soap Factory'—a group of artists' studios, mainly American tenants, a few Italians. (It had been, in fact, a soap factory.)

I had met Paul and Elisse Suttman, who lived at the ex-soap factory. He was a sculptor and she was a painter and they invited me to a party at the American Academy, on the Gianicolo. The party was just before Christmas in 1971.

It was given on the night before Ian and I left for Tuscany. The house was ready enough, and the furniture removers were coming at 6 a.m. with a van. We were all packed up, all prepared for the big move next day.

At the party we told our hosts, the Suttmans, that we had to leave early, as we were moving to Tuscany next morning. They said, how strange, they had just bought a house in Tuscany, too. What was the name of the place? I said it was so unknown and so small, it was useless to say it, but it was called Pieve a Presciano. Elisse and Paul said we must be joking because that was where *they* had bought a house. I told them our place was called Posticcia Nuova and they said theirs was called Posticcia Vecchia. It was just behind us, up the hill!

Then we met Alexander and Susannah Chancellor who lived around the corner from us in Trastevere. When I told them I was moving to Tuscany in the morning they said they had just bought a house there, it was near a town called Pieve a Presciano.

We had bought our houses in different ways, not through Nello Berlingozzi who had found me Posticcia Nuova. The other coincidence was that our Rome residences were all so near, and had the same relative situations: one was behind us, the other was on the first street off Via dei Riari, so you turned left, which I do to go to the Chancellors' house in Tuscany.

Twenty-five years later I am happy to say that all three houses still have the same owners and that we are all good friends.

───────────

Ian and I arrived back in Rome in the first week of January 1971, and when we came out of the customs at Fiumicino we were surprised and happy to see Justin O'Brien, Adrian Cook and Alfredo di Rocco waiting to meet us. We were bubbling over with the excitement of being back in Rome and still filled with the splendours of Persepolis. But they

looked strangely grave. Adrian said he was very sorry, but they had very sad news for us. I thought quickly. The flat has been burnt down, or the dogs run over.

While we were in southern Iran, and completely out of touch, Mic had suffered a terrible asthma attack and had died. He was only 55. It was appalling. He was buried in the chapel at Il Bacìo; the house he was making into such a beautiful home was now his grave.

By the time we were back, they had had the funeral service and he was buried. It was so unbelievably distressing and such a dreadful homecoming that I said, 'Let's all meet at Passetto's tonight, and let's eat and drink a lot and try to forget it.'

The next morning, as I started to come to consciousness, jet-lagged and hung-over, Oliver was pawing at me, anxious to go for his morning walk. As I slowly awakened, the thought arose that there was something terrible at the back of my mind, waiting. And then it burst over me: Mic was dead, I'd never see him again, my oldest friend snatched away. But Oliver went on with his pawing and it dawned on me, 'He doesn't know!' He was full of fun, anxious for the first morning walk since I came back—it was a great comfort, *he didn't know!*

A few weeks after Mic's death I heard that he had left the Villa Il Bacìo to me, for my lifetime. This news came to me from the Hassés. Mic's heir, his nephew who was a lawyer in Adelaide, was reluctant to tell me—even though he was in Rome and I was entertaining him. He feared I might move into the Villa Il Bacìo. I quote from Mic's will (he was a barrister before he joined BP):

Ai detti miei eredi impongo l'onere di mantenere la Villa Il Bacìo, Via di Colline, Monteoriolo, Firenze, e di consentire il diritto di

abitazione gratuitamente ai miei amici, Jeffrey Smart, artista, abitante in Via dei Riari, 70A.

Roughly translated it said, 'I impose on my heirs the duty of maintaining Jeffrey Smart at the Villa Il Bacìo.' Another friend, Jack Henderson, was also to be kept there. Mic left me 10 million lire as well, which in those days was almost enough to renovate our house, and install central heating, something of which he would have really approved—we were both sybaritic. As a result of this, when I moved into a transformed Posticcia Nuova, everybody in the village immediately assumed I was very rich.

It was clearly impossible for me to insist on the terms of the will. To maintain me there, in totally unaccustomed style, would cost Mic's nephew a fortune.

I felt quite a grievance towards Piers, Mic's nephew, mainly because of his legal but naive fears of me moving into Il Bacìo, which were not very complimentary. He was living in Mic's flat, quite near mine in Trastevere. Because he was Mic's nephew I wanted to do all I could for him, and as a young Adelaide lawyer I imagined he wouldn't know how to cook or do any entertaining. So I was quite pleased when, as his last evening in Italy came near, he invited Ian and me to supper. Unfortunately, on the same evening, I was invited to dinner at the Caetani Palace. My host was Prince Schwarzenberg, whom I had met at Morris West's house, and we had become friends. Schwarzenberg wanted me to meet Cecil Day Lewis, whose poetry he knew I admired.

But instead, I had to go around to Piers' place. He produced some saveloys and bread, and only one bottle of not great wine. I was very cheesed off when I had to go out and buy more wine for the occasion. He had inherited Mic's money, but not his warmth and generosity.

411

Mic's large pension stopped at his death, and although he had invested well in Europe, his main family money was still in Adelaide. I was content to have the 10 million lire, but it was a costly godsend. I would have preferred Mic alive as my friend and neighbour—one of the main reasons I went up to Tuscany. As it was, Mic never saw Posticcia Nuova. The only day it was possible for him to come over he had a bad asthma attack, and was too terrified to move.

Only another asthmatic, as I am, can know how absolutely scary it is, to find yourself slowly drowning. I cannot dwell on his passing.

Villa Il Bacìo had been a second home to me, and so I had left clothes and books there. I rang Bruno the butler and said I would be coming, but when I turned up, there was no sign of him. I rang the bell and a woman came to the door. I had already heard of her, Lady Enid Browne.

In his last few months of life, I had heard that Mic had befriended this pleasant, penniless gentlewoman who lived in Florence, but I hadn't met her. I introduced myself, and said I wanted to collect some things.

It was an odd situation, but she had the sense to say, 'I suppose you know your way around,' and I said I thought I did. That was the last time I was in the house.

———

The whole of 1971 was spent in Rome, and when I wasn't working we would go up to Pieve a Presciano and urge the workers to press on. We found out that if we didn't go up there, the builders, the plumbers, everyone would drift off to other jobs. I think it is the same all over the world.

With a lot of cajoling and cunningly not paying them all I owed, I was able to hope to move in for Christmas. We only

just made it. It was great for one's Italian: every verb learnt
saves about ten dollars. The Tuscan accent is quite different
from the Roman, and I discovered there's even a difference
in the vocabulary.

We gave up the flat in Via dei Riari, bestowing plants and
large pots on various friends. We put quite a lot on the ter-
race up at the studio, which we decided to hold on to as a
toe-hold in Rome.

The furniture van arrived just before dawn, because it
was easier getting out of Rome before the first morning
traffic jam. It was an odd feeling, following a van with all
your worldly possessions. I had telephoned the builders the
day before and they had confirmed that all would be ready
when we arrived.

But when we reached Posticcia Nuova, and they started
moving our things in, I noticed a lethal heavy smell of paint.
The walls, which had been covered with a washable white,
were still very wet indeed, and would not be dry for another
24 hours—I knew that, I was a painter, too. So we moved
everything in, but sleeping there was out of the question—
the fumes could be dangerous. We couldn't turn the heaters
on because they had also been painted.

Instead of sleeping in our beautiful new warm home, Ian
and I had to hole up in a nearby hotel which was pretty
grotty. There was a door opposite our beds, a flimsy door,
and when we turned out the lights we saw a bright spot
of light where a keyhole had been. Ian, always a voyeur,
went over and peeked through. 'Come and look at this,' he
whispered.

Life does offer consolations sometimes. We hadn't
expected much of this hotel, and it was quite a bonus to dis-
cover they offered a floor show—before us was the assistant
at our local hardware shop, hard at it with the quite old and

413

endearing whore whose beat was on the road between Pieve a Presciano and Levane.

This wasn't quite how we had imagined we would spend our first night in our new home.

———————

Life was pretty good at Posticcia Nuova I thought. As I had established, the sun poured into the loggia during the winter, and went up high above us in summer, leaving the whole place cool and shaded.

The hay loft, separate from the house, had two floors and there were splendid spaces for studios. This work—the raising of the roof, plus floors, and specially designed studio windows—amounted to about 40 per cent of the renovations.

Ian, in his new studio, embarked on a very good series of paintings based on the theme of wire netting and cyclone fences. I found a lot of material in the village and down at the local garage.

We would work to music. Down in his studio Ian would play records and we had loudspeakers rigged up in my studio. I was treated to Mahler, and lots of Bruchner which I'd not known, as well as the three Bs—Bach, Beethoven and Brahms. It was very pleasant not knowing what music was coming next.

Just a week or so after we moved in, I went into the village bar, for messages. It was also our general store. When I came out I saw Avvocato Oneto, and we chatted a bit. He asked me if I'd like to come into the villa and meet his wife. Signora Oneto greeted me in perfect English, which was quite a surprise. The interior of the villa was grand. The whole place was built in such a way that you saw nothing from the street and the piazza. But the drawing room looked

out into gardens and a vast view. All this was hidden by high walls.

Signora Oneto asked me if I would like a gin and tonic. This was too much of a shock, and I had to tell her I had no idea there was such sophistication in the heart of the village. She asked after my nephew in just a slightly mocking tone, which was amusing and beguiling.

We discovered we had a few friends in common, Prince Tommaso Corsini and Donna Elena who lived nearby, and they asked me if my nephew and I would like to come to dinner in two days' time. Franz Oneto, curiously, spoke no English, but was fluent in French and German. Viola Oneto was multi-lingual, but we usually talked in Italian.

Dinner was grand. These were still 'the good old days' and the Onetos always brought their cook from Genoa, and Viola travelled with her personal maid. We talked a lot about books—I had not expected to be talking about Marcel Proust or Bayreuth in the Pieve.

The Onetos became good friends, and Franz was enchanted with my nephew, whom he always called Stella— well, it was true, Ian shone like a star. He was such a personality, good-looking, with a wild sense of humour.

The first time they came to supper with us and saw a transformed Posticcia, Viola pretended to be cross with Franz. Apparently she had wanted to renovate Posticcia Nuova and move there from the villa; they froze there in the winter and they were envious of our central heating. It was terribly cold in their villa and almost impossible to heat such vast spaces. When they became too cold they would pack up and go to Genoa, but it was obvious they wanted to spend as much time as they could in the country.

Franz suggested we might like to visit their friends the Leveronis who lived in nearby Pergine, 3 kilometres away.

My heart sank when he said, 'He plays the piano and she sings, and they'll give us a little concert before dinner.' We had not expected Richard Strauss's 'Four Last Songs' sung by a mezzo soprano who was one of Toscanini's favourite singers, Iolanda Gardino—now Iolanda Leveroni.

Because we were so isolated, I had felt apprehensive about living in the country, but there was much more society than I dared hope for. We still had no telephone and messages had to be left at the bar where there was a public telephone.

The dogs, of course, adored it, and Franz fell in love with Albertino, and was so besotted that he put himself on the waiting list for a French bulldog, a female for Albertino.

———————

In October of 1972 we went back to Spain, and saw the Haefligers again in Majorca. Ian had sent his show off to the South Yarra Galleries in Melbourne. We came back from Spain and the next thing we heard was from Violet Dulieu— she had completely sold out Ian's show! Every painting had gone. Ian had his own money. Bernard Quigley found him a good house in Newtown, near the university, and so Ian became a landlord.

Violet Dulieu had forgotten to tell us precisely how she had sold out Ian's exhibition. The best art dealer in Paris was Claude Bernard. He was agent for Francis Bacon and Lucian Freud. He went to Melbourne to sell a large multiple sculpture by Jean-Robert Ipoustéguy to the National Gallery of Victoria. It was made in 1967–68, a huge sprawling piece of thirty-nine parts, some of them in Carrara marble, some bits in stainless steel. The purchase price was 65,000 dollars—a lot in those days. It was worth Claude's time to come out and arrange the sale.

It has been described as 'a series of decaying Bishops' heads facing a supposed self portrait', and 'a real dud'. James Mollison put it on display for six months, but now it has mercifully disappeared, and stays in storage. Ipoustéguy was fashionable in the seventies.

While he was in Melbourne, Claude Bernard went around looking at various art shows. He liked Ian's work and took all those that hadn't been sold.

We had arranged a trip to Egypt for January, our coldest month, and the Onetos were interested. It was to be an archaeological river cruise. When we discussed it with Viola and Franz, a strange, sad look came over his face—I had not seen the expression before. He coughed lightly and pointed to his throat. 'I've got something here, and it will have to be looked at next time I'm in Genoa.' They wouldn't go until this thing was cleared up.

Emilia arrived one morning, sobbing. *L'Avvocato è morto'*. It was true. Franz had had the throat operation—it was a benign tumour—but something had gone wrong with the anaesthetic.

That year, 1972, I painted the large picture *Factory and Staff, Erehwyna*, and as central figure, 'the foreman', I painted Franz; I also put Ian in, and a self-portrait.

THIRTEEN

MONTEVARCHI, OUR nearest large town, has many
good nurseries, because of the rich alluvial soil in the valley
of Arno. I was buying some pot plants from the girl in the
plant shop, and she answered me in rather posh English.
She was Pippa Benckendorf, and her parents lived in near-
by Tasso—Angel and Paul von Benckendorf.

We soon got to know them, and when we went there we
found they were living very modestly in what was almost a
pre-fabricated cottage. They had chosen Tuscany, as I had,
because the real estate was cheap, and it was comforting to
meet people who were as poor as I was.

Paul's father was an Estonian count, and was at the
Russian embassy in Berlin in 1919. The 'old order' must
have been very shaky at this time. Paul told me he saw his
father murdered on their property in Estonia in 1921, and
he saw his family's large house burnt down. His Russian
mother, Moura, had been educated at Cambridge and they
escaped to England.

Moura Benckendorf was a famous and beautiful woman.
While she was married to Benckendorf she had a love affair
with Bruce Lockhart who was in St Petersburg. It makes a
heroic story in the early days of communism.

After Benckendorf's murder she married the German

Baron Budberg, but this did not impede a love affair with Maxim Gorky in the twenties—a lot of the time living in Sorrento in Italy, owing to Gorky's bad health. After Gorky returned to Russia, really to die, Moura went to England and lived with H. G. Wells until his death in 1946.

Paul Benckendorf said his mother was looking for a place to live in Tuscany, could they bring her over? I could advise her of anything I knew for sale. Even though I had heard that Moura Budberg was a well-known kleptomaniac, I had no fears. I had nothing to lose, no treasures.

They came over to lunch. Moura was carrying a large carpet bag, and I was thrilled to meet her. She was still striking in her old age and her conversation was riveting. I managed to get the conversation on to H. G. Wells, and she told me that he had a curiously attractive body odour, which was why he was so successful with women. Her voice was pleasant, with absolutely no accent, and she revealed a sort of upper-class Edwardian amorality with her comments on some of the famous people she knew so well. I gathered she still had a weekly 'salon'. When they were leaving and she asked me to look her up in London, I felt honoured. I discovered I had also lost the pretty pewter coaster I had bought in Cambridge in 1948 which had served as an ashtray. It must have gone into that bag and was probably later given to someone to curry favour.

We had become friends of George Deem and Ronald Vance. George was a good painter and well known in New York. His friend Ronald was a writer, an associate of Robert Wilson. We had many cosy suppers in their cottage near Cortona.

One evening we met Germaine Greer there; she had a

house nearby. We were immediately drawn to her; beautiful, intelligent, and wonderfully vivacious, she was a sparkling addition to our group of friends.

Germaine's house was at the end of a long, long road going up an unspoilt valley. Once at her house, you could see for miles, and you could have been in Africa or Australia—no sign of habitation. Germaine had a most splendid and scholarly rose garden, as well as a kitchen garden. It is a joy to eat her fresh home-grown vegetables and meat spiced with her own herbs.

As well as the eclectic herb garden, behind her house she had a small 'laboratory'. Here she made tinctures and medicines, which I am sure were efficacious. I wondered what the locals would have made of this; would they have thought of her as a witch, albeit a glamorous and young one? The situation was classic.

Germaine was a good friend to me, and very supportive when Ian began to rebel and was changing from being a dedicated painter to being a fervent drop-out. She has a good voice and would sing along with Handel when Ian played an oratorio, but she was puzzled when he changed and we had to listen to David Bowie.

Proust said that the human soul is like a water bore: the higher the frame goes up into the sky, the deeper it goes down into the earth. Ian, who was one of the sweetest people I've known, could also become savagely cruel. I saw it many times, and one night was unforgettable, because he made Germaine weep. She criticised Ian for making us listen to Bowie singing 'Ziggy Stardust' in that falsely frail, androgynous voice, haunting songs of 'darkness and despair'.

Ian turned on her, asking her how she could possibly understand his younger generation when she belonged to another, an older one. It must have touched a nerve, she

who thought she represented the young rebels, and Ian's words were wounding. Her tears were also of rage because she was right.

She knew David Bowie. She said he was a nice young straight with a wife and family. All this drug culture stuff was pseudo—it was a pragmatic commercial ploy. I thought of Andy Warhol, also commercially minded, and like Bowie, completely clean of drugs—they were too clever for that trap. Germaine was disappointed that Ian was so gullible.

———————

The Nile cruise was fabulous, the first of many more to come. We had old friends on board, James Fairfax, Richard Walker, Guilford Bell, Mervyn Horton, Denis Kelynack; it was a happy bunch. We also met David and Jill Maher on this cruise, and we still go on archaeological trips with them. Jill is invaluable at the Oriental Institute of the University of Chicago, and David is a Mozart scholar as well as 'a ruthless Chicago lawyer'.

One of our good friends in Rome was Sighè Erikson, the daughter of an Italian general who went to Ethiopia, where Sighè's mother was born. She looked something like Queen Nefertiti, and still does. Sighè bought a house near Bibbiena, on the other side of Arezzo. She came to dinner one evening in January bringing Freddie Fuchs and his friend David Titman.

We had just moved in, and the furniture from the flat had to spread out in the larger spaces of the house. It all looked rather sparse, but the rooms seemed grateful for the few sticks we put about—the effect was not bad. We had a large fire, one of the joys of winter.

It was very cold outside, and after supper we sat around

the fire, chatting. Ian put on my friend Rafael Kubelik's recording of Dvorak's Fourth Symphony (now called the Eighth). The speakers sounded marvellous in the large empty spaces, and when the graceful, elegant allegretto movement started, David, in an inspired moment, jumped up, picked up a bentwood chair and danced around with it, and we all joined in, laughing for joy, each circling around the room with a chair—an ecstatic time.

When it finished we returned to the fire, and then noticed, to our astonishment, that strong light was coming through the windows. It was midnight, and the clouds had cleared and there was bright moonlight. We went out on to the loggia to see that there had been a heavy fall of snow. It was as light as day.

The two cars had become two humps on the ground below the house. We were snowed in. There were, miraculously, enough gum boots, and we all went for a walk up the valley, slow going, but unforgettably still with the branches bearing gleaming snow.

They had to stay the night, and couldn't go until noon next day. Being isolated like that is a great pleasure. I have a siege mentality, so there was plenty to eat for breakfast and lunch. By mid-afternoon enough snow had melted and the road was passable.

———————

Eleanora Arrighi had sold her small flat in the Roman ghetto and had bought a large one just around the corner. It had terraces and wonderful views of Rome. Patrick White and Manoly Lascaris were in Italy travelling, and Eleanora gave a party for them. We drove down to Rome for the occasion. I had never really known Patrick well and our

conversation was difficult. I asked Patrick if he was coming up my way to see the Piero della Francescas. Patrick said he didn't like Piero's work much—it was too cold, impersonal. (He was a great collector of Sidney Nolans.)

Piero was far from being cold, I protested. He was an ardent Christian, and his *Resurrection* is one of the most moving works in all painting. 'No, no,' said Patrick, 'It's all just design, pure shapes, but cold.'

I pointed out to Patrick that if he gave me his opinion on Shakespeare's sonnets I would listen with great interest because he was a writer. Why, then, wouldn't he heed my opinion on painting? But he brushed it all aside. Manoly looked at me almost beseechingly, but we had ground to a halt and that was it.

FOURTEEN

IN FEBRUARY 1973, I found a message left for Ian at the bar to telephone Rome, someone called Sandro Manzo. He telephoned, and Signore Manzo asked if he could come up to see him tomorrow with some friends.

The next day an enormous limousine arrived and the first person we saw coming up the steps was Francis Bacon, followed by Sandro Manzo, of the Il Gabbiano gallery in Rome. Then came someone from the Maeght Foundation and finally Claude Bernard himself.

Francis and I had a drink by the fire while the three gallery people talked to Ian down in his studio and looked at Ian's paintings. I found Francis agreeable and extremely intelligent—he had splendid manners. I was to see more of him.

When the others came out of the studio everyone looked very pleased and happy. Ian was to be paid 1,000 dollars for each large canvas, and 200 dollars for small studies. When he had anything ready, he only had to telephone and they would send a truck for the paintings and give him a cheque on the spot.

The general plan was that Ian was to show the paintings firstly in Rome, at the prestigious Il Gabbiano, and then after that, the big show at Galerie Claude Bernard in Paris next year.

Francis took us all out to our local restaurant at Pergine and we had a vivacious lunch. Francis said he was fed-up with living in London and was thinking of moving to Greece, to live in Athens. I warned him that my American and English friends there had complained that they became depressed with the life there—too much promiscuity and heavy drinking. Francis replied that was just his ideal sort of life and he added, 'And you know, *I never get depressed.*' This seemed a remarkable statement when you visualise some of his paintings.

He said he didn't have to work a great deal on them. His gallery would deliver large canvases to his studio. These were always prepared with the base colour, suggested by Francis, rolled on in acrylic. Then all he had to add were his gestural images, some of them from Eadweard Muybridge, some culled from medical books on plastic surgery with photographic illustrations.

I do not denigrate or deny these ways employed by Francis. 'All's fair in love and war', and art is both these things, and the strength of Francis's images give them validity.

Afterwards as they were leaving Claude Bernard turned to me and said, 'I believe you paint too. Next time I hope I can see your work.'

I was working for my first show with Rudy Komon, to be opened in November 1973.

The money started pouring in for Ian and for me, too. We spent a lot shifting the stairs and making it possible to lock the house with one door, and we had an entrance hall and a laundry made, all on the ground floor.

The first sign that things were changing was in the music coming up from the studio below me. Instead of Fauré, or Debussy or Bach, I was getting something called Pink Floyd. Then I got Lou Reed and the Hot Rats—and worse was to

follow. It was a bit eerie. Ian was changing; we would have violent arguments. Ian would not eat meat at this stage and wanted only organic food.

Instead of sharing the chores, I found I was doing everything. We had daily help for cleaning, but I was doing all the shopping, cooking, paying taxes on the house and on the cars, attending to insurances, all those time-consuming things that Ian had helped me with before.

One of the really odd things was that I had come across a friend who could get me some good grass, but when I told Ian he became absolutely hysterical, shouting he wouldn't allow any drugs in his house.

———————

In November 1973 we left for Sydney, via Beirut, where we planned to spend a few days, and Bombay. In Beirut, Ian disappeared for a whole night, and when he turned up—with barely enough time to catch the flight to Bombay—I realised he was stoned absolutely rotten. Yet he had opposed taking hash in Tuscany. In Bombay, I managed to buy some 'Bombay black', and, taking this together, we got along better. The state of war which had existed for some months seemed to vanish. I didn't see much of Ian in Sydney, he was usually with his friends Michael Ramsden and Jenny Kee. I know he was taking a lot of grass with them and their friends. We had a wonderful night when we all met at Circular Quay, Virginia Osborne, Jenny and Michael, and Ian and me; we all got thoroughly stoned on the ferry. By the time we arrived at Luna Park, we were high. The absurd rides and spills all became hilariously exaggerated under pot, and we had a stupefying and exciting evening.

When I wasn't around, Ian must have been supplying

dope for all his friends. He was spending the most amazing amounts of money. My show went well, and so we were both flush.

In the middle of all this I received a telegram from Rome. My treasured friend Eleanora Arrighi had died, after a long harrowing illness.

We came back to Italy via Bali, seeing Donald, who lent us his car and driver. We went to Jogjakarta, Delhi, Udaipur, Agra and arrived home at the end of January.

Ian had to finish his show, and he was working well. I wanted to tell him that he would never be as happy as he was now but there wasn't much communication between us. Too much Led Zeppelin and Rolling Stones. Ian was always complaining he had no young friends, that all our friends were my age, or more. He was right about that, but he spoke Italian, and I don't think he made much effort with local young people, regarding them as too square—all true.

On 19 April 1974 Ian's show opened at Il Gabbiano in Rome. There was an enormous crowd. There had been a lot of publicity about this talented handsome young man who had been kept hidden and suppressed by an older rich man. This is why he painted fences, bars, netting—a cry for freedom. The communist art critics made much of it. There were placards of Ian's show all over Rome. He was famous. I noticed how people spoke to him.

The exhibition completely sold out, even the very latest paintings which were hardly dry. Ian had moved up into the big money. There was nothing left for what had been intended as the big, more important show in Paris.

At the party afterwards at Sandro's apartment even Balthus came and congratulated the young genius. I could see film star Laura Betti looking at me in a malevolent way.

The next day we returned to the farm for Ian to pack up

his things, and the day after that I put him on the train at Arezzo for his flight out to Australia and freedom. There, in Sydney, he would have the time and money to paint the exhibition for Claude Bernard in Paris, to be held as soon as he had the show ready.

I had to take stock. Here I was, abandoned, holed up in the country, on my own. My nearest and dearest friends had gone. I was very lonely and felt deserted. I'd lost Ian, Mic, the Onetos and now Eleanora, but it was not going to be 'Leftover Life to Kill'.

Adrian Cook suggested we go to Turkey, a place I'd not seen. We had three marvellous healing weeks in that then completely unspoilt country. Adrian, an Australian who lived in Rome, was a dab at working bus timetables. Because the Turks had been nomadic, he pointed out how good they were with buses and timetables. Some of the buses were luxurious—you even got hot towels, as in aeroplanes. We saw Greco-Roman Sidé, and Aspendos.

I think it was while I was swimming in the hilltop pools of Pamukale, gazing over the vast valley, that I felt I could go on living. Everything had been emotionally so precarious. Anyone who survives a terrible separation should be awarded a lovely prize—a medallion and a blue ribbon. Don't we all deserve something?

FIFTEEN

WHEN I arrived back in Rome I came up to the farm with Freddie Fuchs, who lived across the street in Via dei Riari. Freddie immediately put the house straight, decked it out with flowers and plants and made it look liveable and then left me to work. It was strange at first sleeping in a big house, being the only occupant.

When you go to Arezzo from Pieve a Presciano you pass a hill town called Civitella. It looks picturesque with its ruined medieval tower and more recent war memorial. It's not a place for tourists really, and I had hardly ever been there. Civitella was the scene of a horrible massacre during the last world war. The Germans had taken reprisals for some guerilla resistance there and had killed 113 innocent people.

The town has a painting competition every two years, known as the Civitella Biennale. My friends had chided me for not having anything to do with the local artistic scene. They said I should participate in some of the cultural events, like the Civitella Biennale. At their urging, I reluctantly decided to enter a work in the competition. You had to paint a landscape involving Civitella. The size of the canvas—quite small—and the type of frame were both designated.

I painted the tower at Civitella—it made quite a decent composition—and I took the painting in to the council office, filled in the application form and that was it. The painting could be included, as an oil sketch, in a show in London or in Sydney, I reflected.

A week or so later I was notified that I had been awarded first prize. The judge was someone from the Belle Arte in Arezzo and I hadn't thought that a purely realist painting had any chance in 1974.

When the day of the award came, I went with Iolanda Leveroni and I was presented with a silver cup with my name and the occasion engraved upon it. They also presented me with a cash prize of 100,000 lire—about 100 dollars.

At the exhibition, my painting was centred and spot-lighted. I felt very embarrassed when I saw the work of my competitors; they were nearly all untrained amateurs. I received several letters of protest from these local painters. They pointed out that it was unfair of me to enter the competition and they were quite right.

So ended my attempt to participate in local cultural affairs. I gave the cup to our local bar, where it still stands. When I went to collect my painting, I was told the prize was acquisitive so the picture is still there, in the local council office.

I had a long letter from Guilford Bell. He was designing a house for the Rockman family and he wanted me to paint a mural, a large mural. Guilford had taken me over to this house in its early stages, and I had studied plans and drawings for it. It was on a grand scale, a symphonic house.

The only difficulty was time. I didn't want to spend a lot of time painting it. The work could be done in Italy, on

panels, as I had done the McGrath murals in Sydney. But all the hack work for those had been done by Ian, and I had no helper now.

I needed a well-trained assistant, but where are they? With abstract painting so much in vogue, few students had received good realistic training, or had the ability to be realists.

Michael Shannon, to whom I wrote for advice, suggested I get in touch with Ermes De Zan. He was well trained, a good realist painter, and he was studying at Yale where he had a scholarship, obtained for his work in Melbourne. I wrote to him at Yale, telling him of my mural commission and asking if he could assist me. De Zan wrote saying that he could only come over in the holidays from Yale, but that he was willing to help me with the mural. We commenced a correspondence.

Frank Rickwood, my old friend from the Fairlight days in Sydney, had forsaken being a lecturer in geology. He had become an adviser for Oil Search and made brilliant finds in New Guinea and later in Venezuela. After some years in New York and England, working for BP, he was now living in San Francisco. He had become president of BP Alaska, and the Alaskan oil pipeline was his idea. As a scheme it was similar to Mic's Mestre–Ruhr pipeline.

Frank asked me if I would be willing to go to Alaska to paint the works he was supervising. I wrote back and said my last commercial commission, for Rio Tinto Zinc, had been a disaster, and that I was best out of it. In any case, I added, I had a mural commission in Melbourne and that would keep me busy.

———

It was strange living by myself in the country. I would talk to Emilia, who came every morning, but then I'd be at work in the studio most of the day.

A painter's life is a lonely one: you spend all day in silence. I can understand that businesspeople, actors, musicians, labourers and factory workers who have company all day long, probably don't want to talk much when they come home at night. Even a writer has been talking or imagines he has been.

But painters can become very strange if they lead isolated lives, and I knew I was becoming strange. At the end of the day, if there were no visitors, or I wasn't going to see friends, I would go for long walks in the woods.

Osvaldo Righi at the Castello Cenina had put me in touch with the local historical society. It was astonishing to discover that my house was built on an old Etruscan road— the main road from Siena to Arezzo, known as the secondary Cassia. The Cassia was the old Roman road.

Mariolina Ghezzi, an archaeologist from the village, assured me there were still signs of the Roman road, built over the Etruscan one. Sure enough, in the woods up the valley, we discovered clear signs of the old Roman road—the stones are unmistakable.

The village church at Pieve a Presciano, unlike most churches, is not in the town but below it, on my road. It seems there was a Mithraic temple more or less at this site, and it is possible that the present church is built on top. Christianity did not reach this area until about 500 and until 800 the population was mainly Longobards and Bulgarians. Mariolina Ghezzi showed us two Etruscan tombs, large circular ones. They are high up, above the Suttman's house, Posticcia Vecchia. Both of them have fishing symbols, which seems to indicate Pergine was near a lot of water, the lake which the

Romans drained at Incisa about 300 AD. So my evening walks were often rewarding, prodding about these sites.

On one of these walks, I visited a pretty ruin of an old farmhouse called Il Pretello. It was falling to pieces and the roof was beginning to go. When this happens the house quickly declines into rubble.

Il Pretello is up my valley, on the opposite side, quite hidden from Posticcia Nuova. I was looking around the place when I came across a young owl. He was tiny and, like me, he had been abandoned. His name, of course, was Hector the Second, or Ettore Secondo. I brought him back to Posticcia Nuova and put him in a large cage. There are so many predators, like foxes, in the area, that it was a miracle he had survived, abandoned as he was.

Ettore was greedy for the tit-bits I gave him, and nourished on chicken livers and bits of bacon, and a few worms when I could find some, he grew into a handsome and affectionate owl.

When he was fully grown, I would put his cage on the parapet of the loggia and open it and every night Ettore would fly off for his nocturnal life, and in the mornings I would find him back in his cage and I would cover him for the day.

There came the day when he did not return, but for some time I would find that the tit-bits left for him had gone. He has a family now and is one of my best neighbours, joining in with the nightingales. I hear my owls every night, singing with the nightingales.

———

On a visit to Rome I had supper with Paul and Elisse Suttman at their studio in Via delle Mantellate. As I had done, they were still dividing their time between Rome and

Posticcia Vecchia. Paul gave me a letter to give to Don Luigi, our local priest. He said that Il Pretello was owned by the church, and that the letter was an offer to buy the place for his art dealer in New York, who was called Felix Landau. Padre Luigi accepted the offer, and Felix Landau became the owner, and our very valuable neighbour. So later I was able to sincerely compliment him in person on his artistic perception. His French wife Helga is a good painter and an excellent cook—French of course!

If friends were expected, that was a pleasure. But I remember working one afternoon, and a car full of people came up the drive and they all got out and looked about.

I felt a sense of outrage, invasion, my territory had been trespassed. Who are these strangers?

Then I saw Freddie, who knowing I would be lonely, thought to bring a whole crowd and cheer me up. As I still didn't have a telephone, what else could he do? Shortly after that the telephone was finally installed. I put in four.

My visitors' book shows that I had plenty of people to stay. One of these was an old Adelaide friend Madeline Royston-Pigott as she was then, now Robinson. Other friends were old ones from Sydney, Jim and Anne La Farge, who were looking around for a house to buy.

There was a lot of travelling in 1974. Frank Rickwood wrote from San Francisco, upping his offer for pictures of the Alaska project, and offering to fly me to San Francisco and the North Slope, first class all the way.

It was irresistible and I decided to go. I was to take an Air France flight from Paris, so I had a few days there on the way to see some exhibitions and, as always, the Louvre.

As I was staying on the Left Bank, I dropped in to see Claude Bernard and asked him what work he was getting from Ian in Australia. He picked up his telephone and asked for something. A girl turned up with a portfolio and Claude put it down on his desk and opened it and extracted a small piece of paper. On it was a tiny drawing of Minnie Mouse done in coloured pencils. That was all he had received. I have seen this happen before, with gifted painters who take up drugs, or become insane. It seems a classic situation. When I saw this drawing of Ian's I gave up any hopes of being able to live with him again; up until then I had still entertained the idea that he was passing through a phase.

I wrote to Ermes De Zan telling him that the mural for Melbourne was cancelled. But I added there was an empty studio waiting for him, and he could get a lot of work done in his holidays. Justin had met Ermes in Rome and said he was a nice chap. I had met him at Justin's too, but couldn't place him. It would be good having some company in the summer—there was plenty of room in the house.

SIXTEEN

IN EARLY September I set out on the journey to Alaska and a curious thing happened when I arrived at San Francisco to meet Frank. I had left a message with BP telling them the flight I was on. Frank was staying at a hotel, but was in the act of moving into a house he had bought.

An alteration was made to my connection at New York, so my flight was changed and there would be no one to meet me at San Francisco. When I telephoned BP in San Francisco, I was told it was a public holiday. So I had no contact with Frank until the office opened next morning. I arrived late at night. While I was waiting for the luggage I looked at all the hotels illustrated and decided, capriciously, on the Huntington. When I arrived and asked for a room they said they were full, but there was this booked room, and the man hadn't turned up. So I took that—it was very ritzy.

Next morning, I telephoned BP and asked for Mr Rickwood. He wasn't in the office yet so they suggested I ring his hotel, and gave me the number. I rang that number and it wouldn't work. So I asked the operator to make the call and she said, 'But that's the number of this hotel.'

The coincidence was amazing—I was in the room BP booked for me!

In the couple of days I had in San Francisco I went

around the galleries, of course, and discovered the Maxwell Galleries, who were agents for David Park and had been agents for Richard Diebenkorn, just becoming famous on the East Coast.

The Maxwell Galleries showed me their enormous files on Jackson Pollock. Apparently Pollock had been in a mental hospital on the West Coast. Although he was not an art student, the therapists gave him lots of paper and chalks and colours. Pollock did dozens of drawing; a lot of them were very childish, of cowboys and Indians. Then they became even wilder, and more abstract. They were not good abstractions or even good gestural paintings, but they were interesting because they were by Jackson Pollock.

The gallery has carefully conserved these drawings in a special fire-proof steel filing cabinet. All the drawings are authenticated by the psychiatrist and dated. They make a valuable record of the early days of this unhappy painter. I don't think that many people know of the existence of these archives.

Whatever you think of his work, it must be reluctantly said that he is a milestone in the story of 20th century art. He has influenced—for good or bad, and generally bad—so many painters.

The flight up to the North Slope was made via Seattle to Anchorage. There was a dramatic change here, a feeling of being in a frontier town, and shops selling Eskimo art. Signs in hotels, shops and restaurants gave you the temperature outside. There were street shoe-cleaners. Lots of stores sold furs and handsome snow boots, called muk-luks, made from seal skin. I bought a pair for winters in Tuscany.

After a night in Anchorage I took a BP plane up to Prudhoe Bay. This was the North Slope where the drilling was being done. The company had built the most amazing installation at Prudhoe Bay. It was called Dead Horse and was to house VIPs and important heads of oil drilling activities. It sat on 2,000 feet of permafrost, and the outside temperature could go down to –40°C.

As any skier knows, pressure on ice melts it, and it was an engineering triumph to build the huge facility of Dead Horse. It was streamlined, like a space missile so that it could survive the fantastic winds of a blizzard. It sat on pylons, and I could not understand how the enormous weight of Dead Horse did not cause the ice to melt and sink down into the permafrost.

Entering it was like going into a submarine; you had to go through a chamber before reaching the welcoming temperature of the building. Inside were about forty comfortable bedrooms with bathroom, a huge swimming pool, a theatre, gymnasium, a winter garden with high trees (tropical ones on the North Pole!), changing rooms and living areas. The workmen lived in Nissen huts.

Windows were not double-glazed, they were triple-glazed. The reason it was so high above the ground was so that the blizzards would blow under it and not cause snow-drifts. Dead Horse was a great piece of architecture, a triumph of man over his environment.

The facility had luxurious lounges, and two really accomplished chefs for the dining room, one French, the other Italian. Some of the men would insist on putting *spaghetti alla carbonara*, or *poulet champignon*, or *vitello tonnato* between two slices of bread and eating everything as a sandwich.

No alcohol was permitted. With those temperatures your metabolism could become unbalanced. No one was allowed

438

out by himself. I wanted to go out sketching in a truck, but I had to have a driver and radio contact. They pointed out what could happen if your car broke down and the heating stopped. You died.

The oil drillers were not a chatty lot. They were paid enormous fees. I noticed many of them had booklets and paperbacks with titles like *You and Your Wife* or *Being Married* or *How Marriage Works*. Every evening they would gather to watch the fantastic sunsets seen from a large window in the lounge room, and they would reverently gaze at the astonishingly dramatic transformations of colour and shape, but were much too embarrassed to talk about it all.

While I was at Dead Horse, an anthropologist turned up one evening, very excited. A complete Eskimo village, which had had no contact with Western civilisation, had been spotted from a helicopter. It was an outdoor anthropological museum. They were bringing in some Nissen huts and medical supplies. 'In no time,' he said, 'we'll have a sick ward for them.' Some of them were ill and several were suffering from eye diseases, which I heard were congenital with Eskimos.

What do you do in these circumstances? One's first reaction is to give them succour.

My work in Alaska yielded BP four paintings—two studies and two large pictures. They were better than the ones I did for Rio Tinto Zinc, but still not great. I also managed to paint a large mural of hard-edge vertical stripes in the dining room. I had the assistance of the building's resident house-painter. This won universal approval from the most Philistine of oil drillers. Even I liked it, and Frank liked it when he saw it.

After the work on the North Slope I returned to San Francisco and saw Frank again. As he and his friend Justin

439

Rainey were likely to be in San Francisco for several years, they decided to buy a house there.

Justin, who was black, had been with Frank for many years. They first met in New York. Justin was a great personality, a brilliant raconteur and had an unbelievably good eye for real estate. Although I had only been up at Dead Horse for just over two weeks, they had moved into a house which Justin had found a month before. It was in Bellevedere, a pretty harbourside suburb, only about twenty minutes by ferry from the centre of San Francisco.

We went over to the house on the evening I returned and when we got off the ferry, I saw lots of cars waiting for the commuters. Frank said we'd have to walk home, and I asked why Justin hadn't come to meet us. 'Look at all the chauffeurs of the cars,' said Frank. I was surprised to see they were mainly black. Integration hadn't come very far on this part of the West Coast.

SEVENTEEN

I FLEW straight from San Francisco to Rome, and had arranged to meet Jim and Anne La Farge, my friends from Sydney. Jim was an American naval captain who had married an Australian, and they were coming to stay with me at the farm.

We were to meet at the Hotel Minerva, in Piazza della Minerva. I liked this hotel because it was where Diaghilev and the Russian Ballet stayed in the 1900s, and also Picasso stayed there when he was in love with Olga, whom he later married. Piazza della Minerva is home to the best art library in Rome.

The hotel was central and had a large interior courtyard, which glassed over a winter garden. If you had an inner room it was very quiet. (It has since moved 'upward' and been tarted up, and the rooms are smaller.)

Freddie rang me at the hotel and told me, 'Ian is back here at our place, and you're not going to like what you see.'

Ian turned up at the Minerva and he did look terrible. In six months he seemed to have aged. He had dyed his golden hair bright red and had a sort of green glitzy make-up around his eyes. He wore a woman's tweed jacket and a horrid flowery shirt which looked like a blouse. At least he was wearing trousers.

He was completely broke, he said, but that was all he had to say. I had heard that he had asked Bernard Quigley to sell the house in Newtown. Everything had gone up in smoke, I presumed. Anne said, 'Do not bring him back to the Posticcia, you'll never get rid of him.' But I had to, he had nowhere to go. The studio-flat in Trastevere was tenanted.

The La Farges had bought a house in Tuscany at Cacciano, a nearby deserted village. They made it, heroically, into a beautiful home.

It was November and I was in for a nervous winter. It was back to Lou Reed and the Hot Rats, Led Zeppelin, no conversation. Resentment was all I got, and the feeling that I was old and square.

Then Ian's sister Anne turned up. She had been in London and became involved in the lives of the Rolling Stones. She was completely inert, and when I was around said nothing. I suppose she talked to Ian. I was back to all the shopping and cooking. Then David Bent arrived—I was running a drug-rehabilitation centre for the Bent children. David was the most agreeable of them and talked, and helped do dishes and petty chores, but he moved on.

Christmas and New Year 1975 were spent at Posticcia Nuova. I left the silent pair for these feasts and had Christmas dinner with the La Farges, as well as New Year's Eve.

By the end of February I was fed-up with it all, and I bribed Ian to leave. I had told him how I had lived in Procida, and why shouldn't he try that? Anyway I got him off my hands and he went to Procida with the silent Anne.

It didn't occur to me that he would take Oliver and Albertino with him, but he insisted, and I was left alone again, with not even a dog!

We needed to have the studio back, and after a little

harassing and help from Freddie, Ian and Anne were able to move up to Rome and into the studio. Procida had not been a success, and it was wiser not to ask what happened.

Things started to go better in 1975. Ian was temporarily off my hands, and in March and April Desmond Gregory and I motored around Turkey. Desmond was a historian, an old friend of Mic's. We visited Hittite ruins at Bogazkale, wondrous in the snow north-east of Ankara, and then down to the magnificent southern coast, seeing early Greek cities such as Xanthos, Didyma, Miletus and Priene.

The last named, for example, must have been a breath-taking city. It is placed around and above a natural harbour, and immediately behind it high mountains protect it from the north winds. I have seen some of the fragments of the great buildings, in London and Berlin. An extraordinary marble city on the Mediterranean Sea.

Rose Macaulay wrote about the pleasure of ruins, but this journey around the Greek Turkish coast is unrivalled, it is so beautiful, the cities are so perfectly situated. A lot of it required diligence in making out just where the sites might be. There were no signs, no tourists: that came later. We just had to rely on books, and when a knowledgeable guess yielded a ruin, and we actually found the site of ancient Didyma, for example, it was exciting. You can usually guess where the main square was, and working from that, locate the theatre, the treasury, and the main temple. Desmond, being a historian, was a great help. With a picnic lunch, we could devote a day to pottering around a site.

My homecoming from Turkey was very pleasant. I stayed at the Minerva because Ian was in the studio, and came home next day with the writer Robert Katz, a near neigh-bour. I found a letter from Ermes De Zan saying that he could come over for the summer, and was arriving in June.

Looking at my diary for April, I see I was entertaining and going out quite a lot. Other neighbours were Alexander Chancellor and his wife Susannah, and the La Farge family were comfortably installed at Cacciano. It was a steep difficult road to get there, to reach their mountaintop house and garden.

While I was in Rome my old friends Anne and Laurie Le Guay had divorced, and Anne had married Dick Cobden. Anne was a wonderful and very funny woman, and she and Dick were very happy.

Anne had two daughters, Melanie and Candy. Dick Cobden rang from Sydney to say that Melanie had fallen off a cliff and died. I was very fond of her, we had been corresponding for years. I had her last sweet letter with me. Anne had to break the news to Candy, who was studying Italian at Perugia University. Could I please meet Anne, who was on her way, at Rome and take her to Perugia? It is impossible to console someone when you can't find a way to console yourself, but I went to Rome and met a distraught, jet-lagged Anne who arrived about 7.30 a.m.

We set off for Perugia and we were so distressed I got lost. We arrived there at lunchtime and found the school. I waited in a courtyard, while inside I heard Candy starting to scream as she heard the news.

Then the two of them were screaming together. It was a terrible sound. After some time, I went in to them—I knew they couldn't go on like this. I appealed to Anne. I reminded her of how she had always been a stickler for good manners. Now was the time when her training would help her. She and Candy were upsetting the whole school. Why should everyone else also become distressed?

Somehow or other, it worked, and I got them to the car.

Next day, I managed to persuade Anne to do some cooking for us. She was a magnificent cook, and this helped her, I am sure.

―――――――

Ermes De Zan had telephoned from Pordenone. He was coming down by motor car. A friend of his family was driving south and would drop him off at 'nearby Borgo San Sepolcro'—an hour and a half's drive from me. He arrived two days after Anne and Candy.

I went over and collected him opposite the Duomo there. It was Friday, 13 June, which in Italy is not an unlucky day, certainly not for me. It was the beginning of the happiest time in my life.

It must have been strange for Ermes to find the tragic situation here, but he dealt with it magnificently.

Anne and Candy found a flat in Rome and I put them on the train. I think they were recovering a little.

My diary for this time shows a lot of social life, and then I was ill for five days, a temperature—I hadn't been ill for years. The doctor said I had glandular fever. '*Non si scherza con quest malattia*,' he said, so I took it seriously, perforce, I was feeling so ill.

―――――――

After Ian left me, I became even closer to Germaine. She was much sought after in the Cortona area. Her vitality would liven up the dullest party, and she was beloved by my friends over here.

We were all enjoying ourselves one evening, around Germaine's table, when she suddenly had a turn. There was

Ermes and me, George and Ronald and writer David Malouf. She suddenly stopped serving the food.

I understood. It must have dawned on her: 'Here I am, the arch high-priestess of Women's Liberation, and what am I doing—I'm waiting on a whole lot of chappies and I'm back to the medieval scene. Enough!'

We all swore she wasn't to do another thing—*we* would wait on her. *We* had no hang-ups, we boasted.

Just a few months later, she suddenly decided to up and go—typical of her. She walked out of her beautiful cottage and garden, and I've never properly understood why. The place was sold too cheaply, and I miss her still.

EIGHTEEN

AT THE end of June Ian telephoned from Rome to say he had decided to go back to Australia, to live there. He would leave early in August. Ermes and I drove down to the studio and collected Oliver and Albertino, who was ill; his back legs weren't working. He had hepatitis, contracted I suspect because Ian and Anne had dirty needles. When I saw Albertino's terrible plight, his helplessness, I lost any tolerance I may have had for drug-takers—they are self-indulgent monsters.

We came back with the dogs, but Albertino's back legs still seemed paralysed. I took him in to the vet at Arezzo who said that Albertino, who was in his prime, was not going to recover, and it would be better for him if I made a decision about it, so I made it.

When the nurse, who was taking him away, said, 'Would you like to keep his collar?' I said no, and then burst into tears in front of all the people waiting with their dogs. It was not *bella figura* for everyone to see this mature foreigner weeping in front of them. I think I wept about the whole mess of my life.

One of the first things to do was to show Ermes his studio. It had been cleaned up, but easels and tables and chairs

447

remained. There were a lot of plywood boards provided, and even an anatomical plastic sculpture installed, for reference.

It was never used. Ermes did put his painting equipment there, but very soon added a Black & Decker drill, an electric saw, and a tool bench were added. Agricultural equipment was acquired and some sophisticated water pumps.

He started clearing bits of the wood that was encroaching around the house; blackberry bushes seemed to be able to advance a metre a month.

Ermes said I needed some more planting, so we went to a nursery and soon he was transforming the place—there was no garden at all when he came. He only had two months before he went back to America, but by the time he left I had the beginnings of what has become a much admired garden.

His studio acquired a lot of gardening equipment—spades, forks, hoses—and he left with emphatic instructions for Benvenuto to clear certain areas.

Ermes had finished his course at Yale, and with his degree had secured a post at Dartmouth College at Hanover, in New Hampshire. He was assistant professor of fine art in a snob university, one of the Ivy League ones I was told.

Anyway, he wouldn't be back until the Christmas holidays. I had lots of visitors and made several trips to Rome. Now that I had the studio again, I could entertain friends down there. I was working for another exhibition with Rudy Komon, next year, in 1976.

The news from Hanover was all good. The school was too waspy. It was cold. His flat was tiny, with low ceilings his landlady was apathetic, and he didn't find any of his colleagues very friendly. There was no contact with anyone much. I pretended to sympathise, but secretly hoped it would get worse and then he'd throw the job in. I prayed for a really cold

winter over there; and he wrote how lonely he was. I was so pleased, things were going well.

Ermes returned early in December, and we spent Christmas at the hot springs at Saturnia with Adrian and Alfredo. Some days in Rome, then early in January 1976 he had to return to his Via Crucis.

My friends in Cortona, painter George Deem and writer Ronald Vance, were reassuring. They said Ermes was bound to throw it in. It didn't take long for Ermes to decide. He wrote in January that he had decided to resign, although he was contracted to work for one academic year.

I thought it might be good if Ermes came to London for Easter as he had never been there. The Redfern Gallery was helpful and arranged a house exchange for me. It was a splendid arrangement. I was getting a flat in West Halkin Street, overlooking Belgrave Square. It belonged to Eardley Knollys and he and a friend, James Lees-Milne, motored down to the farm. It was a great pleasure to meet Lees-Milne. I had admired his books very much; his diaries are full of cold English houses. I fear now he had a cold Italian one. I think they nearly died of cold. They had the fire, but I had turned the heating off, thinking it was unnecessary in April. But it was a very cold spring in Tuscany unfortunately, and I think my house-sitters were cheesed-off.

It wasn't so cold in London, and Ermes turned up, happy to be away from Dartmouth. As we neared the flat, going through Belgrave Square, he remarked how surprised he was to see London was on such a human scale. I had to point out that this was far from being typical London.

Eardley Knollys said I could arrange bread and milk deliveries with the help of a Mrs Partridge, who lived in the flat below. When I knocked on her door and met her, I realised she was Frances Partridge, famous for her

449

Bloomsbury connections. A few days later she invited us in for a drink. I saw Carrington's much reproduced portrait of Lytton Strachey, several Duncan Grants, and a fire screen by Boris Anrep, who did all the mosaics on the floor of the entrance to the London National Gallery. Not many visitors to the gallery are aware that they walk over the faces of Greta Garbo, Tallulah Bankhead, Virginia Woolf, Clive Bell, Bertrand Russell and many others. It is a Bloomsbury bacchanal. It is one of those quiet British absurdities.

Ermes had a pretty glitzy time. The Bach St Matthew Passion, at St Mary's Marylebone with Janet Baker, then Heitinck conducting at the Festival Hall, and Barry Humphries got us a box for his Edna show. When it came to Gladdie Time, Edna—who had already rudely referred to senior citizens in the box—strenuously tried to pitch a gladioli into ours. She kept missing. Finally, the gladdie landed on the padded railing, and I could feel Barry's nervous energy in the stalk. Later, we were walking down Piccadilly and talking about the show, Sandy Stone and Barry's other characters. It was the first time I'd seen Sir Les and I'm so dim I didn't realise it was Barry. I asked him, 'Who is the actor you got to do that terrible Sir Les part?' and even as I was asking the question, the pleasure on Barry's face told me who it was.

I saw Ermes off on his flight to Boston, and I started the two-day drive home, already looking forward to June or July, when he would be returning to live in Italy.

NINETEEN

ERMES HAD been in the States for three years, and in this time had collected some books and some cooking equipment and some strange clothing, things mainly purchased at 'garage sales'. Anyway, he had too much stuff to be able to fly, so he came by sea.

He'd been with me a week when I received a distressing letter from Ian. It was written from an address in Bondi Junction, from a house he shared with a group of junkies. I imagined they pooled their welfare money.

Ian had decided to come back, after all, after having left me well over two and a half years before. It was difficult to write it but I had to send him a long letter explaining that it was impossible for him to return. I tried to tell him some of the reasons why; it was a long letter and I'd put a lot into it. Unfortunately, I posted it to the address he had given me, and when I was in Sydney a few months later, I saw him. I could not be sure if he ever saw this letter, he was so vague. Despite this, I am sure he has convinced himself that he was ditched in favour of Ermes. The truth was I had given up any hope long before I met Ermes. I had lost all hope in Paris, when Claude Bernard showed me the tiny Minnie Mouse drawing.

———

I keep an appointment diary to remind me when we entertain or are to be entertained. I note that for the first few weeks Ermes was here, we saw almost no one, and besides the profound happiness, I also recall completely idyllic weather.

The lower studio has not been used much, and it now serves as a general repository for gardening equipment. The garden, on the other hand, has been transformed, and over the years I see the wisdom of Ermes's planning, the general design becomes more apparent. Although I have little botanical knowledge, I am impressed with the exclamations of approval which come from the experts as they go around, many of these praises expressed in obscure Latin botanical names.

We've had lots of visitors since Ermes came to live here, and sometimes I wonder if we shouldn't have an index to our visitors' book, so people can work it out—some of the signatures are illegible. But we have Australian prime minsters and governors-general, artists like Francis Bacon, film stars, and one of the most illegible names is Richard Gere's. No one here recognised him with his grey hair. Luciana Arrighi came over with her Oscar.

———————

Posticcia Nuova, like most of the farmhouses in Tuscany, was built by the feudal lords who needed labourers to work the olives and vines and pasture. Sometimes they housed several families.

With agricultural mechanisation, the larger farmhouses became redundant, and the labourers shifted to the towns and cities. This is why there were so many farmhouses for sale in the fifties and sixties, and why they sold for such low

prices. Most of the farmhouses, like Posticcia Nuova, were built in the 18th century; of course there are many much simpler ones that are earlier.

When I purchased Posticcia Nuova from Franz Oneto in 1971, it had little land. I only needed enough to ensure privacy. But Ermes, when he settled here five years later, indicated he wanted more land, more woods and more arable area.

By acquiring adjoining pieces of property he has restored Posticcia Nuova to what it was 250 years ago, a working farm. Each acquisition has involved tortuous and sometimes harrowing negotiations with the sellers.

By lavish but judicious use of the modern earthmover, Ermes has transformed the topography of the property. He has been able to move hillocks and huge boulders, bury rocks under roads he has built in the woods, and add rich earth where there was none. He has done things for which you would have needed fifty men for months in the last century. Some of the terraces have been turned into a gently sloping field, to produce more feed.

When he had less land he had goats, but they eat everything and are hard to contain. Their smell is ubiquitous. As he now has enough flat land to produce fodder, he believes he can run sheep economically. The number of his flock is pathetic in comparison with those of Australian producers, but land values are many times higher here, as well as the price of a sheep.

This area is well known for its olives, and Ermes has increased the number of olive trees many times over. We sell our olive oil; it is very expensive because it costs a lot to produce.

EPILOGUE

MANY OF my paintings have their origin in a passing glance. Something I have seen catches my eye, and I cautiously rejoice because it might be the beginning of a painting. Sometimes it is impossible to stop and sketch there because it was seen from a train or from a fast moving car on the autostrada. And it does happen that when I get back to the place, I wonder what on earth it could have been that enchanted me—it wasn't there. Enchantment is the word for it.

'An artist must first be moved, if he is to move others,' said J. F. Millet. It is not something I care to think about. I cannot analyse my own feelings about 'inspiration', which it must be. A delicate thing not to be handled or bandied about.

Gertrude Stein stated that views from art gallery windows are the most beautiful of all. When you have become very involved in looking at painting in a museum, it suddenly becomes a marvel to see 'the real thing' from a window, because our vision has become heightened.

When I was very young, I had seen *Keswick Siding* many times from the suburban train between Unley Park and Adelaide. Eventually I decided to do something about it, but it was difficult. The siding was on railway property, so I had to

get off at Keswick station and climb down from the platform with my easel and gear and camera, and walk along the tracks with trains rushing past. Once work is started there is always the possibility of an officious railway worker ordering you off the site.

Almost fifty years later the *Portrait of Clive James* came about in the same way. I was staying with friends in Tokyo and was on the train, returning from a tourist excursion, and I saw this marvellous yellow fence. It was much more difficult to get back to than finding Keswick Siding.

Sometimes I am asked if it doesn't seem incongruous that I am painting autostradas and traffic signs while I am living in the beauty of the countryside. If I say that Shakespeare wrote mainly about court life, but never attended it, it might sound pretentious.

So I never know what to say, except that this environment is conducive to work, and that on my frequent forays to Arezzo and Florence, I see a lot of that modern world which I like to paint.

Painters don't retire and go on a pension at 65. Indeed, I have noticed that as a profession, we seem to be able to go on working despite the deprivations of old age. I remind myself of Titian, who worked up to the end of his life, until he was 98, and that is how I should like to be.

POSTSCRIPT

IT IS now twelve years since I wrote that epilogue. What has happened in that time? It has been the happiest and most productive period of my life, mainly thanks to Ermes who leaves me free to work, unimpeded.

I feel that perhaps my painting is better than ever before, but watch it; this might be the dreaded Catch 22! Perhaps my judgment is impaired by vanity and my great age? But I am quite sure that my standards of value have been raised.

Our journalist friend and neighbour, Alexander Chancellor, has told me that good news is no news, only bad news makes news for the papers. So here I must say it's been good news all the way, and so perhaps too boring to write about. Ermes has created the most beautiful large garden, which has become well known, and groups of tourists even pay good money to him for a walk around it to see his many imported plants.

Both Arezzo and Montevarchi, our nearest large towns, have become much larger. There are more factories—light industry of course—and many more blocks of flats to accommodate the numbers of southern Italians who have come north, attracted by work and better living conditions. I find my subjects for pictures coming ever closer. We are still

456

removed from it all in our beautiful little valley, and I have been able to acquire more land to ensure our privacy.

Most reluctantly, we decided we had to put entrance gates down on the road. Not a thing that appealed to me because, after all, Posticca Nuova is a farmhouse, not a villa. By virtue of an old Roman law, citizens are allowed to walk within a hundred metres of a country house, but few people know about that, and those who do, ignore it. But it became obvious we needed gates when one day we returned from Arezzo and were surprised to see a large shiny car in our garage. A man appeared and showed me a bag of mushrooms—'Good ones, you have here, look at these.' I asked him where he came from and he said he was from Perugia. I asked him if he had a garage there and he said of course he had. 'Well then,' I said, 'next time I go to Perugia may I use your garage?' He seemed very indignant at this, and exclaimed, 'No one has ever spoken to me like this', and drove off in a huff—with our mushrooms.

The other incident was worse. I was working on a difficult painting when I heard a car come up the drive, stop and then drive off. I took no notice of this, as people often come delivering things. But then I heard a woman's voice, so I went to the studio door and saw a man and a woman I didn't know standing in front of the house. When she saw me, she screamed, 'That's him, that's Jeffrey Smart!' Then she explained they had come all the way from Adelaide just to see me! They had certainly worked at it. Staying at Arezzo, they had studied the bus schedules and finished up at the petrol station, where they'd asked where I lived and a good-hearted neighbour drove them here and then left.

So I had them on my hands, in the middle of a difficult bit of painting. I asked the man what his job was in Adelaide.

He taught Physics at a high school, so I said, 'What would you do if I showed up at your classroom while you were teaching?' And he said he would have to go on with his lecture. 'And that's what I'm going to do, except I'll have to interrupt my work and drive you back to the petrol station.' When I got the car out and opened the door for his wife, she said '*This* I do not believe,' and was very disgruntled. She kept repeating this as I drove them down to the petrol station. So that day I lost two fans.

Christmas of 2006 was spent in Spain. In the Prado, in Madrid, we saw again the great 'The Deposition' of Rogier van der Weyden. I had quite forgotten how truly magnificent it is. Perhaps the greatest painting in the world?

I had once formed a list of what I considered the best pictures ever made. (In Sydney Jean Bellette and Tas Drysdale called it 'Doing the race horses'.)

My list was:

1. 'The Flagellation', Piero della Francesca.
2. 'The Resurrection', Piero della Francesca
3. 'Madonna and Child with Saints', Giovanni Bellini, in S.Zaccheria in Venice.

But now my list has been changed, because I had not included 'The Deposition', which of course has to be number one.

In Madrid I also saw again Picasso's great masterpiece, 'Guernica', splendidly displayed with all the studies he made for it, indicating how he seemed to invent a special style for perhaps the greatest work of the twentieth century.

Returning to van der Weyden, he has had a great effect on me and my work. If a painter as great as he can go into as much laborious but beautiful detail, then so can I. Yes, he probably had helpers, but so many of the details indicate such mastery that they must be the master—such assurance!

And so I find myself shamed by his humility, his devotion to his work. I am now paying much more attention to my figures, the texture on a concrete wall, the details on the back of a truck. The most ubiquitous thing of our time is the motor car. How many artists paint them with care, and not depicted as in over-blown photographs, like we see in pop art? They are so important I feel they should be painted with respect.

Jean Cocteau said, 'Every time I look in the glass, I see Death at work.' How true, I am eighty-six turning eighty-seven, and daily becoming more grotesque in my appearance and my walk. I have to sort of shuffle along and any rapid movement makes me dizzy. Going up stairs reminds me that my knees will need treatment if I survive much longer. To add to my geriatric woes, most sinister of all, I am showing signs of arthritis. Yes, I know Renoir and Matisse had the same trouble. But Renoir's work is often so woolly, and Matisse could get away with large areas of flat colour. How can a devotee of Rogier van der Weyden cope with this impediment?

We travel quite a lot. I find it stimulating even though I reflect that Vermeer most probably never moved out of Delft. But it is so easy now, with the internet and the jumbo jet. Aerodromes provide wheelchairs for the cripples and semi-cripples, making it so much easier for the very senior citizens, who, if they can afford it, can even go to bed in an aeroplane for the long hauls.

Occasionally I am asked what I believe. By this, I suppose, is meant do I believe in God. All attempts to define God are surely doomed to fail, 'Theology' can be interpreted as 'God in Words'. This has led to bloody wars, all over the planet, for thousands of years. But it has all been said, quite clearly, by Plato in Book VII of *The Republic*. Socrates' analogy of the

cave is, to my mind, the perfect conception of our situation – written in about 360 BC, it has never been bettered.

Sometimes I receive intimations that I've become famous—without having to die young. In Sydney, I went up to the ticket office of the Opera House and booked some seats. The girl asked for my credit card, so I slid it across. As she was recording the details she exclaimed, 'You're not *the* Jeffrey Smart!?' I confess I felt a lovely, warm surge of ego-fruit when I said, with easily assumed pomposity, 'Yes, I am indeed *the* Jeffrey Smart,' and we both went into fits of laughter.

Tuscany, 2008

INDEX